T0260959

Zwischen Karten

ARS ET SCIENTIA

Schriften zur Kunstwissenschaft

Band 25

Herausgegeben von
Bénédicte Savoy,
Michael Thimann und
Gregor Wedekind

Amrei Buchholz

Zwischen Karten

Alexander von Humboldts
Atlas géographique et physique
des régions équinoxiales
du Nouveau Continent

De Gruyter

Diese Publikation entstand im Rahmen des DFG Graduiertenkollegs 1539 Sichtbarkeit und Sichtbar-machung. Hybride Formen des Bildwissens an der Universität Potsdam und wurde durch die Deutsche Forschungsgemeinschaft (DFG) ermöglicht.

Die Dissertationsschrift wurde am 15.12.2014 unter dem Titel *Alexander von Humboldts Modell der Erdkruste. Vergleichendes und verknüpfendes Sehen im „Atlas du Nouveau Continent"* an der Fakultät Bildende Kunst der Universität der Künste Berlin eingereicht und dort am 19.01.2016 erfolgreich verteidigt.

ISBN 978-3-11-063807-3
eISBN (PDF) 978-3-11-069083-5
ISSN 2199-4161

Library of Congress Control Number: 2020931172

Bibliografische Information der Deutschen Nationalbibliothek
Die Deutsche Nationalbibliothek verzeichnet diese Publikation in der Deutschen Nationalbibliografie; detaillierte bibliografische Daten sind im Internet über http://dnb.dnb.de abrufbar.

© 2020 Walter de Gruyter GmbH, Berlin/Boston

Satz: Kösel Media GmbH, Altusried-Krugzell
Coverabbildung: Alexander von Humboldt, Limite inférieure des Neiges perpétuelles à différentes Latitudes, 1814, Berlin, SBB, Foto SBB
Druck & Bindung: Beltz Grafische Betreibe GmbH, Bad Langensalza

www.degruyter.com

Inhaltsverzeichnis

segnius inritant animos demissa per aurem
quam quae sunt oculis subiecta fidelibus

(Schwächer jedoch wirkt auf uns, was man nur den Ohren vertraute,
als was vor Augen uns liegt)

Horaz, *De arte poetica*

Einführende Überlegungen

Landkarten begleiteten Alexander von Humboldts Leben und Wirken schon sehr früh. In seiner letzten großen Publikation, *Kosmos. Entwurf einer physischen Weltbeschreibung*, erinnert er sich zurück an eine in der Kindheit verspürte „Freude an der Form von Ländern und eingeschlossenen Meeren, wie sie auf Carten dargestellt sind"[1]. Nahezu über die gesamte Dauer seiner Forschungstätigkeit verfolgte Humboldt (1769–1859) die intensive Kartenlektüre und die kartographiehistorische Analyse ebenso wie eine umfangreiche eigene Produktion topographischer Karten. Eine Reihe von ihnen gab er zusammen mit Aufsätzen heraus, insbesondere publizierte er aber zwei Atlanten mit entsprechendem Kartenmaterial.[2]

Trotz Humboldts langjährigen, anhaltenden Interesses an dieser Thematik wurden bislang nur einzelne wissenschaftliche Untersuchungen vorgelegt, die sie zentral behandeln. Während zu einigen Aspekten von Humboldts Kartographie, etwa zu der klimatologisch bedeutenden *Carte des lignes Isothermes*[3] (Abb. 6) oder der *Carte itinéraire de l'Orénoque*[4] (Abb. 5), die die Verbindung der Flusssysteme des Orinoko und des Amazo-

1 Humboldt, Alexander von: *Kosmos. Entwurf einer physischen Weltbeschreibung*, Bd. 2, Stuttgart/ Tübingen: Cotta 1847, S. 5.

2 Es handelt sich um den *Atlas géographique et physique des régions équinoxiales du Nouveau Continent*, Paris: verschiedene Verleger 1814[–1837], und den *Atlas géographique et physique du royaume de la Nouvelle-Espagne*, Paris: Schoell [1808–]1811. Humboldt selbst bezeichnete neben seinen topographischen Atlanten auch zwei weitere Bände, die Graphiken enthielten, als „Atlanten": die *Vues des Cordillères, et monumens des peuples indigénes de l'Amérique*, Paris: Schoell 1810[–1813], die ebenfalls zum Reisewerk gehören, und die *Umrisse von Vulkanen aus den Cordilleren von Quito und Mexico. Ein Beitrag zur Physiognomik der Natur*, Stuttgart/Tübingen: Cotta 1853, die den *Kleineren Schriften* zugeordnet sind. In den *Kleineren Schriften* griff der bereits über achtzigjährige Humboldt wesentliche seiner wissenschaftlichen Aufsätze erneut auf und führte sie zusammen. Auch bei dem zugehörigen „Atlas" handelt es sich überwiegend um eine Kompilation zuvor publizierter Stiche.

3 Humboldt, Alexander von: *Carte des lignes Isothermes*, 1817, 19,5 × 24,3 cm; Stich: Adam, *Annales de Chimie et de Physique* 5 (1817). Die Karte erschien zusammen mit Humboldts Aufsatz „Des lignes isothermes et de la distribution de la chaleur sur le globe", in: ebd., S. 102–111.

4 Bei der *Carte itinéraire du cours de l'Orénoque, de l'Atabapo, du Casiquiare, et du Rio Negro offrant la bifurcation de l'Orénoque et sa communication avec la Rivière des Amazones* handelt es sich um die Tafel 16 aus Humboldts *Atlas géographique et physique du Nouveau Continent*.

nas zeigt, umfangreichere Erläuterungen existieren, haben andere so gut wie keine Berücksichtigung gefunden. Vor allem lässt sich hinsichtlich der Konzeption der geographischen Atlanten ein Desiderat feststellen.[5] In besonderem Maße betrifft es den *Atlas géographique et physique des régions équinoxiales du Nouveau Continent* (im Folgenden: *Atlas géographique et physique du Nouveau Continent*), dessen 39 Tafeln (Taf. II – XII, Abb. 18 – 22) zwischen 1814 und 1837 in Paris erschienen.[6] Die hier vorgelegte Publikation liefert nun eine erste Analyse des Aufbaus und der Genese des Bandes.

5 Von einem Forschungsdesiderat sind beide Atlanten Humboldts betroffen, wenngleich in unterschiedlichem Maße. Der Kenntnisstand zu ihnen stehe, wie Hanno Beck noch im Jahr 2000 kommentiert, „nach wie vor im krassesten Widerspruch zum Weltruhm Humboldts". Beck, Hanno: „Alexander von Humboldt – Kartograph der Neuen Welt. Profil des neuesten Forschungsstandes", in: *Die Dioskuren II*, hg. von Detlef Haberland u. a., Mannheim: Humboldt-Gesellschaft für Wissenschaft, Kunst und Bildung 2000, S. 45 – 68, hier S. 65. Ein praktischer Grund für die fehlende Auseinandersetzung mit Humboldts Atlanten findet sich darin, dass der hierfür wesentliche Teil von Humboldts wissenschaftlichem Nachlass lange Zeit als verschollen galt. Er wurde in den 1970er Jahren wieder aufgefunden und befindet sich in der Handschriftenabteilung der Biblioteka Jagiellońska in Krakau. Unter den dort verwahrten Unterlagen befinden sich auch zwei Mappen mit solchen zum *Atlas géographique et physique du Nouveau Continent*. Sie enthalten vor allem Kartenskizzen und -pausen, Messreihen, Briefe und editorische Notizen Humboldts. Vgl. BJK, HA, Nachlass Alexander von Humboldt 8 (acc. 1893, 216), 1. und 2. Teil, nicht foliiert. Ich danke Dr. Monika Jaglarz der HA der BJK für ihre Unterstützung. Inzwischen steht der gesamte wissenschaftliche Nachlass Humboldts auch online zur Verfügung unter http://humboldt.staatsbibliothek-berlin.de/werk/ (zuletzt aufgerufen am 09. 01. 2019). Dass der Krakauer Nachlassteil heute bekannt und partiell ausgewertet ist, ist insbesondere den Publikationen Ulrike Leitners zu verdanken. Vgl. u. a. Humboldt, Alexander von: *Von Mexiko-Stadt nach Veracruz. Tagebuch*, hg. von Ulrike Leitner, Berlin: Akademie-Verlag 2005; Leitner, Ulrike: „»Anciennes folies neptuniennes!« Über das wiedergefundene »Journal du Mexique à Veracruz«", *HiN* III (2002) 5, o. S. Vgl. zur Nachlassgeschichte Erdmann, Dominik/Weber, Jutta: „Nachlassgeschichten – Bemerkungen zu Humboldts nachgelassenen Papieren in der Berliner Staatsbibliothek und der Biblioteka Jagiellońska Krakau", *HiN* XVI (2015) 31, S. 58 – 77; Erdmann, Dominik: *Alexander von Humboldts Schreibwerkstatt – Totalansichten aus dem Zettelkasten,* bislang unveröffentlichte Dissertation.

6 Für bibliographische Angaben zum *Atlas géographique et physique du Nouveau Continent* siehe Fiedler, Horst/Leitner, Ulrike: *Alexander von Humboldts Schriften: Bibliographie der selbständig erschienenen Werke*, Berlin: Akademie-Verlag 2000, S. 152 – 169. Zu den wenigen Bemerkungen, die zur Konzeption des Atlas bislang vorgelegt wurden, zählen vor allem Ette, Ottmar: „Nachwort: Zwischen Welten – Alexander von Humboldts Wege zum Weltbewußtsein", in: Humboldt, Alexander von: *Kritische Untersuchung zur historischen Entwicklung der geographischen Kenntnisse von der Neuen Welt. Mit dem geographischen und physischen Atlas der Äquinoktial-Gegenden des Neuen Kontinents*, Frankfurt am Main: Insel 2009, S. 227 – 241; Beck: „Humboldt – Kartograph der Neuen Welt", 2000, S. 48 – 52. Einzelne Karten des Atlas werden vereinzelt erwähnt; vgl. diesbezüglich vor allem: Beck, Hanno: „Profil – Reliefmodell – Panoramakarte – Reliefkarte – Hochgeprägte Reliefkarte. Das Problem der dritten Dimension in Geographie und Kartographie und die relieforientierte Geographie der Zukunft", *Speculum Orbis* 1 (1985), S. 24 – 28; ders.: „Die Geographie Alexander von Humboldts", in: *Alexander von Humboldt: Leben und Werk*, hg. von Wolfgang-Hagen Hein, Frankfurt am Main: Weisbecker 1985, S. 221 – 238; ders.: „Alexander von Humboldt als größter Geograph der Neuzeit", in: *Die Dioskuren. Probleme in Le-*

Alexander von Humboldt und die Kartographie

Alexander von Humboldts kartographisches Schaffen steht in engem Bezug zu einem von ihm maßgeblich mitgeprägten wissenschaftsgeschichtlichen Paradigmenwechsel: Das Interesse an einer deskriptiven Taxonomie der vordisziplinären Naturgeschichte, die wissenschaftliche Objekte akkumulativ gesammelt und gereiht hatte, verschob sich um 1800 auf deren dynamisches „Ineinanderwirken"[7] und damit auf Prozesse der „Wechselwirkung"[8] in der Natur.[9] Diese natürlichen Dynamiken ließen sich aber nur dann nachvollziehen und darstellen, wenn auch die Umgebung, in der sie vonstattengingen, genau bekannt und soweit möglich beschrieben war. Dementsprechend gewann die präzise Erfassung der Topographie der Erdoberfläche, deren verbreitetes wissenschaftliches Darstellungsformat die Karte war und ist, für Humboldt an grundlegender Bedeutung. Das Kartenbild verlieh den Beobachtungen von den Dynamiken der Natur einen fixierenden Rahmen. Je genauer hierbei die topographische Grundlage erfasst war, desto präg-

ben und Werk der Brüder Humboldt, hg. von dems. und Herbert Kessler, Mannheim: Humboldt-Gesellschaft für Wissenschaft, Kunst und Bildung 1986, S. 126–182, hier S. 154–155; Debarbieux, Bernard: „Mountains between Corporal Experience and Pure Rationality: Buache and von Humboldt's Contradictory Theories", in: *High Places. Cultural Geographies of Mountains, Ice and Science*, hg. von Denis Cosgrove u. a., London: Tauris 2009, S. 87–104; ders.: „The Various Figures of Mountains in Humboldt's Science and Rhetoric", *Cybergeo: European Journal of Geography* 21 (2012), o. S.; Kraft, Tobias: „Die Geburt der Gebirge", *Arsprototo* 1 (2014), S. 32–36; Pérez Mejía, Ángela: „Sutileza de la producción cartográfica en el mapa del Orinoco de Humboldt", *Terra Brasilis* 7/8/9 (2007), S. 2–11; dies.: *La geografía de los tiempos difíciles: escritura de viajes a Sur América durante los procesos de independencia 1780–1849*, Medellín: Edición Universidad de Antioquía 2002; Schäffner, Wolfgang: „Topographie der Zeichen. Alexander von Humboldts Datenverarbeitung", in: *Das Laokoon-Paradigma. Zeichenregime im 18. Jahrhundert*, hg. von dems., Inge Baxmann und Michael Franz, Berlin: Akademie-Verlag 2000, S. 359–382; ders.: „El procesamiento de datos de Alexander von Humboldt", *Un colón para los datos: Humboldt y el diseño del saber*, erschienen in der Reihe *Redes. Revista de Estudios Sociales de la Ciencia* 14 (2008) 28, S. 127–145; Sherwood, Robert M.: *The Cartography of Alexander von Humboldt: Images of the Enlightenment in America*, Saarbrücken: VDM 2008.

7 Vgl. beispielsweise Alexander von Humboldt zitiert nach Gilbert, Ludwig Wilhelm: „Beobachtungen über das Gesetz der Wärmeabnahme in den höhern Regionen der Atmosphäre, und über die untern Gränzen des ewigen Schnees, von Alexander von Humboldt (im Auszuge)", *Annalen der Physik* 24 (1806), S. 1–49, hier S. 2. In den *Ideen zu einer Physiognomik der Gewächse* spricht Humboldt von einem „geheimnissvolle[n] Ineinander-Wirken des Sinnlichen und Aussersinnlichen". Humboldt, Alexander von: *Ideen zu einer Physiognomik der Gewächse*, Tübingen: Cotta 1806, S. 14.

8 Auf seiner Reise durch Südamerika notierte Humboldt in seinem Tagebuch den später viel zitierten Satz „Alles ist Wechselwirkung". Humboldt, Alexander von: *Reise auf dem Rio Magdalena, durch die Anden und Mexico, Teil 1: Texte*, hg. von Margot Faak, mit einer einleitenden Studie von Kurt R. Biermann, Berlin: Akademie-Verlag 2003, S. 358.

9 Siehe zu dieser wissensgeschichtlichen Entwicklung Lepenies, Wolf: *Das Ende der Naturgeschichte: Wandel kultureller Selbstverständlichkeiten in den Wissenschaften des 18. und 19. Jahrhunderts*, München: Hanser 1976, insbesondere S. 52–61.

nanter ließen sich auch die auf der Erdoberfläche ablaufenden Naturprozesse verorten und veranschaulichen. Vor diesem Hintergrund erklärt sich, dass Karten für Humboldt „in einem neuen, auch heute noch fortschrittlichen Sinne die Grundlage seiner Forschungen [bildeten], die er in ihrem räumlichen Bezug und ihrer Wechselwirkung zu verstehen versuchte"[10]. Es greift daher zu kurz, Humboldts kartographische Tätigkeit als eine seiner vielen wissenschaftlichen Interessen zu bezeichnen, vielmehr handelte es sich bei ihr um ein basales Element seiner epistemischen Praxis.[11] Humboldt war sich des Erkenntnis

10 Zögner, Lothar: „Alexander von Humboldt und die Kartografie", in: *Alexander von Humboldt: Netzwerke des Wissens*, hg. von der Kunst- und Ausstellungshalle der Bundesrepublik Deutschland GmbH, Ostfildern-Ruit: Cantz 1999, S. 134.

11 Zu Humboldts kartographischer Tätigkeit vgl. v. a. Humboldt, Alexander von: *Atlas geográfico y físico del reino de la Nueva España*, hg. von der Universidad Nacional Autónoma de México, México D. F.: Siglo Veintiuno 2003; Beck, Hanno: „Landschaften, Profile und Karten aus Alexander von Humboldts Atlanten zum amerikanischen Reisewerk", *Mitteilungen: Alexander von Humboldt Magazin* 40 (1982), S. 31–38; Böhme, Hartmut: „Alexander von Humboldts Entwurf einer neuen Wissenschaft", in: *Prägnanter Moment. Studien zur deutschen Literatur der Aufklärung und Klassik*, hg. von Peter-André Alt und Hans-Jürgen Schings, Würzburg: Königshausen & Neumann 2002, S. 495–512; Engelmann, Gerhard: „Alexander von Humboldts kartographische Leistung", *Wissenschaftliche Veröffentlichungen des Geographischen Instituts der Deutschen Akademie der Wissenschaften*, 27/28 (1970), S. 5–21; Faye Cannon, Susan: *Science in Culture: The early Victorian Period*, New York: Science History Publications 1978, S. 95–102; Godlewska, Anne Marie Claire: „Von der Vision der Aufklärung zur modernen Wissenschaft? Humboldts visuelles Denken", in: *Ansichten Amerikas: neuere Studien zu Alexander von Humboldt*, hg. von Ottmar Ette u. a., Frankfurt am Main: Vervuert 2001, S. 157–194, hier S. 182; *Humboldt in the Americas – Special Issue of Geographical Review* 96 (2006) 3; Rupke, Nicolaas A.: „Humboldtian Distribution Maps. The Spatial Ordering of Scientific Knowledge", in: *The Structure of Knowledge: Classifications of Science and Learning since the Renaissance*, hg. von Tore Frängsmyr, Berkeley: Office for History of Science and Technology, University of California 2001, S. 93–116; Schäffner, Wolfgang: „Verwaltung der Kultur. Alexander von Humboldts Medien (1799–1834)", in: *Interkulturalität zwischen Inszenierung und Archiv*, hg. von Stefan Rieger, Schamma Schahadat und Manfred Weinberg, Tübingen: Narr 1999, S. 353–366; ders.: „Topographie der Zeichen", 2000; Schneider, Birgit: „Linien als Reisepfade der Erkenntnis", in: *KartenWissen: territoriale Räume zwischen Bild und Diagramm*, hg. von Stephan Günzel und Lars Nowak, Wiesbaden: Reichert 2012, S. 175–199; dies.: „Berglinien im Vergleich. Bemerkungen zu einem klimageografischen Diagramm Alexander von Humboldts", *HiN* XIV (2013) 26, S. 26–43; Sherwood: *The Cartography of Alexander von Humboldt*, 2008; Zögner, Lothar: Art. „Humboldt", in: *Lexikon der Geschichte der Kartographie von den Anfängen bis zum ersten Weltkrieg*, hg. von Erik Arnberger, Wien: Franz Deuticke 1986, S. 321–322. Eine kartenübergreifend angelegte Analyse zu Humboldts Werk wurde bislang weitestgehend vernachlässigt. Dies gilt etwa auch für Robert M. Sherwoods oben erwähnte Monographie *The Cartography of Alexander von Humboldt*. Ausgewählte Karten Humboldts werden darin lediglich in spezifischen kulturhistorischen Kontexten verortet. Auch Tobias Kraft, der unter den epistemischen Figuren in Humboldts Werk diejenige des „Atlas" untersucht, beschäftigt sich nicht mit einer kartenübergreifenden Lesart. Die von Kraft stattdessen in den Blick genommenen genreübergreifenden, transgenerischen Darstellungspraktiken beziehen sich vor allem auf Text-Bild-Bezüge. Vgl. Kraft, Tobias: *Figuren des Wissens bei Alexander von Humboldt. Essai, Tableau und Atlas im Amerikanischen Reisewerk*, Berlin: de Gruyter 2014.

generierenden Potentials der Kartenoberfläche durchaus bewusst. In einem klimatologischen Aufsatz bemerkte er in Bezug auf den „Gebrauch graphischer Mittel":

> Besäßen wir statt Länderkarten nur Tafeln, enthaltend die Coordinaten der geographischen Breite und Länge, und der Höhe; so würden eine große Zahl merkwürdiger Verhältnisse, welche die Continente in ihrer Gestaltung und die Ungleichheiten ihrer Oberfläche darbieten, für immer unbekannt geblieben sein.[12]

Für die divergenten Ansprüche, die Humboldt an seine Wissenschaft stellte, lieferten Karten einen konstruktiven Denk- und Repräsentationsraum. Sein Forschungsbereich umfasste nicht weniger als das „Naturganze"[13], wobei er von einem sehr weiten Naturbegriff ausging, der Pflanzen, Tiere und den Menschen, und mit diesem auch kulturelle Entwicklungen, mit einschloss. Das Holon der Natur sollte ganzheitlich, d.h. sowohl in seinem systemischen Zusammenwirken wie auch als sinnlich Empfundenes erfasst und zugleich auf dem neuesten methodischen und technischen Stand aufgenommen und präsentiert werden. Karten ermöglichten es Humboldt, die verschiedenen angesprochenen Aspekte gleichermaßen zu berücksichtigen: Heterogene Informationen und Themen konnten auf ihnen in unterschiedlichen, diagrammatischen[14] genauso wie figurativ-bildlichen, Darstellungsweisen kombiniert und analytisch aufeinander bezogen werden. Denn Karten sind

> ein besonders anpassungs- und wandlungsfähiges Medium, weil sie Bilder, Texte und geographisch bestimmte Linien zu einer kohärenten Repräsentation eines Teils der Erdoberfläche verknüpfen und zusammenschließen können. Gerade die Kombination verschiedener Informationstypen innerhalb eines genau definierten, im Laufe der Entwicklung immer häufiger mathematisch exakt in die Fläche projizierten Raumes macht sie so effizient.[15]

12 Humboldt, Alexander von: „Von den isothermen Linien und der Verteilung der Wärme auf dem Erdkörper", in: ders.: *Kleinere Schriften*, Bd. 1: *Geognostische und physikalische Erinnerungen*, Stuttgart/Tübingen: Cotta 1853, S. 206–314, hier S. 242–243.

13 Humboldt selbst sprach, um sein Forschungsinteresse zu beschreiben, von einem „Naturganzen". So heißt es etwas im *Kosmos*, es solle das „Zusammenwirken der Kräfte in einem Naturganzen" erfasst werden. Humboldt: *Kosmos*, Bd. 1, 1845, S. XIII.

14 Das Diagrammatische wird hier an eine Auffassung angeschlossen, nach der das Diagramm als Aufschreibesystem verstanden wird, in dem vor allem Datenkonvolute nach den Konventionen räumlicher Ordnungen miteinander in Beziehung gesetzt werden. Die auf diese Weise erlangte Darstellung erlaubt es, auch komplexe Informationsmengen schnell zu überschauen, zu beurteilen und von ihr aus auf weitere (systematische) Zusammenhänge zu folgern. Siehe Meister, Carolin: „Diagramme", in: *Räume der Zeichnung*, hg. von Angela Lammert und Frank Badur, Berlin: Akademie der Künste 2007, S. 10–11; Schneider, Birgit: „Diagrammatik", in: *Das Technische Bild. Kompendium zu einer Stilgeschichte wissenschaftlicher Bilder*, hg. von Horst Bredekamp, Birgit Schneider und Vera Dünkel, Berlin: Akademie-Verlag 2008, S. 192–196.

15 Michalsky, Tanja: *Projektion und Imagination. Die niederländische Landschaft der Frühen Neuzeit im Diskurs von Geographie und Malerei*, München: Fink 2011, S. 28.

Auf der kartographischen Oberfläche konnte Humboldt so nicht nur eine ikonische Ähnlichkeitsbeziehung zur Topographie der Erdoberfläche herstellen, die den physiognomischen, oft in situ gewonnenen optischen Eindruck von der Natur zu reflektieren vermochte, sondern auch eine auf definite geographische Daten gestützte, thematisch differenzierte, in Text und Bild vermittelte Datenaufbereitung durchführen. Eine entsprechende Verschränkung von (1) der sinnlichen Wahrnehmung der Natur, (2) der möglichst exakten geographischen Verortung und (3) einer ebenso prägnanten wie komplexen Informationsanalyse ist für Humboldts kartographisches Schaffen in weiten Teilen charakteristisch.

Mit dieser Trias ist zugleich eine generelle, Humboldts gesamte Wissenschaft umfassende epistemische Struktur benannt, die seinerzeit auf große Teile der Wissenschaftslandschaft auszustrahlen vermochte: Humboldts Herangehensweise bot eine pragmatische Lösung für das bis dahin leitende, kontradiktorische Kategoriengefüge von Empirismus versus Idealismus bzw. Aufklärung versus Romantik. Zwischen den vermeintlichen Gegensätzen baute Humboldt eine anwendungsbezogene Brücke. In seinen Karten kehrt sich dieser Brückenschlag ins Augenfällige: Präzise, vielfach numerisch gestützte Datenaufnahme und -analyse und sinnliche, ganzheitliche Naturbeobachtung verband Humboldt auf ihnen konsequent, wobei er letztlich stets auf die Beschreibung zusammenwirkender Prozesse des „Naturganzen" abzielte. Auf diese Weise vereinen seine Karten die zentralen Merkmale einer später als *Humboldtian Science* bezeichneten Wissenschaftspraxis, die weit über Humboldts Schaffen hinaus nachwirkte.[16]

Der *Atlas géographique et physique du Nouveau Continent*: ein kaum bekannter Atlas Humboldts

Den ohnehin breiten und flexibel anpassbaren heuristischen Spielraum der Karte weitete Humboldt zusätzlich aus, indem er Kartenblätter in seinen Atlanten in sinnstiftender Zusammenschau kombinierte. Hierbei kam zum Tragen, dass die „Macht der Kartographie als eine anerkannte Methode, mit der Erdoberfläche auch Räume zu projizieren, […] sich bei […] Atlanten erst recht in der Fähigkeit [entfaltete], Wissensräume zu schaffen"[17]. Humboldt erkannte diese Möglichkeit, die die Zusammenführung verschiedener Karten seiner Wissenspräsentationen bot, früh und experimentierte im Laufe seiner wissenschaftlichen Arbeit immer wieder mit Erkenntnis generierenden Relationen, die sich zwischen kartographischen Blättern ergaben. Als wesentliches Resultat ging aus diesen Auseinandersetzungen der *Atlas géographique et physique du Nouveau Continent* hervor.

16 Den wirkmächtigen Begriff der *Humboldtian Science* prägte Susan Faye Cannon in: *Science in Culture*, 1978, S. 73–110.
17 Michalsky: *Projektion und Imagination*, 2011, S. 86.

Humboldt entwickelte diesen aufwändigen, in Großfolio[18] angelegten Atlas über mehrere Dekaden und über den gesamten Zeitraum einer seiner wesentlichen wissenschaftlichen Schaffensphasen hinweg.[19] Zu dieser Zeit lebte er in Paris, der Stadt, die er sich nach der für seine gesamte Forschung wegweisenden, selbstfinanzierten Reise durch Süd-, Mittel- und Nordamerika (1799–1804) als Lebensmittelpunkt erwählt hatte. Im engen Austausch mit einer Reihe von Wissenschaftlern[20] aus unterschiedlichen Fachbereichen konkretisierte er dort die wesentlichen Positionen einer von ihm entwickelten Disziplin, der „Physikalischen Geographie"[21] (gr. φύσις [*physis*] = Natur; gr. γεωγραφία [*geographía*], γῆ [*gē*] = Erde und γράφω [*gráphō*] = schreiben, beschreiben). Ihre Grundlage bildeten die Ergebnisse seiner Amerikanischen Reise.

Zu dieser war Humboldt aufgebrochen, nachdem er als erster unabhängiger Wissenschaftler von der spanischen Krone die Erlaubnis erhalten hatte, sich länger in der Neuen Welt aufzuhalten und zu forschen.[22] Er stellte dort eine Vielzahl grundlegender Natur-

18 Die Blattgröße beträgt 41–43 × 57,5–60 cm für den Einzel- und 82–86 × 115–120 cm für den Doppelbogen.

19 Einen ersten Überblick über die Biographie Alexander von Humboldts bietet die ehemalige Alexander von Humboldt-Forschungsstelle der BBAW auf ihrer Homepage: http://avh.bbaw.de/chronologie (zuletzt aufgerufen am 31.10.2019).

20 Eine wichtige Rolle nahmen hierbei neben dem Mediziner und Naturforscher Aimé Bonpland (1773–1858), der Humboldt auf seiner Amerikanischen Reise begleitete, u. a. die Astronomen François Arago (1786–1853) und Jabbo Oltmanns (1783–1833), der Zoologe Georges Cuvier (1769–1832) und die Botaniker Karl Ludwig Willdenow (1765–1812) und Carl Sigismund Kunth (1788–1850) ein, später auch der Astronom Friedrich Wilhelm Bessel (1784–1846) und die deutlich jüngeren Jean-Baptiste Boussingault (1802–1887), ein Chemiker, und Christian Gottfried Ehrenberg (1795–1876), ein naturwissenschaftlich umfassend gebildeter Mediziner. Vgl. für eine breitere Übersicht insbesondere Leitner, Ulrike: „Vielschichtigkeit und Komplexität im Reisewerk Alexander von Humboldts. Bibliographischer Hintergrund", *HiN* VI (2005) 10, S. 55–76.

21 Vgl. zur Begriffsdiskussion Beck: „Humboldt als größter Geograph der Neuzeit", 1986, S. 126–182 und ders.: „Einführung", in: Humboldt, Alexander von: *Studienausgabe*, Teil 1: *Schriften zur Geographie der Pflanzen*, hg. und kommentiert von Hanno Beck, Darmstadt: Wissenschaftliche Buchgesellschaft 1989, S. 3–24, hier S. 5–6. Die konzeptionellen Grundlagen der Physikalischen Geographie wurzeln in der Zeit vor der Ausdifferenzierung der akademischen Disziplinen, Humboldts Ansatz war noch von einem entsprechenden holistischen Anspruch geprägt. Daher lässt sich die Physikalische Geographie, obwohl Humboldts wissenschaftlicher Gegenstand als „die Natur" bezeichnet werden kann, in die Kategorien der heutigen akademischen Disziplinen – auch in die Naturwissenschaften – nur unzureichend einordnen. Die Physikalische Geographie zielte darauf, allgemeine „physikalische" Prozesse, d.h. Austauschbeziehungen und Wirkungen in der Natur und von der Natur ausgehend, zu beschreiben, zu deren Ganzheit Humboldt nicht nur die Erde, sondern auch alles Leben auf ihr – Menschen, Pflanzen und Tiere – zählte. Die Auseinandersetzung mit geologischen Schichten war ebenso Teil dieser Naturforschung wie die kulturelle Entwicklung des Menschen in unterschiedlichen geographischen Regionen.

22 Zu Humboldts Verhältnis zu und seinem Aufenthalt in Spanien vgl. Rebok, Sandra: *Alexander von Humboldt und Spanien im 19. Jahrhundert. Analyse eines wechselseitigen Wahrnehmungsprozesses*, Frankfurt am Main: Vervuert 2006.

beobachtungen an und sammelte diverse geographische, anthropologische, geologische, botanische und zoologische Informationen und Materialien, darunter ebenso mündlich tradiertes Wissen wie Proben von Steinen und Pflanzen. Zu seiner Arbeit vor Ort gehörte auch die, innerhalb seiner Möglichkeiten, genaue Kartierung von Teilen des bereisten Gebietes, wofür Humboldt modernstes Instrumentarium – darunter Taschenchronometer, Thermometer, Fernrohre, Sextanten und Barometer – mitführte. Nach seiner Rückkehr nach Europa entstand aus der Analyse dieses vielschichtigen Konglomerats von Informationen über mehr als drei Jahrzehnte hinweg das vielbändige, überwiegend französischsprachige Reisewerk, die *Voyage aux régions équinoxiales du Nouveau Continent: fait en 1799, 1800, 1801, 1802, 1803 et 1804* (im Folgenden: *Voyage*)[23]. Zu dessen erstem Teil, der die *Relation historique*, d. h. die allgemeinen Reisebeschreibungen, enthält, gehört auch der *Atlas géographique et physique du Nouveau Continent*.[24]

Es steht zu vermuten, dass die Forschung diesen Atlas aufgrund seiner Kartenkombination bislang nur zögerlich aufgegriffen hat. Noch in der jüngeren Fachliteratur wird sie als „bunt und merkwürdig"[25] bezeichnet. Die Karten des Atlas würden „Anordnungsprobleme"[26] aufweisen, die sogar mit „Fehlleistungen"[27] Humboldts in Zusammenhang gebracht werden. Diesen Urteilen geht voraus, dass sie geo- und kartographiehistorische Darstellungstraditionen als Norm setzen, die sich um 1800 etablierten, denen Humboldt bei der Gestaltung seiner Karten und deren Arrangement im Kartenverbund jedoch nicht oder nur bedingt nachkam. Sobald der methodische Rahmen der Analyse – wie in der vorliegenden Untersuchung geschehen – aber erweitert wird, lässt sich die abschlägige Bewertung des Atlas nicht mehr bestätigen. Wissens- und vor allem bildgeschichtlich breiter kontextualisiert zeigt sich zunächst, dass die thematischen Diskussionen auf den

23 Die *Voyage aux régions équinoxiales du Nouveau Continent: fait en 1799, 1800, 1801, 1802, 1803 et 1804* erschien bald nach Humboldts Rückkehr in Paris und entstand in Teilen in Zusammenarbeit mit seinem ehemaligen Reisebegleiter Aimé Bonpland, der ebenfalls als Autor ausgewiesen ist. Die *Voyage* wurde ab 1807 nicht als fertiges Buch, sondern in einzelnen Lieferungen ediert, d. h. in Passagen, deren Umfang Humboldt mit seinen Verlegern abstimmte. Auch der *Atlas géographique et physique du Nouveau Continent* und viele weitere Schriften gab Humboldt in dieser Publikationsweise heraus. Zur Editionsgeschichte der *Voyage* siehe Fiedler/Leitner: *Alexander von Humboldts Schriften*, 2000, S. 65–339.

24 Editionsgeschichtlich bildet der *Atlas géographique et physique du Nouveau Continent* zusammen mit der kartographiehistorischen Analyse des *Examen critique* den dritten und letzten Band des ersten Teils der *Voyage*. Im ersten Abschnitt dieses ersten Teils nahm Humboldt die allgemeinen Reisebeschreibungen vor. Diese sogenannte *Relation historique* sollte ursprünglich mit dem Mexikoaufenthalt enden, bricht aber mit der Beschreibung des Cuba-Aufenthalts 1801 ab. Ein geplanter vierter Band wurde nie fertig gestellt. Vgl. Fiedler/Leitner: *Alexander von Humboldts Schriften*, 2000, S. 70; zum Aufbau des Reisewerks Leitner: „Vielschichtigkeit und Komplexität im Reisewerk", 2005.

25 Beck: „Humboldt – Kartograph der Neuen Welt", S. 50.

26 Ebd., S. 49.

27 Ebd., S. 51.

Einzelblättern stets deutlich über eine rein topographische Darstellung des Raumes hinausgehen. Zudem stellte Humboldt diese Karten akribisch zusammen, sodass sie im *Atlas géographique et physique du Nouveau Continent* visuell zu einem aufeinander bezogenen, sinnstiftende Zusammenspiel verknüpft werden konnten:[28] Über die Kombination der Karten entwickelt sich eine hochgradig verdichtete Zusammenschau einzelner Themenaspekte, die das zusammenwirkende „Naturganze", wie es Humboldts wissenschaftlichen Überlegungen entsprach, schematisch vor Augen führt.

Nach etlichen Jahren der Vorbereitung gab Humboldt den Atlas ab 1814 in Paris heraus. Als eines der damaligen wissenschaftlichen Zentren Europas ermöglichte die Stadt auch in der Drucktechnik qualitativ höchste Standards. Die Tafeln[29] des Atlas erschienen zunächst parallel zum Text der *Voyage* und bezogen sich vage auf einzelne darin enthaltene Passagen. Jedoch wurden die Karten von Beginn an in eigenen Lieferungen im Umfang von meist drei bis fünf Bogen ediert, d. h. die Karten lagen als eigener Band der *Voyage* vor und waren keinem der Textabschnitte unmittelbar zugeordnet.

Weil die Karten in einzelnen Lieferungen erschienen, lagen über die gesamte Dauer des Publikationsprozesses also erst einmal kleinere Kartengruppen vor, sodass der Atlas nicht vor der letzten Lieferung in seiner Gesamtheit rezipiert werden konnte. Dies ist entscheidend, um seine gesamte Konzeption zu verstehen, denn die Zusammenstellung der Karten bei ihrer Auslieferung bestand keineswegs aus zufälligen Gruppierungen. Vielmehr hatte Humboldt bestimmte Darstellungsweisen und Motive auf eine blattübergreifende, Erkenntnis generierende Betrachtung hin angeordnet. An dieser spezifischen Zusammenstellung orientierten sich die einzelnen Lieferungen des Atlas, wodurch die Rezeption gezielt angeleitet wurde: Indem sich die Kombination der Karten von Lieferung zu Lieferung wiederholte, konnte in ihrer vergleichenden Betrachtung ein gemeinsames Repräsentationsprinzip erkannt werden. Es zeigte ein dreidimensionales Schema der Erdoberfläche und brachte es mit einem vulkanologischen Ursprungsgedanken in Verbindung. Später ergänzte Humboldt dieses Prinzip zusätzlich um eine ideengeschichtliche Reflexion der geographischen Wissensanreicherung.

Bei der Betrachtung der Einzelblätter des *Atlas géographique et physique du Nouveau Continent* lässt sich dieses verbindende Prinzip allerdings noch nicht erfassen. Es ergibt

28 Da sich die Zusammenstellung der Karten im *Atlas géographique et physique du Nouveau Continent* primär aus ihrem visuellen Zusammenspiel erklärt, tritt in der vorliegenden Untersuchung die Analyse des Text-Bild-Verhältnisses innerhalb der Karten bzw. von Karten und Reisewerk gegenüber einer bildwissenschaftlichen Analyse des gesamten Konvoluts zurück.

29 Humboldt verwendete die Begriffe „Tafel" und „Karte" in vielen Fällen synonym. Eine Unterscheidung lässt sich dahingehend ausmachen, dass Humboldt die „Tafel" vorwiegend als übergeordnete Bezeichnung für eine Graphik innerhalb einer Publikation wählte, während die „Karte" auf eine spezifische Repräsentationsform mit geographischer Referenz – etwa die „Höhenkarte" – verwies. Die vorliegende Arbeit orientiert sich an dieser von Humboldt getroffenen Unterscheidung.

sich erst aus einer gezielten Zusammenschau der Tafeln und kann im gebundenen Atlas, in dem die Kartengruppen der Auslieferung nicht mehr erkennbar sind, leicht übersehen werden. Zwar besitzen hier die Ausgangselemente, d. h. die einzelnen Karten, jeweils noch ihre singuläre Bedeutung im Rahmen der *Voyage*, doch lässt sich ein inhaltlich verknüpfendes, übergeordnetes Rahmenkonzept im Grunde genommen erst ausmachen, sobald die Publikationsweise mit berücksichtigt wird.

Als diese Rahmung erkannt, lässt sich am Atlas zeigen, auf welche Weise die Zusammenführung der im epistemischen Kontext verorteten Kartenbilder[30] Humboldt neue, experimentelle Wege der Wissenspräsentation, aber auch der Wissensgenerierung eröffnete. In seiner komplexen Konzeption weist der *Atlas géographique et physique du Nouveau Continent*, aufgrund seiner Vielschichtigkeit ebenso wie mit Blick auf seine multiplen Lektüremöglichkeiten, die zwischen den Karten entstehen können, in den Kern von Humboldts Wissenschaft – und zugleich deutlich über diese hinaus. Der Atlas liefert ein anschauliches Beispiel für eine von theoretischer Seite insgesamt noch unzureichend erschlossene epistemische Praxis: In ihm werden wissenschaftliche (Karten-)Bilder, die aus heterogenen Darstellungstypen bestehen und diverse Themen verhandeln, systematisch zu einem Erkenntnis generierenden Arrangement verkoppelt. Die vorliegende Untersuchung legt somit nicht nur einen Grundstein für die wissenschaftliche Auseinandersetzung mit Alexander von Humboldts kartographischem Werk, sondern eröffnet auch einen exemplarischen Zugang zur Wissensproduktion, wie sie Ensembles heterogener Bildthemen und -typen bereitstellen. Die leitende These ist hierbei, dass diese Kombina-

30 Humboldts Karten sind in einem epistemischen Umfeld verortet und präsentieren wissenschaftliche Themenaspekte, womit sie – zumindest hinsichtlich ihrer bildlichen Elemente – den Status wissenschaftlicher Bilder einnehmen. Mit dieser Feststellung sind Fragen nach einer spezifischen Heuristik des Repräsentationalen aufgeworfen, insofern als das wissenschaftliche Bild eine Differenz zu Bildern in sozialen oder künstlerischen Diskursen aufweist. Zur Abgrenzung des wissenschaftlichen Bildes vgl. Fischel, Angela: „Bildbefragungen: Technische Bilder und kunsthistorische Begriffe", in: *Das Technische Bild*, 2008, S. 22. Zu Bildern in wissenschaftlichen Kontexten vgl. den richtungsweisenden Aufsatz von Latour, Bruno: „Visualisation and Cognition: Drawing Things Together", *Knowledge and Society: Studies in the Sociology of Culture Past and Present* 6 (1986), S. 1–40. Vgl. ferner *Erkenntnis, Erfindung, Konstruktion: Studien zur Bildgeschichte von Naturwissenschaften und Technik vom 16. bis zum 19. Jahrhundert*, hg. von Hans Holländer, Berlin: Mann 2000; Breidbach, Olaf: *Bilder des Wissens: Zur Kulturgeschichte der wissenschaftlichen Wahrnehmung*, München: Fink 2005; *Kunst und Wissenschaft*, hg. von Dieter Mersch u. a., München: Fink 2007. Für einen allgemeinen Überblick zur Logik des Bildlichen und zum Bilderwissen in den Naturwissenschaften vgl. *Was ist ein Bild?*, hg. von Gottfried Boehm, München: Fink 1994; Kemp, Martin: *Bilderwissen: die Anschaulichkeit naturwissenschaftlicher Phänomene*, Köln: DuMont 2003; *Logik des Bildlichen: Zur Kritik der ikonischen Vernunft*, hg. von Martina Heßler und Dieter Mersch, Bielefeld: transcript 2009; *Datenbilder: zur digitalen Bildpraxis in den Naturwissenschaften*, hg. von Ralf Adelmann u. a., Bielefeld: transcript 2009, darin insbesondere den Aufsatz Martina Heßlers: „BilderWissen", S. 133–161.

tionen visueller Medien eine bislang von der Forschung noch nicht systematisch erarbeitete, alternative Erkenntnisleistung ermöglichen, die weder mit der einzelnen Ansicht noch mittels linear aufgebauter Bildfolgen möglich ist.

Methodischer Rahmen

In der vorliegenden Untersuchung wird die Karte in einem dezidiert bildwissenschaftlichen Kontext analysiert und als ein Medium verstanden, das Räume nicht abbildet, sondern hervorbringt. Nicht der Raum als geographische Referenz steht hierbei also im Mittelpunkt des Interesses, sondern die mittels Karten entwickelten Raumkonzepte, ihre Pluralität von Imaginationen, Konstruktionen und Medialisierungen.[31] In den letzten Jahrzehnten hat die Forschung geographiehistorische, vielfach an der geodätischen Genauigkeit orientierte Kartenanalysen sukzessive um entsprechende Fragestellungen erweitert.[32] Aus dieser kritischen Auseinandersetzung ist ein Methodenrepertoire hervorgegangen, mit dem die „Effekte visueller Konstruktion, die tatsächliche oder imaginierte Räume mit den Mitteln graphischer Inskription zu entwerfen und zu ordnen versuchen"[33], gezielt diskutiert werden können. Die Kunst- bzw. Bildwissenschaft bietet in diesem Zusammenhang nur einen – wiewohl hinsichtlich des primär auf visuellen Korrespondenzen zwischen den Karten fußenden Aufbaus des *Atlas géographique et physique du Nouveau Continent* den entscheidenden – Ansatz, um die „ganze Karte"[34] einer kritischen Revision zu unterziehen.[35] Neben Fragen der Herstellung lassen sich dabei die Wahl der Thematik,

31 Siehe Siegel, Steffen: „Die ganze Karte. Für eine Praxeologie des Kartographischen", in: *Die Werkstatt des Kartographen. Materialien und Praktiken visueller Welterzeugung*, hg. von dems. und Petra Weigel, München: Fink 2011, S. 7–28, hier S. 26–27. Vgl. in diesem Kontext auch die für die kritische Kartenanalyse richtungsweisenden Publikationen J.B. Harleys, darunter insbesondere Harley, J.B.: „Deconstructing the Map", *Cartographica* 26 (1989) 2, S. 1–20.

32 Einen ersten, kritischen Überblick zum Thema bietet der Reader *Spatial Turn: Das Raumparadigma in den Kultur- und Sozialwissenschaften*, hg. von Jörg Döring und Tristan Thielmann, Bielefeld: transcript 2008.

33 Siegel: „Die ganze Karte", 2011, S. 26.

34 Der Begriff wurde übernommen von ebd. Siegel versteht unter der Analyse der „ganzen Karte" die Untersuchung des fertigen kartographischen Produkts, das das Resultat der Voraussetzungen seiner spezifischen visuellen Gestaltung darstellt.

35 Für den Zusammenhang von Kartographie und Kunstgeschichte vgl. insbesondere *Aufsicht – Ansicht – Einsicht. Neue Perspektiven auf die Kartographie an der Schwelle der Frühen Neuzeit*, hg. von Tanja Michalsky, Felicitas Schmieder und Gisela Engel, Berlin: Trafo 2009; Michalsky: *Projektion und Imagination*, 2011; Michalsky, Tanja: „Karten unter sich. Überlegungen zur Intentionalität geographischer Karten", in: *Fürstliche Koordinaten. Landesvermessung und Herrschaftsvisualisierung um 1600*, hg. von Ingrid Baumgärtner, Leipzig: Leipziger Universitätsverlag 2014, S. 321–340; *Der kartographische Blick*, hg. von Lutz Hieber, erschienen in der Schriftenreihe *Kultur: Forschung und Wissenschaft*, Hamburg: Lit

der Maßstab sowie die spezifische Darstellungsweise als maßgebliche Faktoren benennen, die kartographische Suggestionen aus bildwissenschaftlicher Perspektive aufzuschließen vermögen.[36]

Den hier angesprochenen Untersuchungen, die sich mit der Konstruktion von Raum auf einzelnen Karten beschäftigen, steht ein Desiderat gegenüber, das sich bei der Analyse gezielt zusammengeführter, sinnstiftender Kombinationen von Karten ausmachen lässt. Es beschränkt sich nicht auf kartographische Publikationen allein, sondern betrifft Bilderensembles im Allgemeinen, die in wissenschaftlichen Kontexten stehen. Für diese Bilderensembles ist kennzeichnend, dass die Bilder in ihnen „nicht wahllos oder willkürlich, sondern beobachtend, wiedererkennend, differenzierend und insofern im Zusammenstellen interpretierend"[37] kombiniert werden. Hierbei sind die Zwischenräume der Bilder konstituierend, denn erst durch sie vermag sich eine spezifische Argumentationsfähigkeit im Visuellen zu entwickeln. Die heuristische Bedeutung von Ensembles wissenschaftlicher Bilder steckt also „nicht ‚im' Bild (als nur noch zu decodierende ‚Bildsprache'), vielmehr zeigt sie sich, interpretativ, jenseits der äußeren Bildgrenzen im Verhältnis zu ande-

2006; Valerio, Vladimiro: „Cartography, Art and Mimesis", in: *The Osmotic Dynamics of Romanticism: Observing Nature – Representing Experience 1800–1850*, hg. von Erna Fiorentini, Berlin: Max-Planck-Institut für Wissenschaftsgeschichte 2005, S. 57–71; Cosgrove, Denis E.: „Maps, Mapping, Modernity: Art and Cartography in the Twentieth Century", *Imago Mundi* 5 (2005) 1, S. 35–54; Dacosta Kaufmann, Thomas: *Toward a Geography of Art*, Chicago: University of Chicago Press 2004; Casey, Edward: *Representing Place. Landscape Painting and Maps*, Minneapolis: University of Minnesota Press 2002; Harley, J.B.: *The New Nature of Maps: Essays in the History of Cartography*, Baltimore: The Johns Hopkins University Press 2001; Buci-Glucksmann, Christine: *Der kartographische Blick der Kunst*, Berlin: Merve 1997; Rees, Roland: „Historical Links between Cartography and Art", *Geographical Review* 70 (1980) 1, S. 60–78. Mit Bezug auf Humboldt vgl. Schneider: „Linien als Reisepfade der Erkenntnis", 2012; dies.: „Berglinien im Vergleich", 2013. Die Literatur zur kritischen Analyse der Konstruktion von Kartenoberflächen ist mit der Proklamation des *Spatial Turn* in den letzten Dekaden deutlich angestiegen. Unter dem Terminus der *Critical Cartography* fimiert eine vor allem im englischsprachigen Raum vorangetriebene theoretische Auseinandersetzung, die seit der zweiten Hälfte des 20. Jahrhunderts bei dem Gemachtsein von Karten und ihrer damit verbundenen Deutungsmacht über den Raum ansetzt. Einen ersten Überblick liefert Crampton, Jeremy W./Krygier, John: „An Introduction to Critical Cartography", *An International E-Journal for Critical Geographies* 4 (2006) 1, S. 11–33. Für eine vertiefende Beschäftigung mit dem Thema vgl. Wood, Denis: *The Power of Maps*, New York und London: Guilford 1992; Cosgrove, Denis: *Apollo's Eye. A Cartographic Genealogy of the Earth in the Western Imagination*, Baltimore: The Johns Hopkins University Press 2001; *Mappings*, hg. von Denis Cosgrove, London: Reaktion Books 2002; Schneider, Ute: *Die Macht der Karten. Eine Geschichte der Kartographie vom Mittelalter bis heute*, Darmstadt: Primus 2006; *KartenWissen*, 2012.

36 Vgl. Michalsky: „Karten unter sich", 2014, S. 324.

37 Müller, Michael R.: „Figurative Hermeneutik. Zur methodologischen Konzeption einer Wissenssoziologie des Bildes", *Sozialer Sinn* 13 (2012) 1, Seiten 129–162, hier S. 133. Michael R. Müller bezieht sich mit seiner Aussage auf Erving Goffman.

ren Bildern"[38]. An ebendieser Stelle, bei der Analyse argumentativ zusammengefügter Bilderkombinationen, lässt sich eine Lücke in der Bildforschung ausmachen; sie mag ihren Teil dazu beigetragen haben, dass auch zu dem *Atlas géographique et physique du Nouveau Continent* bislang noch keine nennenswerten Untersuchungen vorliegen.[39]

Vor dem Hintergrund dieses Desiderats in der Quellenforschung erklärt sich, dass auch methodologische Beschreibungsmöglichkeiten für die sinnstiftende Zusammenführung wissenschaftlicher Bilder noch nicht umfänglich erarbeitet wurden. Diese Problematik betrifft die Analyse von Humboldts *Atlas géographique et physique du Nouveau Continent* unmittelbar. Auch Humboldt selbst benannte weder die unterschiedlichen von ihm im Atlas umgesetzten Anordnungen der Kartenbilder noch die hierfür erforderlichen Rezeptionsmodi des erkennenden Sehens. In der vorliegenden Arbeit sollen Letztere nun als *verknüpfendes Sehen* einerseits und als *vergleichendes Sehen* andererseits bezeichnet werden. Während das verknüpfende Sehen terminologisch neu eingeführt wird, gehört das vergleichende Sehen zu den grundständigen Methoden des kunst- und bildwissenschaftlichen Arbeitens.[40] Beide Modi unterscheiden sich dadurch, dass sich im verknüpfenden Sehen im Gegensatz zum vergleichenden Sehen ein produktiver Überschuss entwickelt, der nicht über Kongruenzen oder Differenzen im Ikonischen hergestellt wird. Verknüpfende Bildkombinationen gehen nicht wie das vergleichende Sehen in einer formulierten Überblendung von Bildstrukturen auf, vielmehr besteht ihr Erkenntnis generierendes Moment aus einer sinnstiftenden Zusammenschau verschiedener Bildtypen oder -themen.

Mit der Analyse des *Atlas géographique et physique du Nouveau Continent* soll die bildwissenschaftliche Methodologie so vor allem um eine exemplarische Untersuchung zu nichtlinearen Bilderkombinationen ergänzt werden. Grundannahme ist hierbei, dass gezielt zusammengeführten Bilderkombinationen aus heterogenen Bildtypen Mittel der visuellen Argumentation zur Verfügung stellen, die weder das Einzelbild noch die lineare Bilderfolge bieten. Nichtlineare Bilderkombinationen, so die These, weiten das Spektrum

38 Ebd., S. 130.

39 Auf dieses Desiderat verweist auch Pratschke, Margarete: „Bildanordnungen", in: *Das Technische Bild*, 2008, S. 116–119. Einen ersten Zugang zu Bildanordnungen in der Geschichte der Kunstgeschichte bietet Thürlemann, Felix: *Mehr als ein Bild. Für eine Kunstgeschichte des* hyperimage, München: Fink 2013. Vgl. in diesem Zusammenhang auch Ganz, David: *Barocke Bilderbauten. Erzählung, Illusion und Institution in römischen Kirchen, 1580–1700*, Petersberg: Imhof 2003; Kemp, Wolfgang: *Christliche Kunst: ihre Anfänge, ihre Strukturen*, München, Paris und London: Schirmer/Mosel 1994; *Bild im Plural. Mehrteilige Bildformen zwischen Mittelalter und Gegenwart*, hg. von David Ganz und Felix Thürlemann, Berlin: Reimer 2010; *Pendant Plus. Praktiken der Bildkombinatorik*, hg. von Gerd Blum, Steffen Bogen, David Ganz und Marius Rimmele, Berlin: Reimer 2012.

40 Zur Methode des vergleichenden Sehens vgl. insbesondere den Sammelband *Vergleichendes Sehen*, hg. von Lena Bader, Martin Gaier und Falk Wolf, München: Fink 2010. Einen knappen, aber informativen Überblick bietet auch Dünkel, Vera: „Vergleich als Methode", in: *Das Technische Bild*, 2008, S. 24–28.

dessen, was in der visuellen Repräsentation gezeigt und mit ihr erkannt werden kann, deutlich aus. Ihre Wirkmächtigkeit entfaltet sich gerade im Zwischenraum der Bilder: Im Rezeptionsprozess müssen die *relata*, d. h. die einzelnen Bilder, aktiv in Erkenntnis generierende Relationen gesetzt werden.

Wie bei Einzelbildern bzw. -karten ist auch der Sinngehalt der Kombination von Bildern erst entschlüsselbar, wenn diese Rezeption eingeübt wurde.[41] Entsprechend ist davon auszugehen, dass die Konzeption des *Atlas géographique et physique du Nouveau Continent* keineswegs voraussetzungslos war, sondern dass sie sich auf spezifische Sehgewohnheiten und Darstellungskonventionen zurückführen lässt. Wie gezeigt wird, reichen diese Bezüge im Falle von Humboldts Atlas deutlich über kartographische Visualisierungspraktiken im engeren Sinne hinaus: Ingenieurswissenschaftliche und architektonische Darstellungsweisen sind hier ebenso richtungsweisend wie die Objektanordnungen in Kunst- und Wunderkammern[42] oder die Präsentation von Wissen in Tableaus und Schaubildern.[43]

An der Schnittstelle der hier ausgemachten Ansätze, zwischen der wissenschaftlichen Argumentation mehrteiliger Bildformulare und der bildwissenschaftlichen Kartenanalyse, schließt die vorliegende Arbeit mit ihrer Reflexion des Bild(er)wissens an. Sie arbeitet am Beispiel von Humboldts *Atlas géographique et physique du Nouveau Continent* spezifische Modi der Sichtbarkeit und Praktiken der Sichtbarmachung heraus, wie sie sich in Bilderarrangements entfalten, die in wissenschaftlichen Kontexten stehen. Der *Atlas géographique et physique du Nouveau Continent* bietet sich für diese Untersuchung auch aufgrund der Quellenlage in besonderer Weise an: Neben Humboldts wissenschaftlichem

41 Aufmerksam auf das notwendige Einüben des Lesens von Karten macht Anders Engberg-Pedersen in seinem Aufsatz „Die Verwaltung des Raumes: Kriegskartographische Praxis um 1800", in: *Die Werkstatt des Kartographen*, 2011, S. 29 – 49, hier S. 38. Methodologisch wurde diese Problematik schon Anfang des 19. Jahrhunderts aufgegriffen. So entwickelte der Geodät Johann Georg Lehmann (1765 – 1811) für die noch junge Disziplin der Geographie eine Technik, um das ‚richtige Lesen‘ von Karten prüfen zu können. Seine Schrift *Die Lehre der Situations-Zeichnung oder Anweisung zum richtigen Erkennen und genauen Abbilden der Erd-Oberfläche in topographischen Charten und Situations-Planen* erschien 1812 posthum in Dresden.

42 Besonders umfangreich unter den zahlreichen Publikationen zu Kunst- und Wunderkammern ist *Theater der Natur und Kunst/Theatrum Naturae et Artis. Wunderkammern des Wissens: Essays*, hg. von Moritz Ulrich u. a., Berlin: Henschel 2000; zur Heuristik der Kunstkammer vgl. die schmale, inhaltlich unübertroffene Ausführung von Bredekamp, Horst: *Antikensehnsucht und Maschinenglauben*, Berlin: Wagenbach 2007; einen einführenden Überblick bietet der Ausstellungskatalog *Schimmern aus der Tiefe. Muscheln, Perlen, Nautilus*, hg. von Karin Annette Möller, Petersberg: Imhof 2013.

43 Zur Heuristik wissenschaftlicher Bildanordnungen vgl. *Visuelle Modelle*, hg. von Ingeborg Reichle, Steffen Siegel und Achim Spelten, München: Fink 2008; *Erkenntnis, Erfindung, Konstruktion*, 2000; Bann, Stephen: *Parallel Lines: Printmakers, Painters, and Photographers in Nineteenth-Century France*, New Haven: Yale University Press 2001; *The Picture's Image. Wissenschaftliche Visualisierung als Komposit*, hg. von Inge Hinterwaldner u. a., München: Fink 2006; Bender, John/Marrinan, Michael: *The Culture of Diagram*, Stanford: Stanford University Press 2010.

Nachlass, in dem sich diverse Vorarbeiten zum Atlas erhalten haben, liegen sowohl theoretische Äußerungen als auch praxisorientierte Überlegungen Humboldts vor, die Aufschluss über die spezifische Anordnung der Karten und ihre sinnstiftende Verknüpfung geben.

Vom Erkennen im Sehen. Alexander von Humboldts Visualisierung des „Naturganzen"

Wird Alexander von Humboldts Visualisierungspraxis von der Forschung aufgegriffen, so findet sich nicht selten der Hinweis auf ihn als Übergangsfigur hin zu den modernen Disziplinen.[1] Diese Engführung erklärt sich aus dem Umstand, dass Humboldts wissenschaftliche Bilder sowohl eine bemerkenswerte thematische Bandbreite von präzisen Informationen erfassen, die unter verschiedenen Fragestellungen systematisiert und analytisch aufeinander bezogen sind, als sie auch, und zwar maßgeblich, ästhetischen Kriterien gehorchen. Mit den hiermit angesprochenen unterschiedlichen Traditionslinien der Gestaltung weisen sich Humboldts Graphiken als Resultate einer ganzheitlichen Naturbeschreibung aus, in der sich die sinnliche Erfahrung ebenso spiegeln sollte wie die analytische Betrachtung der Natur.[2]

Den theoretischen Boden für seine anspruchsvolle, weit aufgespannte wissenschaftliche Visualisierungspraxis bereitete Humboldts synthetisches und transdisziplinäres Denken, für das die Verknüpfung verschiedener Disziplinen ebenso grundlegend war wie diejenige von Kunst und Wissenschaft.[3] Von der Naturphilosophie des 18. Jahrhunderts beeinflusst, setzten seine diesbezüglichen Überlegungen bei der präsumtiven Annahme

1 So etwa bei Godlewska: „Humboldts visuelles Denken", 2001, S. 157.

2 Zu Alexander von Humboldts wissenschaftlichen Visualisierungen zählen neben geographischen Karten auch Konstruktionszeichnungen sowie botanische, zoologische und kulturgeschichtliche Darstellungen. Obwohl Humboldts Visualisierungen in der Vergangenheit im Einzelnen viel Interesse zugekommen ist, sind sie in ihrer Funktion als Instrumente visueller Erkenntnisgenese einerseits und der anschaulichen Wissenspräsentation andererseits bislang kaum differenziert untersucht worden.

3 Für eine ausführliche Diskussion dieses wissenschaftlichen Ansatzes Humboldts vgl. die unterschiedlichen Positionen von Kraft: *Figuren des Wissens*, 2014, hier insbesondere S. 87–91; Graczyk, Annette: *Das literarische Tableau zwischen Kunst und Wissenschaft*, München: Fink 2004, S. 253–329; Köchy, Kristian: „Alexander von Humboldts Naturgemälde: Zum Verhältnis von Kunst und Wissenschaft", in: *Das bunte Gewand der Theorie: vierzehn Begegnungen mit philosophierenden Forschern*, hg. von Astrid Schwarz, Freiburg im Breisgau u. a.: Alber 2009, S. 71–95; Böhme, Hartmut: „Ästhetische Wissenschaft. Aporien der Forschung im Werk Alexander von Humboldts", in: *Alexander von Humboldt. Aufbruch in*

eines harmonischen „Naturganzen" an, in dem alle Elemente aufgrund gleichförmiger Wechselwirkungen miteinander verbunden waren. Diese wohlgeordneten natürlichen Kräfte entäußerten sich in einer regelhaften physiognomischen Formgestaltung, die wiederum über die Sinne, vor allem den Augensinn, zugänglich war.

Humboldt wollte das große Ganze der Natur jedoch nicht nur der äußeren Form nach typisieren. Vielmehr zielte er auch darauf, das harmonische, sinnlich empfundene Ineinanderwirken in seiner Systematik und Prozesshaftigkeit zu beschreiben, wobei ihm die empirische Einzelbeobachtung und -messung dazu diente, Teilaspekte des Ganzen zu verstehen. In den Ergebnissen im Kleinen müsste sich, so Humboldts Überlegung, auch das Zusammenwirken im systemischen Großen bestätigen. Dennoch bestand bei dieser induktiven Vorgehensweise das Risiko der Zergliederung des Beobachteten. Um diese zu vermeiden und das Gesamtgefüge der Natur nicht aus dem Blick zu verlieren, verband Humboldt seine Analyse der Naturdinge konsequent sowohl mit deren systemischem Rückbezug auf das „Naturganze" als auch mit der Reflexion der ganzheitlichen sinnlichen Naturerfahrung.

Beide Zugriffe auf das Naturwissen, empirische Beobachtung und sinnliche Erfahrung, waren letztlich entscheidend dafür, welche Erkenntnisse Humboldt über das „Naturganze" zu gewinnen vermochte. Empirischer und aisthetischer Ansatz ergänzten einander, indem er sie als wechselseitige Korrektive des Erkannten verstand: So würde sich gemäß Humboldt in der geographischen Messung etwa die sinnlich empfundene Harmonie der physiognomischen Formensprache bestätigen lassen und umgekehrt. Die graphische, insbesondere die kartographische Oberfläche ermöglichte es ihm in diesem Zusammenhang, beide Zugänge zum Naturwissen – sowohl bei der Generierung als auch bei der Präsentation von Erkenntnis – aufeinander bezogen darzustellen: Empirisch gewonnene Einzelbeobachtungen ließen sich in eine ganzheitliche, ebenso präzise wie übersichtliche und ästhetisch ansprechende Darstellung überführen und zugleich hinsichtlich ihres Parts im „Naturganzen" prüfen. Grundlegend ist hierbei, und zwar sowohl für die Genese als auch für die Vermittlung von Wissen, dass dem Augensinn eine kaum zu überschätzende Stellung innerhalb der Problematik zukam, die Natur in ihrer Wesenheit überhaupt erst zu erkennen.

die Moderne, hg. von Ottmar Ette, Berlin: Akademie-Verlag 2001, S. 17–32; Barck, Karlheinz: „»Umwandlung des Ohrs zum Auge«. Teleskopisches Sehen und ästhetische Beschreibung bei Alexander von Humboldt", in: *Wahrnehmung und Geschichte. Markierungen zur Aisthesis materialis*, hg. von Bernhard J. Dotzler u. a., Berlin: Akademie-Verlag 1995, S. 27–42; Knobloch, Eberhard: „Naturgenuss und Weltgemälde", *HiN* V (2004) 9, S. 3–16.

Humboldts theoretische Überlegungen zur Erkenntniskraft des Visuellen

„Segnius irritant animos demissa per aurem, quam quae sunt oculis subjecta fidelibus"

1803 verfasste Humboldt während seines Aufenthalts in Mexiko mit dem *Essay de Pasigraphie*[4] eine der wenigen seiner Abhandlungen, die längere programmatische Passagen zur graphischen, hier explizit zur kartographischen Praxis enthält. Diese inhaltliche Ausrichtung lässt sich auf die Zielgruppe des Essays zurückführen, denn er richtete sich an die Studenten der mexikanischen Bergbauakademie, des Colegio de Minas in Mexiko-Stadt, und sollte dem wissenschaftlichen Nachwuchs kartographisches Grundlagenwissen vermitteln. Dem Text stellte Humboldt ein Diktum voran, das schon vor Beginn der textuellen Ausführungen auf den grundlegenden Erkenntnisgewinn der wissenschaftlichen Visualisierung hinwies. Mit Horaz heißt es dort: „Segnius irritant animos demissa per aurem, quam quae sunt oculis subjecta fidelibus"[5] („Schwächer jedoch wirkt auf uns, was man nur den Ohren vertraute,/Als was vor Augen uns liegt"[6]). Mit diesem Zitat zielte Humboldt, wie auch der *Essay de Pasigraphie* unterstreicht, auf eine Abgrenzung zwischen bildlicher und versprachlichter Wissenspräsentation. Der ersteren räumte Humboldt

4 Der *Essay de Pasigraphie* wurde zu Humboldts Lebzeiten lediglich 1805 in spanischer Sprache von Andrés Manuel del Río herausgegeben. Del Río bekleidete seit 1794 die Professur für Mineralogie am mexikanischen Colegio de Minas. Humboldt hatte ihn während seiner Ausbildung an der Bergakademie in Freiberg kennengelernt und traf ihn in Mexiko wieder. Vgl. für die spanischsprachige Publikation Humboldt, Alexander von: „Introducción a la Pasigrafía geológica", in: del Río, Andrés Manuel: *Elementos de Orictognosía o del conocimiento de los fósiles dispuestos según los principios de A.G. Werner*, Bd. 2, México D. F.: Hurtel 1805, S. 160–173. Im Fußnotenapparat des ersten *Kosmos*-Bandes vermerkte Humboldt allerdings, das Manuskript zum *Essay de Pasigraphie* sei nie publiziert worden (Humboldt: *Kosmos*, Bd. 1, 1845, S. 457, hier Fußnote 12). Hanno Beck vermutet, dass Humboldt sich nicht mehr zu seinen damaligen Vorstellungen, die der Wernerschen Schule entsprungen waren, bekennen wollte. Obwohl Humboldt im *Kosmos* den spanischen Titel nannte, geht Hanno Beck von einer Übersetzung ins Spanische aus, die Fritz G. Lange, Sekretär der Alexander-von-Humboldt-Kommission, nachgewiesen haben will. Vgl. Beck, Hanno: *Alexander von Humboldt und Mexiko. Beiträge zu einem geographischen Erlebnis*, Bad Godesberg: Inter Nationes 1966, S. 25. Das von Humboldt auf Französisch unter dem Titel *Essay de Pasigraphie geologique dressée à l'usage de l'Ecole Royale des Mines du Mexique* verfasste Manuskript befindet sich heute in der HA der SBB im Humboldt-Nachlass, gr. Kasten 5, Nr. 88. Das originale Manuskript des *Essay de Pasigraphie* galt bis zu Hanno Becks Wiederentdeckung 1958 und der anschließenden Transkription und Publikation als verschollen.

5 Humboldt: Manuskript zum *Essay de Pasigraphie*, 1803/1804, 2r (und ein weiteres Mal 2v). Zitat nach Horaz: *De arte poetica*, Zeile 180–181. Hier heißt es: „segnius inritant [sic] animos demissa per aurem [/] quam quae sunt oculis subiecta fidelibus". Horaz (Quintus Horatius Flaccus): „De arte poetica", in: ders.: *Opera*, hg. von Friedrich Klingner, Berlin: de Gruyter 2008, S. 294–311, hier S. 301.

6 Übersetzung entnommen aus: Mendelssohn, Moses: *Ästhetische Schriften*, hg. von Anne Pollok, Hamburg: Meiner 2006, S. 303, hier Fußnote 14.

hierbei, zumindest im Rahmen geologischer Untersuchungen, den Vorzug ein: Selbst die Lektüre der treffendsten Beschreibungen von Gebirgen könne „niemals solche Ideen hervorbringen, wie sie geognostische Karten auf einen Blick präsentieren"[7].

Entsprechend skizzierte Humboldt in seinem Text Überlegungen zu kartographischen Projektionsmethoden, mit denen Gesteinsschichten und -formationen unter Berücksichtigung verschiedener geologischer Aspekte und zugleich anschaulich erfasst werden könnten. Das Wissen über die Erde, so Humboldt, ließe sich leicht vermehren, würden diese Darstellungen in großer Zahl hergestellt: „Ich schmeichle mir zu glauben, dass die Geognosie schnelle Fortschritte machte, wenn man [...] Sammlungen von geologischen Karten anfertigen wird."[8] Doch dürften diese Karten nicht allein geologisches Wissen transportieren, auch die Charakteristik der Landschaft sollten sie mit aufnehmen. Neben der Lagerung von Gesteinsschichten sei die Visualisierung daher auch an spezifischen topographische Eigenheiten der Gegend zu orientieren. Ihre Beurteilung basierte primär auf der sinnlichen Naturerfahrung: Markante Höhen im Gelände, die den landschaftlichen Eindruck dominierten, sollten auf der Graphik zusammengeführt werden. Der Ausspruch des Horaz, der dem Essay vorausgeht, weist vor diesem Hintergrund auf eine doppelte Wirkmacht der Visualisierung hin. Mit dem Diktum ist demnach nicht nur die graphische Wissenspräsentation, d. h. die visuelle Vermittlung des Wissens über die Natur angesprochen. Es lässt sich auch auf die optische Erfahrung der Natur selbst, d. h. auf die Wahrnehmung des Naturdings in situ beziehen.

Die „Weltanschauung"

Dass dem Sehsinn bei Alexander von Humboldt eine entscheidende heuristische Mitarbeit zukam, die sich sowohl auf die Naturbeobachtung als auch auf die Vermittlung von Forschungsergebnissen bezieht, lässt sich mit Blick auf verschiedene seiner theoretischen Ausführungen bestätigen. Diese finden sich versprengt in seinen Texten, bleiben definitorisch aber meist vage und sind argumentativ bisweilen inkonsistent. Innerhalb dieses elastischen Rahmens sind es vor allem die Begriffe der „Weltanschauung" und der „Anschau-

7 Im Original: „[On aurait bien lire des descriptions les mieux faites de la Cordillere des Andes, des Alpes de la Suisse, du Caucase et de cette chaine submergée de Trap de la Mer du Sud,] jamais cette lecture fera naitre les idées qui se presentent à la vue des Cartes geognostiques". Humboldt: Manuskript zum *Essay de Pasigraphie*, 1803/1804, 2v. Im Folgenden wird im Fließtext die deutsche Übersetzung wiedergegeben, während die Fußnote die Originalsprache anführt. Alle Übersetzungen stammen, wenn nicht anderweitig gekennzeichnet, von der Autorin selbst. Texte Humboldts, die er selbst ins Deutsche übertrug, werden in dieser Version zitiert.

8 Im Original: „Je me flatte de croire que la Geognosie ferait des progrès rapides lorsque l'on dressera [...] des Collections de Cartes geologiques." Humboldt: Manuskript zum *Essay de Pasigraphie*, 1803/1804, 2v. Humboldts Begriff der Geognosie meint Erdkunde, nicht Geologie. Siehe Knobloch, Eberhard/Pieper, Herbert: „Die Fußnote über Geognosia in Humboldts Florae Fribergensis specimen", *HiN* VIII (2007) 14, S. 42–58, hier S. 43.

ung", die wesentlichen Aufschluss darüber geben, welchen Status Humboldt dem Sehsinn bei der Genese der Erkenntnis über die Natur zusprach.

Mit dem Begriff der „Weltanschauung", der ab 1800 zunehmend gebräuchlich wurde, rekurrierte Humboldt vermutlich direkt auf Immanuel Kant.[9] Unter dem Terminus verstand Humboldt allgemein die „Erkenntniß eines Naturganzen"[10], für das die sinnlich erfassbare Erscheinungswelt die entscheidende Grundlage liefere. Demgemäß stellte das Auge für Humboldt den primären sinnlichen Zugang zu seinem Forschungsgegenstand, der Natur, her. „Durch Organe nimmt der Mensch die Außenwelt in sich auf. Lichterscheinungen verkünden uns das Dasein der Materie in den fernsten Himmelsräumen. Das Auge ist das Organ der Weltanschauung"[11], heißt es im ersten Band des *Kosmos*. Im zweiten Band explizierte Humboldt das Auge als das „Organ sinnlicher Weltanschauung"[12].

Das Auge galt Humboldt somit in seiner Funktion als wesentlicher Rezeptor der empirischen Annäherung an die Natur als der entscheidende Mittler zwischen sinnlicher Erfahrung und deren intellektueller Verarbeitung. Durch den Augensinn wurde das Wahrgenommene für die Ratio erst zugänglich. Vorläufiges Produkt eines auf diese Weise angestoßenen Erkenntnisprozesses war die „sinnliche Weltanschauung".[13] Humboldts Auslegung der Weltanschauung bildete mithin das Scharnier zwischen dem beschauten Außenraum und dem Ineinanderwirken seiner Kräfte, der sinnlich-perzeptiven Rezeption, die die Wahrnehmung des Außenraumes ermöglichte, und deren Verarbeitung durch die Vernunft, also der Erkenntnis.[14]

Dadurch, dass in der Weltanschauung der menschliche Intellekt und das anvisierte Forschungsding voranalytisch verklammert werden, steht sie auf einer Stufe mit einem von Humboldt geforderten „ordnende[n] Denker"[15]. Während sich dieser der Natur vom

9 Laut Helmut G. Meier handelt es sich bei dem Begriff der Weltanschauung um einen Neologismus Immanuel Kants, allerdings findet der Terminus bei diesem keine systematische Verwendung. Vgl. Meier, Helmut G.: *Weltanschauung: Studien zu einer Geschichte und Theorie des Begriffs*, Münster: Universitätsschrift (Dissertation) 1970, S. 71–73.

10 Humboldt: *Kosmos*, Bd. 2, 1847, S. 138.

11 Humboldt: *Kosmos*, Bd. 1, 1845, S. 85–86. Vgl. zur weiterführenden Lektüre über den Diskurs des Augensinns um 1800 Jehle, Oliver: „Dochtschere und Augenglas – Joseph Wright, John Locke und das denkende Auge", in: *In Bildern denken? Kognitive Potentiale von Visualisierung in Kunst und Wissenschaft*, hg. von Ulrich Nortmann und Christoph Wagner, Paderborn: Fink 2010, S. 175–193.

12 Vgl. Humboldt: *Kosmos*. Bd. 2, Stuttgart u. a. 1847, S. 342.

13 Vgl. Barck: „»Umwandlung des Ohrs zum Auge«", 1995, S. 32.

14 Humboldt verhandelte den Begriff der Weltanschauung bereits 1827/1828 in seinen drei Vorträgen über die „Geschichte der Weltanschauung", die Teil seiner Kosmos-Vorlesungen waren. Vgl. Meier: *Weltanschauung*, 1970, Fußnote 408. Bei der Wahrnehmung des Außenraumes unterschied Humboldt, wenn auch nicht trennscharf, noch einmal zwischen einer „sinnlichen" und einer „physischen Weltanschauung".

15 Siehe Humboldt: *Kosmos*, Bd. 1, 1845, S. 81.

Intellekt her nähert, gibt sich ihm die Weltanschauung als Ordnung des Kosmos zu erkennen. Der ordnende Denkers begegnet der „empirischen Fülle"[16] der Natur also konstruktiv, wodurch sich die Weltanschauung herauszubilden vermag: Sie geht jeder Erkenntnis über die Natur voraus, denn sie konturiert die Bedingungen der Wahrnehmung, die das Verständnis vom „Naturganzen" ermöglichen.[17] Indem der „ordnende Denker" nun die Fülle der Natur bereits in der unmittelbaren Erfahrung nach bestimmten Charakteristika zu systematisieren und in ihren Grundzügen zu erfassen vermag, ist es die Weltanschauung, mit der sich diesem „Denker" die Natur in ihrer zugrunde liegenden Wesenheit zeigt.[18] Der angeschaute Außenraum wird so potentiell schon während seiner sinnlichen Erfassung in situ in einen Reflexionsprozess einbezogen, d. h. er wird seiner unverstellten Natürlichkeit mit der ersten, unmittelbaren Erfahrung bereits teilweise enthoben.[19]

Indem Humboldt in diesem Kontext das Auge zum wichtigsten sinnlichen Zugang zur Außenwelt deklarierte, schloss er an eine Hierarchie der Sinne im aufklärerischen Geiste an. Schon in der Antike war der Sehsinn hochgeschätzt worden; in platonischer Tradition überragte das Auge aufgrund der ihm zugestandenen Nähe zur göttlichen Idee die anderen Sinne. Auch in den postaufklärerischen theoretischen Debatten um 1800 stieß die Bedeutung, die dem Augensinn bei der Erkenntnisgenese zugemessen wurde, auf große Resonanz.[20] Nicht minder prägend war für Humboldt die romantische Diskussion über den Sehsinn. Sie war vor allem aus der rasanten Weiterentwicklung optischer Instrumente, etwa von Fernrohren, Brillen und Lupen hervorgegangen, mit deren Hilfe die menschliche Sehkraft nun systematisch übertroffen werden konnte. In der Folge wurde der künstlich gesteigerte Sehsinn häufig herangezogen, um der durch technische Entwicklungen voranschreitenden Entfremdung des Menschen von der – auch seiner eigenen –

16 Ebd.

17 Helmut G. Meier weist darauf hin, dass Humboldts Verwendung des Begriffs der Weltanschauung dezidiert nicht erkenntnistheoretisch zu verstehen sei. Vgl. Meier: *Weltanschauung*, 1970, S. 161–167. Demgegenüber soll in der vorliegenden Untersuchung argumentiert werden, dass erst der Bezug auf Kant Humboldts Verwendung des Begriffs (Welt-)Anschauung plausibel macht und er sehr wohl in erkenntnistheoretischem Zusammenhang steht.

18 Siehe Humboldt: *Kosmos*, Bd. 1, 1845, S. 81. Vgl. in diesem Kontext auch Breidbach: *Bilder des Wissens*, 2005, S. 80. Breidbach verankert die um 1800 aufkommende Idee, das Wesen der Natur in der genauen Beobachtung finden zu können, in den Traditionen einer „Sehkultur" des 18. Jahrhunderts.

19 Humboldts überindividuelles Wahrnehmungskonzept der Weltanschauung entsprang dem zeitgenössischen Diskurs über das sinnliche Erkenntnispotential, der sich im Zuge anthropologischer Debatten etablierte. Vgl. Pollok, Anne: „Sinnliche Erkenntnis und Anthropologie", in: *Handbuch Literatur und Philosophie*, hg. von Hans Feger, Stuttgart u. a.: Metzler 2012, S. 21–46.

20 Vgl. Utz, Peter: *Das Auge und das Ohr im Text: literarische Sinneswahrnehmung in der Goethezeit*, München: Fink 1990, S. 8; zum Diskurs des Augensinns um 1800 Jehle: „Dochtschere und Augenglas", 2010, hier v. a. S. 176.

Natur Ausdruck zu verleihen. Dem Auge kam in diesem Zusammenhang eine besondere Rolle zu, weil in ihm ein Doppelwesen von Empfindsamkeit und technischer Verfasstheit erkannt wurde: Es stellte zum einen einen optischen Apparat dar, der in den menschlichen Organismus eingebunden Reize von außen an das Gehirn weiterleitete, zum anderen galt es als Spiegel der Seele.[21]

Mit dem Bezug auf das Auge betonte Humboldt die Bedeutung der ganzheitlichen, sinnlichen Erfahrung der Natur und stand darin romantischen Positionen nahe. Sich kritisch zu diesen positionierend, empfand Humboldt aber kein Missverhältnis zwischen menschlicher Wesenheit und technisch gestützten optischen Beobachtungen, die das Wahrgenommene vermeintlich zu Zerrbildern fragmentierten. Vielmehr fasste er das optische Erfassungsvermögen des Menschen und den durch technischen Fortschritt vorangetriebenen „Uebergang des *natürlichen* zum *telescopischen* Sehen"[22] als sich ergänzende Zugänge zum Wissen über die Natur auf: Statt als zergliedernde Instrumente galten ihm die neuen technischen Instrumente als Wissensgeneratoren, die eine genauere Sicht auf die Natur und dadurch den präziseren Einblick in natürliche Prozesse beförderten. Zwar beurteilte Humboldt ein als Einheit wahrgenommenes, mit den Sinnen erfasstes „Naturganzes" als notwendige Vorstufe für ein intellektuelles Durchdringen der Natur, doch resultierte ihm zufolge aus der genaueren Betrachtung einzelner Aspekte, solange sie analytisch wieder der Gesamtsicht zugeführt wurde, auch eine größere Einsicht. Optische Apparaturen halfen demnach dabei, wissenschaftliche Beobachtungen zu verbessern: Dank der Steigerung der menschlichen Sehkraft konnte sowohl – etwa im Blick durch das Mikroskop – ein detailreicherer Einblick als auch – etwa im Blick durch das Fernrohr – eine größere Um- und Weitsicht gewonnen werden. Im dritten Band des *Kosmos* hob Humboldt entsprechend emphatisch an:

> Dem Auge, Organ der Weltanschauung, ist erst seit drittehalb Jahrhunderten, durch künstliche, telescopische Steigerung seiner Sehkraft, das großartigste Hülfsmittel zur Kenntniß des Inhalts der Welträume; zur Erforschung der Gestaltung, physischer Beschaffenheit und Massen der Planeten sammt ihrer Monden geworden.[23]

Der Einsatz technischer Hilfsmittel ging zwar mit einer vorläufigen Zergliederung der Ansichten einher, doch konnten sich laut Humboldt beide, Gesamtschau und Fragment, vermöge der sinnlichen Weltanschauung wieder zu einem für die Erkenntnis notwendigen Ganzen verbinden.[24]

21 Vgl. Utz: *Das Auge und das Ohr im Text*, 1990, S. 8.
22 Humboldt: *Kosmos*, Bd. 3, Stuttgart 1850, S. 75 [Hervorhebungen im Original].
23 Ebd., S. 60.
24 Aufgrund des hier Angeführten unterschied sich Humboldts Verständnis der „sinnlichen Weltanschauung" von seinem Konzept des „Totaleindrucks", das auf eine ästhetisch fundierte Wissenspräsentation abzielte.

Nicht nur Humboldts Bewertung technischer Instrumente wich damit von romantischen Positionen ab, sondern auch seine Auffassung von der Weltanschauung. Indem er dieser in Anbetracht ihrer überindividuellen Ausrichtung eine wichtige Funktion bei der Erkenntnisgenese zuschrieb, entbehrte sie klar der romantischen Konnotation des Begriffs. Nach dieser wurde die Weltanschauung zwar ebenfalls mit einer ganzheitlichen, allerdings aber vom subjektiven Empfinden abhängenden Wahrnehmung zusammengebracht, sodass sie auf dieser Basis – ganz im Gegensatz zu Humboldts Auffassung – eine Alternative zur rationalen Weltsicht darstellte.[25] Humboldts Auslegung implizierte hingegen immer auch eine definite Wahrnehmung, die zwischen subjektiver Sinneswahrnehmung und überindividuell gegebener Erkenntnisleistung vermittelte, womit der Weltanschauung die Stellung einer – gleichwohl nicht näher von ihm spezifizierten – kollektiven Wahrnehmungsbedingung zukam. Humboldt knüpfte hiermit an eine terminologische Entwicklung des Begriffes an, die um 1800 einsetzte und bei der sich beide Seiten – die objektive und die individuelle Auffassung – durch äußere Gegebenheiten beeinflusst in ihrer Konnotation immer stärker miteinander verflochten.[26]

Die überindividuelle Auslegung der Weltanschauung implizierte eine Bedeutungsebene, die von einer mit der Zeit veränderlichen Bewertung des „Naturganzen" ausging und sich letztlich auf Humboldts gesamtes epistemologisches Konzept auswirkte: Dadurch, dass die Weltanschauung von historischen Wandlungsprozessen determiniert war, blieb der Erkenntnisprozess letztlich unabgeschlossen. Die Geschichte der Weltanschauung, so Humboldt, zeige sich als „[allmälige] Auffassung des Begriffs von dem Zusammenwirken der Kräfte in einem Naturganzen"[27]. Sie lehre, „wie in dem Lauf der Jahrhunderte die Menschheit zu einer *partiellen Einsicht* in die relative Abhängigkeit der Erscheinungen allmälig gelangt"[28] sei. Obwohl Humboldt hierin einen deutlichen Fortschrittsgedanken formulierte, wird dieser sogleich wieder zurückgenommen: Aufgrund der Anbindung der Weltanschauung an die inkonsistente menschliche Wahrnehmung blieb die Erkenntnis immer unvollständig. Letztlich stellte die Natur „für die intellectuellen Anlagen der Menschheit ein nicht zu fassendes, und in allgemeiner *ursachlicher* Erkenntniß von dem Zusammenwirken *aller* Kräfte ein unauflösbares Problem"[29] dar.

25 Zur Wort- und Begriffsgeschichte der „Weltanschauung" im Deutschen vgl. Naugl, David K.: *Worldview: the History of a Concept*, Michigan u. a.: Eerdmans 2002, S. 58 – 64.

26 Vgl. Art. „Weltanschauung", in: *Deutsches Wörterbuch von Jacob Grimm und Wilhelm Grimm*, Bd. 14, Teil I:1, hg. von der Deutschen Akademie der Wissenschaften zu Berlin, Leipzig: Hirzel 1955, Spalte 1529–1538, hier Spalte 1531–1532.

27 Humboldt: *Kosmos*, Bd. 1, 1845, S. XIII. Diese Passage der Vorrede bezieht sich direkt auf Humboldts umfassenderen Ausführungen zur Weltanschauung im zweiten Band des *Kosmos*.

28 Ebd., S. 82 [Hervorhebungen im Original].

29 Ebd., S. 81 [Hervorhebungen im Original].

Dennoch war Humboldt von dem relativen Fortschritt der Wissenschaft überzeugt: Bestehende Kulturtechniken und wissenschaftliche Normen seien dafür verantwortlich, dass sich die Weltanschauung fortwährend umformte und weiterentwickelte. Anhand der Analyse der historischen Dispositionen und der Bedingungen der Erkenntnisgewinnung zu einer bestimmten Zeit zeichne sich die Geschichte der physischen Weltanschauung als „Geschichte der Erkenntniß eines Naturganzen, die Darstellung des Strebens der Menschheit [,] das Zusammenwirken der Kräfte in dem Erd- und Himmelsraume zu begreifen" ab.[30] In der „Verallgemeinerung der Ansichten"[31] für einen bestimmten Zeitabschnitt ließen sich dabei, so Humboldt, wissensgeschichtliche „Epochen des Fortschrittes"[32] nachzeichnen. Messbar sei dieser von Humboldt teleologisch aufgefasste Prozess daran, inwieweit die jeweiligen Epochen das Wesen der Natur vermeintlich durchdrungen hätten.[33] Für seine eigene Zeit konstatierte Humboldt an anderer Stelle:

> Auch von dem hohen Standpunkte aus, auf den wir uns zu einer allgemeinen, durch wissenschaftliche Erfahrungen begründeten *Weltanschauung* erheben, kann nicht allen Anforderungen genügt werden. In dem Naturwissen, dessen gegenwärtigen Zustand ich hier entwickeln soll, liegt noch Manches unbegrenzt […].[34]

Fehlschlüsse gehörten für Humboldt explizit zum Prozess der Erkenntnisfindung dazu, denn die temporär als gültig empfundene Weltanschauung konturiere die Erkenntnisbedingungen als „Theil der Geschichte unserer Gedankenwelt, in so fern dieser Theil sich auf die Gegenstände sinnlicher Erscheinung, auf die Gestaltung der geballten Materie und die ihr inwohnenden Kräfte bezieht"[35]. So war die inhaltliche Auffassung von der „physischen Weltanschauung" durch eine doppelte Ausrichtung bestimmt: Nach Humboldt formte sie sich im Austausch zwischen der eingeschränkten Konstitution menschlicher Ratio und der Verfasstheit der natürlichen Materie bzw. der ihr innewohnenden Prozesse. Letztlich blieb die Natur also dem beschränkten Intellekt des Menschen in ihrer Mannigfaltigkeit stets verborgen. Im naturwissenschaftlichen Streben und in der Beschreibung des Kosmos spiegelte sich daher immer auch die beispiellose Wesenheit des Menschen in seiner Unfähigkeit, sich selbst respektive seine Umgebung ganz zu erkennen.[36]

30 *Kosmos*, Bd. 2, 1847, S. 135.
31 Ebd.
32 Ebd.
33 Siehe ebd.
34 Humboldt: *Kosmos*, Bd. 1, 1845, S. 38 [Hervorhebung im Original].
35 Humboldt: *Kosmos*, Bd. 2, 1847, S. 135.
36 Aus Humboldts Begriffsauffassung der Weltanschauung und seiner Erkenntnis von der Unzulänglichkeit der sinnlichen Wahrnehmung folgte nicht zugleich eine differenzierte Betrachtung der demzufolge ebenfalls beschränkten Möglichkeiten, das Wissen über die Natur zu präsentieren. Humboldts Kritik an der Erkenntnisfähigkeit des Menschen zog, mit anderen Worten, keine Kritik an einer möglicherweise defizitären Vermittlungsleistung nach sich. Erst in Gaston Bachelards programmatischem Nachdenken

Die „Anschauung"

Damit sich die von Humboldt überindividuell angelegte Weltanschauung als wesentliches, vorstrukturierendes Moment der Erkenntnisfindung jedoch überhaupt konstituieren konnte, musste die individuell gewonnene Naturbeobachtung zunächst die heuristisch keineswegs triviale Kluft hin zur allgemeinen Erkenntnisfähigkeit überwinden. Diese theoretische Brücke baute Humboldt mit Hilfe der pragmatisch verstandenen „Anschauung". Sie strukturierte das empirisch Wahrgenommene vor, womit ihr ein wichtiger Anteil an der Erkenntnis zukam, ohne den sich für Humboldt unmittelbares sinnliches Erleben und die gleichzeitige Vorarbeit zur Erkenntnis nicht zusammenbringen ließen.[37]

Insgesamt blieb die Anschauung in ihrer definitorischen Abgrenzung bei Humboldt noch wesentlich unschärfer als die Weltanschauung: Wann und auf welche Weise sich individuelle und kollektive Wahrnehmung zu verschränken begannen, ließ sein theoretisches Konstrukt im Unklaren. Humboldt verwendete den Terminus in einer freien und anwendungsorientierten Interpretation der Kantschen Begriffsauffassung – jedoch nicht, um das bei diesem primär verhandelte Leib-Seele-Problem zu thematisieren.[38] Humboldt verstand die Anschauung hingegen als Bezugsgröße, um die bei Kant wesentlichen Komplemente von physischer Wahrnehmung und rationaler Verarbeitung auf eine mögliche Erkenntnis des „Naturganzen" zu beziehen. Mit der Anschauung brachte Humboldt sinnlich erfasste Einheiten, auf denen die Möglichkeit der Naturerkenntnis durch den Menschen basierte, auf einen Begriff.

Ausgangspunkt für Humboldts pragmatische Wendung des Begriffs war, dass Kant den Terminus in seiner Transzendentalphilosophie als dreiteilige Konzeption aus sehendem Subjekt, angeschautem Objekt und der Vorstellung des Objekts verstanden und sie von vornherein logisch, als normativ vermittelnde Instanz der subjektiven, sinnlichen

über Wissenspraktiken stellte die Evidenz der unmittelbaren Anschauung ein „epistemologisches Hindernis" dar. Wissenschaftliches Denken bildete sich nach Bachelard in einem epistemologischen Bruch, d. h. der Alltagserfahrung entgegengesetzt heraus. Vgl. Bachelard, Gaston: *Die Bildung des wissenschaftlichen Geistes: Beitrag zu einer Psychoanalyse der objektiven Erkenntnis*, Frankfurt am Main: Suhrkamp 1984, S. 46; vgl. auch Rheinberger, Hans-Jörg: *Historische Epistemologie zur Einführung*, Hamburg: Junius 2007, S. 38 – 39.

37 Humboldts Verwendung unterliegt hier einer generellen Unschärfe, die für die deutsche Begriffsverwendung kennzeichnend ist. Vgl. Naumann-Beyer, Waltraud: Art. „Anschauung", in: *Ästhetische Grundbegriffe*, hg. von Karlheinz Barck u. a., Stuttgart: Metzler 2000, S. 208 – 246, hier S. 208 – 210. Pirmin Stekeler-Weidhofer weist darauf hin, dass die Anschauung in der ästhetischen bzw. philosophischen Rezeption weder eindeutig umkreist noch intensiv behandelt worden sei. Vgl. Stekeler-Weithofer, Pirmin: „Die soziale Logik der Anschauung", in: *Was sich nicht sagen lässt: das Nicht-Begriffliche in Wissenschaft, Kunst und Religion*, hg. von Joachim Bromand u. a., Berlin: Akademie-Verlag 2010, S. 235 – 256, hier S. 235.

38 Siehe Feger, Hans: „Die Realität der Idealisten. Ästhetik und Naturerfahrung bei Schiller und den Brüdern Humboldt", in: *Die Realität der Idealisten: Friedrich Schiller – Wilhelm von Humboldt – Alexander von Humboldt*, hg. von dems. u. a., Köln u. a.: Böhlau, 2008, S. 15 – 43, hier S. 16 – 17.

Wahrnehmung äußerer Gegenstände, besetzt hatte. Durch deren räumliche und zeitliche Strukturierung, die Eigenschaft und Bedingung einer jeden Wahrnehmung sei, würden phänomenologische Erscheinungen den Sinnen zugänglich, d. h. im Wortsinn anschaulich. Dieses raum-zeitlich organisierte, dem Subjekt Äußere schaffte nach Kant die notwendigen Voraussetzungen für jede Erkenntnis.[39] Für Humboldt war entscheidend, dass Kant mit seinen Überlegungen eine – wiewohl erkenntnistheoretische – Vorarbeit geleistet hatte, die – nun von Humboldt wissenschaftspragmatisch gewendet – eine Brücke zwischen der theoretischen Vorannahme regelmäßiger globaler Kräfte und der sinnlichen Naturerfahrung, zwischen Außenwelt und ihrer Erfahrung durch das Subjekt, zu bauen vermochte. Sinnliche Wahrnehmung und eine darin angelegte, vorstrukturierte Untergliederung des Betrachteten konnten auf diese Weise heuristisch miteinander verzahnt werden.[40]

Vor diesem Hintergrund verhielten sich nach Humboldts Verständnis die Anschauung und die Weltanschauung offenbar so zueinander, dass beide der Erkenntnis vorgelagert waren, wobei die Anschauung die individuellen Voraussetzungen einer potentiell heuristisch vorstrukturierenden optischen Wahrnehmung konturierte und in der Weltanschauung ihre überindividuelle Ausprägung fand. Aus der Weltanschauung, so Humboldt, konnte schließlich der „Begriff von der Einheit der Erscheinungen" als „das selbstständige Streben der Vernunft nach Erkenntniß von Naturgesetzen, also eine denkende Betrachtung der Naturerscheinungen" gewonnen werden, womit nunmehr dezidiert eine

39 Vgl. Stekeler-Weithofer: „Soziale Logik der Anschauung", 2010, S. 244 – 249. Zum Begriff der Anschauung, insbesondere bei Kant, vgl. auch Haag, Johannes: Art. „Anschauung", in: *Neues Handbuch philosophischer Grundbegriffe*, hg. von Petra Kolmer u. a., Bd. 1, Freiburg im Breisgau: Alber 2011, S. 163 – 178; Naumann-Beyer: „Anschauung", 2000.

40 Kristian Köchy führt an, dass für Humboldt in dieser Verklammerung der Anreiz zum Naturstudium, der gerade in der Fülle und gleichzeitigen Ordnung der Natur motiviert war, nicht nur erhalten blieb, sondern noch erhöht wurde. In der doppelten Ausrichtung der Anschauung – der Erfahrung und dem gleichzeitigen Erkennen – lag demnach nicht nur eine erste Systematisierung des Betrachteten, sondern auch eine nähere Hinwendung zu diesem begründet. Der Bezug auf die transzendentalphilosophische Anschauung lieferte Humboldt so die Voraussetzung seiner Synthese von künstlerischer und naturwissenschaftlicher Sphäre. Köchy führt weiter aus, dass der Begriff der Anschauung es Humboldt möglich machte, Kunst und Wissenschaft in der „physischen Weltbeschreibung" des „Naturgemäldes" zu verknüpfen. Vor dem Hintergrund der hier vorgelegten Analyse zeigt sich jedoch, dass – anders als Köchy betont – Humboldts Motivation weniger methodischer Natur war, in der Anschaulichkeit mittels einer systematischen, aber lebendigen und „naturwahren" Darstellung auf eine bessere Kommunikation mit der Leserschaft zu zielen, sondern dass sich sein Anschauungsbegriff aus einem epistemischen Wahrnehmungskonzept ableitete, das in unmittelbarem Zusammenhang mit der wissenschaftlichen Erkenntnis stand. Bei einer genaueren Betrachtung des Humboldtschen Anschauungsbegriffs ist daher zweifelhaft, ob Humboldts Wissenschaft, wie Köchy annimmt, dezidiert erst dort begann, „wo sich der Intellekt des Stoffes bemächtigt und wo der Versuch unternommen wird, die Masse der Erfahrungen der Vernunfterkenntnis zu unterwerfen". Vgl. Köchy: „Alexander von Humboldts Naturgemälde", 2009, S. 81 – 88, Zitat S. 88.

rational reflektierte Ebene angesprochen war.[41] In dieser denkenden Betrachtung wurde demnach die verallgemeinernde Beurteilung der sinnlichen Erfahrung und mit ihr der Schritt zur Erkenntnis vollzogen.

Dass die subjektive, sinnlich-ganzheitliche und zugleich stets ausschnitthafte und beschränkte Wahrnehmung in ein generelles epistemologisches Konzept eingebunden wurde, das zu einer formulierbaren Erkenntnis über die Natur führte, war für Humboldts Leitlinien einer „Erfahrungswissenschaft" grundlegend. Er grenzte sie dezidiert gegen eine transzendental-philosophische Herangehensweise ab – und verwies damit implizit auf den von ihm vorgenommenen, von Kant aus gedachten Bedeutungswandel der Anschauung. Nach Humboldt stand seine „Erfahrungswissenschaft", die durch die „Behandlung [...] eines Aggregats von Kenntnissen, [...] die Anordnung des Aufgefundenen nach leitenden Ideen, die Verallgemeinerung des Besonderen, das stete Forschen nach *empirischen Naturgesetzen*"[42] charakterisiert war, einer der Transzendentalphilosophie nahestehenden Naturphilosophie klar entgegen, da diese sich durch ein „denkendes Erkennen, ein vernunftmäßiges Begreifen des Universums"[43] auszeichnete. Zwar hielt Humboldt gleichzeitig an seinem von der Naturphilosophie geprägten Erkenntnisinteresse eines „Naturganzen" fest.[44] Anschauung bzw. Weltanschauung verschafften ihm indes ein theoretisches Fundament, das ihn in die Lage versetzte, individuelle Erfahrung und das Wesen des „Naturganzen" unter Erkenntnis generierenden Konstanten zusammenzuführen. Idealiter konnte sich dem kenntnisreichen Betrachter so bereits in der individuellen sinnlichen Naturwahrnehmung das Zusammenwirken der natürlichen Kräfte zeigen – wenngleich Humboldt dieses Ziel in der Praxis kaum erreichbar schien:

> Wir sind noch weit von dem Zeitpunkte entfernt, wo es möglich sein könnte, alle unsere sinnlichen Anschauungen zur Einheit des Naturbegriffs zu concentriren. Es darf zweifelhaft genannt werden, ob dieser Zeitpunkt je herannahen wird. Die Complication des Problems und die Unermeßlichkeit des Kosmos vereiteln fast die Hoffnung dazu.[45]

Reine Anschauung reichte also nach Humboldt bei Weitem nicht aus, um die Natur in ihrem Zusammenwirken ganz zu verstehen. Festgehalten werden kann in diesem Zusam-

41 Beide Zitat bei Humboldt: *Kosmos*, Bd. 2, 1847, S. 138. Die denkende Betrachtung wandelte sich laut Humboldt vor allem durch kulturelle Gegebenheiten und neue optische Instrumente. Zur Ebene der Reflexion gehörte auch der von ihm an verschiedener Stelle angeführte Begriff der „Einbildungskraft". Statt auf die Erkenntnisgenese im Sinne der Verallgemeinerung von Ansichten bezog Humboldt jene jedoch vor allem auf eine emotive Dimension der Erfahrung. Vgl. zur denkenden Betrachtung Humboldts ferner Böhme: „Humboldts Entwurf einer neuen Wissenschaft", 2004, S. 200.

42 Humboldt: *Kosmos*, Bd. 1, 1845, S. 68.

43 Ebd. Vgl. zu diesem Aspekt auch Graczyk: *Tableau*, 2004, S. 377.

44 Siehe Graczyk: *Tableau*, 2004, S. 376.

45 Humboldt: *Kosmos*, Bd. 1, 1845, S. 67–68.

menhang jedoch, dass sich für Humboldt die Wesenheit der Natur zwar nicht allein über die optische Wahrnehmung erklären ließ, dass diese aber sehr wohl ein wesentlicher Bestandteil des Erkenntnisprozesses war: Die von Humboldt an die Optik gekoppelte Anschauung schuf die Voraussetzungen für einen überindividuellen, analytischen Einblick in das natürliche System. Mit ihrer Hilfe führte Humboldt in seinen theoretischen Überlegungen zur visuellen Wahrnehmung Sinnlichkeit, Naturerfahrung und Naturwissen zusammen. Der Wissenschaft kam hingegen die Aufgabe zu, die „Masse der Erfahrungen einer Vernunfterkenntniß"[46] zu unterwerfen, wobei eine in situ empfundene, ganzheitliche Wesenheit der Natur bei der Repräsentation des Wissens stets weiterhin berücksichtigt werden sollte. Wissenschaft galt Humboldt in diesem Zusammenhang als „Geist, zugewandt zu der Natur"[47], dem erst entsprochen wurde, wenn sich individuelle Beobachtung und verallgemeinerte Ansicht in Einklang bringen ließen.

Die graphische Vermittlung des Naturwissens

Das „Natur-" oder „Weltgemälde"

Mit dem „Natur-" oder „Weltgemälde" entwarf Humboldt ein methodisch angeleitetes Format der Darstellung, um das harmonische Ineinanderwirken des „Naturganzen" unter Berücksichtigung wissenschaftlicher Ergebnisse präsentieren zu können.[48] Anders als die Anschauung oder die Weltanschauung übernahm das Naturgemälde also keine Funktion im Erkenntnisprozess selbst, sondern stellte ein Instrument zur Vermittlung des Naturwissens dar, mit dessen Hilfe die natürliche Ordnung medial gespiegelt und anschaulich vor Augen gestellt werden konnte. Mit dem Naturgemälde sollte hierbei jedoch nicht nur eine wissenschaftliche Systematik präsentiert, sondern auch die für die Erkenntnis der Natur wesentliche sinnliche Naturerfahrung nachempfunden werden können. Wie Eberhard Knobloch konstatiert, verwendete Humboldt den Titel Natur- und Weltgemälde hierbei synonym, denn er „sprach vom großen und verwickelten Gemeinwesen, welches wir Natur und Welt nennen. Natur und Welt waren für ihn [Humboldt] danach nicht streng getrennte Begriffe, so wie er oft ohne strenge Unterscheidung bald von Natur- bald von Weltgemälde sprach"[49]. Vereinfachend wird daher im Folgenden lediglich das Naturgemälde genannt. Humboldt selbst bezeichnete seinen Text des *Kosmos* und die

46 Ebd., S. 69.
47 Ebd.
48 Das Vermittlungskonzept des Natur- oder Weltgemäldes ist ein häufig besprochener Gegenstand der Forschungsliteratur. Vgl. etwa Hey'l, Bettina: *Das Ganze der Natur und die Differenzierung des Wissens: Alexander von Humboldt als Schriftsteller*, Berlin u. a.: de Gruyter 2007, S. 214–263; Kraft: *Figuren des Wissens*, 2014, S. 126–133; Böhme: „Ästhetische Wissenschaft", 2001.
49 Siehe Knobloch, Eberhard: „Alexander von Humboldts Weltbild", *HiN* X (2009) 19, S. 34–46, hier S. 35.

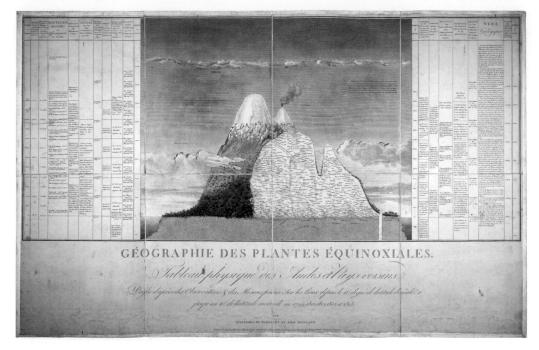

1__Alexander von Humboldt, *Tableau physique des Andes et Pays voisins*, 1807, 67,7 × 95,6 cm

Graphik des *Tableau physique des Andes et Pays voisins*[50] *(im Folgenden: Tableau physique des Andes)* dezidiert als ein solches (Abb. 1). Dementsprechend war das Format der Vermittlung medial nicht festgelegt. Grundsätzlich diente laut Humboldt „[a]lles Wahrnehmbare, das ein strenges Studium der Natur nach jeglicher Richtung bis zur jetzigen Zeit erforscht hat", als „Material, nach welchem die Darstellung zu entwerfen" sei.[51]

Die Schwierigkeit für diesen möglichst in wenigen Zügen angefertigten „Entwurf" sah Humboldt darin, im Reichtum der Natur eine „Trennung und Unterordnung der Erscheinungen"[52] vorzunehmen. Die in der Natur angelegte Ordnung musste hierfür „durch ahnungsvolles Eindringen in das Spiel dunkel waltender Mächte"[53] als solche erkannt und

50 Zur Analyse der Graphik vgl. insbesondere Böhme: „Ästhetische Wissenschaft", 2001; Beck, Hanno: „Zu Alexander von Humboldts »Naturgemälde der Tropenländer«", in: *Orbis pictus: kultur- und pharmaziehistorische Studien. Festschrift für Wolfgang Hein zum 65. Geburtstag*, hg. von Werner Dressendörfer, Frankfurt am Main: Govi 1985, S. 31–42; Graczyk: *Tableau*, 2004.

51 Siehe Humboldt: *Kosmos*, Bd. 1, 1845, S. 80.

52 Ebd.

53 Ebd.

präsentiert werden. Das Naturgemälde besaß folglich einen doppelten Boden, denn es realisierte sich nicht allein dank eines rationalen Denkprozesses durch den Menschen, der die natürlichen Formen schied und ihr Zusammenspiel bei der Vermittlung organisierte; vielmehr entsprang ein solcher Prozess auch und unmittelbar der natürlichen Ordnung selbst, wie auch Humboldts Wortgebrauch vom Kosmos „als *Universum*, als *Weltordnung*, als *Schmuck* des Geordneten"[54] verdeutlicht. Nach dieser Überzeugung entsprach die Systematik, die bei der Naturbeobachtung mit den menschlichen Sinnen erfahren und über das Naturgemälde vermittelt werden konnte, der Ordnung der Natur selbst – und doch bedurfte diese Ordnung des Menschen, um als solche auch erkannt und präsentiert werden zu können. Idealiter stellte das Naturgemälde das Ganze der Natur dabei auf eine Weise vor Augen, dass auch die sinnliche Erfahrung der Naturbetrachtung vermittelt wurde. Dieser sinnliche Eindruck sollte nach Humboldt als lebendiger Ausdruck „naturwahr" wiedergegeben werden.[55] Die besondere Herausforderung des Vermittlungsverfahrens bestand also darin, die Natur in ihrer Fülle zu strukturieren und zugleich ihre zusammenspielende und die Sinne ansprechende Harmonie zu erhalten.

Dennoch war das Naturgemälde seinem Entwurf nach ein Vermittlungsverfahren, das dezidiert in einem wissenschaftlichen Erkenntnisinteresse stand. Ihm gegenüber lassen sich Humboldts Überlegungen zu Repräsentationsformen des Naturwissens, die nicht primär einen Erkenntnis generierenden Bezug aufweisen, abgrenzen. Zu ihnen zählt etwa die Landschaftsmalerei – darunter die sogenannte geognostische Landschaft –[56], die sich, so Humboldt, ebenfalls an einem harmonischen Gesamteindruck der Natur orientieren sollte, dem Naturgemälde gegenüber aber einer systematischen Anleitung für die Darstellung entbehrte.[57] Daher stellte die Landschaftsmalerei für Humboldt keine Form der expliziten wissenschaftlichen Vermittlung dar, sondern diente, ebenso wie die „ästhetische Behandlung von Naturscenen"[58] in der Literatur, als „Anregungsmittel zum Naturstudi-

54 Ebd. [Hervorhebungen im Original].

55 Siehe ebd., S. 80.

56 Die geognostische Landschaft, die in ihrer auf empirischen Naturbeobachtungen basierenden Typenbildung stark idealisierende Akzente aufweist, stellte den Versuch dar, durch eine ganzheitliche Qualität des Dargestellten eine bestimmte Stimmung der Landschaft einzufangen. Einerseits wurden in der Zusammenführung von physiognomisch bzw. morphologisch orientierter Naturbeobachtung und Malerei charakteristische Merkmale der Naturformen hervorgehoben und geographisch strukturiert, andererseits sollte über die einbezogene Stimmung einem Auseinanderdriften von Kunst und Wissenschaft entgegengewirkt werden. Humboldt ging vor allem im zweiten Band seines *Kosmos* auf diesen Darstellungsweise ein.

57 Vgl. Steigerwald, Joan: „The Cultural Enframing of Nature: Environmental Histories during the Early German Romantic Period", *Environment and History* 6 (2000) 4, S. 451–496, hier S. 477–480.

58 Siehe Humboldt: *Kosmos*, Bd. 2, 1847, S. 4.

um".[59] Wie diese „Anregungsmittel" konnte aber auch das Naturgemälde die Intensität des Naturgenusses, die für Humboldt mit der Tiefe der Einsicht in das innere Wesen der Natur korrelierte, intensivieren. Beide Vermittlungsweisen hatten folglich, mit oder ohne wissenstheoretischer Fundierung, entscheidenden Einfluss auf die Beschäftigung mit der Natur. Dadurch, dass sie die Hinwendung zu dieser begünstigten, waren sie maßgeblich dafür verantwortlich, dass der Zugang zu einem möglichen Wissen über die Natur geöffnet wurde. Auch der Malerei geognostischer Landschaften kam daher, ohne dass sie wissenschaftlich angeleitet gewesen sei, eine elementare heuristische Vorarbeit zu. Vor diesem Hintergrund erklärt sich, warum Humboldt Reisemaler entschieden förderte: Sie sollten in ihren Gemälden exotische Landschaften einfangen, damit diese dem europäischen Publikum als „Anregungsmittel" zum Naturstudium vor Augen gestellt werden konnten.[60]

Der „Totaleindruck"

Indem das Naturgemälde das „Naturganze" gedrängt und analytisch angeleitet vor Augen führen sollte, ist mit ihm dem Begriff wie dem Inhalt nach ein komplexes ästhetisches Darstellungsprinzip angesprochen, dessen Wirkung Humboldt mit der Bezeichnung des „Totaleindrucks" auf einen Begriff brachte.[61] Es benennt ein aisthetisches Erlebnis, in dem sich wissenschaftlicher und ästhetischer Anspruch verbinden.[62] Hierbei ging es Humboldt, wie Kristian Köchy feststellt, „[n]aturwissenschaftlich [...] darum, die allgemeinen, gesetzlichen Grundzüge in der Vielfalt der Naturbildung herauszustellen. Künstlerisch geht es um die kompositorische Aufgabe der Erstellung eines schönen Naturbildes, das

59 Siehe Humboldt: *Kosmos*, Bd. 1, 1845, S. XIII und Bd. 2, 1847, S. 3–4. Als weiteres Anregungsmittel führte Humboldt die Verbreitung tropischer Pflanzen in Europa, etwa in botanischen Gärten, auf. Vgl. zur Diskussion über Humboldts „Anregungsmittel zum Naturstudium" Barck: „»Umwandlung des Ohrs zum Auge«", 1995, insbesondere S. 28; Knobloch: „Naturgenuss und Weltgemälde", 2004.

60 Vgl. zur Thematik der Reisemalerei um Humboldt *Beobachtung und Ideal: Ferdinand Bellermann – ein Maler aus dem Kreis um Humboldt*, hg. von Kai Uwe Schierz, Petersberg: Imhof 2014; *Kunst um Humboldt. Reisestudien aus Mittel- und Südamerika von Rugendas, Bellermann und Hildebrandt im Berliner Kupferstichkabinett*, hg. von Sigrid Achenbach, München: Hirmer 2009; Pedras, Lúcia Ricotta Vilela Pinto Brando: *A totalidade encantada. Natureza, ciência e arte em Alexander von Humboldt*, Rio de Janeiro, Universitätsschrift [Dissertation] 2004; Badenberg, Nana: „Sehnsucht nach den Tropen. Wissenschaft, Poesie und Imagination bei Humboldt und Rugendas", *Tropische Tropen – Exotismus. kultuR-Revolution* 32/33 (1995), S. 53–65; Löschner, Renate: *Lateinamerikanische Landschaftsdarstellungen der Maler aus dem Umkreis von Alexander von Humboldt*, Berlin, Universitätsschrift [Dissertation] 1976; vgl. ferner Werner, Petra: *Naturwahrheit und ästhetische Umsetzung: Alexander von Humboldt im Briefwechsel mit bildenden Künstlern*, Berlin: Akademie-Verlag 2013.

61 So erwähnt Humboldt den Begriff etwa in den *Ideen zu einer Physiognomik der Gewächse*, 1806, S. 15.

62 Vgl. dazu auch Werner: *Naturwahrheit und ästhetische Umsetzung*, 2013, S. 72.

den Reichtum der Natur […] durch die Ruhe des harmonischen Totaleindrucks versinn-
bildlicht."[63]

Im Terminus des Totaleindrucks, d. h. der ausgeschöpften Wahrnehmungserfahrung,
klingt bereits an, dass das Naturgemälde von einem angenommenen Standpunkt der Be-
trachtung aus, d. h. unter Berücksichtigung des Verhältnisses zwischen kontemplieren-
dem Subjekt und dessen Umgebung, entworfen werden sollte. Damit der Totaleindruck
unter der Reflexion des subjektiven Eindrucks sinnlicher Wahrnehmung nicht auseinan-
derfiel, sondern verschiedene natürliche Objekte zu einer Erkenntnis generierenden Ein-
heit verkoppelt werden konnten, setzte Humboldt eine bereits geschulte Betrachterin bzw.
einen bereits geschulten Betrachter der Natur voraus. Von dieser imaginierten Perspektive
aus sollte das Naturgemälde entworfen werden und sich dabei die Wahrnehmung des ide-
ellen Subjekts medial im Totaleindruck des Naturgemäldes spiegeln. Wie auf erkenntnis-
theoretischer Ebene, auf der der „ordnende Denker" die Natur schon während des Natur-
erlebnisses im heuristischen Sinne vorzustrukturieren vermochte, zog Humboldt auf
der Ebene der Darstellung folglich ebenfalls eine imaginäre Vermittlungsinstanz ein.[64] In
diesem Sinne war die Welt, der Kosmos, wie Eberhard Knobloch feststellt, für Humboldt
„immer schon als Gegenstand des menschlichen Denkens gemeint"[65]. Für die Erstellung
des Naturgemäldes hatte dies zur Folge, dass hierfür eine grundlegende und umfassende
Einsicht in die Gesamtheit der natürlichen Prozesse und Prinzipien, d. h. eine genaue
Kenntnis der Natur, die erste und notwendige Voraussetzung darstellte.

Dadurch, dass Humboldt von einem imaginären Standpunkt der Betrachtung für das
Naturgemälde ausging, war diesem eine kontemplative Perspektivierung eingeschrieben.
Die Natur war damit nicht mehr voraussetzungslos gegeben, sondern wurde als ange-
schaute Natur in einen Rahmen und mit diesem in eine räumliche Ordnung eingefasst.
Hierdurch verwandelte sich der Naturausschnitt in einen Raum der menschlichen Wahr-
nehmung und Erfahrung oder, mit anderen Worten, in eine Landschaft. Als ästhetische
Kategorie fand die „Landschaft" ab 1800 mit weitreichender Resonanz Eingang in den
theoretischen Diskurs.[66] Im Zuge dessen geriet das Naturding als ein vergleichsweise in-
stabiles Objekt in den Blick, das nun, anstatt als festgefügte Größe, in seiner Auffassung
durch den Menschen verhandelt wurde. Statt die Natur also als statisches Konstrukt zu
begreifen, wurde sie verstärkt als wandelbares, vom Menschen konstituiertes Gefüge ver-
standen. Zugleich affizierte die Natur den Menschen. Ihre Wirkung hing hierbei nicht

63 Köchy: „Alexander von Humboldts Naturgemälde", 2009, S. 82.

64 Vgl. Humboldt: *Kosmos*, Bd. 1, 1845, S. 81.

65 Knobloch: „Naturgenuss und Weltgemälde", 2004, S. 4.

66 Autonome Landschaftsdarstellungen datieren bisweilen deutlich früher. Vgl. Buchholz, Amrei: Art.
 „Diorama, Panorama und Landschaftsästhetik", in: *Handbuch Bild*, hg. von Stephan Günzel und Dieter
 Mersch, Stuttgart u. a.: Metzler 2014, S. 181–187.

primär von den einzelnen Elementen des Betrachteten ab, sondern vom Gesamteindruck und dessen Komposition.[67]

In Anbetracht der auch für das Naturgemälde geltenden Verschiebung der Natur zur Landschaft setzte Humboldt bei dessen Konzeptionierung also nur der Theorie nach bei der ästhetisch wie naturwissenschaftlich organisierten Vermittlung des „Naturganzen" an. Mehr noch bot ihm das Naturgemälde die Möglichkeit zu klären, auf welche Weise und unter welchen Bedingungen das Wissen über die Natur und das natürliche System überhaupt dargestellt werden konnten. Dass Humboldt hierbei selbst an die Grenzen des mit dem Format zu Zeigenden gelangte, zeigt die Fülle der eng gedruckten Informationen im *Tableau physique des Andes* ebenso wie der ausufernde Text des *Kosmos*.

Naturphysiognomische Darstellungspraxis

Wesentliche Voraussetzung, um die Ordnung der Natur entschlüsseln und diese letztlich auch in die Darstellung eines Naturgemäldes überführen zu können, bildete Humboldts naturphysiognomische Theorie. Auf ihrer Grundlage ließ sich die natürliche Vielfalt in formale Typen unterteilen, nach lokalen Aspekten unterscheiden und entsprechend gruppiert präsentieren. Die physiognomischen Typen der Natur wurden in diesem Zusammenhang nicht als Solitäre, sondern als Teile eines korrelierenden, aufeinander bezogenen Formenensembles verstanden, das von Region zu Region andere Ausprägungen aufwies.

Im Hinblick auf die Vegetation erläuterte Humboldt seine naturphysiognomischen Überlegungen vor allem in seinen 1806 erstmals publizierten *Ideen zu einer Physiognomik der Gewächse* (im Folgenden: *Physiognomik der Gewächse*). Darin wurden 16 Hauptformen der Pflanzen unterschieden, die sich statt an einer botanischen Systematik an optischen Kriterien orientierten, und zwar nach dem, „was durch Masse den Totaleindruck einer Gegend individualisirt"[68]. Zu den naturphysiognomischen Formentypen zählte Humboldt unter anderen „Palmen", „Orchideen", „Nadelhölzer", „Gras-" und „Cactusform", deren Anzahl jedoch nicht von vornherein klar begrenzt war, sondern sich, wie Humboldt erwartete, gemeinsam mit dem Wissen über die Natur vermehren würde.[69]

67 Zum Begriff der Landschaft in der ästhetischen Diskussion vgl. Frank, Hilmar/Lobsien Eckhard: Art. „Landschaft", in: *Ästhetische Grundbegriffe: Historisches Wörterbuch in sieben Bänden*, hg. von Karlheinz Barck u. a., Bd. 3, Stuttgart u. a.: Metzler 2001, S. 617–665, hier S. 619–620; Buchholz: „Diorama, Panorama und Landschaftsästhetik", 2014; Zur Natur als Landschaft bei Humboldt vgl. Barck: „»Umwandlung des Ohrs zum Auge«", 1995, S. 29.

68 Humboldt: *Ideen zu einer Physiognomik der Gewächse*, 1806, S. 15. Zwei Jahre später wurde der Text erneut in den *Ansichten der Natur* abgedruckt. Im Kontext der naturphysiognomischen Überlegungen Humboldts erzielten auch dessen Untersuchungen der Vulkane größere Resonanz. Petra Werner weist darauf hin, dass Humboldts diesbezügliche Gruppierung bis heute als optionales Einteilungskriterium für Vulkane genutzt wird. Siehe Werner: *Naturwahrheit und ästhetische Umsetzung*, 2013, S. 72.

69 Siehe Humboldt: *Physiognomik der Gewächse*, 1806., S. 16. Zu den physiognomischen Pflanzentypen und ihrer Beschreibung siehe ebd., S. 18–26.

Bezogen auf die gestalthaft-räumliche Organisation seiner Naturphysiognomie schloss Humboldt insbesondere an die Morphologie an, grenzte sich von dieser aber insofern ab, als er statt von einer Metamorphosen-Theorie auszugehen, die die Form selbst und deren Veränderlichkeit untersuchte, eine von der Physiognomik zentral gestellte räumliche Dimension der Gestalt und ihre emotionale Wirkung auf den Menschen betonte.[70] Diese subjektbezogenen Überlegungen zur Phänomenologie der Naturdinge verband Humboldt mit der Dynamik eines insbesondere von Friedrich Wilhelm Schelling (1775–1854) geprägten Organismus-Modells. Während die von der Natur abgeschauten physiognomischen Grundformen für Humboldt eine konstituierende Rolle für den Zugang zur Natur und die Erkenntnis über einzelne Naturdinge spielten, stellte das Organismus-Modell die Beziehungen der Grundformen zueinander in ein ganzheitliches und dynamisches System.[71] Innerhalb dieses Systems ließen sich anhand der Zusammenstellung bestimmter Formen regional spezifische Typen der Natur unterscheiden.

Für Humboldt zeigten sich die repräsentativen formalen Merkmale der Naturdinge vor allem in ihren Umrissen.[72] In dieser ihnen äußeren Form wurden die Physiognomie und mit ihr das Wissen (gr. γνῶσις [*gnosis*] = Einsicht, Wissen) über die natürliche Beschaffenheit (gr. φύσις [*physis*] = Natur) des Beschauten freigelegt. Humboldts diesbezüglichen Annahmen orientierten sich an Johann Caspar Lavaters (1741–1801) physiognomischer Theorie. Lavater zufolge hatte die Seele einen fundamentalen und irreversiblen Einfluss auf die Ausgestaltung des menschlichen Körpers, weshalb auch dessen Betrachtung unmittelbare Kenntnis über die Bestimmung des Menschen versprach.[73] Diese Abhängigkeiten zu beschreiben, war das eigentliche Ziel Lavaters; statt der Form selbst standen daher letztlich die Schlussfolgerungen im Zentrum seines Interesses, die die formale Gestalt zuließ. Im Anschluss an Lavaters Theorie verstand auch Humboldt seine Naturphysiognomik als Beschreibung einer natürlichen Formgestaltung, die das Resultat eines grundlegenden und nicht zu beeinflussenden Gefüges innerer Naturkräfte darstellte. Ähnlich wie Lavater zielte auch Humboldt darauf, von der formalen, an der Erdoberfläche sinnfällig werdenden Gestaltung der Natur ausgehend Rückschlüsse über die Kräfte des „Naturganzen" zu gewinnen, die er für ebendiese Gestaltung verantwortlich machte.[74] Erst wenn die natürlichen Grundformen und -strukturen erkannt und in ihrem Zusammenwirken verstanden worden waren, war es der menschlichen Ratio letztlich möglich, die Fülle der Natur auch intellektuell zu durchdringen.[75]

70 Siehe Graczyk: *Tableau*, 2004, S. 301.

71 Vgl. ebd., S. 290.

72 Vgl. Humboldt: Manuskript zum *Essay de Pasigraphie*, 1803/1804, 4r–5v.

73 Siehe Pollok: „Sinnliche Erkenntnis und Anthropologie", 2012, S. 25.

74 Vgl. Alexander von Humboldt am 06.08.1794 in einem Brief an Schiller. Abgedruckt in: *Berliner Revue. Social-politische Wochenschrift*, redigiert von Hermann Keipp, 17 (1859) 2, S. 539–540.

75 Zur Naturphysiognomik Humboldts vgl. insbesondere Graczyk: *Tableau*, 2004, S. 299–304.

Nicht jeder Formbestimmung kam innerhalb Humboldts naturphysiognomischem Ansatz die gleiche Bedeutung zu. Einige Naturobjekte stachen in ihrer physiognomischen Bestimmung insofern heraus, als sie den „Totaleindruck" maßgeblich mitbestimmten und von ihnen zugleich auf das systemische Ganze geschlossen werden konnte. Hierbei handelte es sich nicht etwa primär um diejenige von Pflanzen, deren physiognomisches System Humboldt vergleichsweise weit entwickelte, sondern vor allem um die äußere Beschaffenheit von Bergen und Flüssen. Beide Naturphänomene stellten basale Größen in Humboldts Überlegungen dar, weil er sie als maßgebliche Faktoren erkannte, nach denen sich die gesamte Erdoberfläche strukturierte. Bergmassive und Flusssysteme erstreckten sich großflächig und weit über das Lokalkolorit einzelner Regionen hinaus über ganze Kontinentalmassen. Von der Bestimmung der spezifischen Formen eines Berges oder Flusses und deren Vergleich mit anderen Berg- bzw. Flussphysiognomien versprach sich Humboldt Aufschluss über weitreichende topographische Zusammenhänge.[76] Grundlage hierfür war seine Vorstellung von einer nach bestimmten Regeln verlaufenden Formausprägung, nach der kein Naturding in seiner natürlichen Gestalthaftigkeit für sich allein stand. Physiognomische Einzelbeobachtungen ließen sich daher über einen Vergleich mit weiteren Beobachtungen in allgemeine Gesetzmäßigkeiten überführen. Die physiognomische Kenntnis großflächiger topographischer Gegebenheiten stellte für Humboldt mithin wegweisendes Grundlagenwissen der von ihm entwickelten Physikalischen Geographie dar; mit der Karte konnte es visuell vorgeführt werden. Hierbei war entscheidend, dass die „Wechselwirkung" der natürlichen Kräfte maßgeblich von der Struktur des topographischen Reliefs abhing. Das Gelände bestimmte nicht zuletzt, wo und unter welchen Bedingungen sich Menschen, Tiere und Pflanzen ansiedelten oder verbreiteten.[77] Von der Beschreibung der generellen Formationen der Erdoberfläche versprach sich Humboldt daher, auch auf allgemeine, globale Naturgesetze schließen zu können.

76 Überall, so schrieb Humboldt etwa, „bestimmt die Gestaltung des Bodens die Richtung der Flüsse, nach beständigen und gleichförmigen Gesetzen". Humboldt, Alexander von: „Über die Verbindung zwischen dem Orinoko und dem Amazonenfluss", *Monatliche Correspondenz zur Beförderung der Erd- und Himmels-Kunde* 26 (1812), S. 230–235, hier S. 235. Ulrike Leitner merkt an, dass dieser Satz das naturwissenschaftliche Denken Humboldts im Kern erfasse: Die Natur gehorchte demnach geordneten, gleichförmigen Gesetzen, die der Naturforscher anstrebte, in ihren Wechselwirkungen disziplinenübergreifend zu beschreiben. Vgl. Leitner, Ulrike: „Unbekannte Venezuela-Karten Alexander von Humboldts", *HiN* II (2001) 3, o. S.

77 Humboldt selbst erlebte diesen Zusammenhang auf seiner Amerikanischen Reise unmittelbar, indem etwa Flussverläufe, darunter der Orinoko, bisweilen der von ihm eingeschlagenen Route entsprachen. Dieser Wasserweg diente ihm als Fortbewegungsmittel und gab ihm damit auch seinen Handlungs- und Wahrnehmungshorizont vor.

Das *Tableau physique des Andes*

Dass Humboldt die singuläre physiognomische Beobachtung auf den globalen Raum übertrug, zeigt sich am *Tableau physique des Andes*, dem einzigen Naturgemälde, das er selbst graphisch umsetzte (Abb. 1). Zugleich wird an der Graphik die Bedeutung von Bergphänomenen für Humboldts Wissenschaft sowohl in geomorphologischer, d.h. auf seine physiognomische Bestimmung bezogen, als auch in geophysikalischer Hinsicht, d.h. als generelles Höhenphänomen, deutlich. Das *Tableau physique des Andes* erschien erstmals 1807 mit dem französischsprachigen *Essai sur la géographie des plantes accompagné d'un tableau physique*. Noch im selben Jahr publizierte Humboldt Karte und Text als *Ideen zu einer Geographie der Pflanzen nebst einem Naturgemälde der Tropenländer* (im Folgenden: *Geographie der Pflanzen*) auch in deutscher Fassung.[78] Die Graphik zeigt einen auf der Höhe des Chimborazo angesetzten schematisierten Querschnitt durch die Anden und zugleich durch die gesamte südamerikanische Kontinentalmasse. Auf dem zwischen zwei Ozeanen eingefassten, in seiner Höhenentwicklung nach Humboldt Kenntnisstand möglichst präzise wiedergegebenen Bergprofil wird die auch figurativ ausgestaltete, horizontal gestaffelte Verteilung der Pflanzen ansichtig. Die botanischen Bezeichnungen verschiedener Arten sind auf der Schnittfläche des Massivs in der entsprechenden Höhenlage, in der sie prinzipiell vorkommen, eingetragen – darunter auch viele nicht in den Anden heimische Pflanzen. Zusätzliche Informationen, die die Verteilung der Vegetation auf der Erdoberfläche bedingen, sind höhenabhängig in tabellarischen Spalten versammelt, die die Graphik links und rechts umfangen.

Bei Humboldts graphischer Konzeption des *Tableau physique des Andes* war die Profillinie des Chimborazo ausschlaggebend, denn seine Kontur bestimmte die Verteilung und Anordnung aller Informationen auf dem Blatt. In der *Geographie der Pflanzen* vermerkte Humboldt hierzu, die gesamte Darstellung sei „an nebenstehende Scalen profilartig gebunden", wodurch sie „keiner sehr malerischen Ausführung fähig" bleibe, denn „[a]lles was geometrische Genauigkeit erheischt, ist dem Effekt entgegen. Die Vegetation sollte eigentlich bloss als Masse sichtbar seyn, und daher wie in militärischen Planen angedeutet werden."[79] Soweit es die präzise Darstellung des Bergprofils erlaubte, entschied Humboldt sich jedoch im Laufe der Umsetzung, seinen graphischen Entwurf zusätzlich mit einer „malerischen Ausführung" zu versehen. Mit dieser holte er im Nachhinein die Konzeption eines Naturgemäldes ein, wie er sie später im *Kosmos* auch theoretisch formulieren sollte. Im *Tableau physique des Andes* erfüllten sich letztlich „zwei sich oft fast ausschliessende Bedingungen zugleich [...], Genauigkeit der Projection und malerischer

78 Vgl. Humboldt, Alexander von: *Essai sur la géographie des plantes, accompagné d'un tableau physique*, Paris: Schoell 1805 [auf dem Titelblatt irrtümlicherweise angegeben, tatsächlich erschienen 1807]. Eine erste Skizze Humboldts zum *Naturgemälde* stammt von 1803 und entstand während seines Aufenthalts in Ecuador. Die Tuschzeichnung (38,2 × 49,5 cm) befindet sich heute im Museo Nacional de Colombia.

79 Humboldt: *Geographie der Pflanzen*, 1807, S. 43.

Effekt"[80]. Aufgrund dieser „malerischen" Aspekte zeichneten sich „in der Ebene (gleichsam im Vordergrunde) die zartblättrigen Pisanggebüsche und die hohen Blätter der Palmen" ab.[81] Ferner sähe man

> Musagewächse und Fächerpalmen allmählig sich in kleinblättrige Laubbäume, diese sich in niedriges Gesträuch, das Gesträuch sich in die Grasflur verlieren. Die Region der Gräser reicht so weit als die lockere Erdschicht, welche dünner und dünner sich über die Berggipfel ausbreitet. Moose, inselförmig an den klüftigen Felswänden vertheilt, Blätterflechten und buntfarbige Psoren bestimmen stufenweise die obere Begrenzung der Pflanzendecke.[82]

Vor einem weiten Horizont heben sich die schneebedeckte Kuppe des Chimborazo und hinter ihm der rauchende Gipfel des Cotopaxi vor einem weiten Himmel mit eindrucksvollen Wolkenformationen ab; am Ufer des Atlantiks deutet sich Sandstrand an. Humboldt verband im *Tableau physique des Andes* auf diese Weise einen ästhetischen und einen systematisierenden Ansatz, doch macht seine Erläuterung in der *Geographie der Pflanzen* zugleich deutlich, dass das Dargestellte einer klaren Priorisierung unterlag: Die gesamte Anordnung auf dem Blatt, die „malerische Ausführung" ebenso wie die Ergänzung weiterer Informationen, hing letztlich von der auf geographischen Daten basierend ermittelten Profillinie des Chimborazo ab. Aufgrund der darin angestrebten „geometrischen Genauigkeit" lässt sie sich als eine auf Höhendaten gestützte Funktionskurve verstehen, mit der zugleich die (stilisierte) Kontur des Berges und mit dieser dessen Physiognomie freigelegt wurden.[83]

Die grundsätzliche Bedeutung, die das Bergprofil für die graphische Konzeption des *Tableau physique des Andes* hatte, geht mit dessen zentraler Thematik der zonalen, der Höhe der Klimate nach gestaffelten Verteilung von Pflanzengattungen zusammen. Auf der Graphik wird letztlich ein komplexes Prinzip natürlicher Wechselbeziehungen ansichtig, für dessen Darstellung sich Bild- und Text-Elemente ergänzend ineinanderschieben. In den tabellarischen Säulen, die den Querschnitt des Berges flankieren, sind unterschiedliche Informationen aufgelistet, die laut Humboldt mit der Pflanzenverteilung in unmittelbarem Zusammenhang standen. Natürliche Faktoren wie die Schneegrenze werden hierbei um kulturgeschichtliche ergänzt, beispielsweise um Angaben zur europäischen Immigration und zur Sklaverei, da durch beide Saatgut nach Südamerika gelangte, wodurch sich die dortige Flora veränderte. Wie Hartmut Böhme herausstellt, führt das *Tableau physique des Andes* auf diese Weise ein medienübergreifendes, d.h. in Text und Bild angelegtes „Faktorenmodell"[84] vor Augen, das komplexe Verknüpfungen vorstellt:

80 Ebd., S. 44.
81 Ebd., S. 43–44.
82 Ebd., S. 44.
83 Vgl. ebd., S 43.
84 Böhme: „Humboldts Entwurf einer neuen Wissenschaft", 2004, S. 190.

„Das lokale Vorkommen von Pflanzen ist eine abhängige Variable von xyz-Faktoren. Humboldt zielt also nicht auf kausalistische Ketten, sondern darauf, dass wir systemisch-funktionale Zusammenhänge und Interdependenzen in der Natur erfassen."[85] Dass sich hierbei die Verteilung der Informationen auf der Fläche des Blattes, und zwar sowohl in der Profildarstellung als auch in den 18 tabellarischen Säulen, stets unmittelbar an der Höhenangabe orientiert, verdeutlicht nicht zuletzt der repetitive Einsatz von Höhenskalen, von denen alle drei Elemente der Tafel – beide Spalten links und rechts des Profils sowie dieses selbst – eingefasst sind: Schmale Kolumnen geben die Höhe in Metern bzw. in Toises[86] jeweils links und rechts der tabellarisch gelisteten Informationen wieder, womit zugleich die Ansicht des Chimborazo im Mittelteil der Graphik zu beiden Seiten von Höhenangaben gerahmt wird.

Nicht nur mit Blick auf klimatologische Fragestellungen und die graphische Herangehensweise, sondern auch, indem der Chimborazo motivisch ins Zentrum gestellt wird, markiert das *Tableau physique des Andes* wesentliche und grundlegende Aspekte der gesamten Wissenschaft Humboldts. Weil dieser noch davon ausging, dass es sich bei dem Gipfel um den höchsten der Welt handelte, meinte er, mit ihm die Struktur der Erdkruste in ihrer Höhenausdehnung prototypisch zu beschreiben. Dementsprechend vermaß Humboldt in seinem *Tableau physique des Andes* zwar „nur ein Segment der Erde, doch hat er [Humboldt] immer einen gleichsam panoramatischen Blick auf den gesamten Erdball"[87]. Als Grundlagen dieses Kräftefelds mit globalem Anspruch, das Humboldt mit dem *Tableau physique des Andes* entwarf, fungiert die ebenso physiognomisch wie topographisch argumentierende Profillinie des Berges; natürliche, klimatische und auch kulturgeschichtliche Beobachtungen lassen sich erst abhängig von einer entsprechend beschriebenen Höhenstruktur erschließen.[88] Dadurch, dass die Kontur des Chimborazo den Nexus der Graphik bildet und sich hierin mit dem Augensinn aufgefasste physiognomische Darstellung und präzise Datenanalyse eng verklammern, weist sie, wie sich zeigen wird, auf die Grundsätze von Humboldts kartographischer Praxis voraus.

85 Ebd., S. 192.
86 Bis ins 19. Jahrhundert hinein war die Toise die französische Normaleinheit des Längenmaßes. Die Länge einer Toise entspricht knapp drei Metern.
87 Böhme: „Humboldts Entwurf einer neuen Wissenschaft", 2004, S. 190.
88 Vgl. ebd., S. 192.

Das „Naturganze" im Kartenbild

Von der Symbolsprache zur naturphysiognomischen Zeichnung

Die physiognomische Erfassung bestimmter Naturobjekte ist der methodische Schlüssel zu Humboldts geographischer Visualisierungspraxis: Diese Ausrichtung bereitet den Boden, um die Analyse von numerischen, im Gelände gewonnenen Daten und die Reflexion der Form, die oft auf sinnlicher Erfahrung beruhte, zu einer Erkenntnis gerichteten Darstellung des „Naturganzen" verkoppeln zu können. In besonderer Weise gelingt dies auf der gerasterten Kartenoberfläche, auf der sich sowohl der präzise Messwert verorten als auch – zugleich und auf diesen bezogen – die figurative Gestalthaftigkeit eines Objekts wiedergeben lassen.

Bevor Humboldt indes mit der naturphysiognomischen Darstellung von Naturobjekten zu experimentieren begann, die erst mit der Herausbildung seiner Physikalischen Geographie stärker ins Zentrum seines Interesses rückte, beschäftigte er sich zunächst mit den ikonischen Ausdrucksmöglichkeiten sprachlicher Zeichen. In Humboldts wissenschaftlichem Schaffen lässt sich insofern ein Prozess skizzieren, der vor dem Hintergrund einer sich verschiebenden Fragestellung von einer diskursiv orientierten zu einer bildlichen, figurativ-repräsentational operierenden Darstellungspraxis führte: Während Humboldt in seinen frühen Publikationen noch mit Symbolsprachen operierte, um überindividuelle Aspekte des Naturwissens übersichtlich herauszustellen, erweiterte er solche Überlegungen schon bald um Darstellungsformate, die die Naturform selbst ins Zentrum stellten.

Frühe Überlegungen zu wissenschaftlichen Vermittlungsverfahren, die über die rein sprachliche Ausformulierung hinausgingen, stellte Humboldt bereits in seinen 1797 erschienenen *Versuchen über die gereizte Muskel- und Nervenfaser* an. Er erkannte, wie Hanno Beck konstatiert, „daß die Sprache allein die Fülle seiner [Humboldts] Versuche nicht genau beschreiben könne oder zu einer sinnverwirrenden, pedantischen Ausführlichkeit führen müsse"[89]. In einer selbstentwickelten Formelschrift ging Humboldt zunächst von operationalen und ökonomischen Zeichenpraktiken der Mathematik aus:

> Weder das aufmerksamste Lesen […], noch die Betrachtungen der Figuren machen es möglich, jene Fülle von Thatsachen mit einem Blicke zu umfassen. Es schien mir daher wichtig, eine Methode zu erfinden, welche diesem Mangel abhülfe. Die Bequemlichkeit, welche die Mathematik darbietet, durch analytische Zeichen viele Sätze in wenig Zeilen darzustellen, reizte mich zu dem Versuche, die Abänderungen des Galvanischen Apparats, bei dem fast alles auf die kettenförmige Aneinanderreihung der Stoffe beruht, durch eine ähnliche Zeichensprache auszudrücken.[90]

89 Beck, Hanno: „Alexander von Humboldts »Essay de Pasigraphie«, Mexico 1803/04", *Forschungen und Fortschritte. Nachrichtenblatt der deutschen Wissenschaft und Technik* 32 (1958) 2, S. 33–39, hier S. 34.

90 Humboldt, Alexander von: *Versuche über die gereizte Muskel- und Nervenfaser nebst Vermuthungen über den chemischen Process des Lebens in der Thier- und Pflanzenwelt*, Bd. 1, Posen u. a.: Decker 1797, S. 90.

Neben acht Kupfertafeln, die die Anordnung der Apparaturen und die Durchführung sei-
ner galvanischen Versuche in 89 Figuren graphisch nachvollziehen, übersetzte Humboldt
die verschiedenen elektrischen Aufbauten in schematische Formeln. So bedeutete etwa
der „Ausdruck PpP [...], dass ein heterogenes Metall zwischen zwei homogenen liegt"[91].
Ziel dieser Formeln war es, kleine Veränderungen im Versuchsaufbau, die die Interpreta-
tion der Endergebnisse verzerrt hätten, ebenso wie neue Experimentalanordnungen über-
sichtlicher darzustellen und dadurch leichter erkennbar zu machen. Sollten also „in der
Folge Galvanische Versuche als neu angezeigt werden", schreibt er, so würde es „leicht
seyn, dieselben in Zeichen umzusetzen und auszumitteln, ob sie zu einer der schon be-
kannten Formeln gehören".[92]

Sechs Jahre später erprobte Humboldt Formeln, um nicht Versuchsaufbauten, son-
dern die Naturphänomene selbst zu beschreiben: Im bereits erwähnten *Essay de Pasigra-
phie* entwickelte er 1803/1804 während seines Aufenthalts in Mexiko eine Symbolsprache,
mit der sich geognostische Erdschichtungen übersichtlich darstellen ließen. Hierfür spiel-
te Humboldt ein System von Kurzzeichen durch, von dem er sich erhoffte, auch komplexe
und großflächige Gesteinsabfolgen im graphisch aufgenommenen Erdprofil auf einen
Blick präsentieren zu können. Dass Humboldt hierbei wohl auch insgesamt auf ein besse-
res Verständnis der geognostischen Sachverhalte hoffte, klingt in dem Begriff der „Pasi-
graphie" (gr. πας [*pas*] = ganz, alle; gr. γράφω [*gráphō*] = schreiben, beschreiben) an, der
die Idee einer für alle Menschen verständlichen Universalsprache aufruft. Schon deutlich
vor Humboldt waren ähnliche Überlegungen angestellt worden; insbesondere Gottfried
Wilhelm Leibniz (1646–1716) hatte sich mit allgemein verständlichen Schriftsystemen
auseinandergesetzt.[93] Ende des 18. Jahrhunderts erfuhren diese Ansätze eine Aktualisie-
rung, aus der auch die vermutlich auf Joseph de Maimieux (1753–1820) zurückzuführen-
de Bezeichnung „Pasigraphie" hervorging, an die Humboldt anknüpfte.[94]

91 Ebd., S. 91.
92 Ebd., S. 97.
93 Vgl. Müller, Irmgard: „Alexander von Humboldt – ein Teil, Ganzes oder Außenseiter der Gelehrten-
 republik?", in: *Die europäische République des Lettres in der Zeit der Weimarer Klassik*, hg. von Michael
 Knoche und Lea Ritter-Santini, Göttingen: Wallstein 2007, S. 193–210, hier S. 200. Leibniz zielte mit
 seinen theoretischen Überlegungen auf eine zeichenbasierte Universalsprache, in welcher sich die Klar-
 heit der göttlichen Erkenntnis spiegeln sollte. Vgl. zu Leibniz Verwendung der Pasigraphie Bredekamp,
 Horst: *Die Fenster der Monade. Gottfried Wilhelm Leibniz' Theater der Natur und Kunst*, Berlin: Akade-
 mie-Verlag 2004, insbesondere S. 87–100.
94 Das von Joseph de Maimieux entwickelte Schriftsystem umfasste zwölf Zeichen. Vgl. Maimieux, Joseph
 de: *Pasigraphie ou Premiers élémens du nouvel art-science d'écrire et d'imprimer en une langue, de maniè-
 re à être lu et entendu dans toute autre langue sans traduction*, Paris: au Bureau de la Pasigraphie 1797. Die
 deutsche Übersetzung *Pasigraphie oder Anfangsgründe der neuen Kunst-Wissenschaft in einer Sprache
 alles so zu schreiben und zu drucken, dass es in jeder anderen ohne Übersetzung gelesen und verstanden
 werden kann* erschien noch im selben Jahr.

Humboldts Entwicklung der „Höhenkarte"

Mit den Ausdrucksmöglichkeiten der Formelsprachen, wie sie Humboldt in den *Versuchen über die gereizte Muskel- und Nervenfaser* oder dem *Essay de Pasigraphie* erprobt hatte, scheint er sich jedoch spätestens 1804 mit seiner Rückkehr von der Amerikanischen Reise und seinen dortigen intensiven naturphysiognomischen Auseinandersetzungen nicht mehr mit Nachdruck befasst zu haben. Stattdessen wandte er sich nun verstärkt graphischen Präsentationsweisen zu, die die Naturform selbst sichtbar machten und sie zugleich mit einer numerisch gestützten Datenanalyse zu verbinden vermochten. Diese Entwicklung beginnt sich bereits im *Essay de Pasigraphie* abzuzeichnen. In ihm entwickelte Humboldt neben der Symbolsprache mit der von ihm sogenannten Höhenkarte zugleich eine neue Projektionsmethode für geographische Karten, die großflächig aufgenommene Landmassen im Querschnitt zeigten. Diese Darstellungstechnik sollte Humboldts weitere Forschung maßgeblich prägen.

Mit dem Kartentypus der „Höhenkarte", die Humboldt auch „physische Karte" nannte, sollte, wie es im *Essay de Pasigraphie* heißt, die Projektionsmethode der „Formationskarte" ergänzt und beide der topographischen Karte in der Aufsicht – der, vereinfacht gesagt, herkömmlichen Landkarte – an die Seite gestellt werden.[95] Sowohl die Höhen- als auch die Formationskarte zeigen die Erdoberfläche im Schnitt, doch während die Formationskarte, die zum damaligen Zeitpunkt schon in der Geologie Anwendung gefunden hatte, konkrete Querschnitte von Gesteinsschichten bietet, fokussiert sich die Höhenkarte auf die Darstellung von weiträumigen Höhenprofilen. Topographische Karten zeigen also die Aufsicht auf einen Teil der Erde, Formationskarten ermöglichen einen Einblick in den strukturellen Aufbau des Erdinneren, Humboldts Höhenkarten zeigen schließlich die Charakteristika eines spezifischen Oberflächenreliefs. Hierbei sind sie an der physiognomischen Gestalt der Berggipfel orientiert und weisen durch deren Darstellung deutliche Repräsentationsmomente eines lokalisierbaren Reliefs auf. Höhenkarten fassen dementsprechend verschiedene Gipfel auf der Grundlage eines Koordinatensystems der Höhe zusammen, über das diese Gipfel zu einem einzigen Höhenprofil und zu einer gemeinsamen Silhouette verkettet werden.[96]

Bei diesem Höhenprofil handelt es sich nicht um eine rein der Natur abgeschaute Form, sondern um eine virtuelle Gestaltgebung. Die Linie changiert zwischen einer Bergformation, die der Naturansicht nachempfunden ist, und einer diagrammatischen Funktionskurve, die die Gipfelpunkte miteinander verbindet, denn Höhenkarten sollten, so Humboldt, niemals von einer einzigen, durch ein Terrain gezogenen Gerade genommene Höhenwerte wiedergeben, also, mit anderen Worten, nicht schlicht einen linearen Schnitt durch die Erdoberfläche von Punkt A nach Punkt B ins Profil setzen. Stattdessen schlug

95 Humboldt spricht von „cartes des hauteurs" und „cartes des formations". Humboldt: Manuskript zum *Essay de Pasigraphie*, 1803/1804, Bl. 4r–8v.

96 Vgl. ebd., Bl. 4r–5v.

Humboldt vor, dem sinnlich empfundenen Wesen einer Landschaft entsprechend Kombinationen vorzunehmen, bei denen gemittelte Werte mit punktuell ausgewählten, repräsentativen Bergprofilen zusammengebracht werden. Auf diese Weise beziehen sich in den Höhenkarten, in deren graphischer Konturlinie sich diskrete Maximal- und Minimalwerte mit gemittelten Werten des Höhenreliefs abwechseln, individualisiert ausgestaltete Bergkuppen und Täler – wenngleich formal vereinfacht – auf konkrete Pendants im Naturraum, während ihre Profillinie zugleich auf die abstrakte Form eines relativen Höhenreliefs rekurriert.

Letztlich handelt es sich auch beim *Tableau physique des Andes* (Abb. 1) um eine dieser Höhenkarten und keineswegs um eine rein auf Anschauung basierende physiognomische Formfindung. Die Profillinie basiert auf einer Kombination zweier individuell herausgegriffener, ihrer Physiognomie nachempfundenen Höhen der Anden – dem Chimborazo und dem Cotopaxi –, die mit interpolierten Höhendaten zu einer Konturlinie verbunden sind. Dadurch, dass die Längengrade im geographischen Koordinatensystem der Höhe gestaucht sind, treten zudem die Größenverhältnisse der Berge in ihrem Bezug zueinander und mit ihnen räumliche Abhängigkeiten komprimiert hervor; Erhebungen und Senkungen im Gelände zeigen sich markant.

Von der Darstellung des vereinheitlichenden Höhenprofils der Höhenkarte lässt sich später nicht mehr in Gänze nachvollziehen, welche seiner Punkte auf gemittelte und welche auf diskrete Daten zurückgehen. Für Humboldt war jedoch eine andere Einsicht entscheidend: Die individuelle landschaftliche Erscheinung und ihre allgemeine geognostische Beschaffenheit werden miteinander verkoppelt; beide Aspekten waren in ihrem Zusammenwirken für die Erkenntnis des „Naturganzen" für Humboldt grundlegend. An dieser Stelle kreist das Visualisierungsverfahren der Höhenkarte das heuristische Grundprinzip ein, durch das Karten für Humboldt zu einem besonders wertvollen Instrument der wissenschaftlichen Darstellung wurden. Dieses Prinzip beruht darauf, dass die individuelle sinnliche Wahrnehmung in der medialen Reflexion mit einer analytisch erfassten, allgemeinen Ordnung der Natur zusammengeführt werden kann. Auf der Zeichenfläche lassen sich Naturobjekte in ihrer individuellen Physiognomie einfangen, zugleich aber auch – im geographischen Raster der Karte – genau verorten und – etwa über die Mittelwertbildung – abstrahieren und (formal) typisieren. Hierfür ergänzen sich in Humboldts Karten die von ihm weitreichend und experimentell genutzte Syntax der diagrammatischen Darstellung und die an der individuellen Formausprägung haftende, figurative Struktur systematisch.

Die Karte der *Culminations-Punkte (Höchste Gipfel) und Mittleren Höhen (Kammhöhen) der Gebirgsketten von Europa, America und Asien*

Inwiefern die physiognomische Gestalthaftigkeit als Grundprinzip der Darstellung sinnliche Erfahrung und numerische Datenanalyse aufeinander bezogen verklammert, zeigt sich besonders deutlich in Humboldts Karte *Culminations-Punkte (Höchste Gipfel) und*

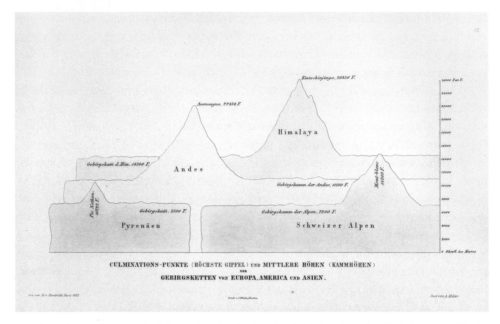

2__Alexander von Humboldt, *Culminations-Punkte (Höchste Gipfel) und Mittlere Höhen (Kammhöhen) der Gebirgsketten von Europa, America und Asien*, 1853, 19,5 × 18,1 cm

Mittlere Höhen (Kammhöhen) der Gebirgsketten von Europa, America und Asien (Abb. 2).[97] Daraus, dass Humboldt im Laufe seiner wissenschaftlichen Überlegungen wiederholt und über viele Jahre hinweg auf sie zurückkam, um seine Ergebnisse zu veranschaulichen, lässt sich eine grundlegende Bedeutung der Darstellung ableiten, die die Karte für ihn hatte. Humboldt entwarf die Karte ursprünglich 1825 für einen französischsprachigen Aufsatz, in dessen deutscher Übersetzung sie im selben Jahr bereits in einer einfachen deutschen Ausführung erschien. Fast 30 Jahre später, 1853, druckte Humboldt eine überarbeitete

97 Die Karte *Culminations-Punkte (Höchste Gipfel) und Mittlere Höhen (Kammhöhen) der Gebirgsketten von Europa, America und Asien* wurde erstmals 1825 unter dem Titel *Points culminants et hauteurs moyennes des chaînes principales de l'Europe, de l'Amérique et de l'Asie* abgedruckt und erschien zusammen mit dem Aufsatz *De quelques phénomènes physiques et géologiques qu'offrent les Cordillères des Andes de Quito et la partie occidentale de l'Himalaya*. Vgl. Humboldt, Alexander von: *Annales des Sciences Naturelles* 4 (1825), S. 225 – 256 und *Planche 15, Annales des Sciences Naturelles: Atlas*, T. 4 – 6 (1825), o. S. Zur deutschen Übersetzung vgl. Humboldt, Alexander von: „Von einigen physischen und geologischen Phänomenen, welche die Cordillera de los Andes bei Quito und der westliche Theil des Himalih-Gebirge darbieten", in: *Neue Allgemeine Geographische und Statistische Ephemeriden* 16 (1825) 1/2, S. 1 – 21 und S. 32 – 48. Die Karte findet sich im zweiten Heft des 16. Bandes als Karte 1 unter dem Titel *Höchste Punkte und mittlere Höhe der Hauptgebirgsketten v. Europa America u. Asien*.

Fassung[98], um sie als letzte Tafel in seinen Atlas zu den *Kleineren Schriften*, den *Umrissen von Vulkanen aus den Cordilleren von Quito und Mexico*, zu integrieren. Zu vermuten steht, dass Humboldt die Karte außerdem im Kontext seiner Kosmos-Vorträge in der Berliner Singakademie zeigte.[99]

Auf der Karte werden die individuellen Umrisse von vier Bergspitzen ansichtig. Es handelt sich hierbei um den Kintschinjinga [sic] des Himalaya, den Aconcagua der Anden, den Mont Blanc der Alpen und den Pic Nethou [sic] der Pyrenäen, die zum damaligen Zeitpunkt als die jeweils höchsten Gipfel der betreffenden Gebirgszüge galten. Die vier Linien, die die Konturen dieser Berge umreißen, gehen in die gemittelten Höhen des gesamten, zugehörigen Bergmassivs über, sodass vier virtuelle Massive entstehen, die jeweils eine Bergkuppe und ein gemitteltes Höhenprofil zeigen. Diese vier Massive sind auf der Zeichenfläche ihrer relativen Durchschnittshöhe nach über- bzw. nebeneinander angeordnet, sodass ihre Vergleichsmerkmale – sowohl mit Bezug auf die physiognomische Wesenheit ihrer Gipfel als auch auf ihre mittlere Höhe – leicht ins Auge fallen. Die mittleren Höhen seien zwar, so Humboldt, nicht sonderlich imposant anzuschauen, für geologische Schlussfolgerungen aber enorm wichtig; für bestimmte Fragestellungen seien „die himmel-anstrebenden Gipfel, die Culminationspunkte, welche so sehr die Neugier aller Völker reizen, für den Geognosten eine minder wichtige Erscheinung als die Kammlinie"[100].

An der Karte der *Culminations-Punkte* zeigt sich exemplarisch, dass nicht nur Humboldts theoretische Überlegungen zur Anschauung, sondern auch seine visuelle Wissensvermittlung vielfach davon bestimmt war, dass sich individuelles sinnliches Empfinden und analytische Generalisierung Erkenntnis generierend verzahnen. Es ist die operative

98 In diese späteren Fassung nahm Humboldt den neuesten Höhenmessungen entsprechend statt des Chimborazo den Aconcagua und statt des Dhawalagiri den Kintschinjinga [sic] auf. Obwohl Humboldts *Umrisse von Vulkanen* erst 1853 erschienen, zeigt die darin enthaltene Karte den Mount Everest noch nicht, der 1852 schließlich zum höchsten Berg des Himalayas erklärt worden war. Da Humboldt diese Ergebnisse nachweislich anerkennend aufnahm, steht zu vermuten, dass die Karte schon vorher fertiggestellt worden war.

99 Diese Annahme beruht darauf, dass eine der wenigen Skizzen, die in den Nachschriften zu Humboldts Kosmos-Vorlesungen an der Berliner Singakademie zu finden sind, das Kompositionsprinzip der Karte aufnimmt. Vgl. das Manuskript N.N.: *Die physikalische Geographie von Herrn Alexander v. Humboldt, vorgetragen im Semestre 1827/28*. Das Original befindet sich im Besitz der Kartenabteilung der Staatsbibliothek zu Berlin, Signatur 8" Kart. GfE O 79, digitalisiert vom Deutschen Textarchiv, online abrufbar unter: http://www.deutschestextarchiv.de/book/view/nn_oktavgfeo79_1828?p=603 (zuletzt aufgerufen am 31.10.2019).

100 Siehe Humboldt, Alexander von: „Verzeichniß der in dem Atlas enthaltenen Kupfertafeln von Vulkanen aus den Cordilleren von Quito und Mexico", in: *Kleinere Schriften*, Bd. 1, 1853, S. 458–471, hier S. 471.

Performanz[101] der kartographischen Oberfläche, die es Humboldt möglich machte, individuelle Naturformen und analysierte Datenmengen aufeinander bezogen, aufs Engste verwoben und zugleich anschaulich zu präsentieren. Im Miteinander von abgeschauter Naturform und diskreter Datenerhebung ließen sich so sowohl mimetische Ähnlichkeitsbeziehungen heraus- als auch eine analytische Aufbereitung verschiedenster Informationen und Datenmengen herstellen. Da das Medium der Karte zwischen repräsentationalen und diagrammatischen Darstellungsweisen changiert,[102] verschieben, diversifizieren und verunklaren sich darin die ohnehin unscharfen Grenzen der Darstellungsformate, etwa von Plan, Diagramm, Modell und Graph, kontinuierlich.[103] Gerade aber aufgrund dieser hybriden Ausdrucksformen und flexiblen Anpassungsfähigkeit erwies sich die kartographische Oberfläche für Humboldts wissenschaftliche Visualisierung als grundlegendes Instrument der Wissensgenese und -präsentation: Auf der Karte konnte er seine verschiedenen wissenschaftlichen Erkenntnisinteressen – empirisch-physiognomischen und holistisch-analytischen Anspruch – heuristisch verklammern und sich dem Naturwissen zugleich aus einer Perspektive nähern, die den Augensinn, d. h. den optischen Eindruck des Naturdings, unmittelbar zu reflektieren vermochte.

101 Zum Terminus der „operativen Performanz" vgl. Mersch, Dieter: „Visuelle Argumente", in: *Bilder als Diskurse – Bilddiskurse*, hg. von Sabine Maasen, Torsten Mayerhauser und Cornelia Renggli, Weilerswist: Velbrück 2006, S. 95–116, hier S. 104–105.

102 Zu dem Verhältnis von Bildlichem und Diagrammatischen in der Karte vgl. Krämer, Sybille: „Karten erzeugen doch Welten, oder?", *Soziale Systeme* 18 (2012) 1/2, S. 153–167; Mersch: „Visuelle Argumente", 2006, S. 100–103. Vgl. zum Zusammenhang von Diagrammatik und spatialer Ordnung ebd., S. 103–106.

103 Zu den terminologischen Grenzen vgl. Goodman, Nelson: *Sprachen der Kunst: Entwurf einer Symboltheorie*, Frankfurt am Main: Suhrkamp 1995.

Worauf die Karten beruhen.
Grundlagen der kartographischen Praxis
Alexander von Humboldts

Die beiden wesentlichen Vorarbeiten zu Humboldts kartographischer Praxis bildeten einerseits die Handzeichnung, die er häufig vor Ort anfertigte, und andererseits die numerische Datenaufnahme, darunter in umfassender Weise geographische Messwerte. Bereits diese praktischen Vorarbeiten zu seinen publizierten Karten und nicht erst diese selbst sind an dem methodologischen Dreiklang von typisierender naturphysiognomischer Theorie, präziser Messgenauigkeit und sinnlicher Naturerfahrung orientiert: So versuchte Humboldt einerseits, mit der Handzeichnung sowohl den optischen Eindruck der Naturdinge in ihrem natürlichen Ambiente als auch ihren physiognomischen Typus zu erfassen, andererseits lieferte seine umfassende Datenerhebung – vor allem geographische Messwerte – eine arithmetische, mathematisch auswertbare Grundlage zur Analyse der Naturphänomene. Hinsichtlich der Kartenproduktion Humboldts lassen sich beide Herangehensweisen als gleichberechtigte epistemische Grundlagen verstehen, wobei Handzeichnung und Datenerhebung ihre jeweilige heuristische Ergänzung bilden: Das Datenmaterial half Humboldt, die physiognomische, oft mit dem Augensinn getroffene naturphysiognomische Formenfindung zu kontextualisieren, zu generalisieren, aber auch zu verifizieren; andersherum lieferte die Handzeichnung Humboldt eine materialisierte, auf dem Papier fixierte „sinnliche Anschauung" und hierdurch eine wesentliche Größe zur Ordnung der Fülle des „Naturganzen", vor allem hinsichtlich dessen Typisierung.[1]

Humboldts Vorarbeiten zu seinen Karten formten heuristische Rahmenbedingungen, durch die die kartographisch visualisierten Ergebnisse von Beginn an konturiert und determiniert wurden, denn schon die Vorarbeiten waren von einem bestimmten übergeordneten Darstellungsinteresse geleitet: Nach Humboldts Überzeugung war es lediglich eine Frage der adäquaten wissenschaftlichen Methode, dass sich die Natur in ihrem harmonischen Gleichmaß auch in der wissenschaftlichen Graphik zeigte. Ebendiese Harmo-

[1] Vgl. zu Humboldts Begriffsverwendung der sinnlichen Anschauung das Unterkapitel *Humboldts theoretische Überlegungen zur Erkenntniskraft des Visuellen* der vorliegenden Untersuchung.

nie sollte sich bereits bei den vorbereitenden Arbeiten bestätigen. Für die Handzeichnung wie für die Datenerhebung lässt sich daher feststellen, dass sie zwar gleichsam *bottom-up*, d. h. von der konkreten Aufnahme der Daten oder den Ansichten vor Ort her entwickelt, dabei aber zugleich *top-down*, d. h. von einem metatheoretischen Überbau her angeleitet wurden.[2] Humboldts theoretischen Voraussetzungen lenkten somit nicht erst die Auswertung seiner empirischen Informationssammlung, deren Analyse und Zusammenführung im wissenschaftlichen Präsentationsformat, sondern bereits die Auswahl der aufgenommenen Beobachtungen. Damit lief diese einem tatsächlich empirischen Ansatz im Grunde genommen entgegen.

Aus dem Umstand, dass Humboldt Handzeichnung und Datenaufnahme bei der späteren Herstellung seiner Karten konsequent kombinierte, erklärt sich die für sie – und für Humboldts wissenschaftliche Visualisierung allgemein – charakteristische „Verschränkung von Exaktheit und Vagheit"[3], denn beide Herangehensweisen verknüpften zwei heterogene Informationsquellen miteinander, die hinsichtlich ihrer Präzision unterschiedliche Qualitäten aufwiesen: Die physiognomische, häufig auf dem Augensinn basierende Kontur tendierte zu einer formalen Vereinfachung, die geographischen Daten in ihrer Fülle dagegen zum Aufbrechen der Form und zur diffusen Streuung auf der graphischen Fläche. Heuristisch war die Kombination beider Aspekte jedoch äußerst wirksam: Auf Handzeichnung und auf (geographischer) Datenaufnahme aufbauend, vermögen es Humboldts Visualisierungen, verschiedene, heute vielfach als getrennt wahrgenommene Wissensbereiche gemeinsam und aufeinander bezogen zu präsentieren.[4]

Die Handzeichnung

„Denkende Hände"

In allen Teilen von Humboldts Notizen – in Briefen ebenso wie in Tagebüchern und in den Kollektaneen – finden sich von ihm angefertigte Handzeichnungen. Offenbar nahm Humboldt viele von ihnen direkt in situ auf, d. h. während der unmittelbaren Naturbe-

2 Vgl. hierzu die Analyse der Datenverarbeitung in Böhme: „Humboldts Entwurf einer neuen Wissenschaft", 2004, S. 193.

3 Schneider: „Berglinien im Vergleich", 2013, S. 30.

4 Humboldt griff bei seiner Kartengestaltung auf die unterschiedlichen medialen Ausdrucksmöglichkeiten von Bild, Text und Zahl zurück. Vgl. Kraft: *Figuren des Wissens*, 2014, S. 22. Darauf, dass die räumlich verortende Datenerhebung Humboldts stets auf ihre Visualisierung ausgerichtet war, weist Nikolaas Rupke hin, bei dem es heißt: „The interest in spatial relations went hand in hand with their visual representation, i. e., with cartography and with a major upturn in the output of geographical atlases [sic]." Rupke: „Humboldtian Distribution Maps", 2001, S. 94.

obachtung.[5] Insbesondere lassen sich Motive ausmachen, die geographische Formationen in ihrer Höhen- oder Flächenausdehnung zeigen, darunter etliche Darstellungen von Flussverläufen, vor allem aber eine große Zahl von Bergumrissen und von Profilschnitten durch die oberen Erdschichten.[6]

Humboldts zeichnende Hände dienten ihm als „denkende Hände"[7], mit denen er seinen Augensinn schulen, das Besehene bereits während der Naturbeobachtung an systematisierenden, insbesondere physiognomischen Kriterien ausrichten und es daran anschließend in eine entsprechende wissenschaftliche Kontextualisierung und Beurteilung überführen konnte. Augenfällig wird dies an der für Humboldts Zeichnungen charakteristischen, einfachen Linienführung, bei der eine deutlich betonte Kontur die dargestellten Objekte einfasst. Hierdurch werden die äußere Form und mit ihr die physiognomisch bedeutenden Umrisse der Objekte hervorgehoben und zugleich individuell dargestellt als auch ihrem Wesen nach erfasst. Das der Natur Abgeschaute trat so schon mit der zeichnerischen Aufnahme in einen heuristischen Reflexionsprozess ein. Auf diese Weise von Anfang an von einer systematisierenden, naturphysiognomischen Theorie angeleitet, legte Humboldts zeichnerische Auseinandersetzung mit dem betreffenden Gegenstand eine wesentliche Grundlage, um ihn im Sinne der Physikalischen Geographie analytisch weiter zu durchdringen.

Humboldt zeichnete sein Leben lang; erste Skizzen verschiedener Sujets sind aus seiner frühen Jugend bekannt. Aus der Fülle dieser Zeichnungen sowie aus der kontinuierlich nachweisbaren Zeichenpraxis lässt sich ablesen, wie konsequent er sich seinen Umraum über Zeichnungen erschloss. Diese Beständigkeit zeigt, dass die Linie für ihn offenbar „auf der Grenze zwischen Gedanken und Materialisierung eine eigne, keiner anderen Äußerungsform zukommende Suggestivkraft"[8] entwickelte. Insofern als also die

5 Einen erhellenden Überblick verschafft der gerade erschienene, von Dominik Erdmann und Oliver Lubrich herausgegebene Band Alexander von Humboldt: *Das zeichnerische Werk. Die bislang unveröffentlichen Originalzeichnungen des genialen Forschungsreisenden*, Darmstadt: wbg 2019.

6 Dass sich die Motive von Bergen und Flüssen häufen, lässt sich auch darauf zurückführen, dass beiden in Humboldts Wissenschaft eine besondere Bedeutung zukam; seiner Meinung nach bestimmten sie die topographische Struktur und mit ihr den „Totaleindruck" einer Gegend maßgeblich. Neben Berg- und Flusszeichnungen finden sich unter Humboldts Handzeichnungen auch Portraitstudien sowie etliche Tier- und Pflanzenzeichnungen, die bisweilen einen großen Detailreichtum aufweisen, zudem architektonische und maschinelle Entwürfe. In der Forschungsliteratur werden die Portraitstudien und insbesondere die Tier- und Pflanzenzeichnungen oft illustrativ eingesetzt, machen jedoch im Gegensatz zu den Skizzen der Naturphänomene einen eher geringen Anteil innerhalb der erhaltenen Zeichnungen aus.

7 Die Formulierung der „denkenden Hände" orientiert sich an der Begriffsverwendung Horst Bredekamps. Vgl. ders.: „Denkende Hände. Überlegungen zur Bildkunst in den Naturwissenschaften", in: *Von der Wahrnehmung zur Erkenntnis — From Perception to Understanding*, hg. von Monika Lessl und Jürgen Mittelstraß, Berlin/Heidelberg: Springer 2005, S. 109–132.

8 Ebd., S. 131.

Zeichnung, wie Horst Bredekamp feststellt, „[u]nabhängig von jeder künstlerischen Begabung […] als erste Spur des Körpers auf dem Papier das Denken in seiner höchstmöglichen Unmittelbarkeit [verkörpert]"[9], wird in Humboldts Skizzen eine Denkbewegung sinnfällig, die von der individuellen Ansicht ausgehend bereits in die physiognomische Beurteilung hineinreicht. Humboldt selbst vertraute seinen „denkenden Händen". Obwohl er das in situ angeschaute Objekt in seinen Zeichnungen meist mit schneller Hand und wenigen Bleistift- oder Federstrichen aufs Papier setzte, maß er ihnen offenbar eine hohe formale Präzision bei: Der Vergleich mit den später auf der Grundlage der Skizzen angefertigten wissenschaftlichen Graphiken zeigt, dass sich diese von den Vorarbeiten meist nur in Details unterscheiden.[10] Bei den Endergebnissen ließ Humboldt neben kleineren formalen Korrekturen bisweilen eine ergänzende Ausgestaltung pittoresker Elemente vornehmen, doch liegen vor allem Umrisslinie, Proportion und Komposition bei Zeichnung und Druckfassung vielfach äußerst nah beieinander.

In Zusammenhang mit der Beobachtung, dass die Linie für Humboldt von vornherein grundlegend für die Erfassung seines Forschungsgegenstandes war, geht seine Zeichenpraxis mit der Disegno-Theorie zusammen. Ihr gemäß stellte nicht zeichnerische Technik oder Imagination, sondern die Übersetzung in den formgebenden Umriss den maßgeblichen Schritt im Prozess der Bildgenese dar. Vor diesem Hintergrund lässt sich die zeichnerische Praxis – auch Humboldts – zugleich als Praxis des Denkens verstehen, denn in der umreißenden Linie, die in der Natur nicht existiert, war der erste Schritt zu einer Deutung des Gesehenen vollzogen. An ihn ließen sich weitere Schritte der Analyse anschließen.[11]

Zeichnerische Prägung

Dem Umstand, dass viele von Humboldts Skizzen an einer physiognomischen Typisierung orientiert waren und eine gerichtete Erkenntnisleistung besaßen, wurde von der Forschung lange Zeit nicht viel Beachtung geschenkt.[12] Zwar nahmen bereits Humboldts

9 Ebd., S. 131.

10 Dieses Verhältnis zeigt sich eindrücklich an dem von Petra Werner zusammengetragenen Bildmaterial in dem Band *Naturwahrheit und ästhetische Umsetzung*, 2013.

11 Vgl. zum Disegno als Praxis des Denkens Mersch, Dieter: „Das Medium der Zeichnung. Über Denken in Bildern", in: *Medien denken. Von der Bewegung des Begriffs zu bewegten Bilder*, hg. von Lorenz Engell, Jiří Bystřický und Kateřina Krtilová, Bielefeld: transcript 2010, S. 83–109, hier S. 89.

12 Insgesamt hat sich das Interesse der Forschung an Humboldts Handzeichnungen erst in jüngerer Zeit stärker herausgebildet. Vgl. Humboldt: *Das zeichnerische Werk*, 2019; Schneider: „Berglinien im Vergleich", 2013; Voss, Julia: „Das Unsichtbare sichtbar machen. Alexander von Humboldt als Zeichner", *Arsprototo* 1 (2014), S. 28–32; Werner: *Naturwahrheit und ästhetische Umsetzung*, 2013, S. 11–85; Wiese, Bernd: *Weltansichten. Illustrationen von Forschungsreisen deutscher Geographen im 19. und frühen 20. Jahrhundert*, Köln: Universitäts- und Stadtbibliothek 2011. Vgl. ferner Buchholz, Amrei: „Alexander von Humboldts Ansichten des Weltbaues. Ausgewählte Handzeichnungen aus seinen Tagebüchern", in: *Umreißen. Registrieren, Fehlgehen und Erfinden im Zeichnen*, hg. von Mira Fliescher u. a., Berlin: Diapha-

Zeitgenossen dessen unbeirrtes Festhalten an seiner eigenen Zeichenpraxis zur Kenntnis, interpretierten sie aber häufig im Sinne einer besonderen ästhetischen Empfindsamkeit. Humboldts Zeichnungen wurden so vor allem mit seinem Anspruch enggeführt, die Natur auch in ästhetisch ansprechender Weise darstellen zu wollen. Einige von Humboldts Zeichnungen wurden offenbar als besonders dekorativ empfunden, darunter die pittoresken Tierskizzen, die auf seinen Reisen entstanden. Aus Humboldts breitem zeichnerischen Darstellungsrepertoire waren es vor allem diese, die reproduziert wurden und in ein allgemeines Bildgedächtnis eingewandert sind. Eine solche Selektion beschränkte Humboldts eigentliche Erkenntnisfindung über die Linie jedoch immens: Seine Zeichnungen gehörten zu dem grundständigen Repertoire epistemischer Praktiken, mit denen er sich dem Wissen der Natur näherte.

Humboldts Zeichnungen als Zeugnisse seiner besonderen ästhetischen Empfindsamkeit auszulegen, mag durch die nach seinem Tod geäußerte Annahme, er sei von Daniel Chodowiecki (1726–1801) ausgebildet worden, zusätzlich genährt worden sein.[13] Von einer künstlerischen Ausgestaltung nach Chodowieckis Prägung, etwa allegorischer Sujets, heben sich Humboldts physiognomisch orientierte, datengestützte Graphiken jedoch inhaltlich und kompositorisch deutlich ab. Zwar kann ein Schüler-Lehrer-Verhältnis beider Männer auch nach heutigem Kenntnisstand nicht ausgeschlossen werden, es wird aber, sofern es dazu kam, sowohl der thematischen Ferne als auch mit Blick auf die fehlenden Nachweise weder intensiv noch von langer Dauer oder besonders prägend gewesen sein.[14]

Demgegenüber lässt sich eine anders gelagerte graphische Ausbildung Humboldts belegen, die in seinen Aufenthalt an der Freiberger Bergakademie in Sachsen 1791/1792 fällt. Während seiner dortigen Lehrzeit wurde Humboldt vom Zeichenmeister Johann Simon Sieghardt im akademischen Situations-, Maschinen- und Perspektivzeichnen unterrichtet, womit das Fundament für maßstabsgerechte Konstruktionszeichnungen und Geländeaufnahmen gelegt wurde. Vor allem die Situationszeichnung, d.h. Schnitte durch Bergwerke oder Erdschichten, und die Maschinenzeichnung, d.h. die Visualisierung von verschiedenen Konstruktionsebenen desselben Objekts, lassen sich mit drei

nes 2014, S. 99–114. Bei diesem Artikel muss darauf hingewiesen werden, dass er fälschlicherweise von einer profunden Zeichenausbildung Humboldts bei Daniel Chodowiecki ausgeht. Julius Löwenberg verweist in seinem Abschnitt der umfassenden, von Karl Bruhn herausgegebenen Biographie Humboldts auf frühe Skizzen. Vgl. Löwenberg, Julius: „Vaterhaus", in: *Alexander von Humboldt: eine wissenschaftliche Biographie*, hg. von Karl Bruhns, Bd. 1, Leipzig: Brockhaus 1872, S. 5–49.

13 Julius Löwenberg erwähnt Daniel Chodowiecki als Lehrer Humboldts, wobei unklar bleibt, ob diese Anmerkung metaphorisch ins Feld geführt wird, d.h. Chodowiecki von Löwenberg zwar als ideell schulendes Vorbild, nicht aber als tatsächliche Lehrperson verstanden wird. Vgl. Löwenberg: „Vaterhaus", 1872, S. 32.

14 Keinen Nachweis finden können auch Schwarz, Ingo/Biermann, Kurt R.: „»Irrtümer, die vorzugsweise in den höheren Volksklassen fortleben«", in: *Alexander von Humboldt: Netzwerke des Wissens*, 1999, S. 204.

3__Alexander von
Humboldt, Ansichten der
Pyramide von Cholula und
der Umgebung, 1804,
Krakau, JBK

wesentlichen Charakteristika der gesamten Zeichenpraxis Humboldts zusammenbringen:
Sie machten – erstens – etwas sichtbar, das dem Auge in dieser Konkretion verborgen war,
bestanden – zweitens – häufig aus unterschiedlichen Elementen, die auf einem Zeichen-
blatt aufeinander bezogen angeordnet waren, und wiesen – drittens – meist diagrammati-
sche Elemente wie Legenden, Symbole oder Skalen auf, die auf das volle Verständnis der
Beschaffenheit oder der Funktionsmechanismen zielten.[15] Sehr viele von Humboldts
Zeichnungen sind in ebensolchen diagrammatischen Verweisstrukturen, die auf Ziffern

15 Vgl. Rees, Joachim: „Daten und Bilder", in: Humboldt, Alexander von: *Sämtliche Schriften (Aufsätze,
 Artikel, Essays)*, Berner Ausgabe, hg. von Oliver Lubrich und Thomas Nehrlich, dtv: München 2019, hier
 Bd. 10: Forschungsband, redigiert von Johannes Görbert, S. 559 – 587, hier S. 567 – 568; auf Sieghardt als
 Lehrer Humboldts weist auch hin: Wagenbreth, Otfried: „Alexander von Humboldt als Student der
 Bergakademie in Freiberg", *Glückauf* 129 (1993) 4, S. 295 – 299, hier S. 296.

und Buchstaben basieren, eingebunden. Vermöge einer solchen Einbettung wurden die von der Natur abgeschauten Formen mit datengestützten, häufig numerischen Prinzipien, aber auch mit erläuternden Kommentaren zusammengeführt. Dank der diagrammatischen Organisation der Zeichnungen ließen sich inhaltliche Zusammenhänge zwischen verschiedenen Elementen auf dem Blatt oder auch über mehrere Blätter hinweg herstellen. Eine Orientierung innerhalb des Gezeigten war hierdurch ebenso gegeben wie dessen weitere Kontextualisierung. Mit der Einbettung vervielfachten sich die Möglichkeiten Humboldts, in seinen Zeichnungen Konkretion und Abstraktion zusammenzudenken, denn die singuläre Beobachtung konnte anhand der Verweisstruktur in generelle, bis ins Globale reichende Zusammenhänge gestellt werden.

Das diagrammatische Prinzip der wissenschaftlichen Aufschlüsselung des Besehenen wie auch die Nähe zu den in Freiberg erlernten Darstellungstechniken zeigen sich exemplarisch an Handzeichnungen aus dem *Journal du Mexique à Veracruz*. Vermutlich handelt es sich hierbei um einen Teil von Humboldts mexikanischen Reiseaufzeichnungen. Sie enthalten unter anderen Zeichnungen auch eine Reihe von Skizzen der zugeschütteten Pyramide im südmexikanischen Cholula, darunter Profilansichten des geographischen Reliefs (Abb. 3).[16] In diesen ebenso wie in anderen Skizzen in der Aufsicht umriss Humboldt die Kontur des Bauwerks mit schnellen Strichen. Diese figurative Darstellung versah er an verschiedener Stelle mit Buchstaben, die ein erläuternder Kommentar als Markierungspunkte für Längenmessungen zu erkennen gibt. Dank dieser Angaben lässt sich die bauliche Struktur der Pyramide in der Breite und in der Höhe nachvollziehen, womit sich der pyramidale Aufbau – oder: die Physiognomie des Besehenen – zugleich als relative Größe erschließt. Wie ein randständiger Kommentar erklärt, liefert diese Erfassung der Pyramide einen ersten Baustein, der sie mit denen anderer Kulturen vergleichen lässt, um sie letztlich in eine kulturelle Systematisierung zu überführen. Eine entsprechende, von der physiognomischen Kontur ausgehende und anschließend systematisierende Einfassung der Naturdinge, die Humboldt in seinen wissenschaftlichen Zeichnungen aufnahm, lässt sich auch bei der Darstellung von Bergen oder Vulkankratern, von Pflanzen, Tieren, Bauwerken oder Maschinenaufbauten finden.

Zeichnerische Raumerschließung

Humboldts zeichnerische Erfassung der Pyramide von Cholula zeigt bereits an, dass ihm die Konturlinie nicht der einzelnen physiognomischen Formfindung und -beurteilung allein, sondern auch einer weiterreichenden inhaltlichen Erschließung und Thesenbildung diente. Von der singulären Physiognomie eines Objekts ausgehend, näherte

16 Die Skizzen liegen in einer edierten Version vor. Vgl. hierfür Humboldt: *Von Mexiko-Stadt nach Veracruz*, 2005, S. 54–69. Heute befindet sich das *Journal du Mexique à Veracruz* im wissenschaftlichen Nachlassteil, der in der BJK verwahrt wird. Vgl. BJK, HA, Nachlass Alexander von Humboldt 1/1, nicht foliiert.

Humboldt sich mit Hilfe der Handzeichnung komplexeren räumlichen Strukturen an, deren Aufbau er auf der Zeichenfläche erprobte. Dieser Aspekt der Handzeichnung Humboldts zeigt sich beispielhaft an Blättern aus seinem wissenschaftlichen Nachlass, in denen er südamerikanische Flusssysteme gedanklich zu durchdringen versuchte.[17] Zuerst setzte Humboldt hierfür kleinere Ansammlungen von dünnen Strichen, die sich erst dank der nebenstehenden Namen als Wasserläufe identifizieren lassen, auf das Papier. Oft handelte es sich hierbei um Kopien oder Pausen von Karten anderer oder um Wissenskompilationen, die Humboldt auf der Basis von lokalem Wissen hergestellt hatte.

Aus diesen Informationsquellen extrahierte Humboldt gezielt einzelne Elemente. Mit einfachen Linien hob er so zunächst die für ihn als wesentlich erachteten Flussverläufe einer Region heraus, um dann auf dieser Grundlage sukzessive weitere zeichnerische Überlegungen zu einem größeren räumlichen Gefüge anzustellen. Derartige Raumexperimente konnten auf der Zeichenfläche zum Teil zu blatteinnehmenden puzzleartigen Entwürfen heranwachsen, in denen Humboldt verschiedene topographische Versionen der Flusssysteme durchspielte. Je dichter dabei das Gemenge der Striche wurde, umso mehr Korrekturen nahm er vor, umso stärker baute er zugleich aber auch weiterführende thematische Fragestellungen aus.

In einer dieser Zeichnungen, die heute im wissenschaftlichen Nachlass in Krakau verwahrt wird, setzte Humboldt sich genauer mit dem Gebiet östlich des heute venezolanischen Río Caura auseinander (Abb. 4).[18] Auf diesem Blatt skizzierte er das Netz von Wasserarmen, das der Caura mit den Flüssen Caroní, Arui, Branco, Ventuario und deren Nebenarmen ausbildete. Seine zeichnerische Argumentation organisierte Humboldt in zwei aufeinander bezogenen Teilskizzen, die jeweils unterschiedliche Ebenen des Dargestellten eröffneten: Der obere Teil diente der Erschließung der Raumstruktur selbst, wofür Humboldt mit Bleistift zunächst ein Koordinatensystem aufbrachte, in das er anschließend mit grober Kontur die Flussverläufe eintrug. Einzelne Elemente zog er später mit der

17 Diese Skizzen haben sich überwiegend in Humboldts Reisetagebüchern und im Krakauer Teil des wissenschaftlichen Nachlasses Humboldts erhalten. Vgl. SBB, Nachlass Alexander von Humboldt (Tagebücher); BJK, HA, Nachlass Alexander von Humboldt 8 (acc. 1893, 216), 1. und 2. Teil, nicht foliiert. Aufgrund des Inhalts und der Art und Weise der Aufzeichnungen kann davon ausgegangen werden, dass zumindest einige dieser Blätter von der Reise selbst stammen. So notierte Humboldt etwa auf einem der Blätter unter dem Titel *Von Honda nach Turbaco*, einen kurzen Abschnitt seiner Reise (allerdings in umgekehrter Reihenfolge, er fuhr von Turbaco nach Honda), dortige Höhenlagen und Fließrichtungen angrenzender Flüsse. Tatsächlich sind wissenschaftlicher Nachlass und Reisetagebücher kaum klar zu trennen, da Humboldt die Tagebücher vermutlich Ende der 1850er Jahre neu binden ließ, Teile von ihnen jedoch als separate Blätter im übrigen Nachlass verblieben. Bis heute ist die genaue Geschichte von Tagebüchern und Nachlass noch nicht gänzlich geklärt. Vgl. für eine diesbezügliche Annäherung Leitner, Ulrike: „Alexander von Humboldts geowissenschaftliche Werke in Berliner Bibliotheken und Archiven", *Berichte der Geologischen Bundesanstalt* (1996), Bd. 35, S. 259–264.

18 Dieses Flusssystem findet sich in nahezu unveränderter topographischer Anordnung auch im *Atlas géographique et physique du Nouveau Continent* auf der Tafel 22, der *Carte générale de Colombia*.

4__Alexander von Humboldt,
Flussskizze zum Gebiet östlich
des Río Caura, undatiert,
Krakau, JBK

Feder nach. Korrekturen und Punktlinien verdeutlichen, dass die Skizze als prozesshafte Erschließung einer geodätisch noch nicht vollständig erfassten Lage der Flüsse und ihrer Relationen zueinander fungierte.

Unter dieser ersten Skizze befindet sich auf demselben Blatt eine zweite. Auf ihr schloss Humboldt eine thematische Diskussion an. Zu diesem Zweck lenkte er den Blick der Betrachtung gezielt auf den zentralen Teil der oberen Skizze, den er herauslöste, vergrößerte und durch eine umrahmende Linie von der ersten absonderte. Koordinatenangaben fehlen nun, stattdessen rückt eine spezifische Fragestellung in den Fokus: Humboldt versah die Flussarme in der zweiten Skizze mit Pfeilen, mit denen er ihr auseinanderdriftendes Strömungsverhalten markierte. Die Detailvergrößerung, die sich aus der oberen Skizze speist, zeigt somit ein bestimmtes wissenschaftliches Interesse Humboldts an, das die Fließrichtung der Wasserläufe betraf.[19]

19 Auf der Grundlage einer Raumerschließung, die zunächst bei der Form ansetzte, um von ihr ausgehend auf komplexe thematische Naturprozesse zu folgern, basierte auch Humboldts zeichnerischer Umgang mit Bergphänomenen. Ebenso wie die Flussverläufe nahm Humboldt Bergformen zunächst meist individuell in ihrer ihre Physiognomie betonenden Umrisslinien auf. Sie boten eine allgemeine Grundlage für Überlegungen zu Naturgesetzen, die von der Höhe abhingen. Bereits auf der Zeichenfläche verband Humboldt häufig verschiedene Berge miteinander und überführte sie auf diese Weise in die Analyse des natürlichen Systems.

Wie die meisten der von Humboldt zeichnerisch zur Ansicht gekommenen Gedankenexperimente gehen auch diese Flussskizzen von einfachen Konturlinien aus, die die Grundzüge der physiognomischen Form des Naturdings hervortreten lassen. Die flüchtigen und dennoch präzise aufgenommenen Linien lieferten Humboldt ein grundständiges Instrument der gedanklichen Orientierung. Von der formalen Erfassung des Naturdings aus ließ es sich auf der Zeichenfläche mit anderen Beobachtungen zu zusammenhängenden Strukturbildern verbinden. Naturphysiognomisch orientiert, ließen diese geographische Raumordnungen erkennen, die hinsichtlich unterschiedlicher Themenbereiche des „Naturganzen" befragt werden konnten.

Datenerhebungen

Humboldtsche Datenmengen

Neben der Handzeichnung bildet Humboldts empirische Erhebung von Daten[20] die zweite wesentliche methodische Grundlage, auf der seine Karten fußen. Einen großen Teil der diesbezüglich zusammengetragenen Informationen machen geographische Messwerte aus, die in Humboldts wissenschaftlichen Notizen einen beträchtlichen Raum einnehmen: Topographische Koordinaten durchziehen sie in vielen Teilen, tabellarisch aufgelistet erstrecken sich entsprechende Zahlenreihen bisweilen über mehrere Seiten. Zusätzlich zu den Daten der Landvermessung sammelte Humboldt jedoch eine Fülle von weiteren Informationen. Sie reichen in unterschiedlichste Themenfelder und sind sprachlich oder numerisch erfasst. Doch nicht nur die Themen, sondern auch die Ursprünge der Quellen weisen eine enorme Bandbreite auf: Publizierte Texte von der Antike bis in Humboldts Gegenwart, Hinweise befreundeter Wissenschaftler und mündlich tradiertes, lokales Wissen begegnen sich.[21]

Bezogen auf die geographischen Messwerte konnten Humboldt und seinen Zeitgenossen nun mittels triangulatorischer, barometrischer oder astronomischer Verfahren[22]

20 Unter dem Terminus „Daten" werden hier überwiegend in Zahlenwerten erfasste, zusammengetragene Informationen zu einem Themenbereich verstanden, die zur weiteren Analyse und Bearbeitung bestimmt sind.

21 Zu Humboldts Datenerhebungen liegen bereits umfassende Untersuchungen vor. Im Jahre 2000 widmete sich ein Kolloquium in Buenos Aires eigens dieser Thematik. Vgl. die daraus hervorgegangene Publikation *Un colón para los datos: Humboldt y el diseño del saber*, 2008. Vgl. zur Thematik der Datenaufnahme ferner Schäffner: „Topographie der Zeichen", 2000.

22 Zu Humboldts eigener Aussage über die Wichtigkeit der Sammlung genauer geographischer Daten siehe Dettelbach, Michael: „El último de los hombres universales: Lo local y lo universal en la ciencia de Humboldt", *Redes. Revista de Estudios Sociales de la Ciencia* 14 (2008) 28, S. 113–126, hier S. 116. Bei dem trigonometrischen Messverfahren der Triangulation (Dreiecksmessung) werden über Winkelbestimmungen von Dreiecken Ortsbestimmungen vorgenommen. Über diese Winkelmessungen lassen sich

immer genauere Daten generieren. Im Laufe des 18. Jahrhunderts hatten sich von Frankreich ausgehend, das die Vorreiterrolle des modernen Vermessungswesens übernommen hatte, jüngst entwickelte technische Geräte verbreitet, mit denen ein sehr genaues geographisches Messen möglich war. Es etablierte sich der flächendeckende Einsatz von Präzisionsinstrumenten, darunter die Nutzung des Fadenkreuzes, mit dem sich das punktgenaue Anvisieren von räumlich weit entfernten Objekten deutlich verbesserte, oder das Chronometer, mit dem sich vor allem auf See die Längengrade relativ genau berechnen ließen. Der Einsatz solcher Messinstrumente führte dazu, dass – vor allem mit Hilfe der Triangulation, die bis in das 17. Jahrhundert hinein nur kleinräumig eingesetzt worden war – ab dem 18. Jahrhundert Karten ganzer Länder und später auch Kontinente mit genauen Messpunkten überzogen wurden.[23] Zudem konnten neben den genaueren Koordinatenmessungen der Fläche mit dem Barometer nun auch Höhenmessungen zunehmend genauer durchgeführt werden. Aus der Verknüpfung der Ordinaten der Höhe und der Fläche erschloss sich zu Humboldts Lebzeiten nach und nach die geographisch vermessene dreidimensionale Struktur der Erdoberfläche.

Abstände im Gelände deutlich einfacher bestimmen als über die zuvor genutzte Messung von Längen zwischen zwei Punkten. Die seit dem 17. Jahrhundert angewandte Triangulation etablierte sich im 18. und 19. Jahrhundert in Kartographie und Geodäsie. Noch das heute verwendete, Satelliten gestützte Vermessungssystem GPS basiert auf diesem Prinzip. Mit dem Barometer lässt sich hingegen der Luftdruck bestimmen, der neben klimatischen Erkenntnissen auch Informationen zur Höhenbestimmung zu liefern vermag. Zudem lassen sich bestimmte trigonometrische Messungen ohne Barometer nicht exakt durchführen. Astronomische Messverfahren funktionieren ebenfalls winkelgestützt. Mittels eines Sextanten werden dabei über Gestirne Positionsbestimmungen vorgenommen. An Bedeutung gewann die astronomische Messmethode insbesondere durch ihren Nutzen für die Schifffahrt. Zu den verschiedenen Messverfahren vgl. Grosjean, Georges: *Geschichte der Kartographie*, Bern: Geographisches Institut der Universität Bern 1996, insbesondere S. 33 – 40; Hake, Günter/Grünreich, Dietmar/Meng, Liqiu: *Kartographie. Visualisierung raumzeitlicher Informationen*, Berlin/New York: de Gruyter 2002, S. 48 – 50. Zu Humboldts Messungen auf seiner Amerikanischen Reise und seinen dort mitgeführten Instrumenten vgl. Faye Cannon: *Science in Culture*, 1978, S. 75 – 76; Seeberger, Max: „»Geographische Längen und Breiten bestimmen, Berge messen«", in: *Alexander von Humboldt: Netzwerke des Wissens*, 1999, S. 57; ders.: „»Die besten Instrumente meiner Zeit«: Humboldts Liste seiner in Lateinamerika mitgeführten wissenschaftlichen Instrumente", in: *Alexander von Humboldt: Netzwerke des Wissens*, 1999, S. 58 – 63.

23 Vgl. Grosjean: *Geschichte der Kartographie*, 1996, S. 113; Engberg-Pedersen: „Verwaltung des Raumes", 2012, S. 30. Eines der bekanntesten Beispiele aus den Anfängen der genauen Landvermessungen sind die Cassini-Karten, mit denen der Geodät César François Cassini de Thury (1714–1784) und später sein Sohn Jean Dominique Cassini (1748–1845) Frankreich mit Hilfe der Triangulation erstmals präzise vermaß. Vgl. insbesondere Pelletier, Monique: *La carte de Cassini: L'extraordinaire aventure de la carte de France*, Paris: Presses de l'École Nationale des Ponts et Chaussée 1990; dies.: *Les cartes de Cassini: La science au service de l'État et des provinces*, Paris: CTHS 2013. Einen Überblick der Entwicklung der Kartographie in Frankreich zu jener Zeit bietet Konvitz, Josef W.: *Cartography in France, 1660–1848: Science, Engineering, and Statecraft*, Chicago u. a.: University of Chicago Press 1987.

Seine eigenen Messungen lassen sich zunächst als unmittelbarer Beitrag zu dieser voranschreitenden topographischen Beschreibung der Erde verstehen. Humboldts Amerikanische Reise fällt noch in die unmittelbare Nachfolge der gut ausgerüsteten Forschungsexpeditionen, wie sie seit der Mitte des 18. Jahrhunderts von Europa aus unternommen worden waren, um vermeintlich neue Regionen ausfindig zu machen und geographisch zu erschließen. Humboldt selbst hob seine Lektüre der Reisebeschreibungen Georg Forsters (1754–1794) hervor, durch die er in der Jugend maßgeblich zum wissenschaftlichen Naturstudium angeregt worden sei.[24] Forster war in den 1770er Jahren auf James Cooks (1728–1779) zweiter Südseereise mitgefahren und hatte in der *Reise um die Welt* von seinen Erlebnissen berichtet.

Während die Küstenlinien der Welt in Europa um 1800 herum durch die Forschungsreisen der Aufklärung bereits gut bekannt waren, war das Binnenland teilweise noch kaum erschlossen. Dies galt auch für viele Regionen Iberoamerikas, das bei Humboldts dortiger Ankunft erst in Grundzügen kartiert war und von ihm in Teilen erstmals präzise aufgenommen wurde.[25] Das in Europa bis dahin verbreitete Wissen über die süd- und mesoamerikanische Geographie stand zudem auf einem wackeligen Fundament:[26] Aus der üblichen kompilatorischen Praxis des Kartographierens, bei der neue Informationen mit solchen aus vorherigen Karten zusammengeführt wurden, entstanden Karten, in denen die bereits erfassten Informationen vielfach nicht noch einmal detailliert geprüft wurden.[27] So konnten einmal verzeichnete Informationen von Karte zu Karte weitergegeben werden, auch wenn sie in Teilen keine geographische Referenz besaßen. Anhand der Kartenbilder allein ließ sich allerdings nicht mehr nachvollziehen, auf welcher Datengrund-

24 Siehe Humboldt: *Kosmos*, Bd. 2, 1847, S. 72. Vgl. für das Verhältnis von Forster und Humboldt auch Görbert, Johannes: *Die Vertextung der Welt. Forschungsreisen als Literatur bei Georg Forster, Alexander von Humboldt und Adelbert von Chamisso*, Berlin u. a.: de Gruyter, 2014.

25 Vgl. Humboldt, Alexander von: „Sur les matériaux qui ont servi pour la construction de l'Atlas géographique et physique", in: ders.: *Voyage aux régions équinoxiales du Nouveau Continent: fait en 1799, 1800, 1801, 1802, 1803 et 1804*, Teil 1 *(Relation historique)*, Bd. 4, Paris: Smith 1817, Appendix mit gesonderter Seitenzählung, S. 1–37, hier S. 2–9. „Sur les matériaux" nimmt einen vorläufigen Charakter ein und wird deshalb vermutlich in spätere Ausgaben oder Übersetzungen der *Relation historique* nicht mehr mit aufgenommen.

26 Faak, Margot: „Einleitung", in: Humboldt, Alexander von: *Reise durch Venezuela: Auswahl aus den amerikanischen Reisetagebüchern*, hg. von dies., Berlin: Akademie-Verlag 2000, S. 11–31, hier S. 11.

27 Siehe Schröder, Iris: *Das Wissen von der ganzen Welt: Globale Geographien und räumliche Ordnungen Afrikas und Europas 1790–1870*, Paderborn: Schöningh 2011, S. 71. Auch Humboldts Karten wurden kopiert, beispielsweise seine Karte vom Rio Magdalena, Tafel 24 des *Atlas géographique et physique du Nouveau Continent*. Nach Humboldts Aussage hatte er dem Botaniker José Mutis (1732–1808) die Erlaubnis erteilt, diese Karte einmal zu kopieren, später seien aber weitere Exemplare aufgetaucht. Vgl. Humboldt, Alexander von: *Reise auf dem Rio Magdalena, durch die Anden und Mexico*, Teil 2: *Übersetzung, Anmerkung und Register*, hg. von Margot Faak, mit einer einleitenden Studien von Kurt R. Biermann, Berlin: Akademie-Verlag 2003, Bd. 2, S. 42–43.

lage die visualisierten Elemente im Einzelnen beruhten; auf der Oberfläche der Karte verbanden sich somit gesichertes und unsicheres Wissen über den Raum miteinander, ohne dass diese unterschiedlichen Qualitäten hätten differenziert werden können. Vor diesem Hintergrund sah sich Humboldt bei seiner Kartierung iberoamerikanischer Gebiete immer auch mit der Aufgabe konfrontiert, vorhergehende Kartenbilder vor Ort zu überprüfen und gegebenenfalls die daraus erwachsenen Hypothesen über das Wissen von der Natur zu revidieren.[28]

Auf die Problematik, die Humboldt in der kompilatorischen Praxis erkannte, geht zurück, dass er den Kartographen verpflichtet sah, die geographische Grundlage der produzierten Karten transparent zu machen und die verschiedenen Quellen seiner Daten so gut wie möglich offenzulegen. Zudem hielt Humboldt es für entscheidend, auch die Instrumente zu explizieren, mit denen die Messdaten aufgenommen worden waren, denn auch sie waren für die kartographische Beurteilung wesentlich.[29] Kartenbilder würden durch nachvollziehbare Datenangaben, so erhoffte er es sich, insgesamt deutlich besser beurteilt und verbessert werden können. Daher war Humboldt nach eigener Aussage darum bemüht, auch die Datengrundlage seiner eigenen Publikationen möglichst genau zu rekonstruieren.[30] In *Sur les matériaux*, einem Kommentar zu den ersten neun publizierten Tafeln des *Atlas géographique et physique du Nouveau Continent*, bemerkte er entsprechend, er lege besonderen Wert darauf, zwischen dem zu unterscheiden, „was in jeder Karte auf meinen eigenen Beobachtungen gründet und was auf unveröffentlichtem Material basiert, das mir durch andere mitgeteilt worden ist"[31]. Im Reisewerk kam Humboldt diesem Anspruch auf Transparenz an verschiedener Stelle nach, unter anderem im *Recueil d'observations astronomiques*. In diesem Band stellte Humboldt nach seiner Rückkehr aus den Amerikas die auf der Reise zusammengetragene Sammlung geographischer Daten in einem eigenen Band zusammen, den er von dem Mathematiker und Astronomen Jabbo Oltmanns (1783 – 1833) redigieren ließ.[32]

28 Humboldt machte die Praxis der fehlerhaften Datenübernahme in zwei Karten des *Atlas géographique et physique du Nouveau Continent* zum Thema: in der Tafel 14, *Histoire de la Géographie de l'Orénoque*, und der Tafel 18, *Carte de la Partie Orientale de la Province de Varinas*. Beide werden in der vorliegenden Untersuchung im Unterkapitel *Zeitgenössische Karten im historischen Vergleich* näher erläutert.

29 Vgl. Humboldt, Alexander von: *Essai politique sur le royaume de la Nouvelle-Espagne*, Bd. 1, Paris: Renouard 1825, S. 5. Da eine solche Quellenkritik nicht innerhalb der Karte selbst, sondern nur in der schriftlichen Ausführung möglich sei, hielt Humboldt die Ergänzung der Karte um den Text für umso wichtiger.

30 Vgl. Humboldt: „Sur les matériaux", 1817, hier insbesondere S. 2 – 3.

31 Im Original: „Je distinguerai surtout, […] ce qui se fonde, dans chaque carte, sur mes propres observations, de ce qui repose sur des matériaux inédits qui m'ont été communiqués par d'autres." Humboldt: „Sur les matériaux", 1817, S. 3.

32 Humboldt, Alexander von: *Recueil d'observations astronomiques, d'opérations trigonométriques et de mesures barométriques*, Paris: Schoell 1810 [1808 – 1811]. Bisweilen verwies Humboldt in den Kartenkommentaren auf die präzise Datendiskussion innerhalb des Textes vom Reisewerk. So machte Humboldt

Geographische Daten und ihre thematische Verknüpfung im Kartenbild

Unter Humboldts zusammengetragenen Daten war es für ihn die möglichst genaue Ortsbestimmung, die das „Fundament der ganzen Geographie"[33] legte.[34] In Anbetracht seiner Zielsetzung, die Disziplin der Physikalischen Geographie zu entwickeln, kann diese Aussage durchaus als leitend für weite Teile seines wissenschaftlichen Denkens verstanden werden. Auch mit Blick auf die Karten sind es diese Ordinaten, die den wesentlichen Ausgangspunkt der wissenschaftlichen Analyse bildeten. Erst auf dieser Basis geographischer Daten bezog Humboldt auch andere Datenmengen mit ein, um unterschiedliche Themenbereiche des Naturwissens zu analysieren.

Dennoch stellte Humboldt die geographischen Messwerte bei der Präsentation des Wissens über die Natur konsequent in einen größeren heuristischen Zusammenhang. Möglichst genau verzeichnete Koordinaten begegneten auf diese Weise heterogenen Daten aus diversen anderen Bezugssystemen.[35] Der Fokus der kartographischen Darstellung verschob sich somit von einer (geographischen) Lokalisierung auf die Analyse der (thematischen) Verteilung und Bezüge bestimmter Aspekte im Raum.[36] Insofern blieben, wie Eberhard Knobloch feststellt, die „Werte einer Größe […] nicht isoliert, sondern wurden in Beziehung zu anderen Größen gesetzt. Messen war kein Selbstzweck, sondern für das gewinnende Weltverständnis unentbehrlich."[37]

etwa in der Tafel 10 *(Carte de la Province de Quixos)* des *Atlas géographique et physique du Nouveau Continent*, die auf Berichte eines Statthalters von Quixos zurückging, auf die externe Datengrundlage aufmerksam. Ein weiteres Beispiel liefert die Tafel 16 des Atlas, die *Carte itinéraire du cours de l'Orénoque*, die vor allem auf Humboldts eigenen Messungen beruht.

33 Alexander von Humboldt an seinen Verleger Cotta am 12.08.1824, in: *Briefwechsel: Alexander von Humboldt und Cotta*, hg. von Ulrike Leitner, Berlin: Akademie-Verlag 2009, S. 131.

34 Wolfgang Schäffner weist darauf hin, dass in Humboldts topographischen Karten die von ihm für sie beanspruchte Genauigkeit der geographischen Gebietsaufnahme letztlich fehlging, da er seine Karten nicht am Messtisch anfertigte und daher kein einziger Messpunkt oder Ort unmittelbar einem einzelnen graphischen Punkt, sondern einem Mittelwert entsprach. Siehe Schäffner: „Topographie der Zeichen", 2000, S. 364.

35 Humboldt nutzte die Fähigkeit der Karte umfassend, eine Vielfalt an Informationen und Darstellungsweisen erkenntnisgerichtet miteinander in Beziehung zu setzen. Vgl. hinsichtlich der Flexibilität des Kartenbildes Michalsky, Tanja: „Stadt und Geschichte im Überblick. Die spätmittelalterliche Karte Roms von Paolino Minorita als Erkenntnisinstrument des Historiographen", in: *Europa in der Welt des Mittelalters. Ein Colloquium für und mit Michael Borgolte*, hg. von Tillman Lohse und Benjamin Scheller, Berlin/Boston: Walter de Gruyter 2014, S. 189–210, hier S. 192.

36 Vgl. Godlewska: „Humboldts visuelles Denken", 2001, S. 159.

37 Knobloch, Eberhard: „Alexander von Humboldt und Carl Friedrich Gauß – im Roman und in Wirklichkeit", *HiN* XIII (2012) 25, S. 70–71, hier S. 68. Im 2005 erschienenen, auf dem Markt erfolgreichen Roman *Die Vermessung der Welt*, der das Bild Alexander von Humboldts außerhalb der Humboldt-Forschung nachhaltig prägen konnte, schildert der Autor Daniel Kehlmann Humboldt als datenversessenen Sturkopf. Aus wissenschaftlicher Perspektive geht diese Darstellung fehl. Vgl. zur literarischen Verarbeitung Kehlmann, Daniel: *Die Vermessung der Welt*, Reinbek bei Hamburg: Rowohlt 2005.

Die kartographische Oberfläche bot Humboldt ein Experimentierfeld, in dem er heterogene Daten innerhalb eines medial begrenzten Bereichs miteinander in Beziehung setzen konnte. Über die Operativität der Zeichenfläche ließen sich räumliche und thematische Informationen aufeinander bezogen präsentieren und ihre Relationen visuell erproben.[38] Der Transfer Humboldts, möglichst präzise geographische Daten mit komplexen thematischen Analysen über Naturzusammenhänge zu verbinden, gilt als eine seiner weit ausstrahlenden wissenschaftlichen Leistungen.[39] Seine Karten lassen sich in diesem Zusammenhang als grundlegende Instrumente verstehen, die nicht nur Ergebnisse präsentierten, sondern ein relationales Zusammendenken unterschiedlicher Aspekte des Wissens über die Natur im Grunde genommen erst möglich machten: Über die kartographische Visualisierung konnten auch zwischen heterogenen Quellen Bezüge sinnfällig werden; bisweilen wurden systemische Abhängigkeiten der Natur, d. h. ihre Wechselbeziehungen, erst auf diese Weise als solche erkennbar.

Die *Carte itinéraire de l'Orénoque*

Inwiefern Humboldts Karten auf der Grundlage möglichst genauer Ordinaten und durch die Kombination unterschiedlicher Wissensbereiche neues Wissen erschlossen, verdeutlicht die *Carte itinéraire du cours de l'Orénoque, de l'Atabapo, du Casiquiare, et du Rio Negro offrant la bifurcation de l'Orénoque et sa communication avec la Rivière des Amazones* (im Folgenden: *Carte itinéraire de l'Orénoque*), die Tafel 16 des *Atlas géographique et physique du Nouveau Continent* (Abb. 5).[40] Das Verdienst der möglichst präzisen geographischen Kartierung wird schnell deutlich: Humboldt visualisierte auf der Karte einen von ihm neu vermessenen Teil des Orinoko, die dortige Abzweigung des Casiquiare sowie dessen Verlauf und Einmündung in den Rio Negro. Wie der Langtitel der Karte aufschließt, war es hierbei Humboldts wissenschaftliches Anliegen, eine bis dahin nicht belegte natürliche Verbindung zwischen den wasserreichsten südamerikanischen Flusssystemen von Orinoko und Amazonas zu bestimmen, denn der Rio Negro mündete, wie damals bereits bekannt war, in den Amazonas.[41] Zugleich aber gestaltete Humboldt die Karte zu einer thematisch komplexen Darstellung der Region aus. Anhand der versam-

38 Auf der Grundlage empirisch erhobener Messungen ließen sich lokale, aber auch überregionale kulturelle und ökologische Folgerungen anstellen. Wolfgang Schäffner spricht mit Bezug auf Humboldts *Atlas de la Nouvelle-Espagne* von der Kartendarstellung als einem „Diagramm von ökonomischen Kräften". Vgl. Schäffner: „Topographie der Zeichen", 2000, S. 370.

39 Vgl. Rupke: „Humboldtian Distribution Maps", 2001, S. 94. Auch Susan Faye Cannon benennt diesen Transfer als einen der wesentlichen Merkmale der *Humboldtian Science*. Vgl. Faye Cannon: *Science in Culture*, 1978, S. 95–102.

40 Vgl. zu Humboldts eigener Diskussion der Karte ders.: „Sur les matériaux", 1817, S. 14–26. Über die Karte existiert ein Aufsatz von Pérez Mejía: „Sutileza de la producción cartográfica", 2007.

41 Vgl. Humboldt, Alexander von: „Note sur la communication qui existe entre l'Orénoque et la rivière des Amazones", in *Journal de l'École Polytechnique* 4 (1810) 1, S. 65–68.

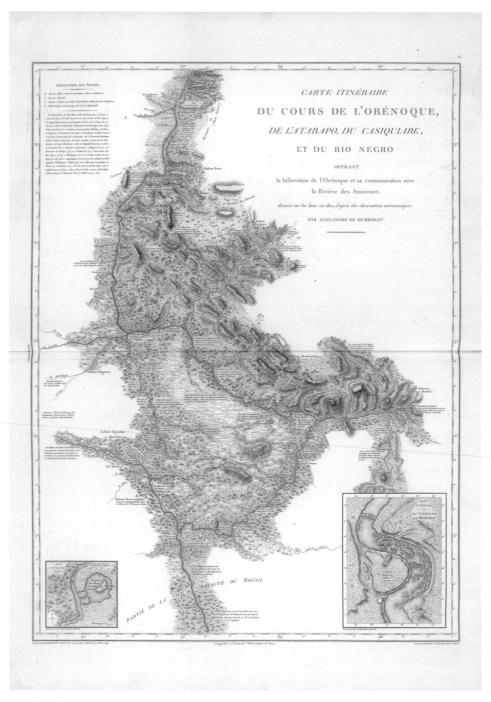

5__Alexander von Humboldt, *Carte itinéraire de l'Orénoque*, 1817, ca. 86 × 120 cm, in: *Atlas géographique et physique du Nouveau Continent*, Tafel 16 (Lieferung 2), Berlin, SBB, Foto SBB

melten Informationen erzielte er eine aisthetisch ebenso wie thematisch aufgefächerte Kartierung, auf deren Grundlage die visualisierten Einzelbeobachtungen aus der Region zu verschiedenen Einsichten verknüpft werden konnten.

Wie der Titel – *Carte itinéraire de l'Orénoque* – vorausweist, konzipierte Humboldt die gesamte Ansicht des Orinoko als Itinerar. Mit diesem Kartentypus ist eine Darstellungsweise angesprochen, die nicht primär auf eine großflächige topographische Überschau abzielt, sondern auf die Wiedergabe von Verbindungswegen zwischen bestimmten Orten.[42] Auf Humboldts Karte fallen diese Wege mit den chronologisch erfassten Reiseabschnitten zusammen, die er selbst auf dem Orinoko zurückgelegt hatte: Vom oberen Kartenrand ausgehend, sind die Ufer des Flusses – mit dem 13. April [1800] beginnend – mit Datumsangaben gesäumt, die die Halte- und Übernachtungspunkte von Humboldts Reisegruppe angeben. Die Karte bietet dementsprechend eine Leseart an, mit der Humboldts Fahrt auf dem Orinoko visuell nachvollzogen werden kann. Durch diese Angaben wird den geographischen Koordinaten ein alternatives Raummaß, nämlich das der Bewegung durch den Raum und damit das der Reisegeschwindigkeit, an die Seite gestellt. Während sich Humboldts Durchqueren des Raumes über die geographischen Einheiten lediglich annäherungsweise und als abstrakte Größe, d.h. unter Berücksichtigung verschiedener dargestellter Faktoren, rekonstruieren ließe, wird sein – auch im wörtlichen Sinne – erfahrenes Raumwissen nun dank der Datumsangaben evident.

Doch nicht nur der Reiseverlauf, sondern auch die Wahrnehmung auf der Reise bestimmt die Kartengestaltung. Durch eine selektive Auswahl des Dargestellten wird suggeriert, dass Humboldt nur den Teil des Umraumes mit in das Kartenbild aufnahm, den er vor Ort selbst beobachten konnte: Die Karte zeigt lediglich die nähere Umgebung des Orinoko. Die Repräsentation des Raumes scheint also dort zu enden, wo das Gebiet vom Flussverlauf aus nicht mehr eingesehen werden konnte bzw. wo es von Humboldt nicht mehr erkundet worden war.

Trotz dieser starken Begrenzung des dargestellten Raumes auf der Karte verweben sich darin zahlreiche Beobachtungen und Informationen heterogener Quellen, darunter lokales indigenes sowie geodätisches Wissen europäischer Prägung. Auf diese Weise wird ein komplexer Eindruck des durchquerten Gebietes evoziert, bei dem optische Sinneseindrücke dominieren. So gab Humboldt etwa an: „Die Wasser vom Rio Zama, vom Mataveni und vom Atabapo sind schwarz (Rios de Aguas negras)"[43], oder: „Wir haben an den Ufern des Rio Vichada die Baumstämme des Laurus Cinamomoides gesehen"[44]. Fer-

42 Siehe Art. „Route Map", in: *Cartographical Innovations. An international Handbook of Mapping Terms to 1900*, hg. von Helen M. Wallis und Arthur H. Robinson, Cambridge: Map Collector Publications 1987, S. 57. Vgl. ferner das Unterkapitel *Die einzelnen Tafeln des Atlas: Funktionsebenen des Erdmodells* der vorliegenden Untersuchung.
43 Im Original: „Les eaux du Rio Zama du Mataveni et de l'Atabapo sont noires (Rios de Aguas negras)".
44 Im Original: „Nous avons vu sur les bords du Rio Vichada des troncs de Laurus Cinamomoides".

ner hob Humboldt besondere Erlebnisse seiner Reise hervor, etwa: „Hier vermaß man Krokodile von mehr als 22 Fuß Länge"[45]. Hinzu traten kulturgeschichtliche Beobachtungen der Gegend: „Diese durch den Casiquiare, den Orinoco, den Atabapo und den Rio Negro eingefasste Ebene ist heute völlig unbewohnt; einige Granitfelsen sind dort mit hieroglyphischen Figuren überzogen"[46]. In einigen Hinweisen verschränken sich Humboldts wiedergegebenen Reiseerfahrungen explizit mit einer Reflexion der geographischen Datengrundlage, wobei auch das Gemachtsein der Karte und ihre möglicherweise fehlerhafte Darstellung des geographischen Referenzobjekts zur Sprache kommen: „Da man zwischen den Mündungen des Yao und des Ventuari nachts weiterfuhr, sind die Windungen des Orinoco unsicher"[47].

Diese Beschreibungen des Raumes durch Humboldt erfolgen aus einer klaren und benennbaren Perspektive: Es sind diejenige eines ortsfremden, wissenschaftlichen Reisenden, der verschiedenes, darunter einheimisches Wissen zusammenträgt und dieses unter einem geowissenschaftlichen Blickpunkt europäischer Prägung reflektiert und selektiert.[48] Als „Spuren der Mündlichkeit"[49] suggerieren diese Einschreibungen in der Karte dennoch eine unmittelbare, als ephemer markierte Empfindung der Natur. Sie werden als Reflexion über und Reaktion auf die geographische Raumstruktur inszeniert, wobei sie einen aisthetisch ergänzenden, die Dynamik der sinnlichen Betrachtung betonenden Kontrast zu dem durchquerten, vergleichsweise stabilen topographischen Gefüge eröffnen.

Indem die *Carte Itinéraire de l'Orénoque* Humboldts Reise auf diese Weise inszeniert, fordert sie zu einem virtuellen Mitreisen auf dem Papier auf. Bestimmte Aspekte ihrer Kartengestaltung lassen sich sogar erst auf der Grundlage dieser Rezeptionsweise verstehen. Dazu zählt der in einer von zwei Nebenkarten hervorgehobene Katarakt, den Humboldt in die rechte untere Ecke der Karte montierte. Das entsprechende Äquivalent in der Hauptkarte lässt sich nur bei sehr gründlicher Kartenlektüre im oberen Drittel ausma-

45 Im Original: „Ici l'on a mesuré des Crocodiles de plus de 22 pieds de long".

46 Im Original: „Cette plaine limitée par le Casiquiare, l'Orénoque l'Atabapo et le Rio Négro est aujourd'hui absolument inhabitée; quelques rochers de granite y sont converts de figures hiéroglyphiques".

47 Im Original: „Comme on a navigué de nuit entre les bouches du Yao et du Ventuari, les sinuosités de l'Orénoque, sont incertaines".

48 Selbst wenn kartographische Hinweise auf ethnische Gruppen oder einheimische Pflanzen möglicherweise auf indigene Mitreisende zurückgingen und Gebiete von Humboldt erst mit ihrer Hilfe durchreist werden konnte, handelt es sich bei der Darstellung solcher Informationen nicht schlicht um übernommenes Wissen der Indigenen, die deren ungehörten Geschichten schließlich Gehör verschafft und in Humboldts *Voyage* weitgehend ausgespart wird, wie Ángela Pérez Mejía annimmt, sondern um eine gezielte aisthetische Repräsentation von Raum vor dem Hintergrund einer als exotisch empfundenen Reiseerfahrung. Vgl. Pérez Mejía: La *geografía de los tiempos difíciles*, 2002, S. 79, 83, 94.

49 Ette, Ottmar: „Der Blick auf die Neue Welt: Nachwort", in: Alexander von Humboldt: *Reise in die Äquinoktial-Gegenden des Neuen Kontinents*. Bd. 2, hg. von Ottmar Ette, Frankfurt am Main / Leipzig: Insel 1991, S. 1563–1597, hier S. 1576.

chen. Mit der Nebenkarte fügte Humboldt in das Blatt eine geoanthropologische Argumentation ein: Dank der prominenten Darstellung der mit Felsen durchzogenen Stromschnelle lassen sich äußerste Schwierigkeiten vermuten, den Fluss an dieser Stelle zu
passieren. Dieser Befund lässt sich auf die Darstellung der gesamten Karte rückbeziehen:
Insbesondere die Gegend unterhalb der Stromschnelle scheint für Humboldt von inhaltlichem Interesse gewesen zu sein, denn erst dort beginnt sich das dargestellte Gebiet bis
fast auf die volle Breite des Blattspiegels zu entfalten, zudem häufen sich nun die in die
Karte eingeschriebenen Angaben zur Reisedauer und zur Umgebung. Dass diese Informationen für Humboldt von besonderer Bedeutung waren, lässt sich, wie im Mitreisen
mit dem Finger auf der Karte leicht nachzuvollziehen, aus der insgesamt schlechten Zugänglichkeit der Gegend und der deshalb nur geringen Kenntnis über sie erklären. Dadurch, dass die Stromschnelle nun als Hindernis erkannt und zugleich im medialen
Nachvollzug problemlos überwunden werden kann, vermag das in Humboldts Perspektive des Reisens versetzte Publikum gewissermaßen aus dem eigenen Erleben heraus
einem vorschnellen europäischen Urteil zu begegnen, das auch Humboldt erst auf seiner
Reise korrigiert hatte. In der *Relation historique* schrieb er, es beruhe darauf, „alle nicht
missionierten Indianer für Wanderer und Jäger zu halten"[50]. Auf der *Carte Itinéraire de
l'Orénoque* verzeichnete Humboldt demgegenüber unterhalb des Katarakts verschiedene
indigene Stämme und beschrieb sie zum Teil näher, darunter die „Curacicanas-Indianer,
die viel Baumwolle anbauen und spinnen"[51]. Wesentlicher Zugewinn der kartographischen Visualisierung war diesbezüglich also, dass die Karte zu erkennen gab, weshalb sich
gewisse Fehlschlüsse bis in Humboldts Gegenwart hatten halten können: Aufgrund der
geographischen Beschaffenheit und einer damit verbundenen schlechten Zugänglichkeit
des mit schwer passierbaren Wassern, Wäldern und Bergketten durchzogenen Geländes
war die Gegend äußerst schwer erreichbar gewesen.[52] Anhand der inszenierten Augenzeugenschaft konnte die Leserschaft das von Humboldt im Text angesprochene Vorurteil

50 Im Original: „C'est une erreur assez répandue en Europe, que de regarder tous les indigènes non réduits,
 comme errans et chasseurs." Humboldt: *Voyage*, Teil 1 *(Relation historique)*, Bd. 1 [Quarto], Paris: Gide
 1814[−1817], S. 460.
51 Im Original: „Ind.ˢ Curacicanas qui cultivent et filent beaucoup de coton".
52 Der Bezug von vielschichtiger räumlicher Repräsentation und Relationierung auf der Karte einerseits
 und textuell breiter eingebetteter Analyse der spatialen Darstellung andererseits kehrt die grundlegende
 Bedeutung von Humboldts textuellen Ausführungen für die individuelle Ausgestaltung der Karten,
 hier am Beispiel seiner *Relation historique* und ihrem Bezug zum *Atlas géographique et physique du
 Nouveau Continent*, deutlich hervor. Die topographisch organisierte Karte verortete die im Text getroffenen Schlussfolgerungen, verifizierte sie, indem ihr eine bestimmte, geodätisch möglichst genau
 ausgestaltete räumliche Position zugewiesen wurde, und stellte sie zugleich in ihren topographischen
 Bezügen vor Augen. Durch die kartographische Repräsentation konnten auch verschiedene, häufig
 weit auseinandergezogene Textpassagen der *Voyage*, etwa die an unterschiedlicher Stelle auftretenden
 Beschreibungen und Rückbezüge zur Orinoko-Reise, in ihrer Zusammengehörigkeit eingeholt und in
 einen räumlichen, relationalen Bezug zueinander gestellt werden.

im bewegten Blick über die Karte gewissermaßen aus dem eigenen Erleben heraus korrigieren.[53]

Zusammenfassend lässt sich sagen, dass die *Carte Itinéraire de l'Orénoque* zwei dominante Lesarten anbietet: Einerseits wird die Rezeption, indem das Publikum in Humboldts Sicht- und Erfahrungsbereich versetzt wird, mit dessen Beobachtungen vor Ort in Übereinstimmung gebracht. Andererseits betont die Komposition der Karte, die die Flussverläufe markant hervortreten lässt, die hydrologische Verbindung des Orinoko und des Amazonas. Der Karte ist auf diese Weise eine doppelte Aussage eingeschrieben, in der sich topographisch-wissenschaftliche und sinnlich-perzeptive Ebenen ineinander verschränken. Am Beispiel der *Carte Itinéraire de l'Orénoque* wird also deutlich, dass die von Humboldt kartographisch verarbeiteten Informationen maßgeblich auf einer möglichst genauen geodätischen Grundlage fußten, auf dieser aber eine an ausgewählten Themen ausgerichtete Datenanalyse vorgenommen wurde. In ihr verschränken sich aisthetische Aspekte und geowissenschaftliche Erschließung des Raumes aufs Engste.[54] Vor diesem Hintergrund wird deutlich, dass topographisch und thematisch orientierte Karten für Humboldt keine Gegensätze darstellten, sondern notwendigerweise ineinandergriffen: Eine möglichst genau vermessene Topographie war nicht nur die Basis für thematische Schlussfolgerungen, sondern auch für eine ganzheitliche Beschreibung der Natur, wie sie im eigentlichen Zentrum von Humboldts Erkenntnisinteresses standen.

Dateninterpretationen: Interpolation und Zonierung

Erkenntnisgenese durch gemittelte Werte

Wollte Humboldt nicht einzelne geographische Ordinaten visualisieren, sondern numerische Daten bezogen auf ihre geographische Verortung analytisch auswerten, so war für ihn das statistische Prinzip der Mittelwertbildung grundlegend. Mit ihm konnten auch großflächig aufgenommene topographische Werte in ihrem Bezug aufeinander dargestellt werden. Die kartographische Visualisierung half dabei, diese Relationen sinnfällig werden zu lassen und sie zu interpretieren. In seinen sogenannten Höhenkarten, etwa in der Karte *Culminations-Punkte und Mittlere Höhen der Gebirgsketten von Europa, America und Asien* (Abb. 2), verband Humboldt beispielsweise gemittelte Werte großer Landmassen,

53 In der Geographiegeschichte sind Augenzeuginnen und Augenzeugen sowie Landvermesserinnen und Landvermesser von rhetorischer Bedeutung, weil sie für die Wahrheit des in Karten und Texten Vermittelten einzustehen vermochten. Siehe Michalsky: *Projektion und Imagination*, 2011, S. 16.

54 Hier wird eine Reflexion der Naturerfahrung sinnfällig, die Humboldt sich als Schilderung vom „Eindruck wie die Natur selbst" auch bei seinem wissenschaftlichen Schreiben abverlangte. Vgl. Humboldt in einem Brief an Varnhagen von Ense, 28.10.1834, in: *Briefe von Alexander von Humboldt an Varnhagen von Ense aus den Jahren 1827 bis 1858. Nebst Auszügen aus Varnhagen's Tagebüchern und Briefen von Varnhagen und Andern an Humboldt*, hg. von Ludmilla Assing, Leipzig: Brockhaus 1860, S. 23.

zuweilen ganzer Gebirgszüge, zu virtuellen Höhenzügen.[55] Letztlich veranschaulichen auch die Karten zur Verteilung von Pflanzengattungen auf der Erdoberfläche, darunter das *Tableau physique des Andes* (Abb. 1), Ergebnisse gemittelter Daten: Eine Pflanzengattung wurde von Humboldt im zugrunde liegenden Koordinatensystem der Höhe an ebender Stelle eingetragen, an der sie in der Natur statistisch gehäuft nachgewiesen worden war.

Konnte Humboldt Mittelwerte nicht über mathematische Berechnungen bilden, etwa weil ihm verlässliche Daten fehlten, half ihm die Interpolation dabei, gemittelte Werte trotz der fehlenden Einzeldaten über die Visualisierung annäherungsweise zu erfassen. Bei diesem Verfahren werden diskrete Messwerte in ein Koordinatensystem eingetragen und mit einer Linie, die ihre mittleren Werte approximiert, zu einer stetigen Funktion zusammengezogen. Obwohl die Funktion nicht auf mathematischen Regeln basiert, werden anhand des Verlaufs der Linie Regelmäßigkeiten bei Datenanstiegen oder -abfällen, die sich über einzelne oder auch punktuell gemittelte Messwerte (noch) nicht nachvollziehen lassen, sichtbar.

Die *Carte des lignes Isothermes*

Vor allem half Humboldt die Interpolation von Daten, um sich großräumige Abhängigkeiten im Naturraum, die sich mit dem bloßen Auge nicht überschauen ließen, zu erschließen. Dieses Potential ist für die *Carte des lignes Isothermes* (Abb. 6) wesentlich, die Humboldt 1817 zusammen mit einem Aufsatz über die Wärmeverteilung auf der Erdoberfläche, *Des lignes isothermes et de la distribution de la chaleur sur le globe*, publizierte.[56] Die Graphik zeigt die Klimazonen der nördlichen Hemisphäre, indem Werte gleicher mittlerer Temperatur, die auf der Nordhalbkugel gemessen wurden, mittels Interpolation zu Linien zusammengezogen sind. Diese Linien wurden auf ein grob skaliertes geographisches Koordinatensystem aufgebracht, in das Humboldt einzelne Städtenamen eintrug. Die Auswahl dieser Städte erfolgte nach ihrer Höhenlage, denn Humboldt nahm

55 Bis in die neuere Wissenschaftsschreibung hinein wird dieser orometrische Ansatz geographiegeschichtlich als eines der wesentlichen Resultate der Studien Humboldts bewertet. Siehe N. N.: Art. „Humboldt, Alexander von", in: *Westermann Lexikon der Geographie*, Bd. 2, Braunschweig: Westermann 1969, S. 467–468, hier S. 468.

56 Humboldts theoretische Grundlage für die Konzeption der Karte bildeten die Arbeiten des Göttinger Astronomen Tobias Mayer (1723–1762). In seinen 1775 posthum von Georg Christoph Lichtenberg veröffentlichten Schriften hatte Mayer eine mathematische Theorie der globalen Wärmeverteilung entwickelt. Vgl. Dettelbach, Michael: „The Face of Nature: Precise Measurement, Mapping, and Sensibility in the Work of Alexander von Humboldt", *Studies in History and Philosophy of Science Part C: Studies in History and Philosophy of Biological and Biomedical Sciences* 30 (1999) 4, S. 473–504, hier v. a. S. 483 Vgl. ferner Model, Fritz: „Alexander von Humboldts Isothermen", *Deutsche Hydrografische Zeitschrift* 12 (1959) 1, S. 29–33; Knobloch, Eberhard: „Nomos und physis. Alexander von Humboldt und die Tradition antiker Denkweisen und Vorstellungen", *HiN* XI (2010) 21, S. 45–55.

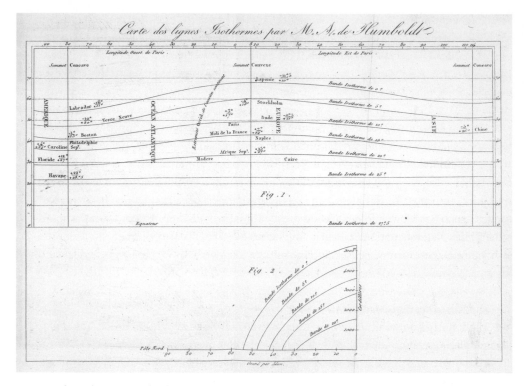

6__Alexander von Humboldt, *Carte des lignes Isothermes*, 1817, 19,5 × 24,3 cm

nur solche in die Graphik auf, die sich etwa auf der Höhe des Meeresspiegels befanden. Diese Selektion geht mit der gesamten auf der Graphik visualisierten Datengrundlage zusammen, denn auch bei den interpolierten Temperaturangaben handelt es sich um solche, die auf dem Niveau des Meeresspiegels aufgenommen worden waren. Hierdurch war hinsichtlich der klimatologischen Auswertung eine größtmögliche Vergleichbarkeit der Daten gegeben. Die kartographische Darstellung der Kontinentalmassen sparte Humboldt hingegen aus, vermutlich um keinen direkten Zusammenhang von Kontinentalmasse und Klimaverteilung zu suggerieren, der sich für Humboldt nicht abschätzen ließ. Die Städte hingegen ermöglichten die Orientierung auf der Karte; dank ihnen ließ sich die Ausbreitung der Klimate auf der Erdoberfläche verorten.

Aus Humboldts Interpolation der Temperaturwerte ergaben sich auf der *Carte des lignes Isothermes* insgesamt sechs weiche, zum Nordpol hin etwas stärker geneigte Kurven, die eine gleichmäßige Ausbreitung der Klimate in der nördlichen Hemisphäre suggerieren. Die zwischen den Wärmekurven entstandenen Bereiche machen hierbei ein zonales Schema auf, nach dem sich die Wärmeverteilung insgesamt gestaltet.[57] Dieses harmoni-

57 Vgl. Schneider: „Linien als Reisepfade der Erkenntnis", 2012, S. 176.

sche, in die Form der Welle überführten Klimabild fügte sich – anders als im Fall der erst später ermittelten Ergebnisse für die südliche Hemisphäre – nahtlos in ein Weltbild ein, das von einer ebenmäßigen Kräfteverteilung im Naturraum ausging.[58]

An der *Carte des lignes Isothermes* wird so nicht nur deutlich, dass Humboldt dank der Visualisierung Sachverhalte – wie hier die Klimate – sichtbar machen konnte, für deren Analyse ihm einerseits vergleichsweise wenige Daten zur Verfügung standen und die sich andererseits der Beobachtung mit bloßem Auge entzogen, sondern auch, inwiefern er mit Hilfe der (karto-)graphischen Komposition eine von ihm von vornherein gesetzte, harmonische Ganzheit der Natur in einer regelmäßigen Formsprache einzufangen vermochte.[59] Denn indem Humboldt Temperaturdaten bei ihrer Präsentation im Kartenbild in ein formales Gleichmaß überführte, schrieb er dem Klimabild zugleich die symbolische Form eines harmonischen Gebildes ein. Somit barg die Visualisierung einer wissenschaftlichen Argumentation, die auf numerischer Nachprüfbarkeit basierend suggerierte, es handele sich um ein wissenschaftliches Faktum, zugleich die angenommene Ordnung des Kosmos in sich.[60] Während die Datengrundlage dabei von Humboldt selbst erarbeitet worden war, schloss er mit der zonalen Einteilung der Erdoberfläche an Darstellungen in Zonen-Karten an, die bis in die Antike zurückverfolgt werden können und in mittelalterlichen Karten verstärkt aufgegriffen wurden.[61] Der metaphysische Gedanke des „Naturganzen" blieb somit erhalten, während sich die Methodologie verschob.

Humboldt selbst verstand die von ihm entwickelte Zonierung nicht als Interpretation der Naturkräfte auf der Erdoberfläche, sondern als unmittelbares Zeugnis der Wesenheit des Systems der Natur selbst. Die wissenschaftliche, auf Daten gestützte Graphik half seiner Ansicht nach dabei, die harmonische Substanz des „Naturganzen" klar hervortreten zu lassen, sodass, sobald „eine große Masse genauer Beobachtungen [...] angesammelt war, [...] die richtige Ansicht des Weltbaues nicht auf lange verdrängt"[62] bliebe. Inwiefern erst eine von vornherein vorgenommene Selektion von Daten und eine damit verbundene

58 Heutige Untersuchungen bestätigen Humboldts Erkenntnisse zu den Klimaten der nördlichen Hemisphäre, wie Birgit Schneider und Thomas Nocke in ihrem Vortrag „Die Klimazonenkarte Alexander von Humboldts im Spannungsfeld von Daten und Ästhetik: Diskussion ihrer Entstehung und computerbasierten Rekonstruktion" im Rahmen der Tagung *Kartographische Episteme. Visuelle Praktiken Alexander von Humboldts* (31. 5. – 1. 6. 2013) an der Universität Potsdam aufgezeigt haben. Demgegenüber breiten sich die Klimate der südlichen Hemisphäre, wie Mitte des 19. Jahrhunderts erkannt wurde, deutlich weniger gleichmäßig aus.

59 Zur Freiheit der graphischen Linie vgl. Mersch: „Medium der Zeichnung", 2010, S. 87.

60 Zur Datenakquise, die ein vermeintlich gesichertes, objektives Wissen verspricht, vgl. Kraft: *Figuren des Wissens*, 2014, S. 69 – 72.

61 Vgl. Schneider: „Linien als Reisepfade der Erkenntnis", 2012, S. 182; Brincken, Anna-Dorothee von den: „Die Rahmung der ›Welt‹ auf mittelalterlichen Karten", in: *KartenWissen*, 2012, S. 95 – 119, hier S. 106 – 112.

62 Humboldt: *Kosmos*, Bd. 2, 1847, S. 140.

Wahl der formalen Gestaltung dazu führten, dass sich diese Harmonie in der Graphik zeigen konnte, hinterfragte Humboldt also nicht.

Humboldts Karte der erdmagnetischen Kräfte

Dass seine Karten auf Vorannahmen basierten, die die Auswahl der visualisierten Daten insofern bestimmten, als sich in ihrer visuellen Darstellung die Ordnung des Kosmos zeigen sollte, wird an Humboldts Karte der erdmagnetischen Kräfte von 1804 (Abb. 7) in besonderer Weise deutlich. Sie erschien zusammen mit dem Aufsatz *Sur les variations du magnétisme terrestre à différentes Latitudes*, den Humboldt gemeinsam mit dem Physiker Jean-Baptiste Biot (1774–1862) veröffentlichte.[63] Anders als vorherige Karten, auf denen isodynamische Werte visualisiert worden waren, beschrieb die Graphik nun isodynamische Bereiche.[64] Humboldt selbst sprach von einem „ersten Entwurf eines isodynamischen Systemes, in Zonen getheilt", den er „für einen kleinen Theil von Südamerika geliefert" habe.[65] Diese von Humboldt selbst markierte Neuausrichtung der graphischen Darstellung macht deutlich, dass er seine Aufmerksamkeit nun nicht mehr auf den konkreten Messpunkt, sondern auf eine räumliche Analyse von zusammengefassten, gemittelten Datenmengen richtete, er also nicht mehr auf die lokalisierte Einzelinformation fokussierte, sondern auf thematisch orientierte Verteilungsfragen im Raum.

Bei der graphischen Präsentation der erdmagnetischen Kräfte handelt es sich dezidiert um eine erste Annäherung an den Sachverhalt: Sowohl die nur spartanisch angedeu-

63 Vgl. Humboldt, Alexandre de/Biot, Jean-Baptiste: „Sur les variations du magnétisme terrestre à différentes Latitudes", *Journal de Physique, de Chimie, d'Histoire Naturelle et des Arts* LIX (1804), S. 429–450. Dem Artikel sind nach S. 480 am Ende des Heftes zwei Tafeln beigefügt, wobei es sich bei der zweiten um die Karte der erdmagnetischen Zonen handelt. Am unteren linken Rand der Karte wird Humboldts Mitwirken ausgewiesen: „Humboldt del." [del. = lat. delineavit für „(er) hat gezeichnet"]. Gestochen wurde die Karte von Geoffroy. In der deutschen Übersetzung des Textes fehlt die Karte. Vgl. Humboldt, Alexander von/Biot, Jean-Baptiste: „Ueber die Variationen des Magnetismus der Erde in verschiedenen Breiten", *Annalen der Physik und Chemie* XX (1805), S. 257–298; wieder abgedruckt von Balmer, Heinz: *Beiträge zur Geschichte der Erkenntnis des Erdmagnetismus*, Aarau: Sauerländer 1956. Balmer geht in derselben Publikation auch auf Humboldts erdmagnetische Beobachtungen im Allgemeinen ein. Vgl. ebd., S. 486–492.

64 Es sind schon frühere kartographische Visualisierungen erdmagnetischer Kräfte bekannt, unter welchen Edmund Halleys Isogonenkarte von 1701 als die erste gilt. Diese trug auch zur graphischen Ausgestaltung von Humboldts Isothermen-Karte bei. Der englische Astronom und Mathematiker Halley (1656–1741 oder 1742) hatte jedoch noch Punkte, nicht Mittelwerte gleicher erdmagentischer Messwerte durch Linien verbunden. Im Gegensatz zu ihnen zeigte Humboldts Karte keine Linien durch einzelne geographisch verortete Messpunkte und damit keine eigentlichen Isodynamen, d.h. Linien gleicher erdmagnetischer Stärke, sondern isodynamische Bereiche. Zu Edmund Halleys Karte vgl. u.a. *Neudrucke von Schriften und Karten über Meteorologie und Erdmagnetismus*, 4: *Die ältesten Karten der Isogonen, Isoklinen, Isodynamen*, hg. und kommentiert von G. Hellmann, Neudruck der Ausgabe Berlin: Asher 1895, Nendeln/Liechtenstein 1969; Balmer: *Erdmagnetismus*, 1956, S. 470–485.

65 Humboldt: *Kosmos*, Bd. 1, 1845, S. 193.

7__Alexander von Humboldt,
*Decroißement de l'Intensité des
forces magnetiques* (Karte der
erdmagnetischen Kräfte), 1804,
18,4 × 23,3 cm

teten Umrisse der südamerikanischen Landmasse mit den wichtigsten Flussverläufen als
auch die ins Leere laufenden Linien, die auf der Auswertung erdmagnetischer Daten
basieren, schreiben der Karte eine ins Auge springende Vorläufigkeit ein. Lediglich mittig
links weist die Darstellung klar umrissene Formen auf, während sich die Linienführung
an drei Rändern – oben, unten und rechts – in großflächigen weißen Flächen verliert. Ein
in Leserichtung von links nach rechts suchendes Auge wird auf diese Weise von der defi-
niten Formgebung aus ins Leere geleitet. Aus Biots und Humboldts Artikel lässt sich ent-
nehmen, dass die weißen Freiflächen mit dem Unwissen zusammengingen, das mit den
bis dahin ungeklärten Ursachen des Erdmagnetismus korrespondierte: Der zugehörige
Text unterstreicht, dass für eine Verallgemeinerung des Naturphänomens insgesamt noch
zu wenige Messungen vorlägen; es handele sich vielmehr um eine, wenngleich auf einer
stabilen Basis aufgestellte Hypothese.[66]

66 Siehe Humboldt/Biot: „Ueber die Variationen des Magnetismus", 1805, S. 270–273.

Trotz der von den Autoren selbst eingeräumten Vorläufigkeit zeigt die Karte dennoch bereits eine gleichmäßige Verteilung der erdmagnetischen Zonen auf der Erdoberfläche, wobei sich die Intensität der erdmagnetischen Kräfte zu den Polen hin steigert.[67] Indes fallen die schwächsten Kräfte nach der These Humboldts und Biots nicht mit der äquatorialen Erdumlaufbahn zusammen, sondern verlaufen entlang eines alternativen, von den Autoren als „magnetisch" bezeichneten Äquators.[68] Von diesem „magnetischen Äquator" ausgehend schlugen Humboldt und Biot südliche und nördliche Zonierungen vor. Auf der Karte werden sie durch Linien voneinander abgegrenzt, die durch gleiche gemittelte Werte der Magnetnadelschwingung in Zeitfenstern von zehn Minuten gezogen wurden.[69] Die in regelmäßigen Abständen parallel zueinander verlaufende, zonale Einteilung suggeriert eine mit der schematischen Einteilung auf Humboldts *Carte des lignes Isothermes* vergleichbare, eindeutige Gesetzmäßigkeit, nach der sich die magnetischen Kräfte gleichförmig auf der Erdoberfläche ausbreiteten. Dass sie von einem entsprechenden Naturgesetz ausgingen, stellten Humboldt und Biot in ihrem Aufsatz klar, jedoch ließen sie darin im Unklaren, nach welchen Kriterien sie die Einteilung in konkrete isodynamische Zonen vorgenommen hatten.

Diese deutlich markierte Zonierung in der Graphik steht in einem gewissen Widerspruch zu der darin zugleich angedeuteten Vorläufigkeit, ebenso wie die Aussage der Autoren, dass vieles an der vorgestellten Hypothese noch unsicher sei, sich mit der gleichzeitigen Behauptung reibt, am Naturgesetz gäbe es grundsätzlich keinen Zweifel. In dieser ambivalenten Rhetorik entsprechen sich Aufsatz und Graphik somit. Während Letztere zwischen Prägnanz der Formgestaltung im Einzelnen und skizzenhafter Anlage der Gesamtkomposition changiert, ist der Text nach dem Prinzip der Beschreibung eines Naturgesetzes angelegt, das zugleich jedoch seiner unmittelbaren Relativierung unterworfen ist:

> Wie diesem indess auch sey, so scheint schon die Zusammenstellung der Resultate aus den Beobachtungen des Herrn von Humboldt in Amerika mit Sicherheit darzuthun, dass die magnetischen Kräfte vom magnetischen Aequator nach den Polen zu wachsen. Auch die in Europa angestellten Beobachtungen, so wenig wir sie mit jenen unmittelbar in Verbindung bringen möchten, stimmen unter einander dahin überein, dieses zu bestätigen.[70]

Obwohl auch die Ausgestaltung der Karte konkrete und unsichere Elemente vereint, diente sie mit Bezug auf den relativierenden Text dennoch dazu, die formulierte These auf unmittelbare Weise evident zu machen. Als Instrument der visuellen Beweisführung bestätigte sich für die Autoren in der graphischen Formgebung, die sich auf der Grundlage der bereits gewonnenen Daten herstellen ließ, ein regelgeleitetes Prinzip des „Natur-

67 Siehe ebd., S. 261.
68 Siehe ebd., S. 264.
69 Siehe ebd., S. 264–265.
70 Ebd., S. 265–266.

ganzen". Für eine globale Verallgemeinerung würden, so Biot und Humboldt, lediglich weitere erhobene Daten fehlen, da das Prinzip in dem bereits Kartierten bereits verifiziert worden war. Bezeichnend ist in diesem Kontext, dass abweichende Messwerte für die Autoren nicht das natürliche Prinzip als solches in Frage stellten, sondern von ihnen als Artefakte[71] interpretiert wurden:

> Wir haben die Beobachtungen in Amerika nach Zonen, welche mit dem Aequator parallel sind, zusammen gestellt, damit die Richtigkeit des Gesetzes, auf das sie leiten, mehr in die Augen springen, und der Beweis nicht durch die kleinen Anomalieen erschwert werden möchte, welche sich diesen Resultaten unvermeidlich einmischen.[72]

Für Humboldt und Biot stellte die kartographische Visualisierung also primär ein Instrument der Wissensgenese dar, das die vermeintliche Gesetzmäßigkeit und damit die Richtigkeit ihrer Annahme bestätigen konnte. In anderen medialen Ausdrucksformen, im Text, aber auch in der tabellarischen Auflistung von Daten, war es als Prinzip (noch) nicht ersichtlich gewesen.

Beide Autoren übersahen bei dieser Einschätzung die Anpassungsfähigkeit der kartographischen Oberfläche, die nicht nur flexibel auf die Analyse von Daten, sondern auch auf die subjektive Herangehensweise der Forscher zu reagieren vermochte. Von den Autoren wurde die Kartendarstellung damit einem Wirklichkeitsbereich überstellt, in der sich das Zusammenwirken des „Naturganzen" als Reales, als Faktum zeigte. Dieses sich in der Graphik Zeigende wurde mit einer Verlässlichkeit belegt, die eine kritische Selbstreflexion der wissenschaftlichen Methode schlicht ausklammerte. Dieses positivistische Vertrauen, das Humboldt (mit Biot) auf die empirisch gewonnen Datengrundlage und deren Präsentation im Kartenbild setzte, steht im Gegensatz zu seiner sensiblen Reflexion fehlerhafter Messdaten, die er auch für seine eigene Arbeit nicht ausschloss. Nach dieser Überzeugung bildete ein präzises Datenmaterial in der kartographischen Auswertung die Wesenheit der Naturprozesse selbst ab. Biot und Humboldt räumten zwar offen ein, dass die zugrunde liegenden Daten gezielt von ihnen selektiert worden waren, um die allgemeine Gesetzmäßigkeit klar hervortreten zu lassen, und dass somit auch die Einteilung der isodynamischen Zonen an präsumtive, bisweilen undeutliche Setzungen gebunden war. Ihre Kritik richtete sich jedoch nicht zugleich auf die Zonen selbst als gemachte Einheiten, die durch die Karte erst konfiguriert worden waren und die sich in der späteren Forschung als unstet erweisen sollten.

Retrospektiv betrachtet treten in Humboldts zonalen Einteilungen in seinen Karten ein wesentliche Erkenntnisinteresse, das er an sie angelegte, und die Erkenntnisleistung,

71 Unter einem Artefakt ist ein aus den übrigen Messwerten ausreißender Wert zu verstehen, der für das Gesamtergebnis unerheblich ist, weil er durch bestimmte Eigenschaften oder Voraussetzungen der zugrunde liegenden Methode oder Versuchsanordnung hervorgerufen wird.

72 Humboldt/Biot: „Ueber die Variationen des Magnetismus", 1805, S. 266.

die er mit ihnen erzielte, partiell auseinander. Denn obwohl Humboldt seine Visualisierungen als direkte Sichtbarmachung des harmonischen Kräftegefüges der Natur verstand und die am jeweiligen Forschungsinteresse ausgerichtete mediale und argumentative Flexibilität des Bildes diesbezüglich kaum berücksichtigte, wurden durch die Visualisierung durchaus Abhängigkeiten in der Natur erkennbar, die sich der direkten Beobachtung entzogen und sich letztlich, anders als Humboldt vorausgesetzt hatte, nicht notwendigerweise bruchlos in das harmonische Zusammenwirken des Kosmos einfügten. Bei der Erkenntnis, die aus der Visualisierung erwuchs, handelte es sich, mit anderen Worten, weniger um eine Bestätigung der angenommenen Harmonie des „Naturganzen", als um die Möglichkeit, Kräftebeziehungen in der Natur überhaupt erst sichtbar zu machen. So wurden zwar in beiden Karten Humboldts die Streuung mittlerer Temperaturwerte auf der Erdoberfläche einerseits als auch das Vorkommen erdmagnetischer Felder andererseits sehr wohl sinnfällig, doch weder für die Verteilung der Klimate noch für jene des Erdmagnetismus traf letztlich ein Gleichmaß zu, wie es Humboldts Karten noch suggerierten. Diese retrospektiv gewonnene Diagnose läuft der Bewertung keineswegs entgegen, dass die kartographische Visualisierung Humboldt ein wertvolles Instrument lieferte, mit dem er auf dem Papier Probleme lösen konnte, die sich ihm in der Natur stellten, sich in ihrer Erkenntnis aber erst mit Hilfe der visuellen Analyse erschlossen. Seine Karten produzierten insbesondere deshalb etwas Neues, noch nicht Gesehenes, weil Humboldt auf ihnen topographische Daten mit weitere Beobachtungen verknüpfte, deren Abhängigkeit von geomorphologischen oder geophysikalischen Faktoren erst durch die Übersetzung ins kartographische Bild erkennbar wurde.

Im Kontext. Die Produktionsbedingungen des *Atlas géographique et physique du Nouveau Continent*

Als Alexander von Humboldt 1837 die letzte der 39 Karten (Taf. II–XII, Abb. 18–22) zu seinem *Atlas géographique et physique du Nouveau Continent* herausgab, lag eine intensive, etwa 35 Jahre währende intellektuelle und praktische Arbeit an dem Kartenband zurück. Er war Teil des 29-bändigen Reisewerks, der *Voyage*, in dem Humboldt die Ergebnisse seiner in Amerika angestellten Forschung publizierte. Als dritter von den drei zur *Voyage* gehörigen „Atlanten" versammelte der *Atlas géographique et physique du Nouveau Continent* unterschiedliche Themen und Regionen der gesamten Reise, weshalb Humboldt ihn auch, je nach Kontext, als „generellen Reise-Atlas"[1], als seinen „geographischen und physischen Atlas"[2] oder, weil der Band sich vor allem auf den ersten, allgemeinen Teil der *Voyage* bezog, als „Atlas de la Relation historique"[3] bezeichnete.[4]

Humboldt dokumentierte den Herstellungs- und Publikationsprozess dieses Atlas genau und konsequent. Noch heute lässt sich daher aus den Beständen seines wissenschaftlichen Nachlasses exemplarisch rekonstruieren, dass Humboldt über die Jahre der

1 Humboldt: *Kleinere Schriften*, Bd. 1, 1853, S. 470.

2 So nannte Humboldt den Atlas etwa in einer Fußnote zur Einführung zu Robert Hermann Schomburgks Reisebericht. Siehe Humboldt, Alexander von: „Über einige sehr wichtige Punkte der Geographie Guayana's", in: *Robert Hermann Schomburgk's Reisen in Guiana und am Orinoko während der Jahre 1835–1839*, hg. von O. A. Schomburgk, Leipzig: Wigand 1841, S. 1–39, hier S. 29, Fußnote 2. In der vorliegenden Arbeit wird von diesem Kurztitel abgesehen, um möglichen Verwechselungen vorzubeugen, da auch Humboldts *Atlas géographique et physique du royaume de la Nouvelle-Espagne* die Wortfolge *Atlas géographique et physique* im Langtitel trägt.

3 Entsprechend bezeichnete Humboldt den Atlas auf dem Umschlag einer Mappe mit Materialien, die er für den *Atlas géographique et physique du Nouveau Continent* zusammengetragen hatte. Sie befindet sich heute im wissenschaftlichen Nachlassteil, der in Krakau verwahrt wird. Vgl. BJK, HA, Nachlass Alexander von Humboldt 8, Teil 1.

4 Während der *Atlas géographique et physique du Nouveau Continent* und die *Vues des Cordillères* dem ersten Teil der *Voyage*, der *Relation historique*, zugeordnet werden, zählt der *Atlas de la Nouvelle-Espagne* zu ihrem dritten Teil und damit zum Textteil des *Essai politique sur le royaume de la Nouvelle-Espagne*. Dieser Text entstand anstatt eines ursprünglich geplanten vierten Abschnitts der *Relation historique*.

Entstehungszeit des Bandes hinweg und trotz einer fehlenden kartographischen Spezial-
ausbildung an allen Teilschritten, in denen die Tafeln zu seinem Atlas entstanden, mit
beteiligt war. Viele der Entwürfe gehen auf Humboldt selbst zurück, zudem korrigierte er
die Vorlagen bis hin zum fertigen Kupferstich und arrangierte die schließlich gedruckten
Tafeln in einer mühevollen intellektuellen Auseinandersetzung zu einem Kartenband. Der
letztlich vorliegende Atlas lässt sich daher als unmittelbares Resultat von Humboldts
Überlegungen und zugleich als Zeugnis einer Schaffensphase verstehen, in der er viele
seiner zentralen wissenschaftlichen Ergebnisse formulierte.

Überdies gibt der *Atlas géographique et physique du Nouveau Continent* Einblick in
einen wissenschaftshistorischen Wandlungsprozess. Anfang des 19. Jahrhunderts war die
gesamte europäische Kartenproduktion einer regen Entwicklung ausgesetzt, von der der
Atlas zeugt. Einerseits wurde die geodätische Vermessung immer präziser, andererseits
beförderten das aufblühende Verlagswesen und neue Druckverfahren, vor allem die breit-
flächige Anwendung der kostengünstigeren Lithographie, die umfassendere Nutzung von
Karten. Graphiken konnten nun relativ preiswert gedruckt und gestreut werden. Zeit-
gleich eröffneten sich durch bildungspolitische Reformen neue Anwendungsgebiete für
die wissenschaftliche Graphik, darunter auch für die Kartographie. Mit diesen Entwick-
lungen ging einher, dass sich in der westlich geprägten Kartographie für das Kartenbild,
für das vorher weniger klare Regeln gegolten hatten, nun – etwa hinsichtlich der Nordung,
der Kartenzeichen und des Gradnetzes – zu Humboldts Lebzeiten nach und nach eine auf
möglichst genauen Geodaten basierende Normierung durchsetzte. Der *Atlas géographi-
que et physique du Nouveau Continent* erweist sich diesbezüglich als Schwellenphänomen:
Humboldt nahm einige der seinerzeit an die Karte herangetragenen neuen Aufgaben –
wie etwa thematische Diskussionen – mit auf, andere – wie die Lithographie – lehnte er
ab. Auf diese Weise vereinte er kartographische Darstellungsrekurse und -innovationen,
wodurch sich der *Atlas géographique et physique du Nouveau Continent* als Dokument
einer Übergangszeit erweist, das sich nach gegenwärtigen geographiehistorischen Kri-
terien einer simplen Einordnung entzieht.

Thematische Kartographie um 1800

Neue Anwendungsbereiche der Karte um 1800

Humboldts Arbeit am *Atlas géographique et physique du Nouveau Continent* fiel in eine
Zeit, in der sich, maßgeblich befördert durch das neue Bildungsideal der Aufklärung und
die bildungspolitischen Reformen um 1800, die Themenbereiche der europäischen Kar-
tenproduktion deutlich ausweiteten und sich zugleich die Gruppe der Kartennutzenden
stark vergrößerte: Mit den sich ausdifferenzierenden akademischen Disziplinen einerseits
und einem enormen Datenanstieg andererseits war insgesamt ein neues Interesse an der
wissenschaftlichen Visualisierung hervorgegangen. Karten, auf denen sowohl große als

auch heterogene Datenmengen analytisch zusammengeführt werden konnten, spielten in diesem Kontext eine entscheidende Rolle. In den jüngst begründeten Fachdisziplinen – darunter auch in der Erd- und Naturforschung – entwickelten sich je eigene Kartentypen, um Sachverhalte ebenso anschaulich wie konzise vor Augen stellen zu können.[5] Waren Karten bis dahin vor allem darauf bezogen, auf der Grundlage der topographischen Darstellung Besitzverhältnisse zu klären, geschichtliche Zusammenhänge darzustellen, politische Zuständigkeiten abzugrenzen, infrastrukturelle Orientierung zu schaffen oder militärische Operationen zu unterstützen, diversifizierten sich nun ihre Aufgaben und Themen. Im Kontext der Möglichkeiten, die die Karte bei der Generierung und Präsentation von Wissen bot, entstanden solche der Meteorologie und der Klimatologie, andere im Bereich des Verkehrswesens und der Demographie, darunter auch Nationalitäten-, Sprach- und Konfessionskarten. Für diese einzelnen Themenbereiche setzten sich erst nach und nach feste Darstellungskonventionen durch, weshalb zunächst experimentelle, den jeweiligen Einzeldisziplinen dienliche Kartentypen entstanden, die an unterschiedlichen, auch an außerkartographischen Darstellungstraditionen anknüpften.[6]

Diese Umbrüche um 1800 werden bisweilen als „Aufstieg der Themakartographie"[7] beschrieben. Zur thematischen Kartographie zählen im Allgemeinen Karten, die ihren Schwerpunkt nicht wie topographische Karten auf die Geländedarstellung selbst, sondern von dieser ausgehend auf Objekte und Sachverhalte nicht primär topographischen Inhalts legen. Alexander von Humboldts Karten, insbesondere seine *Carte des lignes Isothermes* (Abb. 6) und seine Verteilungskarten der Pflanzengattungen (exemplarisch Abb. 1 und Taf. XIII), gelten als Initiationspunkte einer thematischen Analyse im Kartenbild.[8] Bis heute lassen sich Humboldts Entwicklungen in diesem Bereich der Kartographie darin ausmachen, dass sich von ihm eingeführte Neologismen wie „Isotherme" (in klimato-

5 Vgl. Hake/Grünreich/Meng: *Kartographie*, 2002, S. 541; vgl. ferner Rudwick, Martin J. S.: „The Emergence of a Visual Language for Geological Science 1760–1840", *History of Science* XIV (1976), S. 149–195, hier S. 150–151.

6 Vgl. Hake/Grünreich/Meng: *Kartographie*, 2002, S. 5–6; zur Entwicklung der thematischen Kartographie ebd., S. 540–543.

7 Ebd., S. 540.

8 Nils Güttler zeigt, dass pflanzengeographische Karten jedoch erst deutlich nach Humboldt in die botanische Wissenschaftspraxis übernommen wurden. Vgl. Güttler, Nils: *Das Kosmoskop. Karten und ihre Benutzer in der Pflanzengeographie des 19. Jahrhunderts*, Göttingen: Wallstein 2014. Zur Entwicklung der thematischen Kartographie mit Bezug auf Humboldt vgl. ebd., S. 540–543. Vgl. zu diesem Aspekt vgl. auch N. N.: Art. „Humboldt, Alexander von", 1969, S. 467–468; Zögner: Art. „Humboldt", 1986, S. 321; ders.: „Carl Ritter und Alexander von Humboldt. Ihr Beitrag zur Entwicklung der thematischen Kartographie", in: *Studia Geographica*, hg. von Wolfgang Eriksen, Bonn: Dümmler 1983, S. 393–406. Mit Bezug auf Humboldts *Carte des lignes Isothermes* vgl. Robinson, Arthur/Wallis, Helen: „Humboldt's Map of Isothermal Lines: A Milestone in Thematic Cartography", *The Cartographic Journal* 4 (1967) 2, S. 119–123.

logischen Karten) oder „Bevölkerungsdichte" (in demographischen Karten) gehalten haben.[9]

In der Praxis lässt sich die theoretische Differenzierung von thematischer und topographischer Karte gleichwohl kaum eindeutig aufrechterhalten, weil die Einordnung in den einen oder anderen Bereich wesentlich von dem Schwerpunkt der jeweiligen Kartenbetrachtung abhängt. Je nach Bewertung können somit auch Karten, die deutlich vor 1800 datieren, als thematisch verstanden werden. Beispiele hierfür finden sich bereits in der Antike. Die eingezogene Zäsur im 19. Jahrhundert lässt sich mithin darauf zurückführen, dass sich thematisch orientierte Karten erst mit der disziplinären Ausdifferenzierung nach 1800 breitenwirksam durchsetzten. Im Zuge dessen wurden auch neue, speziell für die thematische Kartographie entwickelte Darstellungsmethoden eingeführt. Zu ihnen zählten gezielte Verzerrungen und farbige, von der topographischen Darstellung unabhängige Flächenmarkierungen.[10]

Humboldts thematische Kartengestaltung

Dass dem *Atlas géographique et physique du Nouveau Continent* kein topographisches, sondern ein genuin thematisches Konzept zugrunde liegt, hat bereits Hanno Beck vermutet, es ließ sich für ihn jedoch nicht entschlüsseln.[11] Dies mag auch darauf zurückzuführen sein, dass der Atlas aus einer Zeit stammt, in der sich für die thematische Kartenproduktion im Zuge der disziplinären Ausgestaltung der Geographie erst sukzessive Normen durchsetzten. So griff Humboldt bei der Gestaltung seiner Karten in großen Teilen auf etablierte, primär der topographischen Darstellung entspringende kartographische Zeichenkonventionen zurück, nutzte diese aber dafür, primär thematische Sachverhalte zu beschreiben. Er tat dies, indem er nur wenige Elemente zeigte und sie auf der Karte gezielt in Kombinationen setzte. Obwohl die Tafeln seines Atlas deshalb zunächst wie weitgehend leere, topographische Karten anmuten mögen, ist ihnen letztlich eine andere, nicht vorrangig an der topographischen Gebietsaufnahme orientierte Zielsetzung inhärent. Werden die Karten aus Humboldts Atlas dennoch als primär topographische Karten aufgefasst, so lässt sich auch ihre thematische Zusammenstellung im Kartenverbund nur schwer nachvollziehen.

9 Mit diesen Begriffen, so Axel Borsdorf, habe Humboldt entscheidende Grundlagen für die analytische Geographie und die thematische Kartographie gelegt. Siehe Borsdorf, Axel: „Alexander von Humboldts Amerikanische Reise und ihre Bedeutung für die Geographie", in: *Ansichten Amerikas. Neuere Studien zu Alexander von Humboldt*, hg. von Ottmar Ette und Walther L. Bernecker, Frankfurt am Main: Vervuert 2001, S. 137–155, hier S. 152.

10 Vgl. Pápay, Gyula: Art. „Kartographie und Abbildung", in: *Handbuch Bild*, hg. von Stephan Günzel und Dieter Mersch, Stuttgart/Weimar: Metzler 2014, S. 187–194, zur thematischen Kartographie hier S. 192–194.

11 Vgl. Beck: „Humboldt – Kartograph der Neuen Welt", 2000, S. 50–51.

Wie eben angedeutet, ist der entscheidende Unterschied in der Gestaltung, an dem auf Humboldts Karten die Verschiebung hin zur thematischen Aussage sinnfällig wird, nicht am qualitativen, d. h. an der graphischen Umsetzung der einzelnen Elemente, sondern am quantitativen Umgang mit Kartenzeichen auszumachen: Humboldts Karten zielen zwar – wie topographische Karten üblicherweise – auf eine zweidimensionale Repräsentation dreidimensionaler Körper auf der Fläche und weisen darin eine geometrische Ähnlichkeit zur Erdkruste auf, jedoch ist diese topographische Darstellung bei Humboldt hochgradig selektiv. Auf der Darstellungsebene der Karten entkoppelte er demnach zwei Aspekte, die sich beide mit der geodätischen Landvermessung sukzessive als wesentliche Kriterien der topographischen Karte durchzusetzen begannen: die möglichst präzise geographische Landaufnahme einerseits und deren großflächige Repräsentation im Kartenbild andererseits. Demgegenüber fußen Humboldts Karten zwar auf möglichst großräumigen und präzisen geographischen Daten, entfernen sich aber in deren graphischen Weiterverarbeitung gezielt von einem kartographischen Produkt, das eine topographisch möglichst umfassende Darstellung der Erdoberfläche bietet. Während also – mit anderen Worten – die Darstellungsweise dessen, was in Humboldts Karten zur Ansicht kommt, weitgehend den Konventionen der damaligen Zeit entspricht, richtet sich das Komposit[12] nach einzelnen, ausgewählten geographischen Strukturen. Humboldts Karten widersetzen sich damit einer für die Kartographie des 19. und 20. Jahrhunderts charakteristischen Sichtbarkeit, die „im Dienst deiktischer Strategien [steht], zu deren wesentlichen Aufgaben immer auch gehört, das konstruktive Prinzip dieser spezifischen visuellen Deixis zugunsten der Funktionalität des Kartographischen zu minimieren"[13]. Dagegen ist Humboldts Karten ein konstruktivistisches Merkmal inhärent, durch das die Erdoberfläche bzw. ein Teil von ihr im Kartenbild gerade *nicht* als geschlossenes räumliches Gebilde repräsentiert wird, sondern mit dem stattdessen singuläre topographische Einzelaspekte hervortreten. Mit dieser beschränkten Gestaltung des Raumes geht einher, dass dem Kartenbild eine der grundlegenden Funktionen des Kartographischen entzogen wird, die darin besteht, anhand der Darstellung eine verbesserte topologische Übersicht über einen bestimmten Raum und mit ihr Orientierung zu verschaffen.

12 Unter dem Begriff des Komposits wird hier in Anlehnung an Inge Hinterwaldner und Markus Buschhaus die Struktur eines darzustellenden Gegenstandes verstanden, die sich aus vielen einzelnen, in sich geschlossenen Komponenten zusammensetzt. Ihre Anordnung lässt eine übergeordnete Gestaltung erkennen, ohne dass die einzelnen Komponenten dabei verdeckt würden. Das Komposit grenzt sich gegen die Komposition insofern ab, als diese sich auf den formalen und geschlossenen Aufbau von Gestaltungselementen im Bild bezieht. Vgl. Hinterwaldner, Inge; Buschhaus, Markus: „Zwischen Picture und Image", in: *The Picture's Image*, 2006, S. 9–19, hier S. 16–17.

13 Vgl. Siegel: „Die ganze Karte", 2011, S. 25.

8__Alexander von Humboldt, *Carte itinéraire de la Route de Zacatecas a Bolaños*, 1834, ca. 43 × 60 cm, in: *Atlas géographique et physique du Nouveau Continent*, Tafel 8 (Lieferung 7), Berlin, SBB, Foto SBB

So zeigt beispielsweise die *Carte itinéraire de la Route de Zacatecas a Bolaños*, Tafel 8 des *Atlas géographique et physique du Nouveau Continent* (Abb. 8), lediglich einige ausgewählte Berge, durch die sich eine Straße schlängelt; einzelne Ansiedlungen und wenige weitere Elemente ergänzen die Darstellung. Dem Kartenkommentar ist zu entnehmen, dass es sich um mexikanisches Terrain handelt, unklar bleibt jedoch, wo genau es sich befindet oder wie es zu erreichen wäre. Keineswegs bietet die Karte also – wie von einer topographischen Karte angenommen werden könnte – eine generelle Orientierungsgrundlage vor Ort, etwa indem eine breitere Einbettung des Geländes vorgenommen oder Zufahrtswege dargestellt worden wären; zudem schließt sie mit ihrer geographischen Gebietsaufnahme nicht an die übrigen Karten des Atlas an.

Stattdessen entspinnt sich, gestützt auf die Selektion der Naturphänomene und deren graphische Anordnung auf dem Blatt, eine enkaptische visuelle Argumentation. Auch das zugrundeliegende Koordinatensystem ist auf sie ausgerichtet. Es arbeitet der Inszenierung des Wegverlaufs insofern zu, als es gegenüber einer üblicherweise nach einer Himmelsrichtung, meist nach Norden, ausgerichteten Karte um etwa 45° in westliche Richtung gekippt ist. Auf diese Weise wird nun nicht das Koordinatensystem, sondern das Itinerar rahmenparallel ausgerichtet und damit senkrecht ins Kartenbild gesetzt. Diese Inszenierung stützt gemeinsam mit der Selektion des überhaupt Dargestellten eine spezifische wissenschaftliche Aussage, die die topographische Referenzialität des Gezeigten in den Hintergrund treten lässt. Stattdessen wird auf der Karte am Beispiel des an Bodenschätzen reichen Zacatecas die Abhängigkeit bestimmter natürlicher und kultureller Faktoren exemplarisch vor Augen geführt. Vom räumlichen Setting der bergigen Landschaft aus, die wegen ihrer Rohstoffvorkommen bereits vom 16. Jahrhundert an von besonderem Interesse für die Spanier war, ließ sich auf generelle Kulturtechniken der infrastrukturellen Erschließung von Höhenlagen sowie auf bestimmte Besiedelungsstrukturen schließen.[14]

Weiße Flächen: Freiräume für die Erkenntnisgenese

Für die kartographische Diskussion in der *Carte itinéraire de la route de Zacatecas a Bolaños* sind weiße Flächen konstituierend, die die gezeigten Elemente als *relata*, die in gegenseitiger Abhängigkeit stehen, markieren. Der zeitliche Kontext, in dem Humboldt diese weißen, für die Erkenntnis wesentlichen Freiflächen entwickelte, verdient hierbei einer genaueren Betrachtung: ,Weiße Flecken' auf Karten wurden vielfach noch mit einer *terra incognita* in Verbindung gebracht, der durch die Entsendung von Forschungsreisenden

14 Im Kartenkommentar verwies Humboldt auf Messwerte, die er in der ersten Ausgabe seines *Essai politique sur le royaume de la Nouvelle-Espagne* diskutierte. Vgl. zum Thema der Karte ferner Humboldt: *Kosmos*, Bd. 4, Stuttgart/Tübingen: Cotta 1858, S. 432–433; Humboldt, Alexander von: „Ueber die Schwankungen der Goldproduktion mit Rücksicht auf staatswirthschaftliche Probleme", *Deutsche Vierteljahrs Schrift* 1 (1838) 4, S. 1–40.

planmäßig entgegengearbeitet werden sollte.[15] Dennoch wertete Humboldt die Konnotation der weißen Flächen im von ihm umgesetzten Kartenbild partiell um:[16] Aus dem markierten Nichtwissen erwuchs nun eine spezifische Erkenntnis.[17] Die geschaffenen Freiflächen boten Humboldt ein heuristisches Instrument, mit dem bestimmte topographische Elemente herausgestellt, in ihrer Bedeutung betont und zugleich gedanklich leichter zusammengeführt werden konnten. Zudem ließen sich bestimmte topographische Elemente auch über mehrere Kartenblätter hinweg gezielt aufeinander beziehen.

Es sind diese monochromen Flächen, die Humboldts Karten als „Produkte eines individuellen […] Willens zu spezifischer Gestaltung von Sichtbarkeit"[18] ausweisen, und hinter denen, wie hinter jeder kartographischen Konstruktionen, „ein reich differenziertes Ensemble von Techniken und Verfahren interessegeleiteter Sichtbarmachung"[19] steht. Humboldts graphische Leerstellen erweisen sich in diesem Zusammenhang als die wesentliche Voraussetzung für die Heuristik seiner Visualisierungspraxis. Sowohl kompositorisch als auch ihrer Operativität nach schließt sie an diagrammatische Darstellungen bzw. Tableaus an:[20] Die reduzierte Darstellung einzelner Elemente wird auf weißem Grund in eine Erkenntnis gerichtete Anordnung überführt, die auf einem bestimmten Notationssystem aufbaut. Auf Farbigkeit weitgehend verzichtend und mit Chiffren oder erklärenden Beschriftungen versehen, zielt die diagrammatische Darstellung darauf, Korrelationen zwischen visualisierten Einzelaspekten deutlich hervortreten zu lassen.[21] Entsprechend betonen auch Humboldts meist nicht oder nur dezent kolorierte Karten

15 Vgl. zur Geschichte der ‚weißen Flecken' in der kartographischen Darstellung Hiatt, Alfred: „Blank Spaces on the Earth", The Yale Journal of Criticism 15 (2002) 2, S. 223–250. Bei Jean-Baptiste d'Anville, mit dessen Werk Humboldt vertraut war, findet sich ein dem heuristischen Nutzen nach vergleichbarer Einsatz weißer Flächen auf der Karte. Vgl. zu d'Anvilles Karten Haguet, Lucile: „Specifying Ignorance in Eighteenth-Century Cartography, a Powerful Way to Promote the Geographer's Work: The Example of Jean-Baptiste d'Anville", in: The Dark Side of Knowledge, hg. von Cornel Zwierlein, Leiden: Brill 2016, S. 358–381, hier S. 361–364.

16 Als Ausnahmen können die Tafel 10, die Carte de la Province de Quixos, und die Tafel 11, die Esquisse d'une Carte de la Province d'Avila des Atlas géographique et physique du Nouveau Continent, beide 1834 (Lieferung 7), angeführt werden, die beide nicht auf Humboldts eigenen geographischen Messungen basieren, sondern auf vor Ort gesammelten Berichten anderer beruhen. Auf beiden Karten werden die „pays inconnus" im Kartenbild durch Punktlinien von der jeweils zentralen topographischen Darstellung separiert.

17 Die terra incognita als freie Fläche im Kartenbild darzustellen, setzte sich erst mit der Aufklärung durch. Vorher wurde unbekanntes Terrain im Kartenbild vielfach genutzt, um topographische Hypothesen anzustellen oder um Vorstellungsbildern, etwa Fabelwesen, einzufügen. Vgl. Hiatt: „Blank Spaces on the Earth", 2002, insbesondere S. 248.

18 Vgl. Siegel, Steffen: „Die ganze Karte", 2011, S. 23.

19 Vgl. ebd., S. 26.

20 Vgl. Bender/Marrinan: The Culture of Diagram, 2010, S. 43–44.

21 Siehe ebd., S. 7.

gegenüber einer großflächigen topographischen Repräsentation des Realraumes eine Operativität des Kartographischen, die eine auf bestimmten Regeln basierende, auf spezifische Wissensbestände und Fragestellungen fokussierte Präsentation der Topographie visiert.[22] Vor eine primär indexikalische Darstellung des Geländes schiebt sich auf Humboldts Karten somit diejenige thematisch relational verbundener Raumelemente.[23]

Humboldts Karten und ihre Nähe zu wissenschaftlichen Tableaus

Bezogen auf die Traditionen wissenschaftlicher Wissensvermittlung um 1800 lassen sich Humboldts Karten vor diesem Hintergrund zwar nicht hinsichtlich der Ausgestaltung der einzelnen Kartenzeichen, jedoch mit Blick auf ihre reduzierte Darstellungsweise sowohl formal als auch funktional mit der Anordnung wissenschaftlicher Schaubilder oder Tableaus zusammenbringen, wie sie sich in der Druckgraphik des 17. und 18. Jahrhunderts in verschiedenen, darunter in den geographischen Disziplinen etablierten.[24] Spätestens ab dem 18. Jahrhundert stellte das Tableau die primäre Präsentationsform wissenschaftlicher Erkenntnis dar und stieg zum „Ideal der klassischen Episteme […], die die Dinge in einem abstrakten Systemraum scheinbar dauerhaft gültiger Verhältnisse vergegenwärtigt"[25], auf. Zerstreute Einzelbeobachtungen wurden nach übergeordneten Parametern und präsumtiven Kategorienbildungen zusammengestellt, übersichtlich angeordnet und zugleich systematisch und funktional gegliedert. Auf dieser Grundlage der spatialen Wissensorganisation ließen sich dank visueller Brücken Relationen zwischen den Objekten erproben.[26]

22 Für einen ersten Überblick vgl. Bauer, Matthias/Ernst, Christoph: *Diagrammatik. Einführung in ein kultur- und medienwissenschaftliches Forschungsfeld*, Bielefeld: transcript 2010. Die Philosophin Sybille Krämer setzt sich insbesondere mit diagrammatischen Aspekten im Schrift-Bild-Kontext auseinander. Vgl. v. a. Krämer, Sybille: „Operative Bildlichkeit. Von der ›Grammatologie‹ zu einer ›Diagrammatologie‹? Reflexionen über erkennendes ›Sehen‹", in: *Logik des Bildlichen. Zur Kritik des ikonischen Vernunft*, hg. von Martina Heßler und Dieter Mersch, Bielefeld: transcript 2009, S. 94–122, und dies.: „Diagrammatisch", *Rheinsprung. Zeitschrift für Bildkritik* 11 (2013), S. 162–174. Für eine Annäherung aus bildwissenschaftlicher Perspektive vgl. *Das Technische Bild*, Berlin 2008, hier insbesondere Schneider, Birgit: „Diagrammatik", S. 192–196.

23 Zum Zwitterstatus der Karte zwischen Diagramm und Bild vgl. Günzel, Stephan/Nowak, Lars: „Das Medium der Karte zwischen Bild und Diagramm. Eine Einführung", in: *KartenWissen*, 2012, S. 1–32.

24 Zur heuristischen Funktionsweise des Tableaus ist insbesondere im angelsächsischen Sprachraum publiziert worden. Vgl. in der vorliegenden Untersuchung *Einleitende Überlegungen*, Fußnote 43. Eine umfassende Auseinandersetzung mit dem (literarischen) Tableau bei Alexander von Humboldt und Johann Wolfgang von Goethe bietet Graczyk: *Tableau*, 2004, hier v. a. S. 12–13. Viele Bildbeispiele mit Bezug auf das Hüttenwesen, in dem Humboldt ausgebildet wurde, finden sich in: Holl, Frank/Schulz-Lüpertz, Eberhard: *„Ich habe so große Pläne dort geschmiedet …": Alexander von Humboldt in Franken*, Gunzenhausen: Schrenk-Verlag 2012.

25 Graczyk: *Tableau*, 2004, S. 14.

26 Vgl. ebd., S. 12.

Durch den Rückgriff auf die Traditionen dieser Darstellungstechnik fand in Humboldts Karten eine Verschiebung im quantitativen Umgang mit Kartenzeichen, nicht aber in ihrem äußeren Erscheinungsbild statt. Daher scheint es sich bei den Karten des *Atlas géographique et physique du Nouveau Continent* auf den ersten Blick vielfach um unzureichend ausgeführte Landkarten zu handeln, da für sie große weiße Flächen charakteristisch sind. Diese Darstellungsweise mag bei der heutigen, nachzeitigen Betrachtung irritieren, weil sich inzwischen andere Visualisierungspraktiken – etwa die farbige Ausgestaltung oder die gezielte Verzerrung der dargestellten Elemente – für thematische Karten etabliert haben. Auf Humboldts Karten sind es hingegen die Freiflächen, die eine wesentliche Funktion für die Generierung von Erkenntnis besitzen: Sie heben die für die thematische Aussage entscheidenden Elemente aus dem topographischen Datenpool auch optisch heraus.

Der *Atlas géographique et physique du Nouveau Continent*: ein thematischer Atlas
Anders also als etwa für seinen Zeitgenossen Carl Ritter (1779–1859), der großflächige topographische Kartenbilder herstellte, wählte Humboldt Kartenzeichen gezielt aus, um thematische Kartenbilder zu realisieren.[27] Für diese Argumentationen waren – wie an der *Carte itinéraire de la Route de Zacatecas a Bolaños* gezeigt – eine Auswahl bestimmter Naturobjekte ebenso wie eine bisweilen gezielte formale Zurichtung des Dargestellten, die physiognomische Besonderheiten stärker hervortreten ließ, die entscheidenden Voraussetzungen. Selektion und graphische Inszenierung bestimmter topographischer Merkmale können mithin als das verbindende Moment aller Tafeln des *Atlas géographique et physique du Nouveau Continent* ausgemacht werden. Durch dieses Moment stellt sich eine „Einheitlichkeit in Form und Inhalt" her, die als „wesentliches Merkmal eines Atlasses" zu bezeichnen ist.[28]

Auf der Grundlage der einzelnen Karten kann der *Atlas géographique et physique du Nouveau Continent* sodann als thematischer Atlas angesprochen werden. Gegenüber diesem Typus des Atlas sind topographisch orientierte Atlanten bzw. atlasähnliche Kartensammlungen schon aus der beginnenden Frühen Neuzeit bekannt. Als eine der ersten gelten diejenigen des griechischen Gelehrten Claudius Ptolemäus (um 100–160), der die Datengrundlage für Karten lieferte, die ab der Mitte des 15. Jahrhunderts in verschiedenen Ausführungen verzeichnet und gedruckt wurden, aber noch keine inhaltliche oder formale Homogenität aufwiesen. In der diesbezüglich vereinheitlichten Form finden sich Beispiele vom Ende des 16. Jahrhunderts, darunter das *Theatrum orbis terrarum* (1570) von Abraham Ortelius (1527–1598). Eine erste Blütezeit erlebten topographische Atlanten in den Niederlanden im 17. Jahrhundert, auch in Frankreich und England entstanden zu

27 Zum Verhältnis von Humboldt und Ritter vgl. *Alexander von Humboldt – Carl Ritter: Briefwechsel*, hg. von Ulrich Päßler, Berlin: Akademie-Verlag 2010.
28 Beide Zitate bei Hake/Grünreich/Meng: *Kartographie*, 2002, S. 543.

dieser Zeit und im darauffolgenden Jahrhundert bedeutende Kartenbände. Doch erst Anfang des 19. Jahrhunderts wurden Atlanten ihres Status als Luxusgüter enthoben, auch für den Bildungsbetrieb erschwinglich und einem breiteren Publikum zugänglich. Zur gleichen Zeit konnte sich der Begriff „Atlas" durchsetzen, den Gerhard Mercator (1512 – 1594) schon Ende des 16. Jahrhunderts geprägt hatte.[29]

Erste thematisch organisierte Atlanten werden dagegen etwa auf die Mitte des 19. Jahrhunderts taxiert.[30] Zu ihnen zählt der prominente, von dem Potsdamer Kartographen Heinrich Berghaus (1797 – 1884) in den 1830er und 1840er Jahren herausgegebene *Physikalische Atlas*, der auf Anregung Humboldts entstand.[31] Dieser Atlas sollte, wie Humboldt in einem Brief an Berghaus formulierte, den *Atlas géographique et physique du Nouveau Continent* zum Vorbild haben:

> Was ich Ihnen nun heute mit einigen Worten zu sagen habe, ist der Wunsch, daß Sie die *geographischen Erläuterungsblätter* zu meinem Buche bearbeiten mögten [sic], einen *Atlas der physischen Erdkunde*, etwa nach dem Muster der Versuche, die ich in dem Atlas zu meiner Reise gemacht habe: Karten für die Vertheilung der Pflanzen und Thiere über die Erde, für Meer- und Flußgebiete, für Verbreitung der thätigen Vulkane, für Declination und Inclination der Magnetnadel, Intensität der magnetischen Kraft, für Meeresströme und Ebbe und Fluth, Luftströmungen, für Züge der Gebirge, Wüsten und Ebenen, für Verbreitung der Menschenracen, ferner für Darstellung der Gebirgshöhen, Stromlängen, u. s. w. Länderprofile habe ich von Ihrer Hand schon vor zwei Jahren gewünscht [...].[32]

29 Einen guten Überblick über die Atlantengeschichte bis 1700 mit einem Schwerpunkt auf der niederländischen Kartenproduktion bietet Michalsky: *Projektion und Imagination*, 2011, S. 78 – 86; für eine knappe Übersicht vgl. Hake/Grünreich/Meng: *Kartographie*, 2002, S. 543 – 544. Vgl. zur Entwicklung von Atlanten im deutschen Sprachraum des 19. Jahrhunderts Espenhorst, Jürgen: *Andree, Stieler, Meyer und Co: Handatlanten des deutschen Sprachraums (1800 – 1945) nebst Vorläufern und Abkömmlingen im In- und Ausland. Bibliographisches Handbuch*, Schwerte: Pangaea 1994. Für die Entwicklung des Schulatlas ab dem beginnenden 19. Jahrhundert vgl. Lehn, Patrick: *Deutschlandbilder: historische Schulatlanten zwischen 1871 und 1990. Ein Handbuch*, Köln: Böhlau 2008, S. 1 – 16.

30 Vgl. Hake/Grünreich/Meng: *Kartographie*, 2002, S. 544.

31 Während die Forschung die Leistung des Berghaus-Atlas lange Humboldt zusprach, ist sie inzwischen weitgehend darin übereingekommen, dass dieser zwar entscheidende Impulse für die Publikation lieferte, sie aber als eigenständiges Werk von Berghaus anzusehen ist. Die Zusammenarbeit von Humboldt und Berghaus wurde im Laufe der Zeit maßgeblich belastet, weil sich Berghaus mit Humboldts Verleger Cotta überwarf, bei dem Humboldt den Atlas zum *Kosmos* erscheinen lassen wollte. Vgl. Fiedler/Leitner: *Alexander von Humboldts Schriften*, 2000, S. 431 – 432. Zu Heinrich Berghaus hat Gerhard Engelmann eine inzwischen etwas in die Jahre gekommene Biographie vorgelegt, die auch auf den Atlas eingeht. Vgl. Engelmann, Gerhard: *Heinrich Berghaus. Der Kartograph von Potsdam*, Halle: Deutsche Akademie der Naturforscher Leopoldina, 1977. Eine kommentierte Neuauflage des Atlas liegt seit Kurzem vor: Berghaus, Heinrich: *Physikalischer Atlas*, hg. und kommentiert von Petra Weigel, Darmstadt: wbg Edition 2018.

32 Alexander von Humboldt an Heinrich Berghaus am 20. Dezember 1827, in: *Briefwechsel Alexander von Humboldt's mit Heinrich Berghaus aus den Jahren 1825 bis 1858*, Bd. 1, Leipzig: Costenoble 1863, S. 117 – 119, hier S. 118.

Das von Humboldt skizzierte Kartenprojekt, das er hier an den *Atlas géographique et physique du Nouveau Continent* angelehnt wünschte, wurde von Berghaus mit dem *Physikalischem Atlas* später inhaltlich in ähnlicher Weise, gleichwohl deutlich erweitert, umgesetzt. Die Nähe von Berghaus' Band zur konzeptionellen Grundidee von Humboldts Atlas weist auch diesem also – zunächst der Idee nach – retrospektiv eine thematische Ausrichtung zu. Die These, dass die Zusammenstellung der Karten des *Atlas géographique et physique du Nouveau Continent* nicht primär nach topographischen, sondern nach thematischen Kriterien erfolgte, lässt sich jedoch nicht nur mit Blick auf die Darstellung der einzelnen Karten und Humboldts Hinweise auf die Nähe zum Berghaus-Atlas erhärten. Auch die Analyse von Humboldts Konzeption des Atlas, von den Motiven der Karten und von der Publikationsweise stützt diese Annahme, wie noch dargelegt wird.

Teamarbeit am Atlas

Kombiniertes Spezialwissen

Wie für Karten im Allgemeinen üblich, handelt es sich auch bei denen des *Atlas géographique et physique du Nouveau Continent* um Resultate kombinierten Spezialwissens. Erst Humboldts Kooperation mit anderen Fachleuten, die über Jahre häufig dieselben blieben, sicherte die hohe Qualität der kartographischen Druckwerke. Dies galt bereits für die zugrunde liegenden Messwerte: Hatte Humboldt sie selbst erhoben, diskutierte er sie mit anderen Wissenschaftlern, darunter mit Jabbo Oltmanns (1783–1833), und übernahm von diesen gegebenenfalls zusätzliche oder neue Werte. Immer wieder bekam Humboldt im Laufe seiner Arbeit an dem *Atlas géographique et physique du Nouveau Continent* auch jüngst gewonnene geographische Informationen anderer zugespielt, die er in seine Karten integrierte.

Jean-Baptiste Boussingault (1802–1887), dessen Forschung maßgeblich von Humboldt unterstützt und gefördert wurde, erhielt sogar gezielte Angaben von diesem, welche Messungen er einholen möge.[33] Boussingault war Anfang der 1820er Jahre unter den europäischen Wissenschaftlern, die nach den erfolgreichen Unabhängigkeitsbewegungen der iberoamerikanischen Länder nach Kolumbien geholt wurden, um die natürlichen Ressourcen des Landes zu untersuchen. Gegenüber Humboldts eigenem Aufenthalt herrschten in Süd- und Mittelamerika nun, etwa hinsichtlich der kartographischen Landaufnahme, deutlich bessere Arbeitsbedingungen für Wissenschaftler. Von den neuen Erkenntnissen profitierte auch Humboldt dank seiner Korrespondenzen.[34]

33 Vgl. *Alexander von Humboldt – Jean-Baptiste Boussingault: Briefwechsel*, hg. von Ulrich Päßler und Thomas Schmuck, Berlin: Akademie-Verlag 2014.

34 Aus diesem Material, das Humboldt neu zugespielt wurde, entwickelte er verschiedene Karten für den *Atlas géographique et physique du Nouveau Continent*, darunter die *Carte hydrographique de la Province*

Humboldts Anteil an der Gestaltung seiner Karten

Humboldt führte schon während seiner Amerikanischen Reise diverse Vorarbeiten, darunter Vorzeichnungen, für Karten aus. Auf dieser Grundlage entwickelte er später detaillierte Kartenentwürfe. In seinem wissenschaftlichen Nachlass finden sich zahlreiche solcher Skizzen in ganz unterschiedlichen Stadien der Ausarbeitung. Eine Vielzahl von ihnen lässt sich einzelnen der später gedruckten Karten des Atlas zuordnen, darunter der des Rio Meta[35] (Tafel 19 des *Atlas géographique et physique du Nouveau Continent*), der des Orinokogebietes[36] (Tafel 15 des *Atlas géographique et physique du Nouveau Continent*) und der des Rio Grande de la Magdalena[37] (Tafel 24 des *Atlas géographique et physique du Nouveau Continent*). Von einer kompositorischen Ausgestaltung Humboldts lässt sich indes auch dann ausgehen, wenn das Ausgangsmaterial nicht von ihm selbst stammte. In diesen Fällen vermerkte er seine Mitarbeit zwar nicht auf dem Kartenblatt selbst, sie lässt sich aber über den Nachlass rekonstruieren. So kann die intensive Mitarbeit Humboldts am Gestaltungsprozess beispielsweise an der *Carte hydrographique de la Province du Chocó* (Abb. 9), der Tafel 25 des *Atlas géographique et physique du Nouveau Continent*, kleinschrittig nachvollzogen werden. Für sie hat sich im Krakauer Teil des wissenschaftlichen Nachlasses ein ganzes Bündel an Vorarbeiten erhalten.[38]

Bei seiner Amerikanischen Reise hatte Humboldt die Region selbst nicht besucht, weshalb er für die Karte, auf der die Diskussion eines Netzes von Wasserarmen im Nordwesten Kolumbiens im Zentrum steht, vollständig auf das Datenmaterial anderer zurück-

du Chocó. Anders als Ulrike Leitner und Gerhard Engelmann es darstellen, nutzte Humboldt dieses neue Datenmaterial also nicht gezielt für die sieben im Atlas enthaltenen Tafeln zu mexikanischen Gebieten. Leitner und Engelmann gehen davon aus, dass Humboldt das Material zu diesen Karten erst mit der mexikanischen Unabhängigkeit in den 1820er Jahren zukam und sie daher eher dem *Atlas de la Nouvelle-Espagne* zugeschlagen werden müssten. Einige der Karten, die im *Atlas géographique et physique du Nouveau Continent* mexikanische Gebiete zeigen, wurden von Humboldt jedoch bereits mit der ersten Lieferung 1814, d. h. deutlich früher veröffentlicht, und gingen direkt auf Vorarbeiten zurück, die auf der Amerikanischen Reise entstanden. Diese Angaben zu Produktion und Herausgabe belegen, dass eine geographische Ausweitung des Gebietes über die äquatornahe Zone hinaus für die Konzeption des Atlas von Anfang an vorgesehen war und nicht erst produktionsbedingt entstand. Leitners Schlussfolgerung geht daher fehl, Hanno Beck habe die sieben Karten zu Mexiko in seiner Studienausgabe zu Humboldts Schriften zu Recht dem „Mexiko-Werk" zugeordnet. Vgl. Leitners Kommentar zu Humboldt: *Von Mexiko-Stadt nach Veracruz*, 2005, S. 15; vgl. ferner Engelmann, Gerhard: „Alexander von Humboldts Mexiko-Atlas. Eine Nachlese", *Geographische Zeitschrift* 59 (1971) 4, S. 315–320, hier S. 317–318.

35 Siehe Humboldt, Alexander von: Tagebuch der Amerikanischen Reise IV: *Journal de la navigation sur l'Apure, l'Orenoque, le Cassiquiare et le Rio Négro*, 1800 [Ergänzungen bis 1859], S. 100r; siehe ferner Humboldt: *Reise durch Venezuela*, 2000, S. 100r.

36 Siehe Humboldt, Alexander von: Tagebuch der Amerikanischen Reise VIIbb/c, ungezähltes Komplement.

37 Siehe Humboldt, Alexander von: Tagebuch der Amerikanischen Reise VIIa/b, S. 219r–220v.

38 Diese Vorarbeiten sind in einer Mappe verwahrt, die Humboldt mit der Aufschrift „Analyse de ma Carte du Choco" versah. Vgl. BJK, HA, Nachlass, Nachlass Alexander von Humboldt 8, 2. Teil, nicht foliiert.

9__Alexander von Humboldt, *Carte hydrographique de la Province du Chocó*, 1831, ca. 86 × 120 cm, in: *Atlas géographique et physique du Nouveau Continent*, Tafel 25 (Lieferung 6), Berlin, SBB, Foto SBB

greifen musste. Es stammte unter anderem von den Kolumbianern José Manuel de Restrepo (1781–1863) und Joaquín Acosta (1800–1852). Welche Aspekte der Kartendarstellung auf welche Quelle zurückzuführen sei, schlüsselte Humboldt im Kartenkommentar kleinteilig auf:

> Diese Skizze einer hydrographischen Karte der Landkreise Zitara und Novita, die im April 1827 von Herrn Brué gezeichnet wurde, basiert auf dem Plan des Rio Atrato, der 1780 von Don Juan Donoso, dem Hauptmann der Genietruppe im Dienste Spaniens, aufgestellt wurde, und auf Materialien, die ich dem Wohlwollen des Herrn Jose Manuel Restrepo, dem Innenminister in Bogota, verdanke. Bisher fehlt es an astronomischen Positionen der Verläufe des Atrapo, des Rio San Juan und des Dagua. Ich habe die Breiten- und Längengrade der Karte Nr. 22 beibehalten. Die Verortung von Cupica und der Bucht San Francisco Solano richtet sich nach einer Karte des Kapitäns der M. Illingrot. Bezüglich des Rio Atrato, des mit Booten nicht zu befahrenden Abschnitts des San Pablo und der Wasserstraßen von Cauca nach Choco behalf ich mir mit Ratschlägen von Herrn Joaquin Acosta, einem jungen kolumbianischen Offizier, der vor Ort lebte.[39]

Im wissenschaftlichen Nachlass findet sich unter den Materialen zur *Carte hydrographique de la Province du Chocó* ein großformatiger Bogen, auf dem Humboldt die konzeptionelle Anlage der späteren Karte vorbereitet hatte (Abb. 10). Die Skizze ist im Hochformat angelegt und, in einer Randnotiz, auf 1819 datiert. Mit Bleistift ist ein feines Koordinatensystem mit den Breiten und Längen des kolumbianischen Andengebietes angelegt, in das einzelne Flüsse eingetragen und mit Namen versehen sind, wobei einige mit Bleistift skizziert auf eine vorläufige Positionierung im Kartenspiegel hinweisen, während andere bereits mit der Feder nachgezogen sind. In der Zeichnung näherte Humboldt sich auf diese Weise visuell vortastend der relationalen Verortung der regionalen Flussverläufe.

Zusätzlich zu den bereits verzeichneten Uferlinien der Flüsse und des Ozeans, die sich letztlich im Druck der Karte auf ähnliche Weise wiederfinden sollten, ist die Vorarbeit von schriftlichen und zeichnerischen Kommentaren durchzogen. Da die auf dem ersten Bogen visualisierten Ergebnisse durch entsprechende Hinweise vermutlich unübersichtlich geworden wären, klebte Humboldt drei weitere Zettel mit zusätzliche Notizen und Skizzen auf das Blatt. Mit ihnen hob er bestimmte Flüsse der Region noch einmal gesondert heraus, diskutierte sie, prüfte Koordinaten, verglich die unterschiedlichen Darstellungen

39 Humboldt, *Carte hydrographique de la Province du Chocó*, 1831. Im Original: „Cette esquisse d'une carte Hydrographique des Cantons de Zitara et de Novita, tracée en Avril 1827, par Mr. Brué, se fonde sur le Plan du Rio Atrato levé en 1780 par Dn. Juan Donoso, Capitaine du Corps du Gènie au service d'Espagne, et sur des matèriaux que je dois à la bienveillance de M. Jose Manuel Restrepo, Ministre de l'intèrieur à Bogota. On manque jusqu'ici entièrement de positions astronomiques dans les cours de l'Atrapo, du Rio Sn. Juan et du Dagua. J'ai conservé les latitudes et les longitudes, sans doute peu correctes, de la carte No. 22. Cupica et la Baie de Sn. Fr. Solano sont placés d'après un plan du Capitaine de vaisseau M. Illingrot. Je me suis aidé pour le Rio Atrato, le Portage de San Pablo, et les routes du Cauca au Choco, des conseils obligeans de M. Joaquin Acosta, jeune officier colombien qui a résidé dans ces lieux."

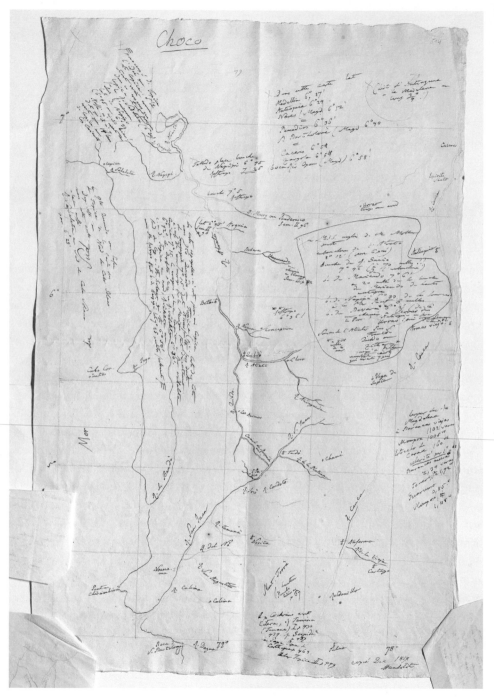

10__Alexander von Humboldt, Skizze zur *Carte hydrographique de la Province du Chocó*, zwischen 1825 und 1831, Krakau, JBK

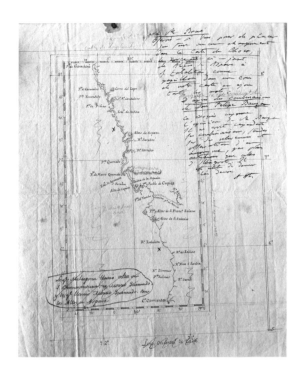

11__Felipe Bauzá: Karten-
skizze mit Anmerkungen
Alexander von Humboldts,
zwischen 1829 und 1831,
Krakau, JBK

einzelner Verläufe mit- oder ihre topographischen Relationen zueinander. Zusammenge-
nommen geben diese Vorarbeiten zu erkennen, dass die konkrete kartographische Aus-
gestaltung der *Carte hydrographique de la Province du Chocó* einer selektiven Auswahl
dortiger Flussverläufe Humboldts eigenes Produkt war – selbst wenn die zugrunde liegen-
den Informationen nicht auf seine eigenen Beobachtungen zurückgingen.

Doch Humboldt war nicht nur für die Auswahl der geographischen Elemente im Kar-
tenbild, sondern auch für das Komposit verantwortlich. Er gab sehr genaue Anweisungen,
welche Aspekte wo und auf welche Weise auf dem Blattspiegel zu platzieren seien. Zusam-
men mit geographischen Koordinaten, die Humboldt in Skizzen und rechnerischen Ope-
rationen zueinander in Beziehung gesetzt hatte, gab er diese Informationen an den Karto-
graphen weiter, im Fall der *Carte hydrographique de la Province du Chocó* an Adrien-Hubert
Brué (1786 – 1832). Dieser sollte die Vorlage in die kartographische Planprojektion über-
führen. Zu den genauen Angaben, die Humboldt machte, zählte zudem der Kartenkom-
mentar, den er vorformulierte und an einer bestimmten Stelle des Blattes platziert wissen
sollte.[40] Ferner bekam Brué im Laufe des Entwurfsprozesses den Auftrag, neu gewonnene

40 Der Kartenkommentar sollte zunächst links unten im Blattspiegel untergebracht werden, wurde letztlich
 jedoch rechts unten integriert. Auf wen diese Entscheidung zurückzuführen ist, erschließt sich aus dem
 Material des Nachlasses nicht. Vgl. BJK, HA, Nachlass Alexander von Humboldt 8, 2. Teil, nicht foliiert.

12__Alexander von Humboldt, Skizze zur *Carte du Rio Caura*, 1800?, Krakau, JBK

Kenntnisse im Nachhinein zu integrieren: Bei der *Carte hydrographique de la Province du Chocó* war Humboldt beispielsweise eine Karte zur kolumbianischen Küste von dem Spanier Felipe Bauzá y Cañas (1764–1834) zugespielt worden. Bauzá war Ende des 18. Jahrhunderts mit der Expedition Alessandro Malaspinas bis an die kolumbianische Küste gelangt und hatte die dortige Gegend in Teilen selbst kartiert.[41] Als Humboldt dieses Kartenmaterial in die Hände fiel, bat er Brué, es in den Blattspiegel einzufügen (Abb. 11).[42]

Allein diese Vorarbeiten lassen sich über acht Jahre verfolgen, bis die *Carte hydrographique de la Province du Chocó* 1827 schließlich von Brué gezeichnet wurde. Dieser gab sie darauf an den Kupferstecher Artus weiter. Auch bei diesem Produktionsschritt waren noch Änderungen und Nachbesserungen wahrscheinlich, denn erst 1831 erschien die Karte mit der sechsten Lieferung zum *Atlas géographique et physique du Nouveau Conti-*

41 Insbesondere sei hier auf Felipe Bauzás *Carta esferica que comprehende la costa occidental de America*, gestochen von Fernando Selma, 1800, verwiesen.

42 Der Brief Felipe Bauzás hat sich im Krakauer Nachlass erhalten und ist auf den Oktober 1825 datiert. Vgl. BJK, HA, Nachlass Alexander von Humboldt 8, 2. Teil, nicht foliiert.

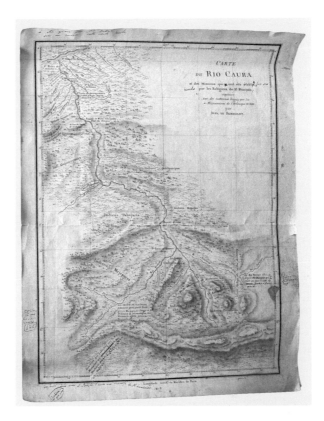

13__Jean-Baptiste Poirson, Vorzeichnung zur *Carte du Rio Caura*, annotiert von Alexander von Humboldt, 1816?, Krakau, JBK

nent. Sie wurde damit erst zwölf Jahre nach dem Zeitpunkt, zu dem sich die erste Skizze zu ihr nachweisen lässt, publiziert.

Anhand dieses großen Zeitfensters lässt sich der Aufwand, der hinter der Produktion jeder einzelnen Karte des Atlas stand, bereits vermuten. Er war nicht nur für Humboldt immens, wie ein Vergleich eines seiner Entwürfe für die *Carte du Rio Caura* (Tafel 20 des *Atlas géographique et physique du Nouveau Continent*)[43] (Abb. 12) mit der Vorzeichnung für den Stich, den Jean-Baptiste Poirson (1761–1831) (Abb. 13) anfertigte, zeigt. Während Humboldt mit dem Entwurf versuchte, den Flussverlauf in einer Kombination aus verschieden skalierten Koordinatensystemen zunächst annäherungsweise in seiner gesamten Formation zu erfassen, übertrug der französische Kartograph Poirson, mit dem Hum-

43 Im Text des Reisewerks gab Humboldt an, er habe in den Franziskaner-Missionen „viele geographische Materialien über den Caura" zusammentragen können. Er wies hierbei auf die Tafel 20 des Atlas hin, die aus diesen Daten hervorgegangen sei. Siehe Humboldt, Alexander von: *Reise in die Aequinoctial-Gegenden des Neuen Continents in den Jahren 1799, 1800, 1801, 1802, 1803 und 1804,* in deutscher Bearbeitung von Hermann Hauff, Bd. 4 [Octav], Stuttgart/Tübingen: Cotta 1823, S. 595.

boldt schon bei der Produktion seines *Atlas géographique et physique du royaume de la Nouvelle-Espagne* (im Folgenden: *Atlas de la Nouvelle-Espagne*) zusammengearbeitet hatte, die Ordinaten in eine einheitliche Planprojektion. Wie Humboldts Notizen zeigen, die er in diese Projektion eintrug, änderte er diese auf kartographischem Spezialwissen aufbauende Vorzeichnung, für deren Umsetzung ihm selbst die Kenntnisse fehlten, nur noch unwesentlich. Er korrigierte lediglich einzelne inhaltliche Aspekte, etwa nachträglich zu ergänzende Missionen, Ortsbezeichnungen oder den Kommentar zur Karte.

Dennoch eröffnet der Blick in den Produktionsprozess von Humboldts Karten, dass die beteiligten Kartographen vergleichsweise geringe Freiheiten besaßen, was die Gestaltung der Blätter betraf. Zwar kam dem Kartographen in der Zusammenarbeit mit Humboldt insofern eine eigenständige Leistung zu, als er die Materialien, die Humboldt ihm übergab, sichten, zusammenführen und in die kartographische Projektion übersetzen musste. Der Vergleich der Vorarbeiten mit der *Carte du Rio Caura* (Taf. III, Detail) zeigt aber, dass diesem Gestaltungsfreiraum enge Grenzen gesetzt waren: Humboldt führte sowohl die quellenkritische Analyse historischer Karten als auch die schöpferische Arbeit, neu hinzugekommene Forschungsergebnisse zu beurteilen, selbst aus.[44] Darüber hinaus beauftragte er offenbar auch jeden Teilaspekt der Kartengestaltung selbst. An seinen Notizen lässt sich nachvollziehen, dass er mit den jeweiligen Experten alle Teilschritte im Entstehungsprozess einer Karte diskutierte – die ersten Zeichnungen, die Messdaten, die Gravur der Topographie und der Schrift und schließlich die durchgeführten Korrekturen – und sich auf dieser Basis für die endgültige Ausführung entschied.

Keine klaren Vorgaben finden sich von Humboldt hingegen hinsichtlich der dekorativen Ausgestaltung der Tafeln, an der er insgesamt wenig Interesse gehabt zu haben scheint: Seine Anmerkungen und Korrekturen beziehen sich vor allem auf geographische Messpunkte, Beschriftungen und Kommentare oder aber auf das Komposit. Mit Blick auf Humboldts umfangreiches Mitwirken beim Produktionsprozess seiner Karten lässt sich daher erklären, warum deren kompositorische Ausgestaltung – beispielsweise die strenge Selektion des überhaupt Dargestellten, die Typographie und die Blattaufteilung – über den gesamten Tafelverbund des *Atlas géographique et physique du Nouveau Continent* hinweg verhältnismäßig homogen ausfällt, während sich insbesondere hinsichtlich der landschaftlichen Kartenzeichen deutliche Unterschiede ausmachen lassen.[45]

44 Zum Aufgabenbereich des Kartographen vgl. Engelmann: *Berghaus*, 1977, S. 107.

45 Ab der siebten Lieferung des Atlas, die 1834 publiziert wurde, zeichnet sich hinsichtlich der Präzision des gesamten Kartenbildes ein Bruch ab. Die Tafeln sind nun flüchtiger ausgeführt als die vorherigen; die Strichführung ist nicht mehr so genau wie vorher, die Schrift gröber und der Detailreichtum geringer. Humboldt selbst äußerte zu diesem Zeitpunkt Ermüdungserscheinungen hinsichtlich der Auswertungen seiner Amerikanischen Reise; seine Russlandreise lag hinter ihm, zudem hatte er bereits mit den konkreten Arbeiten am *Kosmos* begonnen. Vgl. Beck: „Humboldt – Kartograph der Neuen Welt", 2000, S. 58.

Der *Atlas géographique et physique du Nouveau Continent* als Teil des Reisewerks

Erste Pläne zum *Atlas géographique et physique du Nouveau Continent*

Dass der *Atlas géographique et physique du Nouveau Continent* editionsgeschichtlich einem einzelnen Text, dem *Examen critique de l'histoire de la géographie du Nouveau Continent et des progrès de l'astronomie nautique aux quinzième et seizième siècles* (im Folgenden: *Examen critique*) zugeordnet ist, irritiert bei seiner Rezeption insofern, als sich der Atlas produktionsgeschichtlich und inhaltlich auf das gesamte Reisewerk und hierin insbesondere auf die *Relation historique* bezieht. Eine sinnstiftende Lesart des Atlas kann sich daher im Grunde genommen erst einstellen, wenn das *Examen critique* nicht als begleitender Text zum Atlas, sondern als nachträglich hinzugefügter, ideengeschichtlicher Kommentar zu Humboldts Kartierung Amerikas und stattdessen insbesondere Passagen der *Relation historique* als Erläuterungen und Kommentare zu den Karten des Atlas verstanden werden. Erste Belege für diese inhaltliche Bezüglichkeit von Texten und Karten finden sich in der frühen Produktionsgeschichte des Atlas.

Erste Pläne für den *Atlas géographique et physique du Nouveau Continent* lassen sich bis in das beginnende erste Jahrzehnt des 19. Jahrhunderts zurückverfolgen und sind Teil von Überlegungen, mit denen Humboldt 1803, und damit noch während seines Aufenthalts in den Amerikas, Umfang und Aufbau seines Reisewerks skizzierte. In seinem Reisetagebuch listete er hierfür, in einem *Testament littéraire*[46] zusammengefasst, sechs Schriften auf, die er nach seiner Rückkehr nach Europa zu veröffentlichen gedachte. An erster und zweiter Stelle standen zwei Kartenbände,[47] ein „Atlas geologique botanique et physique [sic]" und ein „Recueil de Cartes des 2 Ameriques [sic]".[48]

Während der erste thematisch orientiert war und neben verschiedenen Profilkarten, darunter mineralogische Querschnitte, auch eine Karte mit Wassertemperaturen enthal-

46 Das hier beschriebene *Testament littéraire* von 1803 findet sich in Humboldts Tagebuch der Amerikanischen Reise VIII, 1802–1804, S. 167 (Rückseite). Humboldt fertigte auf seiner Reise eine Reihe verschiedener „literarischer Testamente" an. Das im Fließtext erwähnte ist von der Forschung bislang kaum berücksichtigt worden und deckt sich nicht mit jenem, das Hanno Beck eingehender analysiert. Vgl. Beck, Hanno: „Das literarische Testament Alexander von Humboldts 1799", *HiN* XIV (2013) 27, S. 87–94.

47 Der hier vorliegenden Einteilung in zwei Atlanten entspricht eine „Vorläufige Anzeige der Buchhändler Levrault und Schoel [sic], die Werke betreffend, welche Alex. von Humboldt über seine Reise nach Amerika in ihrem Verlage herausgeben wird", *Annalen der Physik* 20 (1805), S. 361–368, hier S. 366–367.

48 Humboldt sprach im *Testament littéraire* bei seinem Vorhaben nicht von „je", „ich", sondern in der ersten Person Plural: „nous", „wir". Hiermit ist offenbar Aimé Bonpland gemeint. Im *Testament littéraire* sind Überlegungen zu folgenden Schriften aufgelistet: (1) „Atlas geologique botanique et physique", (2) „Recueil de Cartes des 2 Ameriques", (3) „Icones plantarum aequinoctialium", (4) „Plantae aequinoctiales", (5) „Voyage aux Tropiques", ein Reisebericht von Humboldt und Bonpland, und ein (6) „Essay geologique sur la Construction du Globe". Humboldt: Tagebuch der Amerikanischen Reise VIII, 1802–1804, S. 167 (Rückseite).

ten sollte, war der zweite topographisch angelegt und beinhaltete eine Reihe von hydrologischen Tafeln aus der Aufsicht.[49] Humboldt führte die Konzeption des zweiten Kartenbandes nicht näher aus, ging aber auf den ersten genauer ein: Zu jeder Bildtafel sollte ein Text erscheinen. Auch das damals bereits entworfene und mit Erläuterungen versehene *Tableau physique des Andes* (Abb. 1) – das *Naturgemälde der Anden* – war ursprünglich als Teilbeitrag dieses Bandes gedacht: „Der Prospekt für die Geographie der Pflanzen wird für dieses Werk genutzt werden."[50] Als die Graphik kurz nach Humboldts Rückkehr nach Europa zusammen mit dem französischsprachigen *Essai sur la géographie des plantes* erschien, bildeten beide jedoch einen abgeschlossenen Band.[51] Das *Tableau physique des Andes* wurde auch später nicht mehr in den Kontext eines Atlas gesetzt; stattdessen betonte Humboldt wiederholt dessen singuläre Bedeutung für seine Forschung.[52]

Letztlich zerschlug sich auch die weitere Planung der Atlanten, wie Humboldt sie im *Testament littéraire* skizziert hatte: Zwar ließ er die meisten der dort angekündigten Graphiken später tatsächlich stechen und führte sie, anders als das *Tableau physique des Andes*, auch in Tafelverbünden zusammen, doch unterschied sich die Konzeption dieser Bände deutlich von den ersten Überlegungen. Statt der zwei anvisierten Atlanten zur Amerikanischen Reise entstanden letztlich drei; zudem änderte sich ihre inhaltliche Ausrichtung. Bestanden, wie gezeigt, zunächst Pläne für einen thematischen Atlas einerseits und einen topographischen Atlas andererseits, erhielt Humboldt diese klare Trennung später nicht mehr aufrecht. Schlussendlich orientierten sich alle drei Atlanten zur *Voyage* primär an thematischen Leitlinien: Bei dem *Atlas de la Nouvelle-Espagne* (1808–1811) handelte es sich um ein spezifisches landeskundliches Werk zu Mexiko, das Aufsichts-, Profil- und statistische Karten vereinte,[53] während die *Vues des Cordillères, et monumens*

49 Humboldt nannte diesbezüglich explizit seine Vorlagen für Karten des Rio Magdalena, des Rio Negro, der Provinz Quixos und Avila. Später sollten die entsprechenden Tafeln größtenteils dem *Atlas géographique et physique du Nouveau Continent* beigefügt werden. Vgl. ebd.

50 Ebd. Im Original: „Le Prospectus pour la Geographie des Plantes servira pour cette ouvrage." Humboldts Vorzeichnung befindet sich heute im Museo Nacional de Colombia. Es handelt sich um eine Tuschzeichnung auf Papier mit den Maßen 38,2 × 49,5 cm.

51 Bei dem *Essai sur la géographie des plantes* handelt es sich zwar um den ersten Part, der vom Reisewerk erschien, auf das gesamte Konzept bezogen jedoch um den fünften Teil der *Voyage*.

52 Siehe Fiedler/Leitner: *Alexander von Humboldts Schriften*, 2000, S. 234.

53 Vom Frühjahr 1808 bis Juni 1811 erschien der *Atlas de la Nouvelle-Espagne*. Er bildet zusammen mit dem *Essai politique sur le royaume de la Nouvelle-Espagne* den dritten Teil der *Voyage*. Das *Testament littéraire* macht deutlich, wie eng die Entstehung der Tafeln zu diesem Atlas mit denen des *Atlas géographique et physique du Nouveau Continent* zusammenhängt. Da beide Atlanten von Anfang an nicht etwa nach geographischen Regionen, sondern nach inhaltlichen Aspekten gegliedert waren, bekamen die jeweiligen Fragestellungen, die darin diskutiert wurden, gegenüber einer rein geographischen Ordnung ein deutlicheres Gewicht. Aus dieser aufeinander bezogenen Entstehungsgeschichte erklärt sich auch, dass der *Essai politique sur le royaume de la Nouvelle-Espagne* nicht nur für den *Atlas de la Nouvelle-Espagne*, sondern auch für den *Atlas géographique et physique du Nouveau Continent* umfangreiches

des peuples indigènes de l'Amérique (im Folgenden: *Vues des Cordillères*) (1810–1813) einen „pittoreske[n] Atlas"[54] boten, der archäologische Funde ebenso visualisierte wie Landschaftsansichten. Beide lagen bereits vollständig ediert vor, als Humboldt die erste Kartenlieferung des *Atlas géographique et physique du Nouveau Continent* 1814 herausgab. Dieser Atlas lieferte schließlich mit seinen Aufsichts- und Profilkarten, den vulkanologischen und historischen Karten Süd- und Mittelamerikas einen „generellen Reise-Atlas", der die Kernergebnisse der Amerikanischen Reise zusammenführte.

Der Stellenwert der wissenschaftlichen Visualisierung im Reisewerk

Unabhängig von dieser Neuausrichtung der Bände ist für die wissenschaftliche Graphik, d. h. der Visualisierung der Naturbeobachtungen, wie sie im *Testament littéraire* von 1803 vorgestellt wird, der hohe Stellenwert bemerkenswert, der ihr von Humboldt bezogen auf die Konzeptionierung des Reisewerks beigemessen wurde. Demnach ging ein wesentlicher Impuls der textuellen Ausführungen offenbar unmittelbar von Humboldts ins Bild gesetzten Forschungsergebnissen aus: Nicht nur in der Reihenfolge der sechs Bände zum geplanten Reisewerk standen die Atlanten an den ersten beiden Stellen, auch innerhalb ihrer knappen Beschreibungen sollten, sofern die Bände Graphiken enthielten, erst auf deren Grundlage „descriptions"[55], also textuelle Erklärungen, angefertigt werden. Noch Alexander von Humboldts Bruder Wilhelm hielt bei seiner Beschreibung von Alexanders Arbeit an dieser Reihenfolge der Produktion fest, wenn er an Goethe schrieb, die Ausführungen in der *Geographie der Pflanzen* seien „eigentlich Kommentar zu einer Karte der Tropenländer"[56], d. h. zum *Tableau physique des Andes*.

Freilich sagt diese Feststellung nur bedingt etwas über den generellen heuristischen Stellenwert von Bild und Text in Alexander von Humboldts Werk aus, zumal seinen wissenschaftlichen Visualisierungen im Allgemeinen ein diagrammatisches Prinzip zugrun-

Analysematerial liefert. In dem *Essai politique* erörterte Humboldt u. a. sein kartographisches Vorgehen sowie die von ihm auf der Reise genutzten Instrumente und Materialen. Vgl. zu einzelnen Karten aus dem *Atlas de la Nouvelle-Espagne* Beck: „Landschaften, Profile und Karten", 1982, S. 31–38; Schäffner: „Verwaltung der Kultur", 1999; ders.: „Topographie der Zeichen", 2000; Azara, Francesca: „Die Neu-Spanien-Karten von Alexander von Humboldt und Zebulon Montgomery Pike", *Cartographica Helvetica* 47 (2013), S. 3–10; Humboldt: *Atlas geográfico y físico del reino de la Nueva España*, 2003; Sherwood: *Cartography of Alexander von Humboldt*, 2008; Kraft: *Figuren des Wissens*, 2014. In der US-amerikanischen Forschung findet Humboldts *Atlas de la Nouvelle-Espagne* wiederholt Erwähnung. Vgl. u. a. *Humboldt in the Americas – Special Issue of Geographical Review* 96 (2006) 3.

54 Siehe Humboldt an Cotta am 09.09.1809, in: *Briefwechsel: Alexander von Humboldt und Cotta*, 2009, S. 103.

55 Humboldt: „Testament littéraire", Tagebuch der Amerikanischen Reise VIII, 1802–1804, S. 167 (Rückseite).

56 Wilhelm von Humboldt an Johann Wolfgang von Goethe aus Rom am 05.06.1805, in: *Briefe an Goethe*, Bd. 2: *Briefe der Jahre 1764–1808*, kommentiert von Karl Robert Mandelkow, Hamburg: Wegner 1965, S. 427–430, hier S. 430.

de liegt, das im Miteinander von Text und Bild operiert. Jedoch weist die beschriebene Reihenfolge, nach der der Text der Visualisierung nachfolgt, auf eine Erkenntnis generierende Bedeutung hin, die der bildlichen Erfassung in Humboldts Überlegungen grundsätzlich entsprang. Diese Beobachtung untermauert, dass Humboldts Atlanten keinesfalls willkürlich, sondern vielmehr auf eine bestimmte Erkenntnis zielend zusammengestellt wurden. Ihre Konvolute bildeten für Humboldt entscheidende Ausgangspunkte, von denen aus sich weitgespannte wissenschaftliche Diskussionen entfalteten.

Dass Humboldt hierbei nicht nur die einzelnen Aussagen der Karten im Blick hatte, sondern auch ihre gezielte Kombination, belegen nahezu zeitgleich mit den ersten Notizen zum Reisewerk entstandene Überlegungen. Während seines Mexikoaufenthalts entwickelte Humboldt einen entsprechenden Plan für einen geognostischen, d.h. erdkundlichen Atlas, in dem eine spezifische Erkenntnis aus der Zusammenschau heterogener Kartentypen erwuchs. Beim „Durchblättern eines solchen Atlas"[57] sollte sich ein heuristischer Zugewinn aus dem vergleichenden sowie dem sich ergänzenden Betrachten der verschiedenen kartographischen Projektionen ergeben. Zum einen könnte dadurch über Ähnlichkeiten, die sich zwischen den Karten auftäten, auf allgemeine Gesetze der Stratifikation, d.h. auf den Aufbau der oberen Erdschichten geschlossen werden. Zum anderen sollten den üblicherweise in der Fläche des Erdbodens aufgenommenen mineralogischen Karten Profilkarten an die Seite gestellt werden, d.h. Schnitte durch die Erdoberfläche.[58] Dank dieser Kombination von Horizontal- und Vertikalprojektionen würde sich, so Humboldt, die „Bauweise des Erdballs"[59], d.h. der geognostische und topographische Aufbau der Erde, leichter entschlüsseln lassen.

Wie das heute vorliegende Ergebnis zeigt, nahm Humboldt nach seiner Rückkehr von der Amerikanischen Reise Abstand sowohl von einer ausschließlich geognostischen Publikation als auch von der im *Testament littéraire* angestellten Überlegung, seine topographischen Karten von Flussverläufen in der Aufsicht in einem eigenen Band zusammenzuschließen. Stattdessen trieb Humboldt die Arbeit an einem Atlas voran, der die beiden angeführten Pläne verband: Zum Schluss enthielt der *Atlas géographique et physique du Nouveau Continent* topographische Ansichten unterschiedlicher Themenbereiche, überdies wurden in ihm Vertikal- und Horizontalprojektionen, d.h. Profilschnitte und Aufsichtskarten, gemeinsam und aufeinander bezogen präsentiert.

57 Humboldt: Manuskript zum *Essay de Pasigraphie*, 2v. Im Original: „Quelles analogies geognostiques [sic], quelles loix de Stratification ne devrait-on pas decouvrir en feuilletant un Atlas de cette Nature."

58 Vgl. ebd., 3r. Vgl. zu der Ergänzung der Horizontalkarten um Profilkarten auch Graczyk: *Tableau*, 2004, S. 323.

59 Im Original: „la Construction du Globe". Humboldt: Manuskript zum *Essay de Pasigraphie*, 1803/1804, 3r.

Der *Atlas géographique et physique du Nouveau Continent,* die *Relation historique* und das *Examen critique*

Auf dem eben beschriebenen Aufbau fußend, laufen im *Atlas géographique et physique du Nouveau Continent* wesentliche Forschungsergebnisse von Humboldts Amerikanischen Reise zusammen. Anders als die beiden anderen Atlanten zur *Voyage* bezieht sich der *Atlas géographique et physique du Nouveau Continent* dabei als „genereller Reise-Atlas" aber konsequenterweise nicht auf einen konkreten Textteil. Stattdessen korrelieren seine Tafeln mit ganz verschiedenen Abschnitten der *Voyage*, insbesondere mit solchen aus der *Relation historique*, die die allgemeinen Beschreibungen der Reise enthält.

Anfangs, in den ersten Lieferungen, edierte Humboldt diese und die Tafeln des *Atlas géographique et physique du Nouveau Continent* gleichzeitig und verwies auf dem Deckblatt der Lieferungen auf diesen Zusammenhang.[60] Der inhaltliche Bezug von Text und Karten bleibt jedoch vage, denn Karten und Text verweisen nur selten direkt aufeinander; ferner lassen sich auch in anderen Passagen Verweise auf die Karten finden bzw. in den Texten Bezüge zu Karten, die nicht gemeinsam mit ihnen ediert wurden. Dennoch wurde die inhaltliche Zusammengehörigkeit der *Relation historique* und des Atlas zur Zeit der Publikation als solche wahrgenommen, wie eine der wenigen Rezensionen zum Atlas, hier eine US-amerikanische von 1823, verdeutlicht:

> In addition to the Atlas Pittoresque and the Atlas of New Spain, each part of the Historical Narrative is accompanied with four or five maps, so that when this division of the work is completed there will be a third atlas in three folio volumes. This being sold separately will be equally useful to the possessors of the quarto and of the octavo edition of the work.[61]

Der *Relation historique* gegenüber lässt sich eine Beziehung von dem *Atlas géographique et physique du Nouveau Continent* und dem ihm editorisch zugeordneten *Examen critique* produktionsgeschichtlich hingegen erst ausmachen, als die ersten 32 Karten des Atlas

60 So heißt es etwa auf dem Deckblatt der sechsten Lieferung: „Voyage de MM. Alexandre de Humboldt et Aime Bonpland. Atlas Geographique et Physique, pour Accompagner la Relation Historique. Sixieme livraison. Paris, J. Smith, Rue Montmorency, No. 16; Londres, Dulau et Compie, Soho-Square. 1831. Imprimerie de J. Smith". Die gemeinsame Herausgabe von Text und Tafeln gilt für die ersten sechs Lieferungen des *Atlas géographique et physique du Nouveau Continent*, die mit denen der *Relation historique* herausgegeben wurden. Insgesamt wurde das Reisewerk von Humboldt ab 1804 in sechs Partien und 29 Bänden ediert. Siehe Leitner: „Vielschichtigkeit und Komplexität im Reisewerk", 2005, S. 57. Innerhalb dieser Bände – auch der Atlanten – sticht der *Atlas géographique et physique du Nouveau Continent* mit einer sehr langen Entstehungs- und Publikationsdauer hervor, er weist die bei Weitem längste Publikationsdauer auf. Der äußerst lange Zeitraum der Auslieferung des *Atlas géographique et physique du Nouveau Continent* hatte vermutlich zur Folge, dass zu ihm im Gegensatz zu den anderen Atlanten Humboldts nur wenige Rezensionen auffindbar sind.

61 N. N.: „Humboldt's works", *The North American Review* 16 (1823) 38, S. 1–30, hier S. 25.

schon publiziert worden waren: Als Humboldt ab 1835[62] sieben Nachstiche von Karten aus der Zeit um 1500 auf den Markt brachte und mit ihnen den *Atlas géographique et physique du Nouveau Continent* im Nachhinein erweiterte, erschienen diese Lieferungen nun gemeinsam mit jenen der Textpassagen aus dem *Examen critique*. Die von 1834 bis 1838 herausgegebene Schrift bildet insgesamt den Schlusspunkt des ersten Teils des Reisewerks. Doch bezieht sich das *Examen critique* nicht mehr direkt auf Humboldts selbst vorgenommene Kartierung, wie sie die zunächst herausgegebenen 32 Karten des *Atlas géographique et physique du Nouveau Continent* darstellen, sondern vor allem auf kartographiehistorische Zusammenhänge. Dennoch rezipierte die spätere Forschung den Atlas und das *Examen critique* aufgrund der editorischen Zuordnung als inhaltliche Komplemente; die Relationen von Karten und den Textteilen der *Voyage* sind, wie sich hier zeigt, gleichwohl komplexer.[63]

Zwar gab Humboldt in der Vorrede des *Examen critique* tatsächlich an, er habe mit diesem einen Kommentar zum *Atlas géographique et physique du Nouveau Continent* abzufassen beabsichtigt.[64] Letztlich bot der Text jedoch keine Erläuterungen zum Atlas, sondern stellte geographiehistorisch unterfütterte ideengeschichtliche Überlegungen zur ‚Entdeckung' Amerikas ins Zentrum. Diese Ausführungen beziehen sich nur noch sehr vage auf den *Atlas géographique et physique du Nouveau Continent* in seiner zuerst geplanten Form; allein zwischen den Nachstichen, die dieser enthält, und dem *Examen critique* lässt sich ein direkter inhaltlicher Bezug ausmachen. Ein indirekter Bezug stellt sich hingegen sehr wohl dadurch her, dass Humboldt das *Examen critique* gleichsam als Reflexion seiner eigenen Kartenproduktion entwarf. Dem ursprünglich geplanten Kartenkorpus gegenüber bildeten die Nachstiche historischer Karten und das *Examen critique* eine ergänzende Rückschau auf die eigene Erkundung des amerikanischen Kontinents und dessen Kartierung. Insofern legen beide die Quellen Humboldts offen, mit denen er sich im Zuge der Vor- und Nachbereitung seiner Reise auseinandersetzte.[65]

62 Das Jahr 1835 als Beginn der Publikation der Nachstiche ist nicht durch archivalische Nachweise belegt, erschließt sich jedoch aus dem Umstand, dass 1835 die letzte der Karten, die auf zeitgenössischem geographischem Wissen beruhten, die Tafel 31 (Lieferung 9), erschien. Für die nachfolgenden sieben Lieferungen sind je einzelne, beigegebene Karten dokumentiert, jedoch ist bis auf die Lieferung 12, mit der die Tafel 37 erschien, nicht bekannt, welche Nummern die Tafeln trugen. Vgl. Fiedler/Leitner: *Alexander von Humboldts Schriften*, 2000, S. 162–163.

63 Vgl. ebd., S. 152. Zu einer durch die Forschung hergestellten Nähe von *Atlas géographique et physique du Nouveau Continent* und dem ihm editionsgeschichtlich zugeordneten *Examen critique* vgl. Beck: „Kommentar", in: Humboldt: *Mexiko-Werk*, 1991, S. 527–578, hier S. 527–528; Ette: „Nachwort: Zwischen Welten", 2009. Ette betont zwar, dass in *Atlas géographique et physique du Nouveau Continent* und im *Examen critique* die Fäden des gesamten Reisewerks zusammenlaufen, allerdings differenziert er nicht zwischen dem voneinander abweichenden Status von Atlas und Text in Bezug auf die *Relation historique* bzw. die *Voyage*.

64 Siehe Humboldt, Alexander von: *Examen critique de l'Histoire de la Géographie du Nouveau Continent*, Bd. 1, Paris: Gide 1836, S. XXI–XXII.

65 Vgl. Engelmann: „Alexander von Humboldts kartographische Leistung", 1970, S. 17.

Gegenüber dem *Examen critique* lassen sich weit mehr direkte Bezüge zwischen den Karten des *Atlas géographique et physique du Nouveau Continent* und verschiedenen Passagen in anderen Teilen des Reisewerks ausmachen. Insbesondere zwischen der *Relation historique* und den Tafeln ergeben sich zum Teil anspruchsvolle Text-Bild-Beziehungen; zahlreiche Bezüge der *Voyage* sind direkt auf den Kartenblättern vermerkt.[66] Eine besonders enge Verbindung lässt sich für die Tafel 23 des *Atlas géographique et physique du Nouveau Continent*, die *Carte d'ile de Cuba*, und die *Analyse raisonnée de la Carte d'ile de Cuba* ausmachen, mit der Humboldt einen eigenen Aufsatz zu der Karte vorlegte. Er ist dem zur *Relation historique* gehörenden *Essai politique sur l'ile de Cuba* vorangestellt. Karte und Text bilden somit, neben der Zugehörigkeit Ersterer zum Atlas, einen eigenen, klar umrissenen Abschnitt der *Voyage* und wurden als solcher auch unabhängig veröffentlicht.[67]

Über diese einzelnen Textpassagen hinaus existiert jedoch kein zusammenhängender, textuell verfasster Kommentar zum Atlas, der seine Tafeln oder aber deren Zusammenstellung zu einem Band erläutert.[68] Die einzige einer solchen Ausführung ähnliche Beschreibung bildet ein 37-seitiges Fragment mit dem Titel *Sur les matériaux qui ont servi pour la construction de l'Atlas géographique et physique*. Es beschloss 1817 die letzte Lieferung des ersten Teils der *Relation historique* und beinhaltete Anmerkungen zu den ersten neun bis dahin publizierten Tafeln des Atlas.[69] Wie aus *Sur les matériaux* selbst hervorgeht, waren die Erläuterungen ursprünglich als Ausgangsmaterial für einen umfang-

66 So verweisen etwa die Kommentare auf der Tafel 13, die *Exemple de bifurcations et de deltas d'affluens*, und jene der Tafel 14, die *Histoire de la Géographie de l'Orénoque*, des *Atlas géographique et physique du Nouveau Continent* dezidiert auf die entsprechenden Passagen im Reisewerk.

67 Weitere separat von der *Voyage* publizierte Aufsätze gehen in unterschiedlichem Umfang auf einzelne Karten des *Atlas géographique et physique du Nouveau Continent* ein. Diese Publikationen sind bisher noch nicht umfassend zusammengetragen worden. Ein Beispiel hierfür liefert Humboldt, Alexander von: „Ueber die Gestalt und das Klima des Hochlandes in der iberischen Halbinsel", *Hertha. Zeitschrift für Erd-, Völker- und Staatenkunde* 4 (1825), S. 5 – 23. Der Aufsatz bezieht sich auf das *Profil de la Peninsule Espagnole*, Tafel 3 des *Atlas géographique et physique du Nouveau Continent*. Dieser Text und die Lieferung 5 für den Atlas, die die Tafel enthielt, erschienen im selben Jahr.

68 Eine solche Feststellung wendet sich gegen Hanno Becks These, dass Alexander von Humboldts Atlanten mit derart beträchtlichen Textkonvoluten erschienen, dass diese nicht als eigene Werke aufgefasst werden könnten. Beck: „Landschaften, Profile und Karten aus Humboldts Atlanten", 1982, S. 31; ders: „Kommentar", in: Humboldt: *Mexiko-Werk*, 1991, S. 527 – 578, hier S. 527 – 528. Mit Blick auf Becks Proklamation einer engen Bindung des Atlas an den Text des *Examen critique* steht zu vermuten, dass diese feste Zuordnung ein Forschungsdesiderat zur Folge hatte, insofern als das inhaltliche Auseinanderdriften von *Atlas géographique et physique du Nouveau Continent* und *Examen critique* ein semantisches Hindernis darstellt. Im Gegensatz zum *Atlas géographique et physique du Nouveau Continent* ist es um die Forschungslage zu dem *Atlas de la Nouvelle-Espagne* deutlich besser bestellt. Der Grund hierfür mag darin zu suchen sein, dass der zu diesem Atlas veröffentlichte *Essai politique sur le royaume de la Nouvelle-Espagne* unmittelbar Bezug auf dessen Tafeln nimmt.

69 Diese neun Tafeln entsprechen jenen der ersten und der zweiten Kartenlieferung des Atlas.

reicheren Textband zum *Atlas géographique et physique du Nouveau Continent* gedacht, denn auf der ersten Seite sicherte Humboldt zu, seine Ausführungen durch einen neuen Kommentar zu ersetzen und darin die Beschreibungen der Karten mit einer *Analyse raisonnée* fortzuführen.[70] Dieses Versprechen löste Humboldt jedoch nicht ein. Ein als *Analyse raisonnée* betitelter Text erschöpfte sich später in dem bereits erwähnten Aufsatz über die *Carte d'ile de Cuba*. Es lässt sich dementsprechend festhalten, dass zum *Atlas géographique et physique du Nouveau Continent* kein Text vorliegt, der sich inhaltlich direkt auf seine Karten bezieht.

Humanitas. Literæ. Fruges. Das Frontispiz zum Atlas

Dass der *Atlas géographique et physique du Nouveau Continent* als inhaltlicher Nexus fungiert, in dem unterschiedliche Themenbereiche der *Voyage* – oder zumindest diejenigen ihres ersten Teils – zusammenlaufen, unterstreicht das zugehörige Frontispiz (Abb. 14).[71] Humboldt hatte es 1814 nach einer Zeichnung François Gérards (1770 – 1837) von Barthélemy Roger (1770 – 1841) stechen lassen. *Humanitas. Literæ. Fruges.* sollte ursprünglich der *Relation historique* vorangestellt werden, später eröffnete der Kupferstich jedoch lediglich den Atlas. Darin wird dessen Bedeutung für das gesamte Reisewerk deutlich, denn die allegorische Darstellung nimmt nicht nur vom Atlas, sondern auch aus anderen Bänden wesentliche Aspekte auf und übersetzt sie in ein gemeinsames Bild.[72]

Im Vordergrund der Graphik werden drei Figuren ansichtig. Ihre Attribute weisen sie als Verkörperung Amerikas, die im Gewand eines Azteken-Herrschers auftritt, und die antiken Gottheiten Athene/Minerva und Hermes/Merkur aus.[73] Hinter der nach vorne gebeugten Amerika steigt ein Berg auf, der seinem Umriss nach leicht als Chimborazo zu identifizieren ist. Humboldt selbst kommentierte den Stich 1817 mit den Worten, die Allegorie zeige Amerika, „angesichts der Schrecken der Eroberung spenden Minerva und Merkur Trost"[74].

70 Vgl. Humboldt: „Sur les matériaux", 1817, S. 2.

71 Zum ersten Teil der *Voyage* gehören editionsgeschichtlich (1) die *Relation historique*, (2) die *Vues des Cordillères*, (3) der *Atlas géographique et physique du Nouveau Continent* und das *Examen critique*. Vgl. Leitner: „Vielschichtigkeit und Komplexität im Reisewerk", 2005, v. a. S. 57.

72 Vgl. Kügelgen, Helga von: „Amerika als Allegorie. Das Frontispiz zum Reisewerk von Humboldt und Bonpland", in: *Alexander von Humboldt: Netzwerke des Wissens*, Bonn 1999, S. 132 – 133.

73 Vgl. zur Ausdeutung Meissner, Jochen: „Merkur und Minerva helfen Cuauhtémoc auf die Beine. Europäisierte Amerikaerfahrung im Medium der Antike bei Bartolomé de Las Casas und Alexander von Humboldt", in: *Aktualisierung von Antike und Epochenbewusstsein*, hg. von Gerhard Lohse, München und Leipzig: Saur 2003, S. 198 – 246.

74 Im Original: „Le Frontispice […] représente l'Amérique consolée par Minerve et Mercure des maux de la conquête." Der Kommentar erschien in einem *Supplément*, der den ersten Band der *Relation historique* 1817 abschloss. Humboldt: *Voyage*, Teil 1 *(Relation historique)*, Bd. 4, Paris: Smith 1817, S. 328 [Octav]. Übersetzung übernommen aus Ette: „Nachwort: Zwischen Welten", 2009, S. 232.

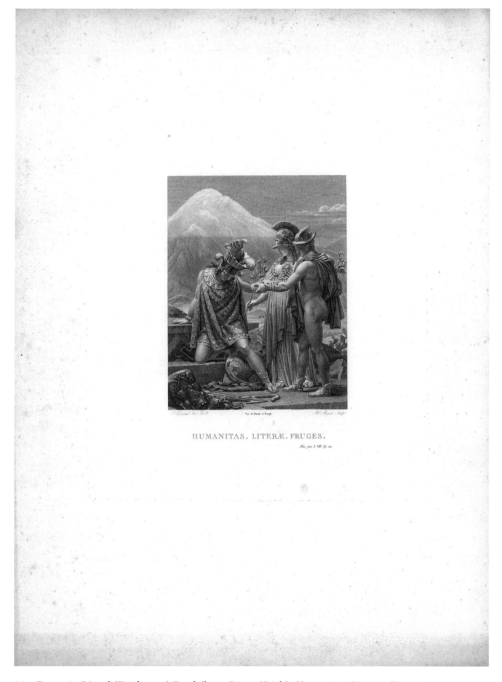

14__François Gérard (Zeichnung)/Barthélemy Roger (Stich), *Humanitas. Litterae. Fruges.*, 1814, ca. 43 × 60 cm, in: Humboldt, Alexander von: *Atlas géographique et physique du Nouveau Continent*, Frontispiz

Infolge der Conquista, die hier eine ambivalente bildliche Ausdeutung findet, treffen europäische und präkolumbische Kulturen am Fuße des Chimborazo zusammen. Trotz der furchtbaren Schrecken, die die Europäer mitbrachten, mündet die Begegnung letztlich, so suggeriert die harmonische Darstellung, in der Merkur der Amerika aufhilft, in einen wechselseitigen Profit: Amerika wird im Zeichen einer griechischen Leitkultur „Zivilisation", „Wissenschaft" und „Weizen" zuteil; zugleich führt die Begegnung der Europäer mit der Neuen Welt dazu, dass diese neue und wichtige wissenschaftliche Erkenntnisse erlangen. Sinnbildlich übersetzt wird diese Wissensanreicherung in der prominent inszenierten Linie, die den im Hintergrund aufragenden Chimborazo horizontal umläuft. Sie markiert die Grenze des ewigen Schnees, der sich die Amerika (noch) beugen muss, die Minerva als Göttin der Weisheit aber mit ihrem Helm überragt. Auf diese Weise wird der Berg in ein Symbol der empirisch fundierten, von der europäisch geprägten Wissensordnung ausgehenden Naturerkenntnis übersetzt, für die Humboldts Beobachtungen vor Ort eine wesentliche Grundlage bildeten. Als eine der entscheidenden Erkenntnisse seiner Reise wird hier das Naturphänomen der klimatischen Zoneneinteilung in Höhenstufen herausgehoben, das Humboldt erst mit seinen global vergleichenden Beobachtungen in Süd- und Mittelamerika hatte erkennen können.

So wie die in den Kupferstich aufgenommene Schneegrenze thematisch auf die erste Tafel des *Atlas géographique et physique du Nouveau Continent* (Taf. XIV) und deren Erläuterungen in der *Voyage* verweist, beziehen sich auch andere Details aus dem Frontispiz auf verschiedene Abschnitte des Reisewerks. So findet sich beispielsweise eine umfassende, in Text und Bild erfasste Beschreibung der Büste, die unten links seitlich gekippt zu Füßen der Amerika liegt, im ersten Abschnitt der *Vues des Cordillères*. Auch die Pyramide, von der sich die Amerika hochstützt, lässt sich als ein in vorspanischer Zeit entstandenes Bauwerk identifizieren, das im Abschnitt 49 des *Vues des Cordillères* erläutert wird. Zudem ist auf einer weiten landschaftlichen Ebene, die sich zwischen der Minerva und der Amerika auftut, eine Wachspalme erkennbar, wie sie in den *Plantes équinoxiales*, dem sechsten, botanischen Abschnitt des Reisewerks, beschrieben wird.[75]

Diverse Elemente auf dem Frontispiz verweisen so auf ganz unterschiedliche Themen und Bände des Reisewerks. Hierdurch formuliert sich im Komposit ein grundlegender Anspruch, der die umfassenden Reiseauswertungen im Bild komprimiert. Indem Humboldt das Frontispiz nun aber dem *Atlas géographique et physique du Nouveau Continent* voranstellte, weist die Darstellung auf eine zentrale Aussage voraus, die Humboldt diesem Atlas innerhalb der versammelten Bände beimaß.

75 Vgl. Humboldt, Alexander von und Bonpland, Aimé: *Botanique. Plantes équinoxiales* [*Voyage*, Teil 6], Bd. 1, Paris: Schoell/Tübingen: Cotta 1808, Tafel 1 a und b, S. 1–6.

Das konzeptionelle Gerüst. Themenbereiche, Aufbau und Publikationsweise des *Atlas géographique et physique du Nouveau Continent*

Aus einer Perspektive, die an heutigen geographischen Atlanten geschult ist, mögen die von 1 bis 39 durchnummerierten Karten des *Atlas géographique et physique du Nouveau Continent* (Taf. II – XII, Abb. 18 – 22) zunächst als freie Zusammenstellung von Motiven, Ansichten, Gebieten sowie historischem und zeitgenössischem Material erscheinen: Humboldt integrierte europäische, kanarische, mittel- und südamerikanische Bergketten, Flussläufe und Vulkane, die in der Aufsicht oder als Querschnitt durch die Erdoberfläche dargestellt sind, in seinen Atlas. Angestoßen von dieser Kombination sieht sich Hanno Beck noch im Jahr 2000 zu dem Urteil veranlasst, ein heutiger Geograph könne sich leicht eine „sinnvollere Anordnung"[1] für einen Atlas vorstellen.

Bei einem genaueren Blick auf Humboldts Atlas fallen jedoch durchaus bestimmte übergreifende Aspekte der motivischen Auswahl, der Darstellungsweise und der Zusammenstellung der Karten ins Auge. Dies gilt vor allem dann, wenn die Produktionsgeschichte des Bandes berücksichtigt wird, denn Humboldt hatte zunächst nur die ersten 30 Karten geplant und aufeinander bezogen konzipiert. Sowohl die Tafeln 31 und 32 als auch die Nachstiche historischer Karten auf den Tafeln 33 bis 39 ergänzten den Band erst im Nachhinein und fügen sich nicht mehr bruchlos in die ursprüngliche von Humboldt entwickelte Systematik ein. Die nachfolgenden Überlegungen konzentrieren sich daher zunächst auf die ersten 30 Karten des Atlas. Verstanden als zusammengehöriger Komplex lassen sich für diese vor allem drei Gesichtspunkte ausmachen, die sie verbinden und anhand derer übergreifende Analysekriterien entwickelt werden können: erstens eine enge motivische Auswahl – die Darstellung von Bergen und Flüssen –, zweitens bestimmte Kartentypen – entweder Profil- oder Aufsichtskarten – und drittens drei in der numerischen Reihenfolge der Karten aufeinanderfolgende thematische Gruppen, und zwar zunächst allgemeine Höhenphänomene, darauffolgend Flussdarstellungen und zuletzt vulkanologische Karten.[2]

1 Siehe Beck: „Humboldt – Kartograph der Neuen Welt", 2000, S. 50.

2 Wenngleich es gewisse Überschneidungstendenzen innerhalb der drei Kategorien gibt, etwa von Bergdarstellungen und Profilkarten, handelt es sich bei den Unterteilungen in Motiv, Kartentyp und Thema

Unter Einbeziehung der Publikationsweise des Atlas zeigt sich schließlich, dass nur mit Blick auf heutige Publikationsstandards die Annahme naheliegt, seine Aussage gehe primär aus seiner Gänze und hierbei aus der numerischen Reihenfolge der Tafeln hervor. Das zeitgenössische Publikum war hingegen mit anderen Konditionen konfrontiert: Wie viele andere Publikationen aus der Zeit wurde Humboldts Atlas zunächst in einzelnen Lieferungen herausgegeben. Im Falle des *Atlas géographique et physique du Nouveau Continent* lagen die Karten bei ihrer Auslieferung daher nur als kleine Auswahl und nicht in der späteren aufeinanderfolgenden Zählung der Blätter im Band vor.[3] Aus dieser Publikationsweise erschließt sich eine spielerische, zur sinnstiftenden Verknüpfung anregende Kombination heterogener Kartentypen und -themen.

Motive

Zentrale Motive: Berge und Flüsse

Die 30 Tafeln, die zur ursprünglichen Konzeption des *Atlas géographique et physique du Nouveau Continent* gehören, konzentrieren sich auf die Darstellung von Höhen- und Flussphänomenen. Nahezu alle von ihnen stammen aus Regionen, die Humboldt auf seiner Amerikanischen Reise besuchte, so auch von den Kanarischen Inseln und aus Mexiko. Der geographische Fokus der Naturphänomene, die in den Karten aufgegriffen werden, liegt jedoch auf Südamerika.

Dass Humboldt sich in seinem Atlas motivisch auf Berge bzw. Bergketten und Flüsse konzentrierte, erklärt sich aus ihrer basalen Bedeutung für die Struktur des Reliefs der Erdoberfläche. Dieses zu beschreiben war für Humboldt wiederum wesentliche Voraussetzung, um das Zusammenwirken der Kräfte in der Natur zu verstehen.[4] Auf den Karten des *Atlas géographique et physique du Nouveau Continent* akzentuierte Humboldt insbesondere die physiognomischen Umrisse beider Naturphänomene, die weiteren Elemente richten sich an diesen aus. Durch diese graphische Zurichtung werden Berge und Flüsse ihrem geographischen Umraum partiell enthoben und fungieren auf den Karten als zentrale Elemente einer spezifischen thematischen Argumentation.

um Aspekte, von denen aus nicht zugleich auf einen anderen der Aspekte geschlossen werden kann. Etwa werden Berge, je nach Karte, entweder in der Aufsicht oder im Profil gezeigt, und stellen thematisch entweder ein allgemeines Höhen- oder ein Vulkanphänomen dar.

3 Noch heute lässt sich eine solche zeitgenössische Rezeption des Atlas daran ablesen, dass nur wenige Exemplare des *Atlas géographique et physique du Nouveau Continent* vollständig vorliegen; vielfach fehlen ein oder mehrere Lieferungskonvolute.

4 Zu der motivischen Dominanz von Bergen und Flüssen und ihrer physiognomischen Ausgestaltung in Humboldts Kartographie vgl. Engelmann: „Alexander von Humboldts kartographische Leistung", 1970, S. 16.

Auf der zweiteiligen Tafel 21 des *Atlas géographique et physique du Nouveau Continent* mit der *Carte spéciale de la partie du Rio Apure comprise entre la ville de Sn. Fernando et l'Embouchure de la Rivière* (im Folgenden: *Carte spéciale du Rio Apure*) und dem *Cours du Rio Guaviare* (Abb. 15) fallen Humboldts eng gefasste motivische Auswahl und die auf sie abgestimmte Inszenierung des gesamten Komposits besonders deutlich aus.[5] Die hier ausgewählten Flüsse waren deshalb von Interesse für Humboldt, weil sie zum hydrologischen System des Orinoko gehörten. Beide Kartenteile, auf denen sie dargestellt sind, sind von einer eigenen Blattrandlinie eingefasst und weisen somit separate Blattspiegel auf. Sowohl auf der oberen „Spezialkarte" des Rio Apure als auch bei dem darunter positionierten Verlauf des Rio Guaviare treten die Konturen der aufgenommenen Wasserläufe auf einem wenig ausgestalteten, hellen Grund markant hervor. Zusätzlich betont werden die Flüsse durch einen jeweils sorgfältig ausgewählten geographischen Raumausschnitt und dessen graphisches Arrangement. Dadurch, dass sich das gezeigte Terrain in beiden Fällen unmittelbar am Flussverlauf orientiert, ergeben sich zwei langgestreckte, rahmenparallel übereinander angeordnete Querformate. Mit ihren Höhen-Längen-Verhältnissen übertreffen sie das des gesamten querformatigen Bogens noch einmal beachtlich. Zusätzlich verstärkt wird die Horizontale der Flüsse dadurch, dass sich die Ausrichtung der Karten nicht, wie angenommen werden könnte, an der Himmelsrichtung, sondern unmittelbar an den Flussverläufen orientiert: Die Kartenteile sind nur vage genordet und stattdessen so entworfen, dass die Flüsse das Blatt möglichst senkrecht durchziehen.

Hervorgehoben werden die Flüsse zusätzlich durch die Darstellungsweise beigeordneter Kartenelemente: Die seitlichen Blattrandlinien werden – insbesondere auf der unteren Teilkarte des Guaviare – optisch intensiviert, indem an der Quelle links auf dem Blatt und an der Mündung rechts auf dem Blatt topographische Phänomene in leicht vertikaler Anordnung auf das Blatt gesetzt sind, die die horizontal organisierten Flussläufe kontrastiv einfassen. Durch dieses Arrangement wird die Aufmerksamkeit verstärkt auf die mittig platzierten, wesentlichen Elemente der Karten, die Flussverläufe, gelenkt. Die Blickführung bei der Kartenbetrachtung verläuft auf diese Weise unmittelbar entlang der südamerikanischen Flussverläufe.

Beide Flussverläufe sowie die auf sie und auf die zentrale Kartenaussage unmittelbar bezogenen Kartenelemente – etwa Flussabzweigungen und ufernahe Orte – sind nach geographisch möglichst genauen Koordinaten verzeichnet. Dieser individuellen Ausgestaltung gegenüber lassen sich auf Humboldts Karten andere, beigeordnete Elemente unterscheiden, die häufig zum Überindividuellen, Symbolischen tendieren. Ihre Interpretation und graphische Ausgestaltung variiert von Karte zu Karte sehr viel deutlicher als diejenige der zentralen Motive. Diese Differenz findet ihre Begründung darin, dass Humboldt in den Vorzeichnungen zu seinen Karten die zentrale Thematik, d. h. die jeweiligen

5 Der *Cours du Rio Guaviare* geht auf eine Skizze Humboldts von 1814 zurück, die in der BJK, HA, Nachlass Alexander von Humboldt 8, 2. Teil verwahrt wird.

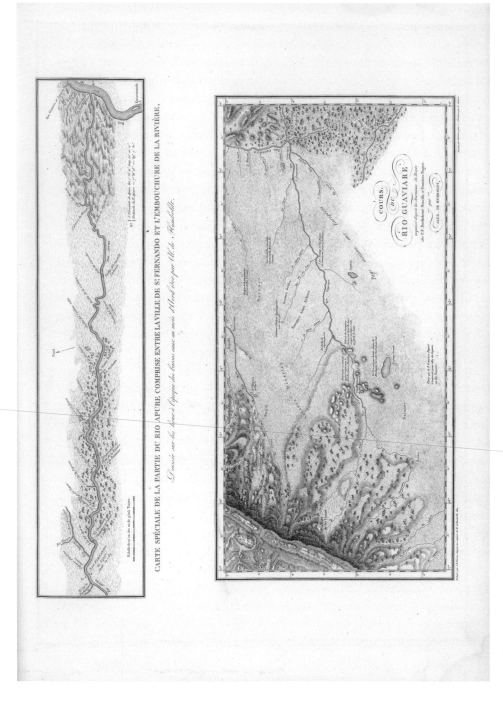

15_Alexander von Humboldt, *Carte spéciale du Rio Apure/Cours du Rio Guaviare*, 1819, ca. 43 × 60 cm, in: *Atlas géographique et physique du Nouveau Continent*, Tafel 21 (Lieferung 3), Berlin, SBB, Foto SBB

Höhen- oder Flussphänomene, klar vorgab, während er die Kartographen oder Stecher bei der weiteren Ausgestaltung offenbar recht frei gewähren ließ.[6]

Zu den beigeordnete Elementen zählen beispielsweise vegetabile Kartenzeichen. Wollte Humboldt bezüglich der botanischen Informationen – wie im *Tableau physique des Iles Canaries* (Taf. XIII) – Eindeutigkeit herstellen, griff er stattdessen auf die sprachliche Bezeichnung zurück und setzte sie in die Karte ein. Dagegen weisen sich die vegetabilen Kartenzeichen meist durch eine vereinheitlichende Visualisierung aus, die kaum spezifische Rückschlüsse auf das Dargestellte zulässt. Die Flora ist, wie auch auf der *Carte spéciale du Rio Apure*, in undifferenzierter, den zeitgenössischen Konventionen entsprechender Seitenansicht erfasst. Mit den allgemeinen Kennzeichen einer Pflanzengruppe versehen – beispielsweise durch büschelweise zusammengefügte Striche als grasartiges Gewächs identifizierbar –, sind diese Kartenzeichen auf der ihnen zugewiesenen Fläche des Blattes in regelmäßiger, unbestimmter Anordnung und Ausgestaltung verteilt. Diese zum Symbolischen tendierende Darstellungsweise lässt sich in Humboldts Karten auch für andere beigeordnete Elemente feststellen, wie etwa für Rauchwolken von Vulkanen oder für Schneekuppen. Statt eine spezifische Charakteristik des singulären Naturphänomens auszuweisen, wird hier eine allgemeine Typisierung markiert. So zeigen die vegetabilen Elemente das grundsätzliche Vorkommen vage bestimmbarer Pflanzenfamilien in einer Region an, die Rauchwolken generelle vulkanische Aktivität, die Schneekuppen allgemeine Gletschervorkommen.

Beigeordnete Kartenelemente

Humboldts symbolische Ausgestaltung verdeutlicht, dass die beigefügten Kartenzeichen eine andere Qualität des Dargestellten besitzen als die zentralen Motiven der Karten: Während Höhen- und Flussphänomene, die als individuelle Marker einer kartographisch aufgenommenen Region fungieren und die thematischen Einzelaussagen der Karten maßgeblich bestimmen, auf möglichst präzisen, konkreten Datenmengen fußen, handelt es sich bei den beigefügten Elementen um generelle, überindividuelle Zuweisungen. Die Funktionen des Dargestellten treten mithin auseinander: Tendenziell lässt sich das zentrale Motiv vom Fluss und vom Berg im Bereich der kartographischen Landaufnahme verorten, während die ihm beigefügten Elemente sich als eine allgemeinere, oft funktionale

6 Vgl. hierzu in der vorliegenden Untersuchung das Unterkapitel *Verknüpfendes Sehen II: Hypothesen zur Erdentstehung*. Gestützt wird diese Beobachtung durch Archivmaterial: In der Kartenabteilung der BNF haben sich mit der Feder gezogene Pausen zu drei Karten des *Atlas géographique et physique du Nouveau Continent* erhalten, die Humboldts Hand zugeschrieben werden (Signatur GE D-15681). Es steht zu vermuten, dass Humboldt die Pausen an den Asienwissenschaftler Heinrich Julius Klaproth (1783–1835) weitergab, von dessen Nachlass aus sie in die BNF gelangten. Sollten diese Pausen von Humboldt selbst stammen, so belegen sie, dass er die Karte im Akt des Kopierens gänzlich auf die von ihm offenbar als wesentlich erachteten Elemente, den Flussverlauf und die angrenzenden Ortsbezeichnungen, reduzierte.

Zuweisung des Gezeigten beschreiben lassen. Die überindividuelle Ausgestaltung übernimmt in diesem Zusammenhang aber nicht nur die Aufgabe, eine wissenschaftlich breiter angelegte Einordnung vorzunehmen, sondern auch, die Aufmerksamkeit auf bestimmte Aspekte der kartographischen Darstellung zu lenken und nicht zuletzt, das Kartenbild ästhetisch ansprechend zu gestalten.

Auch Humboldts Einsatz der Schraffe in den Aufsichtskarten lässt sich letztlich als beigeordnetes Kartenzeichen verstehen. Die Schraffe visualisiert zwar ein topographisches Gefälle, doch stellte Humboldt seine spezifischen Diskussionen von Höhenphänomenen in seinen Profilkarten an. Grundsätzlich lassen sich auch mit Schraffen Hangneigungen in der Aufsicht reliefartig und, zumindest in großmaßstäbigen Karten, präzise darstellen. Bereits deutlich vor 1800 wurden Schattenschraffuren in Federzeichnungen oder im Holzschnitt genutzt, um plastische Effekte zu erzielen. In Karten fanden sie sich früh als Formschraffen für Aufrissdarstellungen von Bergen, sie betonten Küsten- und Uferlinien oder, als Talschraffen, Täler. Im Zuge der kartographiegeschichtlichen Entwicklungen um 1800 wurde die Dichte der nebeneinander gesetzten Schraffen sukzessive auf unterschiedlich große Böschungswinkel, d. h. auf Hangneigungen, bezogen. 1799 systematisierte der Geodät Johann Georg Lehmann (1765–1811) die Schraffendarstellung schließlich in seiner *Darstellung einer neuen Theorie der Bezeichnung der schiefen Flächen im Grundriß, oder der Situationszeichnung der Berge*.[7]

Humboldt kannte diese Normierung der Schraffe, orientierte sich daran aber nur bedingt. Zwar erprobte er eine wissenschaftlich präzise Schraffendarstellung punktuell, etwa in seinem *Plan du Volcan de Jorullo*, der Tafel 29 des *Atlas géographique et physique du Nouveau Continent* (Abb. 16), doch lässt sich Humboldts Gebrauch der Schraffe in der überwiegenden Zahl seiner Karten eher mit denjenigen Traditionen zusammenbringen, die vor ihre kartographische Standardisierung fallen. So heben sich auch in der Karte des *Cours du Rio Guaviare*, der unteren Teilkarte der Tafel 21, am rechten Rand des Bergmassivs deutlich Schraffen ab. Zunächst führen sie hier eine generelle, flächige Ausbreitung der Berge in der gezeigten Region vor Augen. Doch lassen sich die regelmäßigen Bergschraffen nicht auf ein besonders steiles Gefälle, sondern, indem sie wie Schatten anmuten, auf einen inszenierten Lichteinfall zurückführen. Wie in der Druckgraphik des 18. Jahrhunderts üblich, übernimmt dieser auf Humboldts Karte die deiktische Funktion, den Blick in Leserichtung gezielt von links nach rechts über das zentrale Motiv der Karte, hier den Flussverlauf des Rio Guaviare, zu leiten.[8] Durch diesen Gebrauch der Schraffe

7 Vgl. zur Entwicklung der Schraffendarstellung ferner Hake/Grünreich/Meng: *Kartographie*, 2002, S. 537–539; Pápay: „Kartographie und Abbildung", 2014, S. 191; Stams, Werner: Art. „Schraffen", in: *Lexikon der Kartographie und Geomatik*, online abrufbar unter: https://www.spektrum.de/lexikon/kartographie-geomatik/ (zuletzt aufgerufen am 31.10.19).

8 Vgl. zum Lichteinfall der Druckgraphik in der Aufklärung Wild, Adolf: *Von Gutenberg zu Diderot: die Handwerke des Buches im Kupferstich der Aufklärung*, Mainz: Edition Erasmus 2000, S. 41.

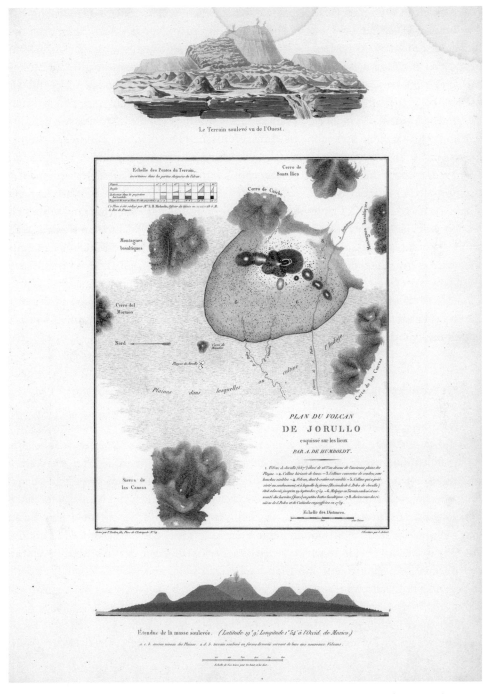

16__Alexander von Humboldt, *Plan du Volcan de Jorullo*, 1817, ca. 43 × 60 cm, in: *Atlas géographique et physique du Nouveau Continent*, Tafel 29 (Lieferung 2), Berlin, SBB, Foto SBB

erweist sich ihre graphische Referenzialität statt als möglichst präzise Darstellung der dreidimensionalen Topographie als eine visuell argumentierende Bildhaftigkeit, die das Relief der Erdoberfläche nicht auf der Basis eines geographischen Referenzobjekts modelliert. Die von Humboldt in seinen Aufsichtskarten genutzten, unterschiedlichen Strichdichten markieren insofern zwar Hangneigungen, geben aber keine genaue Auskunft über die Höhenbeschaffenheit. Anders also als die sich seinerzeit nach und nach durchsetzende, an der konkreten Hangneigung orientierte Böschungsschraffe inszeniert die Schraffe in Humboldts Gebrauch primär eine kartographische Plastizität und zählt damit zu den beigeordneten, thematisch nicht zentralen Kartenelementen.

An den überindividuellen Elementen, die sich in Humboldts Karten von den thematisch zentralen Motiven qualitativ unterscheiden und zu denen auch die Schraffen zählen, zeigt sich, dass die Ausgestaltung der Karten nur teilweise auf möglichst präzisen Messwerten aufbaute. Wie auf kartographischen Oberflächen im Allgemeinen werden auch von Humboldt diverse Informationen unterschiedlicher Qualität im Kartenbild zusammengeführt und in eine einheitliche Kodierung übersetzt. Gegenüber anderen topographischen Karten zeichnet Humboldts Karten jedoch aus, dass nur einzelne topographische Elemente geographisch möglichst exakt kartiert ins Kartenbild fanden und durch ihnen beigefügte Kartenzeichen, die ebenfalls topographischer Art sein konnten, optisch gezielt in Szene gesetzt wurden.

Kartentypen

Die Aufsichtskarte

Alle Tafeln des *Atlas géographique et physique du Nouveau Continent* lassen sich in zwei Kartentypen unterteilen: in Profil- oder in Aufsichtskarte. Während die Aufsichtskarten maßstäblich generalisierte Draufsichten auf ein Gelände und somit die Lage und Verteilung von Naturobjekten auf der Fläche in Merkatorprojektion zeigen,[9] handelt es sich bei den Profilkarten um topographische Darstellungen der Vertikale, in denen das Relief eines Berges oder einer bestimmten Region der Erde ansichtig wird. Primäres Kriterium zur Unterscheidung beider Kartentypen ist insofern nicht eigentlich das Motiv, sondern der Blickpunkt, von dem aus die Topographie aufgenommen wurde; Humboldts Aufsichts- und Profilkarten inszenieren somit zwei verschiedene (virtuelle) Blickwinkel auf die Erdoberfläche.

Den zwei Kartentypen ordnete Humboldt je eigene Darstellungsweisen und Kompositionsregeln zu. Zwar zeigen sich sowohl Profil- als auch Aufsichtskarten in den Tradi-

9 Vgl. Beck, Hanno: „Einleitung", in: Alexander von Humboldt: *Atlas géographique et physique du Royaume de la Nouvelle-Espagne* – vom Verfasser auch kurz benannt: Mexico-Atlas, hg. und kommentiert von dems. und Wilhelm Bonacker, Stuttgart: Brockhaus, 1969, S. 11–34, hier S. 17.

tionen der wissenschaftlichen Druckgraphik des 18. Jahrhunderts verankert, jedoch beziehen sie sich jeweils auf unterschiedliche Aspekte der Darstellungstradition oder gewichten jene verschieden stark. Zugleich, und maßgeblich, knüpfen die Aufsichtskarten des *Atlas géographique et physique du Nouveau Continent* an die damaligen Darstellungskonventionen topographischer Landkarten an. Auf dieser gestalterischen Grundlage basierend, entwickelte Humboldt letztlich zwei eigene Kartentypen.

Auf den einzelnen Tafeln wies Humboldt den Kartentypus der Vertikalprojektion als „Profil", „Esquisse" oder als „Tableau", die Aufsichtskarten hingegen meist als „Carte" oder „Plan" aus. Beide Darstellungsweisen subsumierte Humboldt dennoch, als „cartes physiques" („physische Karten", d. h. Karten, die das Höhenprofil der Erde visualisieren) oder „cartes géographique" („geographische Karten", d. h. Karten, die die Erdoberfläche aus der Aufsicht zeigen), dem Darstellungstypus der Karte. Beide Projektionsmethoden werden mit dieser zusammenführenden Kategorisierung der geographischen Erkenntnisgewinnung zugeschlagen.[10]

Darauf, dass Humboldt in seinem *Atlas géographique et physique des régions équinoxiales du Nouveau Continent* Profil- und Aufsichtskarten systematisch zusammenführte, wies er mit dem Langtitel hin. Die Differenzierung von „physischen" und „geographischen" Ansichten findet sich ebenfalls in dem Langtitel des neuspanischen Atlas, dem *Atlas géographique et physique du royaume de la Nouvelle-Espagne*, und entspricht keiner damaligen Konvention, sondern geht auf Humboldts eigene Einteilung zurück.[11] Bei den „geographischen Karten" handelte es sich um „Horizontal-Projectionen, die man schlechthin geographische Karten zu nennen pflegt"[12], d. h. um Darstellungen, die an den damaligen Konventionen der Landkarte orientiert waren. Von ihnen befand Humboldt jedoch, durch sie lerne man „die Ungleichheiten des Bodens und die Physiognomie eines Landes nur sehr unvollkommen kennen"[13]. Denn herkömmliche Projektionsverfahren würden weder Einsicht in die absolute Höhe der Landmassen über dem Meer noch in deren bisweilen gravierend ausfallenden Höhenunterschiede liefern. In Europa sei diese Problematik wegen der relativ ebenmäßigen und niedrigen Kontinentalmasse nie in den Fokus der Forschung gerückt, für eine Kartographie des Neuen Kontinents trete dieses Defizit aber

10 So etwa in Humboldt, Alexander von: *Tableau de cartes géographiques et physiques*, 1834[?]. Diese Übersicht stellt ein provisorisches Inhaltsverzeichnis des *Atlas géographique et physique du Nouveau Continent* dar und erschien vermutlich 1834 zusammen mit der siebten Lieferung.

11 Humboldt grenzte „geographische" und „physische" Karten wiederum gegenüber „pittoresken" Ansichten ab. Siehe Humboldt: *Examen critique*, Bd. 1, 1836, S. XXI.

12 Humboldt, Alexander von: *Versuch über den politischen Zustand des Königreichs Neu-Spanien*, Bd. 1, Tübingen: Cotta 1809, S. CXXXI. In der französischen Version heißt es: „Les projections horizontales que l'on désigne communément par le nom de cartes géographiques, ne font connoître que très-imparfaitement les inégalités du sol et la physionomie du pays." Humboldt, Alexander von: *Essai politique sur le royaume de la Nouvelle-Espagne*, Bd. 1 [Octav], Paris: Schoell 1811, S. 147.

13 Ebd.

umso deutlicher hervor. Als Lösungsvorschlag entwickelte Humboldt die „physische Karte",[14] mit der er der „Unvollkommenheit unserer graphischen Methoden"[15] begegnen wollte. Ihre Darstellungsmethode hätte „noch kein Geograph versucht [...], vielleicht weil man immer am spätesten auf die einfachsten Ideen fällt. Ich habe ganze Provinzen, weite Strecken Landes, in einer Vertikal-Projection vorgestellt, wie man schon längst Aufrisse von Bergwerken oder Canälen gemacht hat."[16] So lassen sich vor Humboldt, etwa in der Geologie, durchaus Profilschnitte ausmachen, die einzelne Gipfel oder bestimmte Massive visualisieren, nicht aber solche, die wie die „physischen Karten" den Versuch unternehmen, von diskreten Daten ausgehend auf allgemeine Merkmale einer Bergkette oder eines Hochplateaus zu abstrahieren und sie auf diese Weise strukturell zu erfassen.[17] Zusätzlich zu diesen Höhenkarten integrierte Humboldt in seinen *Atlas géographique et physique du Nouveau Continent* jedoch auch drei an herkömmlichen Darstellungstraditionen orientierte Profilkarten. Sie weichen zwar in ihrer kompositorischen Ausgestaltung nicht von den „physischen Karten" ab, zeigen aber statt schematisierter Höhenprofile individuelle Bergphänomene.[18]

In den Aufsichtskarten ist die visualisierte Topographie in Übereinstimmung mit den damaligen Darstellungskonventionen topographischer Karten mit einer schlichten, ornamentlosen, meist in Doppel- oder Dreifachlinien ausgeführter Blattrandlinie eingefasst, die häufig mit der Skala des geographischen Koordinatensystems zusammenfällt. Auch Humboldts Auswahl der Kartenzeichen basiert in großen Teilen auf einer seinerzeit etablierten kartographischen Formensprache, etwa im Hinblick auf die Visualisierung von Vegetation oder Uferlinien. Dennoch unterscheiden sich die Aufsichtskarten des *Atlas géographique et physique du Nouveau Continent* – wie im Abschnitt zur thematischen Kartographie bereits ausgeführt –hinsichtlich der damaligen kartographischen Konventionen

14 Vgl. das Unterkapitel der vorliegenden Untersuchung *Das „Naturganze" im Kartenbild*.

15 Humboldt: *Versuch über den politischen Zustand des Königreichs Neu-Spanien*, Bd. 1, 1809, S. CXXXIII. In der französischen Version heißt es: „l'imperfection de nos méthodes graphiques". Humboldt: *Essai politique sur le royaume de la Nouvelle-Espagne*, Bd. 1 [Octav], 1811, S. 149.

16 Humboldt, Alexander von: *Versuch über den politischen Zustand des Königreichs Neu-Spanien*, Bd. 1, 1809, S. CXXXIII. In der französischen Version heißt es: „Pour faire complètement connaître des pays dont le sol a une configuration si extraordinaire, j'ai cru devoir recourir à des moyens que les géographes n'avaient point encore tentés. Les idées les plus simples sont généralement celles qui se présentent les dernières. J'ai figuré des pays entiers, de vastes étendues de terrain, dans des projections verticales comme depuis long-temps on a tracé le profil d'une mine ou celui d'un canal." Humboldt: *Essai politique sur le royaume de la Nouvelle-Espagne*, Bd. 1 [Octav], 1811, S. 150.

17 Siehe Beck: „Landschaften, Profile und Karten aus Alexander von Humboldts Atlanten", 1982, S. 31. Zu Humboldts Diskussion von Profilkarten vgl. auch Humboldt: „Von einigen physischen und geologischen Phänomenen", 1825.

18 Im *Atlas géographique et physique du Nouveau Continent* zählen zu diesen die Tafeln 2, 7 und 28, mit Einschränkungen auch die Tafeln 9 und 29.

signifikant: Statt großflächiger Gebietsaufnahmen, die einen Großteil des Blattspiegels ausfüllen, versammelte Humboldt Karten, auf denen monochrome Freiflächen dominieren. Bestimmte topographische Elemente wurden auf diese Weise herausgehoben und als Komponenten eines relational verbundenen Gefüges markiert.

In der Regel unterließ es Humboldt, seine Aufsichtskarten kolorieren zu lassen. Eine der wenigen Ausnahmen bildet diesbezüglich die *Carte générale de Colombia*, die Tafel 22 des *Atlas géographique et physique du Nouveau Continent* (Taf. I). Auf ihr werden die Flussverläufe der Hauptströme – des Orinoko, des Amazonas und des sie verbindenden Rio Negro – sowie die Uferlinien der Meere zusätzlich durch einen blauen Farbauftrag betont. Diese spärlich eingesetzte Farbigkeit kommt gezielt als Kontrastmarker zum Einsatz, um die bedeutungstragenden Elemente innerhalb der vergleichsweise kleinmaßstäbigen Übersichtskarte als solche zu kennzeichnen, denn auf ihr vermag es die von Humboldt in seiner kartographischen Praxis betriebene motivische Selektion nicht mehr allein, den Blick auf das für die Darstellung Wesentliche zu lenken:[19] Im optischen Gewirr von Strichen, die Flussverläufe darstellen, heben sich die Hauptströme nur ungenügend ab, sodass ein weiteres Moment der Differenzierung notwendig wird. Dies liegt nicht nur an der Vielzahl der Linien allein, sondern auch daran, dass die weiße Fläche, die Humboldt als ordnender Grund des Dargestellten diente, ihre semantische Neutralität eingebüßt hatte: Sie stellt auf der *Carte générale de Colombia* sowohl Wasser- als auch Landmasse dar – doch gerade diese Differenzierung ist für das in der Karte verhandelte Thema, die südamerikanischen Wasserwege, ihre Verzweigungen und ihre Zugänge zum Ozean, wesentlich. Die *Carte générale de Colombia* weist mit ihrer herausfallenden farbigen Ausgestaltung somit zugleich auf eine generelle Schwierigkeit hin, vor die Humboldt bei kleinmaßstäbigen Karten gestellt war: Auf ihnen war eine von der topographischen Einzelbeobachtung ausgehende, induktive und präzise Argumentation nur noch schwer möglich.[20]

Die Profilkarte

Doch nicht nur die Aufsichtskarten des *Atlas géographique et physique du Nouveau Continent*, sondern auch die darin enthaltenen Profilkarten basieren auf einer stark selektiven Darstellungspraxis. In den Profilen sind es Berggipfel und -täler, die sich in ein Koordinatensystem der Höhe eingefügt auf dem weißen Grund des Blattes abheben. Gegenüber der Aufsichtskarte weisen die Profilkarten keinen separaten Blattspiegel, d. h. keine Blattrandlinie auf. Statt in Druckbuchstaben, wie in den stärker an kartographischen Darstellungs-

19 Die Wertung des Kleinmaßstäbigen ist hier relativ zu den anderen Karten des Atlas getroffen, die alle nach größeren, jedoch meist nicht genau ausgewiesenen Maßstäben entworfen sind.

20 Hierin mag ein Grund zu finden sein, warum Humboldt kleinmaßstäbige Karten nur selten realisierte. Diese Überlegungen bedürften einer weiteren Klärung, die im Rahmen dieser Untersuchung nicht möglich ist.

traditionen orientierten Aufsichten, ist der Titel der Profile, wie in der wissenschaftlichen Druckgraphik damals üblich, mit sanft geschwungener Kurrentschrift unterhalb der Darstellung auf das Blatt gesetzt.

In das Koordinatensystem der Höhe ist eine deutlich ausgeführte, in gedeckten Farbtönen kolorierte Silhouette von Gipfeln eingesetzt, die zu einer zusammenhängenden Höhenlinie verbunden sind.[21] In einigen Tafeln sind die Gipfel mit geweißten Schneekuppen versehen. Meist ist das Höhenprofil beidseitig von Skalen eingefasst, wobei die Begrenzung des Profils am unteren Rand mit der Höhe Null der Meeresoberfläche zusammenfällt. Während das Profil nach oben hin mit der durchgezogenen Linie der Gipfelsilhouette klar abschließt, wird die Distinktion von Schnittdarstellung und Blattfläche am unteren Rand meist lediglich durch den Pigment- bzw. den Farbauftrag hergestellt. Insofern die gezogene Linie also „das einfachste und konzentrierteste Mittel [ist], Formen zu beschreiben, Greifbares darzustellen"[22], so markiert der bewusste Verzicht auf sie am unteren Rand der Profildarstellung eine Unabgeschlossenheit der Erdformation zum Erdmittelpunkt hin. Kompositorisch wird der Raum hier fortgesetzt, d. h. visuell ist er gerade *nicht* determiniert. Rezeptionsästhetisch betrachtet bedeutet dies zugleich, dass die Aufmerksamkeit des Blicks vom unteren Rand abgezogen und auf die definite Profillinie gelenkt wird.

Für Humboldts physische Karten ist zudem charakteristisch, dass darin eine gezielte räumliche Verzerrung des Dargestellten, die einer spezifischen Argumentation zuarbeitet, vorgenommen wird. Diese Verzerrung betrifft nicht nur die Komprimierung der Tiefe, d. h. eine solche, die geographische Ordinaten des Raumes auf der x-Achse zusammenzieht, sondern auch die Darstellung der Höhenverhältnisse zueinander. Letztlich kommen auch Flächenaufnahmen, wenngleich dieser Effekt zu minimieren versucht wird, nie ganz ohne Verzerrungen aus, weil sich die gekrümmte Erdoberfläche nicht ohne Verluste der räumlichen Relationen auf dem planen Papier in eine winkeltreue Projektion überführen lässt. Gegenüber dieser unbeabsichtigten Ungenauigkeit der Darstellung weisen Humboldts physische Karten jedoch eine von ihm willentlich herbeigeführte Maßstabsverzerrung auf. In seinem *Essai politique sur le royaume de la Nouvelle-Espagne* bemerkte Humboldt diesbezüglich:

> Wenn die Orte, deren absolute Höhe angegeben werden soll, selten auf einer Linie liegen, so besteht der Schnitt entweder aus mehreren Abteilungen, deren jede eine verschiedene Richtung hat, oder man denkt

21 Eine generelle Ausnahme der hier beschriebenen Darstellungsweise der Profilkarten bildet die Tafel 7, die *Esquisse géognostique des formations entre la Vallée de Mexico, Moran et Totonilco*, die einzige sogenannte Formationskarte im Atlas. In Humboldts frühen Überlegungen zum Atlas lässt sie sich nicht nachweisen und gliedert sich nicht in dessen Konzeption ein. Es steht mithin zu vermuten, dass sie dem Band von Humboldt erst nachträglich als Subsitut für eine andere Karte hinzugefügt wurde.

22 Frieß, Peter: *Kunst und Maschine: 500 Jahre Maschinenlinien in Bild und Skulptur*, Berlin/München: Deutscher Kunstverlag 1993, S. 25.

sich eine Fläche außerhalb des durchlaufenden Weges, auf welche Perpendikularlinien niedergelassen sind. In dem letzteren Fall weichen die Distanzen der physischen Karte sehr von den absoluten ab […].[23]

Zusätzlich zur Verzerrung der räumlichen Distanzen, die über die hier von Humboldt beschriebene Stauchung der Tiefe erreicht wird, wird auch, wie sich im *Profil de la Peninsule Espagnole*, der Tafel 3 des *Atlas géographique et physique du Nouveau Continent* (Abb. 17), eindrücklich zeigt, die räumliche Breite der Profils insgesamt zusammengezogen. Durch dieses Vorgehen erscheinen die Berge deutlich überhöht. Ein solches Verfahren hatte für Humboldt zunächst pragmatische Gründe, da in „Profilen ganzer Länder […] der Maßstab der Distanzen nicht dem Maßstab der Höhe gleich sein kann. Wenn man zwei gleiche Maßstäbe wählen wollte, so müssten die Zeichnungen eine ungeheure Länge erhalten"[24]. Doch war die Projektionsmethode auch programmatisch motiviert, denn bei einem einheitlichen Maßstab, so Humboldt, verschwänden „die auffälligsten Ungleichheiten des Bodens"[25]. Gerade diese lieferten Humboldt aber wertvolle Einsichten für das systemische Zusammenwirken in der Natur.

Aufsichts- und Profilkarten ergänzten sich im *Atlas géographique et physique du Nouveau Continent* gezielt. In einer seiner wenigen kartentheoretischen Reflexionen bemerkte Humboldt, dass sich mit einem Kartentypus oder einer Karte allein notwendigerweise immer nur eine bestimmte Anzahl von Aussagen treffen ließe:

> Wer über graphische Methoden nachgedacht und sie zu vervollkommnen gesucht hat, wird zugeben, daß keine Methode alle Vorteile vereinigen kann. Enthält eine Karte allzuviele Zeichen, so entsteht Verwirrung, und ihr Hauptzweck, mit einem Blick vielerlei Gegenstände anschaulich zu machen, geht verloren.[26]

23 Im Original: „Comme les endroits dont il importe de faire connoître la hauteur absolue, se trouvent rarement sur la même ligne, la coupe est composée de plusieurs plans qui diffèrent dans leur direction, ou bien elle n'offre qu'un seul plan qui est placé hors du chemin parcouru, et sur lequel sont abaissées des perpendiculaires. Dans le dernier cas les distances que présentent la carte physique, diffèrent des distances absolues […]." Humboldt: *Essai politique sur le royaume de la Nouvelle-Espagne*, Bd. 1, 1811 [Oktav], S. 150–151.

24 Im Original: „Dans les profils de pays entiers […] l'échelle des distances ne peut pas être égale à l'échelle des hauteurs. Si l'on vouloit tenter de donner la même grandeur à ces échelles, on seroit forcé ou de faire des dessins d'une longueur démesurée". Humboldt: *Essai politique sur le royaume de la Nouvelle Espagne*, Bd. 1, 1811 [Oktav], S. 151.

25 Im Original: „les inégalités du sol les plus remarquables deviendroient insensibles." Ebd.

26 Im Original: „Ceux qui ont réfléchi sur les méthodes graphiques, et qui ont essayé de les perfectionner, sentiront, comme moi, que ces méthodes ne peuvent jamais réunir tous les avantages. Aussi une carte que l'on charge de trop de signes, devient confuse, et perd son avantage principal, celui de faire saisir à la fois un grand nombre de rapports." Ebd., S. 155–156. Übersetzung übernommen von Hanno Beck, siehe Humboldt: *Mexico-Werk*, 1991, S. 77.

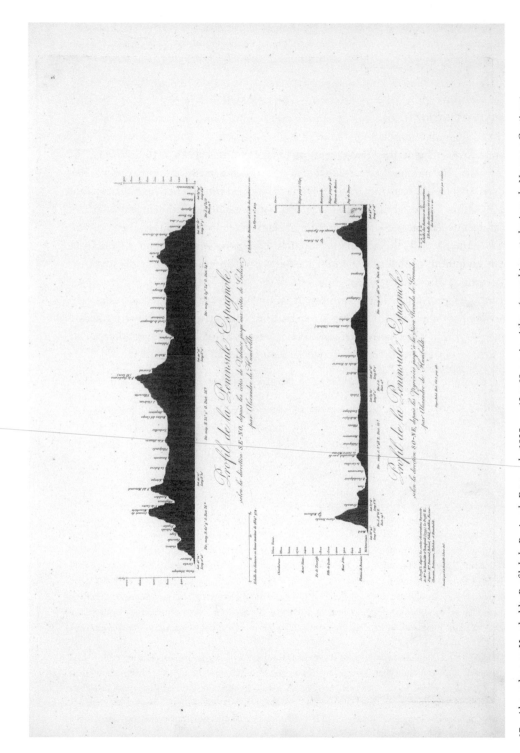

17_ Alexander von Humboldt, *Profil de la Peninsule Espagnole*, 1825, ca. 43 × 60 cm, in: *Atlas géographique et physique du Nouveau Continent*, Tafel 3 (Lieferung 5), Berlin, SBB, Foto SBB

Erst in der Kombination verschiedener Karten und Kartentypen, so lässt sich schließen, vermochte Humboldt die unterschiedlichen, heuristisch miteinander verwobenen Aspekte seiner Forschung zu präsentieren.

Themengruppen

Vier Themengruppen im *Atlas géographique et physique du Nouveau Continent*
Wird der *Atlas géographique et physique du Nouveau Continent* in der numerischen Reihenfolge seiner Karten, d. h. von Tafel 1 bis 30 und in der späteren Erweiterung bis Tafel 39 durchblättert, lassen sich anhand der inhaltlichen Fokussierung drei, später vier aufeinanderfolgende Themengruppen von unterschiedlichem Umfang ausmachen.[27] Diese bandinterne Unterteilung ließ Humboldt für sich selbst sprechen, denn der Atlas enthält weder ein endgültiges Inhaltsverzeichnis, das alle Tafeln umfasst, noch eingeschobene Deckblätter oder ähnliche Hinweise zu den Gruppierungen der Karten. Von vorne nach hinten durchgesehen, bilden die Tafeln 1 bis 9 die erste thematische Abteilung. Sie verhandelt Naturphänomene, die primär von der Höhe der Erdoberfläche über dem Meeresspiegel abhängen, und besteht vor allem aus den sogenannten physischen Karten, d. h. aus Profilkarten. In der zweiten, umfangreichsten Gruppe mit den Tafeln 10 bis 25 stehen Fluss- bzw. Wasserphänomene zentral, bei denen es sich um Aufsichtskarten handelt.[28] Mit den Tafeln 26 bis 30 werden diese beiden ersten Themenbereiche um eine dritte, dem Umfang nach schmale Gruppe ergänzt, die sich vulkanologischen Themen widmet und Aufsichts- und Profilkarten versammelt. Auf zwei im Nachhinein von Humboldt hinzugefügte Karten, die Tafeln 31 und 32, die sich der thematischen Gruppierung entziehen, folgt mit den Tafeln 33 bis 39 eine vierte und letzte, kartographiehistorische Gruppe, die sich aus sieben Nachstichen historischer Karten zusammensetzt.

27 Auch Hanno Beck stellt thematische Abteilungen im *Atlas géographique et physique du Nouveau Continent* fest, kann sie aber nicht mit einer sinnstiftenden Anordnung in Verbindung bringen. Vgl. Beck: „Humboldt – Kartograph der Neuen Welt", 2000, S. 50. Gerhard Engelmann beschreibt die Gruppierungen des Atlas als „Länderprofile", „Länderkarten" und „Pläne und Ansichten", wobei er sich auf Unterkapitel der *Voyage* bezieht. Siehe Engelmann: „Alexander von Humboldts kartographische Leistung", 1970, S. 5.

28 Die Tafeln 10 bis 14 fallen sowohl motivisch als auch kompositorisch tendenziell aus den anderen Karten dieser zweiten thematischen Gruppe heraus und könnten daher als gesonderter Abschnitt gewertet werden. Die genannten fünf Tafeln wurden erst ab 1825 konzipiert und gedruckt, zudem vereint sie, dass sie zu großen Teilen auf das geographische Wissen Dritter zurückgehen. Einige dieser fünf Karten verhandeln bereits überholtes geographisches Wissen, womit sie eine Brücke zu den Nachstichen von Karten aus der Zeit um 1500 schlagen.

Herausbildung der Themengruppen im Laufe des Publikationsprozesses

Diese Abfolge von Kartengruppen bildete sich erst im Laufe des Publikationsprozesses heraus. Als Humboldt im Januar 1808 in einer Sitzung der Pariser Akademie erste Proben zum *Atlas géographique et physique du Nouveau Continent* vorlegte,[29] unterschied sich die Gesamtkonzeption des Bandes noch deutlich von derjenigen, die er 1837, bei der letzten Lieferung seiner Karten, schließlich aufweisen sollte. Bei einem genaueren Blick auf den Produktionsprozess kristallisieren sich zwei Zeiträume heraus, in denen Humboldt den Aufbau seines Atlas grundlegend modifizierte: Gleich zu Beginn der Lieferungsphase in den Jahren zwischen 1814 und 1817 und nach Abschluss des ursprünglich für den Atlas angedachten Umfangs von 30 Karten in den beginnenden 1830er Jahren. Durch beide Neujustierungen verdichtete sich die Komplexität der wissenschaftlichen Diskussion im Atlas entscheidend.

Diese sukzessiv erfolgende Weiterentwicklung des Bandes lässt sich dank Humboldts Notizen rekonstruieren, die er über die lange Dauer der Publikation hinweg regelmäßig anfertigte, um den Stand seiner Arbeit am Kartenverbund zu dokumentieren. Diese Aufzeichnungen haben sich vor allem für die Zeit, als dessen Produktion bereits vorangeschritten war, erhalten. Die hierbei entstandenen, handschriftlich verfassten provisorischen Inhaltsverzeichnisse erfassen jeweils die gesamten Karten des Atlas,[30] wobei Humboldt zwischen demjenigen Material, das bereits gedruckt oder mit der jeweiligen Ausgabe erschienen war, und solchem, das noch publiziert werden musste, unterschied.

29 Vgl. hierzu insbesondere den wissenschaftlichen Nachlass, der sich in Krakau zum *Atlas géographique et physique du Nouveau Continent* erhalten hat, Signatur: BJK, HA, Nachlass Alexander von Humboldt 8, 1. und 2. Teil. Die Blätter, die Humboldt bei der Pariser Akademie vorlegte, präsentierte er zusammen mit seinen Entwürfen zu den *Vues des Cordillères*. Siehe Fiedler/Leitner: *Alexander von Humboldts Schriften*, 2000, S. 152.

30 Die Anmerkungen der handschriftlichen Inhaltsverzeichnisse zeigen, dass diese immer wieder überarbeitet wurden. Eines von ihnen lässt sich gemäß der bis dahin gedruckten Karten, die darin mit Doppelstrichen markiert sind, zwischen 1825 und 1827 datieren. Eine weitere Übersicht muss zwischen 1831 und 1833 entstanden sein, zwei Inhaltsverzeichnisse im Jahre 1834. Eines davon ist Teil des Manuskripts zum *Tableau de cartes géographiques et physiques*, das später gedruckt und der letzten Lieferung der ursprünglich geplanten Karten beigelegt wurde. Fiedler/Leitner gehen davon aus, dass diese zweite Übersicht erst 1835 erschien. Vgl. Fiedler/Leitner: *Alexander von Humboldts Schriften*, 2000, S. 152. Verschiedene Hinweise lassen jedoch darauf schließen, dass sie schon 1834 publiziert wurde. Etwa betonte Humboldt im kurzen Eingangstext des *Tableau de cartes* die lückenlose Auflistung aller Tafeln, jedoch fehlt auf ihr die Tafel 31, die nachweislich im Januar 1835 erschien. Ferner verwies Humboldt im handschriftlichen Manuskript dezidiert auf die zusammen mit dem *Tableau de cartes* erschienenen Tafeln, die nachgewiesenermaßen bis 1834 mit den Lieferungen 7 herausgegeben wurden. Vgl. BJK, HA, Nachlass Alexander von Humboldt 8, 2. Teil, nicht foliiert. Die andere Übersicht von 1834 (jedoch nicht das Manuskript zum *Tableau de cartes géographiques et physiques*) findet sich im Nachlass Alexander von Humboldt 8, 1. Teil.

Zudem wurden der ersten Auslieferung der Karten zu dem *Atlas géographique et physique du Nouveau Continent* von 1814 und der letzten Lieferung der ursprünglich geplanten zeitgenössischen Karten von 1834 gedruckte Übersichten beigelegt. Beide sind jedoch provisorischen Charakters. Die frühere dieser beiden gedruckten Übersichten, die 1814 mit der ersten Kartenlieferung erschienene *Table des matières*[31], enthält die einzige von Humboldt explizite Unterteilung der Tafeln in thematische Untergruppen. Sie dient dem *Atlas géographique et physique du Nouveau Continent* als prospektives Inhaltsverzeichnis. Auf ihr ist das gesamte Kartenmaterial noch in zwei statt in die späteren drei oder gar vier Gruppen eingeteilt, wobei die erste mit den Tafeln 1 bis 13 „Cartes physiques et géologiques", die zweite mit den Tafeln 14 bis 33 „Cartes géographiques" subsumiert.[32] Bereits diese Unterteilung richtete sich also offenbar nach inhaltlichen Aspekten und nicht nach Kartentypen, denn die erste Gruppe umfasste sowohl Karten, die aus der Aufsicht und solche, die im Profil aufgenommen werden sollten; die zweite sollte, soweit ersichtlich, weitgehend oder sogar ausschließlich Aufsichtskarten enthalten.[33]

31 Vgl. BJK, HA, Nachlass Alexander von Humboldt 8, 2. Teil. Das Inhaltsverzeichnis stimmt nur mit den numerischen Angaben der Tafeln aus der ersten Lieferung überein und kann daher kaum später als 1814 entstanden sein; vermutlich erschien es zusammen mit dieser. Vom *Table des matières* haben sich – ebenso wie vom *Tableau de cartes géographiques et physiques* – auch unabhängig vom Nachlass Humboldts Exemplare erhalten, da sie in der Funktion eines (gleichwohl inhaltlich abweichenden) Inhaltsverzeichnisses in den *Atlas géographique et physique du Nouveau Continent* eingebunden wurden.

32 Bereits 1814 verwarf Humboldt einige vorherige, im *Testament littéraire* von 1803 anvisierte Karten, ersetzte sie durch andere und richtete die thematische Gruppierung der Tafeln neu aus. 1814 hatte Humboldt die Anzahl der Karten auf 33 beziffert, das Konvolut verkleinerte sich später jedoch auf 30 Karten. Dieser Umfang zeitgenössischer Karten blieb in allen nachfolgenden Notizen Humboldts konstant. Von den anfangs entworfenen 33 Tafeln wurde letztlich nur gut die Hälfte gedruckt, die andere Hälfte ersetzte Humboldt mit anderen Inhalten. Vgl. Humboldt: *Table des matières*, BJK, HA, Nachlass Alexander von Humboldt 8, 2. Teil, nicht foliiert; Humboldt, Alexander von: „Testament littéraire", Tagebuch der Amerikanischen Reise VIII, 1802–1804, S. 167 (Rückseite).

33 Aus der Zuordnung der in der Aufsicht aufgenommenen „geographischen Karten" fällt retrospektiv betrachtet die Karte 28 heraus, die im *Table des matières* lediglich mit dem Titel *Volcan de Jorullo* angegeben ist: Sie bietet keine Aufsicht, sondern mit dem *Tableau Géologique du Volcan de Jorullo* eine Profilkarte des Vulkans. Diesen Kartentypus subsumierte Humboldt im prospektiven Inhaltsverzeichnis jedoch klar der ersten Gruppe von Karten. Zu vermuten steht daher, dass Humboldt im *Table des matières* zunächst an die Aufsicht des Vulkans dachte, wie sie der *Plan du Volcan de Jorullo*, die spätere Tafel 29 des *Atlas géographique et physique du Nouveau Continent*, zeigt. Diese inhaltliche Unstimmigkeit von tatsächlichem Lieferungsgehalt und dem vorläufigen Inhaltsverzeichnis deutet darauf hin, dass Humboldt sich im Zuge der ersten Lieferung des Atlas noch einmal eingehend mit der sinnstiftenden Kombination bestimmter Kartentypen und -themen beschäftigte und die Konzeption des Atlas im Zuge der direkten, materiell vorliegenden Zusammenschau der (Vor-)Drucke entwickelte. Sollte diese Überlegung stimmen, so setzte Humboldt die Konzeption des Atlas, bei der sich Aufsichts-, Profil- und Vulkankarten ergänzen, bereits 1814 mit der ersten Lieferung um. In diesem Falle würde sich die Neuausrichtung des Atlas lediglich nicht im *Table des matières* niedergeschlagen haben.

Von dieser frühen Übersicht von 1814 ausgehend zeigt sich, dass Humboldt den thematisch binär organisierten Atlas bereits mit der zweiten Lieferung von Karten 1817 neu strukturiert hatte und nun eine dritte thematische Gruppe, die der vulkanologischen Tafeln, hinzutrat. Hatte Humboldt diese in der *Table des matières* zunächst – als geognostische Karten – unter die erste Gruppe sortiert, bildeten sie von der zweiten Lieferung an eine eigene thematische Abteilung. Für den Aufbau des gesamten Tafelverbundes bedeutete diese Verschiebung, dass bei der numerischen Abfolge der Karten – und damit zugleich bei der Durchsicht des Atlas von vorne nach hinten – zunächst allgemeine Bergphänomene den Band eröffneten, gefolgt von hydrologisch orientierten Karten und, abschließend, von Vulkandarstellungen. Nach dieser ersten, grundsätzlich neuen Ausrichtung änderte sich die Konzeption des *Atlas géographique et physique du Nouveau Continent* bis 1834 nicht mehr.[34] In diesem Jahr legte Humboldt, nachdem weitere gedruckte Übersichten zum Band seit der *Table des matières* von 1814 ausgeblieben waren, mit dem *Tableau de cartes géographiques et physiques* retrospektiv ein dreiseitiges Inhaltsverzeichnis vor, das nun jedoch nicht mehr in thematische Untergruppen unterteilt war. Eine kurze, darin enthaltene Einleitung erklärte den Kartenkorpus für abgeschlossen.[35]

Dennoch ergänzte Humboldt den Atlas kurz darauf, noch im selben Jahr, um weitere Karten. Nach dem heutigen Forschungstand lässt sich davon ausgehen, dass 1834 und 1835 mit der achten und neunten Lieferung die Tafeln 31 und 32 erschienen, deren zugrunde liegende Informationen Humboldt erst nach seiner Amerikanischen Reise zugekommen war. Anders als die ersten 30 Tafeln gingen diese beiden Karten somit vermutlich nur in sehr geringem Maße auf Humboldts eigene Vorarbeiten zurück, zudem fügten sie sich nicht in die thematische Dreiteilung des Atlas ein.[36] Noch im selben Jahr nahm Humboldt eine weitere Ergänzung zum Band vor: die vierte Kartengruppe mit den sieben Nachstichen historischer Karten.

Diese zweite Rekonzeptionalisierung in den beginnenden 1830er Jahren kann ebenso wie diejenige 1814/1817 unmittelbar mit neuen wissenschaftlichen Erkenntnissen Hum-

34 Waren in der ersten Übersicht von 1814 noch großflächige Übersichtskarten wie eine *Carte physique de l'Océan Atlantique* und eine zweiteilige *Carte générale de l'Amérique* geplant, fiel bis 1827 die erste, bis 1834 auch die zweite ganz weg. Warum Humboldt keine derartige Karte integrierte, muss an dieser Stelle offen bleiben. Mutmaßlich fehlten ihm einerseits Messwerte, andererseits entsprachen diese kleinmaßstäbigen Karten letztlich weder der empirischen Beobachtungspraxis noch Humboldts primären topographischen Erkenntnisinteressen und fügten sich dementsprechend nicht in die Konzeption des Atlas ein.

35 Vgl. Humboldt, Alexander von: *Tableau de cartes géographiques et physiques.* Auch in der späteren Eigenzitation behielt Humboldt das Jahr 1834 bei, um den Abschluss seines Atlas zu datieren. Vgl. Humboldt: *Kosmos*, Bd. 4, 1858, S. 533, Fußnote 59.

36 Mit diesen Karten änderte sich die konzeptionelle Ausrichtung des Atlas nicht grundsätzlich, sie fügten sich jedoch auch nicht in den ursprünglich geplanten Aufbau ein. In den Übersichten des Krakauer Nachlasses sind bis 1834 zu keiner der beiden Karten Hinweise finden.

boldts in Verbindung gebracht werden. Zunächst betrifft dies die separate Gruppierung vulkanologischer Karten, die Humboldt ursprünglich zu den physischen und geognostischen Karten sortiert hatte. Dass Humboldt einen zusätzlichen thematischen Schwerpunkt setzte, geht mit einer sukzessiven Weiterentwicklung von seinen Überlegungen zur Erdentstehung zusammen: War er zu Beginn seiner Amerikanischen Reise noch davon ausgegangen, die Struktur der Erdoberfläche sei auf Sedimentablagerungen des Meeres zurückzuführen, kamen ihm mit Beobachtungen, die er in Amerika angestellt hatte, Zweifel am regelmäßigen Streichen und Fallen der Gesteinsschichten. Nach seiner Rückkehr ergänzte Humboldt daher nach und nach sowohl die Theorie des Loxodromismus[37], nach der die Entstehung der Gesteinsschichten einer gesetzmäßigen Ausrichtung unterworfen war, als auch jene des Neptunismus, nach dem die Erdkruste sich aus ozeanischen Sedimentablagerungen gebildet hatte, um vulkanologische Überlegungen.[38] Als deren Resultat lässt sich die gesonderte Abteilung der Karten von Vulkanen im Atlas verstehen.

Auch die neu hinzugekommene Gruppe der Nachstiche in den beginnenden 1830er Jahren kann direkt mit Humboldts damaliger wissenschaftlicher Beschäftigung in Verbindung gebracht werden. Das von ihm aufbereitete historische Material findet seine Vorlagen in frühen europäischen Karten der Neuen Welt, die zwischen 1500 und 1513, d. h. kurz nach Christoph Kolumbus' (um 1451–1506) dortiger Ankunft, angefertigt worden waren. Ausschlaggebend für Humboldts interpretierende Reproduktionen und deren Eingliederung in den *Atlas géographique et physique du Nouveau Continent* war insbesondere eine Seekarte aus dem Jahre 1500, die von Juan de la Cosa (1449/1460–1510), dem Kapitän des Kolumbus, stammte. Der französische Baron Charles Athanase Walckenaer, ein Bekannter Humboldts, hatte sie Anfang der 1830er Jahre angekauft und im Bekanntenkreis, darunter Humboldt, gezeigt. Mit den Nachstichen der Karte fügte dieser dem *Atlas géographique et physique du Nouveau Continent* ab 1835 eine im Visuellen geführte kartographiehistorische Reflexion hinzu. Zugleich knüpften sie implizit an eine Entwicklung an, die eine Neukonzipierung des Atlas nach 1814 erforderlich gemacht hatte: Die

37 Die geognostische Theorie des Loxodromismus besagt, dass die Gesteinsschichten einem gesetzmäßigen Streichen und Fallen unterworfen sind. Die Begriffe des Streichens und Fallens von Gesteinsschichten übernahm Abraham Gottlob Werner, Humboldts Lehrer aus Freiberg, in die Geologie. Unter Streichen verstand er den im geometrischen Modell gemessenen Winkel, den eine Gesteinsschicht zwischen einer Geraden auf einer geneigten Fläche und magnetisch Nord bildete, Fallen bezog sich auf die Richtung der stärksten Neigung einer Gesteinsschicht zur Horizontalebene. Siehe Wagenbreth, Otfried: *Geschichte der Geologie in Deutschland*, Stuttgart: Thieme 1999, S. 53; vgl. ferner Beck: „Das literarische Testament 1799", 2013, S. 88.

38 Im Zuge dieser Neuausrichtung seiner Überlegungen nahm Humboldt im Laufe der 1810er Jahre Abstand von einer noch 1811 mit dem Geologen Leopold von Buch (1774–1853) geplanten Übersicht über die geognostische Beschaffenheit der Erdoberfläche. Vor diesem Hintergrund lässt sich die Konzeption des *Atlas géographique et physique du Nouveau Continent* auch als Versuch verstehen, diese Überlegungen dennoch umzusetzen, nun jedoch von einem anderen wissenschaftlichen Standpunkt aus. Zu der geplanten Publikation von Buch vgl. Beck: „Das literarische Testament 1799", 2013, S. 90.

Überlegungen zu einer Geschichte der Erdkruste, wie sie in den vulkanologischen Karten sinnfällig wird, erweiterten die Nachstiche um eine kulturhistorische Dimension, nämlich um das Wissen des Menschen über die terrestrische Geographie.

Publikationsprozess

Die Zusammenstellung der Lieferungen: Kombinationen aus Aufsichts-, Profil- und Vulkankarte

Die Zusammenstellung der Karten zu einem Atlas und ihre Anordnung in thematischen Untergruppen lässt sich letztlich kaum als sinnstiftende Konstellation verstehen, wird nicht die Publikationsweise des *Atlas géographique et physique du Nouveau Continent* mit berücksichtigt. Sie lässt sich dem heute meist vorliegenden, gebundenen Format des Atlas nicht mehr entnehmen, sondern muss aus archivalischen Informationen rekonstruiert werden. Zeitgenössisch stand der Zugriff auf dieses Wissen jedoch unter ganz anderen, gewissermaßen entgegengesetzten Vorzeichen: Wie seinerzeit bei aufwändigeren Publikationen üblich, kamen die Tafeln als kleinere, nacheinander ausgelieferte Gruppen von je drei bis fünf, als lose Blätter edierten Stichen auf den Markt. Da sich die Herausgabe des *Atlas géographique et physique du Nouveau Continent* über 23 Jahren erstreckte,[39] lag dieser über einen langen Zeitraum gerade *nicht* im gebundenen Format, sondern in Form einzelner Blätter vor. In der zeitgenössischen Rezeption ließen sich die 39, einseitig bedruckten Karten zunächst also nicht als Verbund, sondern nur in den gelieferten Kleingruppen bzw. gemeinsam mit den bereits edierten Bogen betrachten. Damit unterschied sich bis zum Zeitpunkt der letzten Lieferung nicht nur der Umfang des Bandes vom heutigen Zugriff auf ihn, sondern auch die Art und Weise der Rezeption war eine andere: Im Auslieferungszeitraum konnten die Karten noch nebeneinander gelegt und simultan betrachtet werden. Erst nach der letzten Lieferung wurden sie, sofern von der Käuferin oder dem Käufer gewünscht, zusammengebunden und hierdurch ins Buchformat überführt.[40]

Werden nun die Kartengruppen der Lieferungen in den Blick genommen, so zeigt sich, dass Humboldt im Atlas eine bestimmte sinnstiftende Konzeption realisierte, die in einem gebundenen Format, bei dem die Karten in ihrer linearen Abfolge wahrgenommen werden, leicht übersehen werden kann. Diese Sinngebung des Atlas erfolgte über die ge-

39 Die Auslieferungen verzögerten sich immer wieder. Neben großen finanziellen Mitteln, die Humboldt für den Druck auftreiben musste, dauerte es zudem oft Monate, bis eine Karte fertig gedruckt vorlag. Sie entstand in einer langwierigen, präzisen Prozedur in mehreren Zwischenschritten und in der Zusammenarbeit von verschiedenen Spezialisten; immer wieder wurden Korrekturen an der Druckplatte vorgenommen, einzelne Elemente geglättet und neu gestochen. Vgl. das Unterkapitel *Teamarbeit am Atlas*.

40 Editorische Notizen zum Atlas finden sich im Anhang der Untersuchung. Vgl. auch Fiedler/Leitner: *Alexander von Humboldts Schriften*, 2000, S. 163.

zielte Zusammenstellung ausgewählter Karten. Sie konnte sich deshalb einstellen, weil Humboldt die Tafeln nicht in ihrer numerischen Reihenfolge edierte, sondern diese auflöste.

Dementsprechend erschienen 1814 mit der ersten Lieferung die Tafeln 1, 15, 18, 19 und 28 (Taf. II), mit der zweiten Lieferung 1817 die Tafeln 2, 16, 20 und 29[41] (Taf. III), 1819 wurden mit der dritten Lieferung die Tafeln 4, 17, 21 und 30 herausgegeben (Taf. IV), 1821 mit der vierten Lieferung die Tafeln 6, 23, 24 und 26 (Taf. V). 1825 folgten mit der fünften Lieferung die Tafeln 3, 9, 13, 14 und 22 (Taf. VI) und mit der sechsten Lieferung 1831 die Tafeln 5, 25 und 27 (Taf. VII). 1834 edierte Humboldt mit der siebten Lieferung, bestehend aus den Tafeln 7, 8, 10, 11 und 12 (Taf. VIII),[42] die letzten der ursprünglich geplanten 30 Karten seines Atlas. Zur achten Lieferung 1834 liegen keine genaueren Angaben vor, jedoch kann allein die Tafel 32 (Abb. 18) keiner der Lieferungen zugeordnet werden, weshalb zu vermuten steht, dass sie zu diesem Zeitpunkt ediert wurde, gefolgt von der Tafel 31 (Abb. 19) in der 1835 herausgegebenen neunten Lieferung. Anschließend erschienen die Nachstiche historischer Karten von 1835 bis 1837 als je einzelne Blätter (Taf. IX–XII; Abb. 20–22).[43]

Dieser Übersicht lässt sich entnehmen, dass bei der Zusammenstellung der Karten für die einzelnen Lieferungen die fortlaufende Nummerierung der Tafeln von 1 bis 39 in den Hintergrund trat. Ebenso wenig wie numerisch können die Lieferungen aber auch thematisch oder geographisch nicht als homogen beschrieben werden. So kombinierte Humboldt beispielsweise für die erste Lieferung des *Atlas géographique et physique du*

41 Die Lieferung 2 enthielt zusätzlich eine überarbeitete Fassung der Tafel 19, der *Carte du Cours de Rio Meta et d'une partie de la Chaîne Orientale des Montagnes de la Nouvelle Grenade*.

42 Die Lieferung 7 enthielt zusätzlich eine überarbeitete Fassung der Tafel 23, der *Carte d'île de Cuba*.

43 Alle sechzehn Lieferungen des *Atlas géographique et physique du Nouveau Continent* erschienen bei verschiedenen Verlegern: Schoell (Lieferung 1, 1814), Vendrys (Lieferung 2, 1817), Maze (ab 1819, Lieferung 3 und 4; kaufte vermutlich Vendrys und Schoells Restauflagen 1825), Smith/Gide fils (Lieferung 5, 1825), Gide fils (Lieferung 6, 1831, und 7, 1834), Gide (Lieferung 9–16, 1835–1837). Diesbezügliche Angaben zur Lieferung 8 liegen nicht vor. Da Smith den Druck bis 1834 übernahm, ab 1835 Pilhan Delaforest, wird die 1834 erschienene Lieferung 8 bei Smith gedruckt worden sein. Die hier angeführten Angaben stimmen nur zum Teil mit Fiedler/Leitner in dies.: *Alexander von Humboldts Schriften*, 2000, S. 152–163 überein. So beziehen sich die in der vorliegenden Untersuchung getroffenen Angaben zur sechsten Lieferung auf ein Deckblatt des *Atlas géographique et physique du Nouveau Continent*, das sich in der Kartenabteilung der BNF befindet. Die siebte Lieferung ergibt sich aus Humboldts Notizen auf dem Manuskript zum *Tableau de cartes géographiques et physiques*. Sie zeigen auch, dass – anders als Fiedler und Leitner vorschlagen – der Neudruck der Kuba-Karte (Tafel 23b) nicht schon 1826, sondern erst 1834 ediert wurde. Durch diese Karte sollte der 1826 erschienene Teil des Kuba-Werks nachträglich ergänzt werden. Humboldt plante zunächst, eine einleitende Übersicht und das Deckblatt, nicht aber die Karten, auch auf Deutsch erscheinen zu lassen. Dieses Vorhaben setzte er jedoch nicht um. Siehe Humboldt an Cotta am 13.05.1898, in: *Briefwechsel: Alexander von Humboldt und Cotta*, Berlin 2009, S. 89–90.

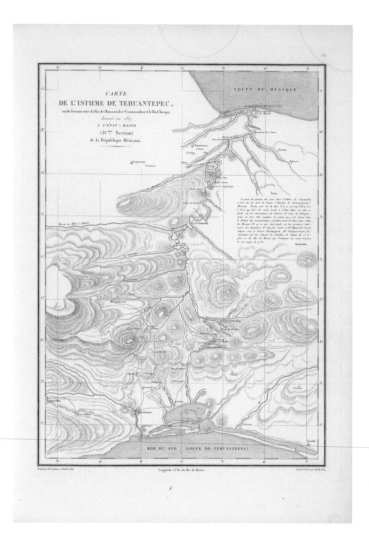

18__Alexander von Humboldt, *Carte de l'isthme de Tehuantepec*, 1834/1835, ca. 43 × 60 cm, in: *Atlas géographique et physique du Nouveau Continent*, Tafel 32 (Lieferung 8), Berlin, SBB, Foto SBB

Nouveau Continent mit der Tafel 1 eine vergleichende Profilkarte verschiedener virtueller Bergketten, mit den Tafeln 15, 18 und 19 drei Aufsichtskarten von Flussverläufen und mit der Tafel 28 eine vulkanologische Profilkarte (Taf. II).[44] Zu einer Darstellung der Grenze des ewigen Schnees auf verschiedenen Breiten der nördlichen Hemisphäre traten infolge-

44 Es handelt sich um *Limite inférieure des Neiges perpétuelles à différentes Latitudes*, Tafel 1; *Carte du Cours de l'Orenoque depuis l'Embouchure du Rio Sinaruco jusqu'à l'Angostura*, Tafel 15; *Carte de la Partie Orientale de la Province de Varinas comprise entre l'Orenoque, l'Apure et le Rio Meta*, Tafel 18; *Carte du Cours de Rio Meta et d'une partie de la Chaîne Orientale des Montagnes de la Nouvelle Grenade*, Tafel 19; *Tableau Géologique du Volcan de Jorullo*, Tafel 28.

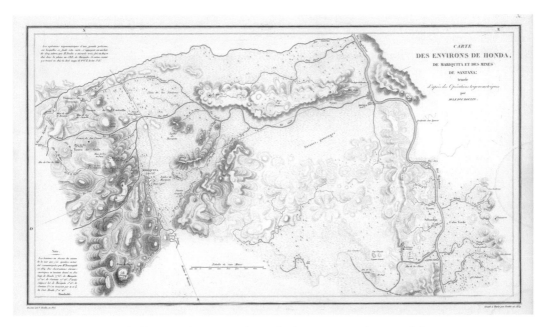

19__Alexander von Humboldt, *Carte des environs de Honda, de Mariquita et des mines de Santana*, 1835, ca. 43 × 60 cm, in: *Atlas géographique et physique du Nouveau Continent*, Tafel 31 (Lieferung 9), Berlin, SBB, Foto SBB

dessen Flussverläufe Südamerikas sowie ein mexikanischer Vulkan, der Jorullo. Auch ein narrativer Zusammenschluss der Karten kann nur bedingt hergestellt werden: Zwar besuchte Humboldt die meisten dieser Orte auf seiner Amerikanischen Reise, jedoch orientiert sich die Kartenkombination nicht am Reiseverlauf und nur vage an der Abfolge der textuellen Beschreibungen in der *Relation historique*.

Demgegenüber zeichnet sich für die Lieferungen des Atlas eine spezifische Zusammenstellung von Kartentypen und -themen ab, die sich nach der ersten in den weiteren wiederholt: Profil- und Aufsichtskarten – und damit zugleich Karten, die eher Berg- und solche die eher Flussphänomene thematisieren – treten systematisch zusammen, wobei sich mindestens eine von ihnen mit einem vulkanologischen Thema auseinandersetzt. Dieses Prinzip, das die zunächst geplanten, ersten 30 Karten des Atlas betrifft, erweiterte Humboldt später um die kartenhistorische Perspektive einer vierten Themengruppe.

Die „fraktale Konstruktion" des Atlas
Durch diese gezielte Zusammenstellung von Berg-, Fluss- und Vulkankarten einerseits sowie von Aufsichts- und Profilkarten andererseits kehrt in den Lieferungen im Kleinen eine Anordnung wieder, die im Großen derjenigen der ersten 30 Karten des gesamten Atlas entspricht: An seinem Beginn stehen die Höhenkarten, die sich mit allgemeinen

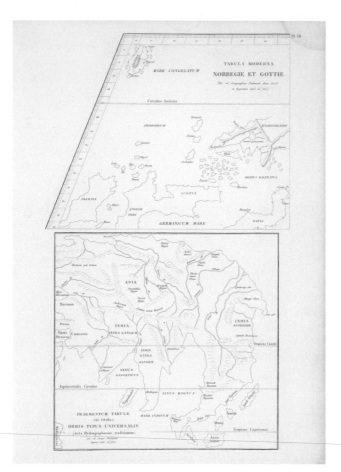

20__Alexander von Humboldt, Nachstiche von Martin Waldseemüllers *Tabula Moderna Norbegie et Gottie* und *Orbis Typus Universalis juxta Hydrographorum Traditionem*, 1835–1837, ca. 43 × 60 cm, in: *Atlas géographique et physique du Nouveau Continent*, Tafel 38 (Lieferung 10–16), Berlin, SBB, Foto SBB

Bergphänomenen auseinandersetzen (Tafel 1 bis 9), mittig sind hydrographisch orientierte Aufsichtskarten versammelt (Tafel 10 bis 25), während vulkanologische Karten den Band abschließen (Tafel 26 bis 30). Aus diesen drei aufeinanderfolgenden Themengebieten wählte Humboldt jeweils mindestens eine Karte aus und edierte sie in einer Lieferung gemeinsam; für die erste beispielsweise stammte die Tafel 1 aus der ersten Gruppe, die Tafeln 15, 18 und 19 aus der zweiten Gruppe und die Tafel 28 aus der dritten Gruppe.[45]

45 Entsprechend lässt sich für die Reihenfolge der publizierten Karten nachzeichnen, dass diese zunächst deutlich, später annäherungsweise entlang ihrer fortlaufenden Nummerierung innerhalb der thematischen Gruppen erschienen: Im ersten thematischen Abschnitt der Höhenphänomene folgte auf die Tafel 1 der ersten Lieferung in der zweiten die Tafel 2, im zweiten Abschnitt folgte auf die Tafel 15 mit der zweiten Lieferung die Tafel 16 sowie auf die Tafeln 18 und 19 (1814) die Tafel 20 (1817), auf die Tafel 28 der vulkanologischen Karten in der ersten Lieferung in der zweiten die Tafel 29 usf. Diese innerhalb der

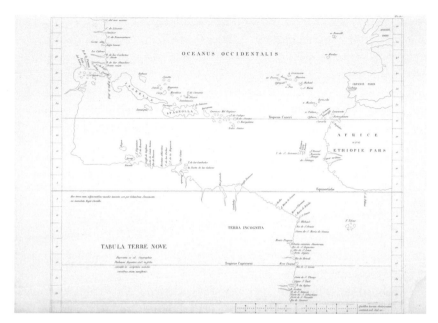

21__Alexander von Humboldt, Nachstich von Martin Waldseemüllers *Tabula Terre Nove*,
1835–1837, ca. 43 × 60 cm, in: *Atlas géographique et physique du Nouveau Continent*,
Tafel 37 (Lieferung 10–16), Berlin, SBB, Foto SBB

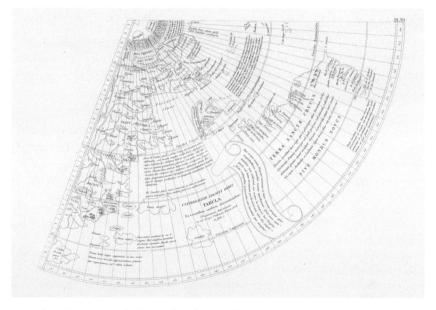

22__Alexander von Humboldt, Nachstich von Johannes Ruyschs *Universalior Cogniti
Orbis*, 1835–1837, ca. 43 × 60 cm, in: *Atlas géographique et physique du Nouveau Continent*,
Tafel 39 (Lieferung 10–16), Berlin, SBB, Foto SBB

Indem die Kombinationen der Karten für die Lieferungen eine Struktur zu erkennen geben, bei dem im Kleinen angelegt ist, was sich im Großen, im gesamten *Atlas géographique et physique du Nouveau Continent*, wiederholt, kann diese mit einem generellen Arbeitsprinzip Humboldts in Verbindung gebracht werden. Es lässt sich als eine sich selbst repetierende Anordnung beschreiben, die „auf Selbstähnlichkeit gerichtete Konstruktions- und Repräsentationsformen"[46] entwirft. Ottmar Ette schlägt vor, bezogen auf Humboldts Gesamtwerks von einer „fraktalen Konstruktion" zu sprechen, da

> dessen Einheit nicht durch zentrierende oder totalisierende Strukturen, sondern durch die *Relationalität* sich wiederholender Muster und Verfahren hergestellt wird. Der fraktalen Geometrie der Natur entspricht bei Humboldt eine fraktale Geometrie des Schreibens wie der wissenschaftlichen Modellbildung insgesamt.[47]

Vor dieser Folie zeigt sich die numerische Reihenfolge der Tafeln im *Atlas géographique et physique du Nouveau Continent* als sekundäre Ordnung, die antizipativ in der primären Ordnung der einzelnen Lieferungen vorgeführt wird.

Für das zeitgenössische Publikum, dem der Atlas während der Veröffentlichungsphase nur in den einzelnen Lieferungen vorlag, mag sich dessen Aufbau daher sehr viel leichter erschlossen haben als heutigen Rezipientinnen und Rezipienten. Auch in der numerischen Abfolge der Karten zeigt sich zwar eine thematische Strukturierung, doch ist diese ohne die Kenntnis der Lieferungsumfänge nicht als Überbau einer selbstähnlichen Konstruktion erkennbar. Aus der heutigen Perspektive kann dieses Verweissystem der Karten aufeinander daher leicht übersehen werden, und ferner deshalb, weil die Betrachtung inzwischen an einem Format des Atlas geschult ist, dessen Blätter geographisch oder thematisch aneinander anschließen. Einer solchen linearen Logik entspricht der ineinander verschachtelte Aufbau des *Atlas géographique et physique du Nouveau Continent* nicht. Vor diesem Hintergrund mag sich erklären, dass auch der Deutungshorizont, den der Atlas über seine Kartenkombination anbietet, bislang nicht von der Forschung erkannt

thematischen Abschnitte numerisch aufeinander aufbauende Abfolge suggeriert noch einen vierten Abschnitt, der auf hydrologische Systeme fokussiert ist. Dass der zweite Abschnitt in der ersten Lieferung erst mit der Tafel 15 einsetzt, nicht schon mit der Tafel 10, mit der die thematische Gruppierung beginnt, erklärt sich aus der Umstrukturierung des Kartenverbundes nach 1814. Dadurch rücken die Schnittkarten der Vulkane vom ersten in den letzten thematischen Abschnitt und verkleinern die Anzahl der ersten Themengruppe insgesamt.

46 Ette, Ottmar: „Alexander von Humboldt, die Humboldtsche Wissenschaft und ihre Relevanz im Netzzeitalter", *HiN* VII (2006) 12, S. 31–39, hier S. 37. Vgl. zur Diskussion des Fraktalen in Humboldts Werk auch Hans-Otto Dills affirmative Positionierung gegenüber Ette. Siehe Dill, Hans-Otto: *Alexander von Humboldts Metaphysik der Erde: Seine Welt-, Denk- und Diskursstrukturen*, Frankfurt am Main: Peter Lang 2013, S. 158–160.

47 Ette: „Die Humboldtsche Wissenschaft und ihre Relevanz im Netzzeitalter", 2006, S. 37–38 [Hervorhebung im Original].

worden ist. Der Zusammenstellung entspringt jedoch eine wissenschaftliche Erkenntnis, die die induktiven Beobachtungen, wie sie Humboldt in den einzelnen Kartenblättern vornahm, zu einer übergeordneten sinnstiftenden Argumentation zusammenzieht.[48]

48 Diese Feststellung behält ihre Gültigkeit auch in Anbetracht der Tatsache, dass das für die Lieferungen aufgezeigte kombinatorische Prinzip im Laufe der Zeit zunehmend zerfaserte. Dies lässt sich auf verschiedene Gründe zurückführen: Anfangs hatte Humboldt den Band zwei- und nicht dreiteilig angelegt, weshalb die später abgeteilte vulkanologische Gruppe mit nur fünf Tafeln sehr schmal ausfiel und nicht alle Lieferungen mit Material daraus versorgt werden konnten. Indes lassen sich diesbezüglich zwei Tafeln der ersten Gruppe, die Tafel 9, *Voyage vers la cime du Chimborazo*, und die Tafel 10, *Carte de la Province de Quixos*, die sich beide am Rande mit Vulkanen auseinandersetzen, als Substitute bewerten: Mit ihnen ergänzte Humboldt die Lieferung 5 bzw. die Lieferung 7 um den vulkanischen Themenschwerpunkt. Ferner kehrte Humboldt 1826, während der *Atlas géographique et physique du Nouveau Continent* in Paris erschien, nach Berlin zurück. Hierdurch wurde zum einen die intensive und enge Zusammenarbeit mit den in Paris angesiedelten wissenschaftlichen Spezialisten, die an der Kartenproduktion beteiligt waren, beeinträchtigt. Zum anderen stand in Berlin die Arbeit am *Kosmos* im Vordergrund, für den ein eigener Atlas, der *Physikalische Atlas* von Heinrich Berghaus, entstehen sollte. Auch deshalb wollte Humboldt den *Atlas géographique et physique du Nouveau Continent*, dessen Auslieferung sich deutlich in die Länge gezogen hatte, wohl endlich zu einem Abschluss bringen. Offenbar traf Humboldt nun auch pragmatische Entscheidungen, wie etwa die Zweitverwertung bereits vorliegender eigener Karten und den entsprechenden Verzicht auf ursprünglich anvisierte Kartenblätter, um die Produktion der Tafeln insgesamt zu beschleunigen.

Ein virtuelles Erdmodell. Das Kartenensemble im *Atlas géographique et physique du Nouveau Continent*

Als gebundenes Buch ist die Kartenkombination des *Atlas géographique et physique du Nouveau Continent* nur schwer verständlich. Wird aber der Publikationsprozess berücksichtigt, so zeigt sich, dass dieser Humboldt dazu diente, die Rezeption gezielt anzuleiten: Durch die Zusammenstellung bestimmter Karten für die einzelnen Lieferungen wurde maßgeblich erleichtert, dass auch der später von den Käuferinnen oder Käufern gebundene Atlas als sinnhaftes Ensemble von Karten aufgefasst werden konnte.

Die daraus hervorgehende Erkenntnis ist über den Atlas hinaus für die gesamte Naturforschung Humboldts grundlegend: Vermöge der gezielten Zusammenschau von Höhen- und Flächenprojektionen der Erdoberfläche, die vulkanologische Ansichten integrieren, vermag sich bei der Betrachtung ein Gefüge zu entfalten, das das Relief der Erdoberfläche schematisch vorführt und es zudem mit vulkanischer Aktivität in Bezug setzt. Dieses virtuelle, topographisch-dynamische Modell der Erdkruste kehrt eine zentrale Erkenntnis ins Sinnfällige, die Humboldt, wie er in seinem *Essay de Pasigraphie* erwähnte, mit seiner wissenschaftlichen Arbeit zu erreichen anstrebte: ein Verständnis von der „Bauweise des Erdballs, die das höchste Ziel der Wissenschaft ist"[1]. Die Karten des Atlas fungieren als Funktionsebenen dieses Modells, auf denen spezifische Themen des Naturwissens einzeln und vertiefend in den Blick genommen werden.

Um die heuristische Zusammenschau der Karten im *Atlas géographique et physique du Nouveau Continent* analytisch zu beschreiben, lassen sich zwei Modi der kartenübergreifenden Rezeptionslenkung differenzieren: ein *verknüpfendes* und ein *vergleichendes* Sehen. Während die unterschiedlichen Kartentypen, die von Humboldt während der Publikation in den einzelnen Lieferungen zusammengeführt wurden, visuell miteinander *verknüpft* werden müssen, lässt sich die serielle Wiederholung einer bestimmter Kombination von Kartentypen in den nacheinander edierten Lieferungen hingegen in einem *vergleichenden* Rezeptionsprozess erschließen. Die visuelle *Verknüpfung* entsteht also aus

1 Im Original: „la Construction du Globe qui est le grand objet de la Science". Humboldt: Manuskript zum *Essay de Pasigraphie*, 1803/1804, 3r.

der sinnstiftenden Zusammenschau heterogener Bildtypen, während das heuristische Potential des *Vergleichs* aus der Überblendung oder Differenzierung homogener Bildstrukturen erwächst.

Dieser zweite Modus des Vergleichens lässt sich ex post mit einer inzwischen etablierten kunst- und bildwissenschaftlichen Methode beschreiben: dem vergleichenden Sehen. Miteinander konfrontierte Zwei- oder Mehrbildprojektionen werden unter bestimmten Fragestellungen auf ihre Kongruenzen oder Differenzen hin untersucht. Schon um 1800, und damit zu Beginn von Alexander von Humboldts wissenschaftlicher Karriere, traf das methodische Vergleichen in den europäischen Wissenschaften auf wachsendes Interesse.[2] Auch in Humboldts Werk reicht es weit über die Konzeption des *Atlas géographique et physique du Nouveau Continent* hinaus. Humboldt nutzte den Vergleich wiederholt, um Einzelbeobachtungen zu verallgemeinern und innerhalb eines globalen Kontextes zu analysieren und zu verorten. Sowohl in seinen Texten als auch in seinen Graphiken lassen sich zahlreiche Verweise dieser Art finden.[3]

Dem *vergleichenden* Sehen gegenüber lässt sich mit dem *verknüpfenden* Sehen der zweite Modus des erkennenden Betrachtens benennen, der im *Atlas géographique et physique du Nouveau Continent* wirksam ist. Als methodologische Begriffskategorie wird es in der vorliegenden Arbeit neu eingeführt, um einen visuellen Rezeptionsvorgang zu beschreiben, der sich zwischen heterogenen Darstellungs- bzw. Kartentypen herausbildet. Das verknüpfende Sehen ist dem Prinzip der ‚visuellen Brücken‘ verwandt, mit dem Horst Bredekamp ein auf das Sammlungs- und Repräsentationskonzept der Kunstkammer bezogenes Rezeptionsprinzip fasst.[4] Anders aber als bei diesem betont das verknüpfende Sehen nicht ein freies Pendeln des Blicks zwischen Objekten, sondern eine durch eine spezifische Anordnung hervorgebrachte Blicklenkung, mit der verschiedene, ausgewählte Darstellungstypen gezielt zu einer bestimmten Einsicht verbunden werden sollen. Diesbezüglich nähert sich das *verknüpfende* Sehen einem Terminus von Birgit Schneider an. Diese beschreibt mit konkretem Bezug auf die Visualisierungspraxis Alexander von Humboldts eine synthetisierende Perspektive, durch die verschiedene Informationen in einer

2 Vgl. Eggers, Michael: „»Vergleichung ist ein gefährlicher Feind des Genusses.« Zur Epistemologie des Vergleichs in der deutschen Ästhetik um 1800“, in: *Kulturen des Wissens im 18. Jahrhundert*, hg. von Ulrich Johannes Schneider, Berlin: de Gruyter 2008, S. 627–636.

3 Auf den Aspekte von Humboldts vergleichender Analyse innerhalb einzelner Karten des *Atlas géographique et physique du Nouveau Continent* geht das Unterkapitel *Die einzelnen Tafeln des Atlas: Funktionsebenen des Erdmodells* an ausgewählten Beispielen ein. Zu vergleichenden Beobachtungen in Humboldts Schreiben vgl. u. a. Ette, Ottmar: „Unterwegs zu einer Weltwissenschaft? Alexander von Humboldts Weltbegriffe und die transarealen Studien“, *HiN* VII (2006) 13, S. 34–54, hier v. a. S. 46.

4 Zu den Überlegungen über „visuelle Brücken“ vgl. Bredekamp: *Antikensehnsucht und Maschinenglauben*, 2007, hier v. a. S. 71.

„Synopsis" verkoppelt werden.[5] Schneiders Überlegungen gegenüber, und damit wiederum den ‚visuellen Brücken' Bredekamps verwandt, adressiert das verknüpfende Sehen aber nicht das Resultat, sondern den aisthetischen Prozess des betrachtenden Erkennens. Denn das in Humboldts Atlas wirkmächtige Prinzip des Verknüpfens baut maßgeblich darauf auf, dass die visuellen Bezüge zwischen den Karten beim Durchblättern immer wieder neu hergestellt werden können und müssen. Für die Erkenntnis ist also eine Bilderanordnung essentiell, mittels derer sich Bezüge temporär herstellen, aber auch wieder lösen lassen.

Verknüpfendes Sehen I: evozierte Dreidimensionalität

Die Verknüpfung von Höhen- und Flächenprojektion

Bereits bei einem ersten Durchblättern des *Atlas géographique et physique du Nouveau Continent* ist zu erkennen, dass sich darin bestimmte Kartentypen wiederholen. Dass Aufsichts- und Profilkarten aber gezielt zusammen rezipiert werden sollten, verdeutlicht erst der Prozess der Auslieferung: Beide Projektionsmethoden, jeweils auf unterschiedlichen Blättern realisiert, begegneten sich in den von Humboldt konzeptionierten Lieferungsumfängen für die zunächst geplanten 30 Karten des Atlas systematisch (Taf. II – Taf. VIII). Indem Humboldt im Zuge der Publikation des Atlas die numerische Reihenfolge der Tafeln auflöste, traten Projektionen der Höhe und der Fläche zusammen. Auf diese Weise wurde die Aufmerksamkeit bei der Betrachtung auch auf die in den einzelnen Karten jeweils nicht mit aufgenommene, dritte Dimension der Erdoberfläche gelenkt.

Ursprünglich hatte Humboldt eine solche Konzeption auch für seinen *Atlas de la Nouvelle-Espagne* geplant, verwarf das Unterfangen, wie er selbst angab, allerdings aus Kostengründen wieder:

> Die Befürchtung, meiner Arbeit einen zu großen Umfang zu verleihen, die Probleme, die sich bei der Veröffentlichung eines Atlas ergeben, für den keine Regierung die Kosten übernimmt, veranlassten mich, das Projekt aufzugeben, das ich ursprünglich entwickelt hatte, nämlich jedem Abschnitt des Landes eine physische Karte in horizontaler Projektion beizufügen.[6]

5 Vgl. Schneider: „Linien als Reisepfade der Erkenntnis", 2012, S. 188–192; dies.: „Berglinien im Vergleich", 2013, S. 38–41.

6 Im Original: „La crainte de donner trop d'étendue à mon ouvrage, les difficultés que présente la publication d'un atlas pour lequel aucun gouvernement ne fournit les frais, m'ont fait abandonner le projet que j'avois formé d'abord, celui de joindre à chaque coupe de terrain une carte physique en projection horizontale." Humboldt, Alexander von: *Essai politique sur le royaume de la Nouvelle-Espagne*, Bd. 1 [Oktav], Paris 1811, S. 114.

Dass Humboldt im *Atlas géographique et physique du Nouveau Continent* eine ähnliche Konzeption schließlich doch umsetzte, unterstreicht die Bedeutung, die die Reflexion der dreidimensionale Gestalt des Topographischen für ihn besaß. Ihre Beschreibung wird in der Forschung bisweilen sogar als Grundgerüst der gesamten Wissenschaft Humboldts erkannt.[7] So vermutet auch Anne Godlewska:

> Humboldts Arbeit war zweckmäßig mit Theorie, Analogie, Verallgemeinerung und Erforschung der Ursache versehen. Es ist schwierig, irgendeine der vielen von ihm entwickelten Theorien gegenüber anderen zu privilegieren. Die jedoch am weitesten sein Werk durchdringende Theorie, welche eigentlich mit all seinen Theorien übereinstimmte, besteht möglicherweise in der Auffassung, daß die Aufnahme eines Ortes in drei Dimensionen (Breitengrad, Längengrad und Höhe) […] der Schlüssel zum Verständnis der Naturwelt sei.[8]

Godlewskas Annahme bestätigt sich in der gezielten Kombination von Profil- und Aufsichtskarten im *Atlas géographique et physique du Nouveau Continent*: Über die verknüpfende Betrachtung der Flächen- und Höhenprojektionen wird darin zwar nicht das Relief der Erdoberfläche visualisiert, wohl aber ein dreidimensionales Schema aufgerufen.

Der *Plan du Volcan de Jorullo*

Wie eng die Kombination von Horizontal- und Vertikalprojektion für Humboldt mit der räumlichen Erschießung der Erdoberfläche in Verbindung stand, zeigt eine der ersten Tafeln des Atlas. Auf ihr sind beide Projektionsmethoden noch auf demselben Blatt realisiert und werden zusätzlich durch eine illusionistische Landschaftsansicht ergänzt. Die hochformatige Tafel 29, der *Plan du Volcan de Jorullo* (Abb. 16), versammelt diese drei Ansichten, wobei eine gerahmte, geostete Aufsichtskarte des mexikanischen Vulkans die Mitte des Blattes prominent einnimmt. Oberhalb und unterhalb ist sie von zwei nebengeordneten Darstellungen eingefasst: Während die obere einen zentralperspektivischen, nach Osten hin ausgerichteten Ausblick in das Terrain eröffnet, handelt es sich bei der unteren um eine ebenfalls in östliche Richtung hin aufgenommene Profilkarte des Gebietes. Durch diese Kombination unterschiedlicher, in der geographischen Ausrichtung aufeinander abgestimmter Ansichten und Darstellungsweisen liefert der *Plan du Volcan de Jorullo* einen heuristisch aufgefächerten Einblick in das aufgenommene Gelände: Perspek-

7 Hans-Otto Dill verweist in diesen Kontext auf die Stockwerk-Metapher, mit der Humboldt Klimazonen beschrieb. Vgl. Dill: *Metaphysik*, 2013, S. 64–66; vgl. zum dreidimensionalen Grundprinzip in Humboldts Wissenschaft ferner Beck: „Einführung", in: Humboldt: *Atlas géographique et physique du Royaume de la Nouvelle-Espagne*, 1969, S. 11–14, hier S. 13; Ette, Ottmar/Lubrich, Oliver: „Versuch über Humboldt", in: Humboldt, Alexander von: *Ueber einen Versuch den Gipfel des Chimborazo zu ersteigen*, hg. und kommentiert von dies., Frankfurt am Main: Eichborn 2006, S. 7–76, hier S. 50–51; Wilhelmy, Herbert: „Humboldts südamerikanische Reise und ihre Bedeutung für die Geographie", in: *Die Dioskuren*, 1986, S. 183–198, hier v. a. S. 191.

8 Godlewska: „Humboldts visuelles Denken", 2001, S. 166.

tivische Landschaftsaufnahme, topographische Flächenprojektion und abstrahiertes Höhenprofil treten zu einer komplexen räumlichen Erfassung des mexikanischen Vulkans zusammen.

Das Verständnis der Tafel setzt eine Verknüpfung der Perspektiven voraus. Geschieht dies, gewährt der *Plan du Volcan de Jorullo* einen Einblick in den Zusammenhang von vulkanischer Aktivität und der Oberflächenstruktur der Erde, wobei gleichzeitig der landschaftliche Eindruck der Gegend vermittelt wird. Während die Aufsicht dabei eine Übersicht über das gesamte Gelände und dessen Topologie bietet und die perspektivische Ansicht das Einfühlen in das Gebiet ermöglicht, verdeutlicht der unter beide eingefügte Schnitt als „Étendue de la masse soulevée" anhand von diagrammatischen Beschriftungen die Entstehung des entsprechenden Reliefs durch vulkanische Prozesse. Das ursprüngliche Niveau der Erdoberfläche (a, b, c) wird hierfür mit dem eruptiv angehobenen Terrain (a, d, b), das für neue Vulkane (e) als Basis dient, in Beziehung gesetzt.

Das Darstellungsprinzip, das im *Plan du Volcan de Jorullo* aufgerufen wird, liegt dem gesamten *Atlas géographique et physique du Nouveau Continent* zugrunde:[9] Durch die Zusammenführung verschiedener Projektionsmethoden wird ein konkreter topographischer Raum vorstellbar und zudem mit vulkanischer Aktivität in Zusammenhang gebracht. Jedoch führte Humboldt dieses Prinzip nicht in jeder Karte einzeln aus. Stattdessen implementierte er dem Atlas die Reflexion einer dreidimensionalen Verfasstheit der Erdoberfläche als Abstraktum: Durch die verknüpfende Zusammenschau verschiedener Kartenblätter ließ sich die Kombination von Aufsichten und Profilen in der Betrachtung zu einem virtuellen dreidimensionalen Schema des Raumes zusammenführen.[10]

Höhen- und Tiefenausdehnung der terrestrischen Bauweise gemeinsam zu präsentieren, schließt sowohl der inhaltlichen Zielsetzung als auch der Darstellungsweise nach an Konstruktions- oder Architekturzeichnungen an, wie sie bereits aus der Antike bekannt

9 Dass die perspektivische Ansicht im *Atlas géographique et physique du Nouveau Continent* eine Ausnahme bildet, mag sich aus Humboldts Anspruch einer möglichst exakten topographischen Kartierung erklären: Auf dem Papier können jeweils nur zwei Ordinaten genau verzeichnet werden. Auch die perspektivische Ansicht des *Plan du Volcan de Jorullo* war ursprünglich nicht für den *Atlas géographique et physique du Nouveau Continent* gedacht, sondern für die *Vues des Cordillères*. Siehe Humboldt: „Sur les matériaux", 1817, S. 36–37. Neben der perspektivischen Darstellung auf dem *Plan du Volcan de Jorullo* kann im *Atlas géographique et physique du Nouveau Continent* auch die Tafel 2, das *Tableau physique des Iles Canaries*, als Mischform von Profilkarte und perspektivischer Landschaftsdarstellung gewertet werden.

10 Einzige Ausnahme bildet hier die sechste der sieben Lieferungen, die lediglich Aufsichtskarten enthielt. Neben den zwei orohydrographisch orientierten Tafeln 5 und 25 besteht sie aus der Tafel 27, der Aufsicht des Vulkans Pichincha. Diese sechste Lieferung erschien 1831, als Humboldt bereits mit den Arbeiten an seinem *Kosmos* beschäftigt war. Mit der sechsten Lieferung beginnt sich die darin aufgemachte systematische Kombination der Karten insgesamt zu verunklaren.

sind.[11] Der römische Ingenieur und Baumeister Vitruv (um 84 v. Chr. – um 27 v. Chr.) beschrieb ein Verfahren, mit dem sich Maschinen und Gebäude in ihrer dreidimensionalen Gestalt visuell erfassen lassen. Hierbei sind nicht nur bestimmte Konstruktionsregeln einzuhalten, sondern auch verschiedene Ansichten zu verknüpfen. In *De architectura libri decem* unterschied Vitruv dafür zwischen den Darstellungsweisen der *ichnographia* (Grundriss), der *orthographia* (Aufriss der Fassaden) und der *scenographia* (perspektivische Ansicht). In ihrer Kombination boten sie eine differenzierte Präsentation von räumlichen Objekten.

Im Rückgriff auf Vitruv etablierten sich mit Leon Battista Alberti (1404–1472) und Jacques Androuet du Cerceau (1510–1584) räumliche Entwurfsregeln, bei denen Aufriss und Grundriss, bisweilen auch der Schnitt, in orthogonalen Plänen entworfen und als *lineamenta* bezeichnet von der illusionistischen Ansicht, der *portraicture*, abgegrenzt werden.[12] Gegenüber der *portraicture* fußen die *lineamenta* auf festgelegten mathematischen, rasteranalogen Projektionsregeln, sodass über den berechneten Raum sowohl das Volumen eines Objekts als auch seine geometrische Struktur ermittelt werden kann, zugleich lassen sich Schlüsse über seine Funktionsweise und Statik ableiten. Um hierbei eine möglichst überindividuelle Ansicht zu erlangen, wird bei Grund- und Aufriss ein mit der Zentralperspektive verbundener Standpunkt der Betrachtung nach Möglichkeit vermieden.[13]

Die Zusammenschau von Höhen- und Flächenprojektionen im *Atlas géographique et physique du Nouveau Continent*, die die räumliche Ausdehnung der Erdoberfläche evoziert, lässt sich mit einer solchen Darstellungspraxis engführen: Auch Humboldts Karten gehorchten präzisen Projektionsregeln und zielten darauf, die Natur strukturell und daran anschließend hinsichtlich ihrer funktionalen Zusammenhänge zu beschreiben. Dennoch weist Humboldts kartographische Präsentation, wie bereits angedeutet, wesentliche Unterschiede zum konkreten Entwurfsprozess der Architektur- oder Konstruktionszeichnung auf – und zwar mit entscheidenden heuristischen Folgen: Während Architektur- oder Konstruktionszeichnungen in der Regel mehrere Ansichten desselben Objekts gemeinsam präsentieren, verteilen sich diese Ansichten in Humboldts Atlas nicht nur auf

11 Vgl. zur Nähe von Konstruktionszeichnung und Humboldts Kartographie Schäffner: „Topographie der Zeichen", 2000, S. 368.

12 Zur Entwicklung seit Vitruv vgl. Melters, Monika/Wagner, Christoph: „Einleitung", in: *Die Quadratur des Raumes. Bildmedien der Architektur in Neuzeit und Moderne*, hg. von dies., Berlin: Gebrüder Mann Verlag 2017, S. 7–10, hier S. 8–9.

13 Vgl. Philipp, Klaus Jan: „Die Imagination des Realen: Eine kurze Geschichte der Architekturzeichnung", in: *Die Realität des Imaginären: Architektur und das digitale Bild*, hg. von Jörg H. Gleiter, Norbert Korrek und Gerd Zimmermann, Weimar: Schriften der Bauhaus-Universität 2007, S. 147–157, hier S. 147 (online abrufbar unter: http://e-pub.uni-weimar.de/opus4/frontdoor/index/index/docId/1292, zuletzt geprüft am 31.10.2019). Zur Konstruktion und Funktionsweise von Maschinendarstellungen vgl. Holländer, Hans: „Spielformen der Mathesis universalis", in: *Erkenntnis, Erfindung, Konstruktion*, 2000, S. 325–345, insbesondere S. 332–337.

verschiedene Kartenblätter, sondern visualisieren auch unterschiedliche natürliche Erscheinungen. Zudem weisen diese hinsichtlich ihrer geographischen Lage häufig weite Entfernungen zueinander auf und liegen bisweilen sogar auf unterschiedlichen Kontinenten. So wurden 1814 in der ersten Lieferung des Atlas beispielsweise drei jeweils in der Aufsicht aufgenommene südamerikanische Flussverläufe zusammen mit einem geographisch interkontinental aufgespannten Gipfelprofil und einer Schnittdarstellung des mexikanischen Vulkans Jorullo präsentiert (Taf. II). Aus diesem Auseinandertreten der Ansichten auf der Inhaltsebene resultiert, dass in Humboldts Atlas zwar eine räumliche Dimension des Dargestellten aufgerufen wird, diese aber stets vage bleibt. Statt also – mit Ausnahme des genannten *Plan du Volcan de Jorullo* (Abb. 16) – ein spezifisches Objekt oder Gebiet in seiner dreidimensionalen Gestalt zu erschließen, wird jedes kartographisch präsentierte Phänomen erst durch die Zusammenschau der verschiedenen Projektionsweisen assoziativ mit einer entsprechenden Verfasstheit verknüpft.

In Anbetracht der Fülle an Themen, die der Atlas versammelt, lässt sich die Evokation der dreidimensionalen topographischen Gestalt, die Humboldt in den Lieferungen verfolgte, als Moment verstehen, durch das die Einzelbeobachtungen der Karten zu einem gemeinsamen Axiom verknüpft werden; die Karten erweisen sich vor diesem Hintergrund als Varietäten der sie verbindenden räumlichen Struktur. Dieses übergeordnete Schema erschließt sich jedoch erst auf der Basis einer zusammenführenden Betrachtung der verschiedenen Kartentypen und noch nicht bei der Ansicht des einzelnen Kartenblattes. Dennoch wirkt die imaginäre Verknüpfung mit der dritten Dimension potentiell auf jede einzelne in den Karten des Atlas diskutierte Beobachtung zurück. Für die Tafel 2 des *Atlas géographique et physique du Nouveau Continent*, das *Tableau physique des Iles Canaries. Géographie des Plantes du Pic de Ténériffe* (im Folgenden: *Tableau physique des Iles Canaries*) zeigt sich diese Konsequenz beispielsweise darin, dass die darauf am Beispiel des Pico del Teide vorgestellte, zonale Pflanzenverteilung nach Höhen ihrer einfachen Zu- und Anordnung enthoben wird (Taf. XIII): Eine der Darstellung unterlegte räumliche Auffassung von der Erdoberfläche verdeutlicht, dass nicht nur die Höhe, sondern auch Längen- und Breitengrade für die Verbreitung bestimmter Pflanzen in einer Region einen entscheidenden Faktor darstellen. Vollgültige Aussagen über diese Naturbeobachtung lassen sich dementsprechend im Grunde genommen nur auf der Grundlage einer dreidimensional erfassten Topographie treffen.

Für Humboldt war es dieses Bewusstsein, das ein tieferes Verständnis vom Ganzen der Natur beförderte, hingen für ihn doch „die Phänomene der Erdkunde, die Gewächse und überhaupt die Vertheilung der organisirten Wesen von der Kenntniß der drei Coordinaten: der Breite, Länge und Höhe"[14] ab. Letztlich erschlossen sich erst über die Kenntnis dieser drei Angaben die systemischen Zusammenhänge des „Naturganzen". Den

14 Humboldt: *Kleinere Schriften*, Teil 1, 1853, S. 207.

ihm zugrunde liegenden Bauplan visualisierte Humboldt in den gezielt zusammengeführten Kartentypen des *Atlas géographique et physique du Nouveau Continent* schematisch.

Dreidimensionale Entwurfspraxis in Humboldts Werk

Humboldts Interesse an der dreidimensionalen Visualisierung beschränkte sich nicht allein auf die Topographie, sondern bezog sich auf verschiedenste Bereiche des Wissens von der Natur. Auch diese Auseinandersetzung mag die Konzeption des *Atlas géographique et physique du Nouveau Continent* inspiriert haben. So sind beispielsweise große Teile von Humboldts wissenschaftlichem Nachlass von Skizzen durchzogen, die Objekte räumlich zu erfassen versuchen. Bisweilen weisen sie eine andere Autorschaft auf, in weiten Teilen stammen sie aber von Humboldt selbst; sie können flüchtig und grob angedeutet oder aber gründlich und detailliert ausgearbeitet sein und umfassen ein breites Spektrum von Gegenständen und Themen. Neben Naturdingen lassen sich vor allem Objekte aus dem architektonischen und ingenieurswissenschaftlichen Bereich ausmachen: Grundrisse, Aufsichten, Aufrisse und Querschnitte, manchmal in ihrer Kombination, zeigen Pyramiden, Kirchen- und Festungsgebäude sowie Schmelzöfen, Barometer und andere wissenschaftliche Instrumente.[15]

Auffällig ist diese Darstellungsweise auch in den zoologischen Graphiken, die aus mehreren Blickpunkten aufgenommene Ansichten von Tieren zeigen.[16] Eine von ihnen findet sich im Aufsatz *Ueber den Manati des Orinoko*, zu dem eine Visualisierung der südamerikanischen Seekuh aus der Seitenansicht und der Untersicht sowie im Querschnitt und in einzelnen Details gehört (Abb. 23).[17] Mit der polyfokalen Darstellung sollten spezifische Merkmale der Spezies genau dokumentiert werden, um sowohl ihre Artenbestimmung als auch ihre taxonomische Erfassung nach morphologischen Kriterien zu erleichtern.

Diese Art der Erfassung von Tieren lässt sich in eine um 1800 im akademischen wie populärwissenschaftlichen Feld verbreitete Visualisierungspraxis naturwissenschaftlichen Wissens einordnen. In der Darstellungsweise drückt sich neben einer detaillierten und möglichst allansichtigen Dokumentation des Naturdings auch der Wunsch nach einer (intellektuellen) Beherrschbarkeit der natürlichen Sphäre aus: Im Anvisieren eines indivi-

15 Neben den wissenschaftlichen Nachlassteilen in Krakau und Berlin sei hier auf das Archiv der Bergakademie Freiberg verwiesen, an der Humboldt ausgebildet wurde. Unter den dort verwahrten Materialien befinden sich eine große Zahl Architektur- und Konstruktionszeichnungen.

16 Vgl. Alexander von Humboldts *Recueil d'observations de zoologie et d'anatomie comparée* erschien von 1812 bis 1833 in Paris. Es stellt den zweiten Teil der *Voyage* dar. Für den Publikationsprozess vgl. Fiedler/Leitner: *Alexander von Humboldts Schriften*, 2000, S. 170–182. Nicht alle der im *Recueil* publizierten Graphiken stammen von Humboldt selbst.

17 Humboldt, Alexander von: „Ueber den Manati des Orinoko", *Archiv für Naturgeschichte* 4 (1838) 1, S. 1–18, Tableau I und II. Humboldts Vorzeichnungen zum Manati haben sich im wissenschaftlichen Nachlass erhalten. Vgl. SBB, HA, Alexander von Humboldt, gr. Kasten 6, Nr. 15, Bl. 10r und 12 r.

23__Alexander von Humboldt, *Der Manati des Orenoko*, 1838, Tableau I und II

duellen Objekts wurde durch die Betonung allgemeiner Merkmale zugleich auf einen zugrunde liegenden Typus verwiesen. Individuelle und allgemeine Ansicht gerieten hierdurch in Oszillation. Dadurch, dass auch die charakteristischen Merkmale herausgestellt wurden, konnte das Forschungsding unmittelbar in eine vergleichende Beurteilung und mit ihr in eine die Natur strukturierende und der Ratio unterworfene Systematik überführt werden.

Von beiden Ansprüchen, der Dokumentation des einzelnen Phänomens und dessen intellektueller Durchdringung und systematischer Klassifizierung, war auch Humboldts Interesse an der dreidimensionalen Aufnahme seiner Forschungsgegenstände geleitet. Deutlich wird dies mit Blick auf die Erfassung eines inkaischen Gebäudes, die sich von der Zeichnung Humboldts bis hin zu einer Druckgraphik in den *Vues des Cordillères* verfolgen lässt. Dabei erlangt die auf der eigenen Anschauung Humboldts basierende, dreidimensional ausgerichtete Aufnahme des Gebäudes bereits im Zuge der ersten deskriptiven Annäherung einen typisierenden Verweischarakter, der letztlich auf die Beschreibung globaler Zusammenhänge zielte.

24__Alexander von Humboldt,
Skizze zu *Maison de l'Inca*, 1802,
Berlin, SBB

Eine der ersten Skizzen zum *Maison de l'Inca* findet sich im wissenschaftlichen Nach-lass in einer Mappe mit Materialien zu Peru, Neu Granada und Quito.[18] Nach eigenen Angaben fertigte Humboldt die Zeichnung im April 1802 während einer Exkursion zum Vulkan Cotopaxi an.[19] Bereits in dieser ersten Visualisierung ist neben dem Grundriss des Gebäudes auch die in Form eines fragmentarischen Aufrisses ausgeführte Ansicht ei-ner Tür und des sie rahmenden Mauerwerks erfasst (Abb. 24). Aus dieser Skizze entstand

18 Humboldt, Alexander von: Skizze zu einem inkaischen Gebäude, SBB, HA, Kleiner Kasten 7b, 47a, Blatt 15.
19 Siehe Humboldt: *Vues des Cordillères*, 1810[–1813], S. 195.

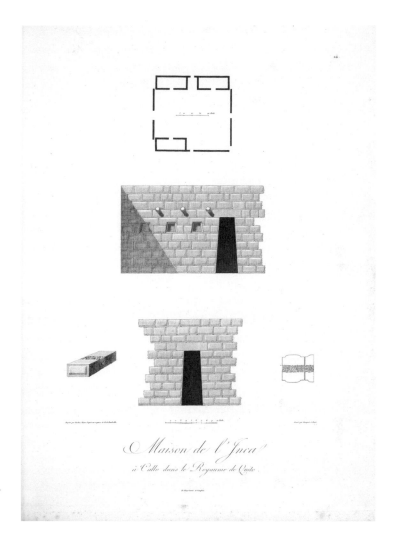

25__Alexander von Humboldt,
*Maison de l'Inca à Callo dans le
Royaume de Quito*, 1810[–1813],
40,5 × 55,5 cm, in: *Vues des
Cordillères*, Tafel XXIV

später ein der Vorlage sehr naher Stich, den Humboldt 1811 als Tafel XXIV in den *Vues des Cordillères* publizierte (Abb. 25).[20]

Schon die zeichnerischen Ausführung zeigt, dass Humboldt nicht allein darauf zielte, ein bestimmtes Gebäude räumlich wiederzugeben, sondern dass er zugleich eine allgemeine Baustruktur erfassen wollte: Die Skizze entspricht zwar, indem verschiedene Ansichten und Projektionsweisen desselben Gebäudes zusammentreten, konventionalisier-

20 Siehe Humboldt: *Maison de l'Inca à Callo dans le royaume de Quito*, in: ders.: *Vues des Cordillères*, 1810[–1813], darin Tafel XXIV (Lieferung 3, 1811). Die Skizze wurde von Wilhelm Friedrich Gmelin in Rom ausgearbeitet und von Louis Bouquet in Paris gestochen.

ten Entwurfsverfahren der Architekturzeichnung, doch bleiben individuelle bauliche Details oder eine perspektivische Wiedergabe ausgespart. In der zugehörigen Textpassage der *Vues des Cordillères* bestätigt sich, dass die Darstellung letztlich nicht die singuläre, von Humboldt besichtigte Ruine zeigen, sondern auf den generellen Aufbau inkaischer Gebäude abstrahieren sollte:

> Die Türen, die denen der ägyptischen Tempel gleichen; die Nischen, achtzehn in jedem der Gemächer und mit der größten Symmetrie verteilt; die Zylinder zum Aufhängen von Waffen; der Zuschnitt der Steine, deren Außenfläche konvex und an den Rändern abgeschrägt ist […]. […] von größtem Interesse scheint mir die Gleichförmigkeit der Bauweise zu sein, die alle peruanischen Monumente verbindet. Es ist unmöglich, ein einzelnes Bauwerk aus der Inka-Zeit zu studieren, ohne denselben Typus in allen anderen zu erkennen […].[21]

Humboldt suchte mithin nach allgemeinen Elementen des Besehenen und spannte einen kulturellen Wissenshorizont auf, vor dem aus er sogleich nach inner- und interkulturelle Überschneidungen von Bautypen suchte. An diesem Anspruch richtete er bereits aus, was er in situ zeichnerisch aufnahm. Als Referenz der Graphik diente damit zwar ein individuelles Gebäude, die Repräsentation transportierte von Beginn an aber auch ein allgemeines klassifikatorisches Wissen. Bei seiner architektonischen Visualisierung des *Maison de l'Inca* ging es Humboldt demzufolge nicht primär um die Wiedergabe eines bestimmten Objekts, sondern um eine strukturelle Typisierung des Gemäuers. Anhand dieser sollte letztlich nicht nur ein vermeintlich inkaischer Baustil erkenntlich, sondern auch eine Beurteilung im globalen Kontext ermöglicht werden, d. h. ein globaler Vergleich, der kulturelle Dependenzen augenfällig werden ließ:

> Es wird ein leichtes sein, anhand der Zeichnung in diesem Werk eines Tages zu überprüfen, ob es […] in Oberkanada Bauwerke gibt, die im Zuschnitt der Steine, in der Form der Türen und der kleinen Nischen sowie in der Anordnung der Gemächer Spuren des *peruanischen Stils* aufweisen […].[22]

21 Humboldt, Alexander von: *Ansichten der Kordilleren und Monumente der eingeborenen Völker Amerikas*, hg. und kommentiert von Ottmar Ette und Oliver Lubrich, Frankfurt am Main: Eichborn 2004, S. 237. Im französischen Original: „Les portes semblables à celles des temples égyptiens; les niches, au nombre de dix-huit dans chaque appartement, distribuées avec la plus grande symétrie; les cylindres servant à suspendre des armes; la coupe des pierres, dont la face extérieure est convexe et coupée en biseau […]. […] mais ce qui me paroît digne du plus grand intérêt, c'est l'uniformité de construction que l'on remarque dans tous les monumens péruviens. Il est impossible d'examiner attentivement un seul édifice du temps des Incas, sans reconnoître le même type dans tous les autres […]." Humboldt: *Vues des Cordillères*, Paris 1810[–1813], S. 197 [Folio].

22 Humboldt: *Ansichten der Kordilleren und Monumente der eingeborenen Völker Amerikas*, 2004, S. 237 [Hervorhebungen im Original]. Im französischen Original: „Il sera facile de vérifier un jour, d'après les dessins que renferme cet ouvrage, si, dans le Haut-Canada, […] il existe des édifices qui, dans la coupe des pierres, dans la forme des portes et des petites niches, et dans la distribution des appartemens, offrent

Die Visualisierung war somit bereits der kompositorischen Anlage nach darauf ausgelegt, eine individuelle Struktur ihrem Typus nach möglichst umfassend aufzunehmen, um auf dieser Grundlage weitere, ins Globale reichende Schlüsse ziehen zu können. Nicht nur der räumlichen Erfassung, sondern auch der Zielsetzung nach kommt Humboldts Beschreibung des inkaischen Baus an diesem Punkt mit dem dreidimensionalen Schema zusammen, nach dem die Karten im *Atlas géographique et physique du Nouveau Continent* organisiert sind: Auch die darin vorgestellten Einzelbeobachtung werden – wenngleich erst über die assoziative Verknüpfung mit anderen Karten – in ein typisierendes Schema des Naturwissens eingefasst; den Einzelbeobachtungen wird hierdurch ein ihnen gemeinsamen Prinzip unterlegt.

Als globales, letztlich dem Ganzen der Natur zugrundeliegendes Prinzip, das Humboldt in seinen drei Dimensionen entwarf, ist das Sphärenmodell seiner *Carte des lignes Isothermes* aufzufassen (Abb. 6). Es ergibt sich aus der Kombination von zwei über- bzw. untereinander angeordneten Abbildungen, der „Fig. 1" und der „Fig. 2." Während erstere in der oberen Hälfte der Graphik die Klimate der nördlichen Halbkugel in der Aufsicht, d. h. in ihrer Verteilung auf der Erdoberfläche zeigt, visualisiert die in die untere Blatthälfte gesetzte zweite Abbildung die Klimate im Profil, d. h. in ihrer Höhenstaffelung. Während also die „Fig. 1" mit Linien unterteilte Wärmezonen in ihrer globalen Verteilung auf der nördlichen Hemisphäre zeigt, liefert die „Fig. 2" die entsprechende zonale Staffelung der Höhe – und somit die entscheidende Ergänzung, soll eine Gegend auf der Basis ihrer geographischen Ordinaten der Länge, Breite und Höhe einer bestimmten Klimazone zugeordnet werden. Die Bezeichnungen als „Fig. 1." und „Fig. 2." unterstreichen hierbei, dass beide Teilgraphiken logisch zusammengehören. In ihrem Zusammensehen kann nun theoretisch die gesamte nördliche Erdhalbkugel – vorausgesetzt, die entsprechenden Ordinaten liegen vor – klimatisch beschrieben werden.[23]

Die Veröffentlichung der Karte 1817 fiel in dieselbe Zeit, in der Humboldt den *Atlas géographique et physique du Nouveau Continent* grundsätzlich neu strukturierte und die Zusammenschau der Karten gezielt auf eine grundsätzlich dreidimensional verfasste Topographie ausrichtete. Vor dem Hintergrund erhellt sich einmal mehr die Erkenntnis-

des traces du *style péruvien* [...]." [Hervorhebung im Original], Humboldt: *Vues des Cordillères*, Paris 1810[–1813], S. 197–198 [Folio].

23 Diese Erkenntnis war für Humboldt deshalb wichtig, weil die Bestimmung der Klimazonen weitere Rückschlüsse auf Naturgesetze und -phänomene ermöglichte, etwa solche zur Pflanzenverteilung. Mit der großräumigen dreidimensionalen Klimakarte wollte Humboldt die Voraussetzung schaffen, den Problemen einer rein induktiven Beobachtungspraxis zu begegnen. Im Zusammenhang mit seiner langjährigen und intensiven Beschäftigung mit Temperaturmessungen warnte er vor einer Wissenschaftspraxis in den „physikalischen Wissenschaften" (Humboldt bezog sich hier auf die Wissenschaften, die sich mit den Wechselwirkungen in der Natur auseinandersetzen), die von lokalen Phänomenen aus auf allgemeine Zusammenhänge abstrahierte, ohne das System des „Naturganzen" im Blick zu behalten. Siehe Humboldt: *Kleineren Schriften*, Teil 1, 1853, S. 211.

dimension der Kartenkombination von Aufsichts- und Profilkarten im *Atlas géographique et physique du Nouveau Continent*: In der *Carte des lignes Isothermes* ist das Zusammensehen der kartographischen Aufsicht und des Schnitts bzw. Profils bereits angelegt.

Dreidimensionale kartographische Entwürfe vor Humboldt

Nicht erst Humboldt nutzte die räumliche Darstellung, bei der Grund- und Aufriss respektive Schnitt verbunden werden, auch für die Kartographie. So wurden etwa auf Seekarten spätestens vom 16. Jahrhundert an und bis in das 18. Jahrhundert hinein Aufsichten und topographische Ansichten des Höhenreliefs miteinander verknüpft.[24] Meist gehorchte hierbei, anders als später in Humboldts Vertikalprojektionen, nur die in der Aufsicht aufgenommene Landkarte mathematischen Projektionsregeln, wohingegen die sogenannten Vertonungen freier und oft illusionistisch aufgenommene Küstenansichten zeigten. Sie wurden den Aufsichten als separate Blätter beigefügt oder direkt ins Kartenfeld montiert und dienten vor allem dazu, die Orientierung der nautischen Navigation in Ufernähe zu erleichtern.[25]

Erste virtuelle Querschnitte durch die Erdoberfläche lassen sich dagegen in Karten des 18. Jahrhunderts nachweisen. Als geologisch orientierte Schnittdarstellungen wurden sie meist gemeinsam mit Aufsichten auf die Erdoberfläche präsentiert. So treten auch in dem 1780 in Paris erschienenen *Atlas et description minéralogiques de la France* beide Darstellungsweisen konsequent zusammen.[26] Die 31 Karten zeigen die flächige Verteilung mineralogischer bzw. geologischer Zonen Frankreichs in der Aufsicht in Kombination mit entsprechenden Schnitten durch die Erdoberfläche, teilweise auch mit perspektivischen Ansichten der Gegend (Abb. 26). Alle Tafeln des Atlas gehorchen einer sich entsprechenden, dreiteiligen Gliederung des Blattes: Ein mittlerer, die Kartenfläche dominierender Part zeigt in großflächiger Aufsicht eine Region Frankreichs, links und rechts wird sie von zwei schmalen, hochformatigen Rechtecken flankiert. Diese enthalten neben einer Le-

24 Zu der Entstehung dieser Kombination vgl. Pápay: Art. „Kartographie und Abbildung", 2014, S. 190–191.

25 Auch eine von Humboldts Karten zeigt eine Vertonung. Es handelt sich dabei um die Tafel 11 des *Atlas de la Nouvelle-Espagne*, die auf eine Karte von F. Wittich zurückgeht. Eine umfassende und anwendungsorientierte Nutzung von Vertonungen stellen die auf James Cooks Reise aufgenommenen Ansichten und Landkarten dar. Eine umfassende Übersicht bietet *The Charts and Coastal Views of Captain Cook's Voyages*, hg. von Andrew David, London: The Hakluyt Society in association with the Australian Academy of the Humanities 1988, Bd. 1: *The Voyage of the Endeavour 1768–1771*. Zur Entwicklung der Seekarte vgl. Gierloff-Emden, Hans-Günter: *Geographie des Meeres: Ozeane und Küsten*, Bd. 1, Berlin: de Gruyter 1980, S. 255–288.

26 Vgl. Guettard, Jean-Etienne/Monnet, Antoine Grimoald: *Atlas et description minéralogiques de la France*, Paris: Didot/Desnos/Alexandre Jombert 1780. Der Atlas enthält neben den Karten einen ausführlichen Textteil. Vgl. zur Bewertung des Atlas in der Fachgeschichte der Geologie Rudwick: „A Visual Language for Geological Science", 1976, S. 160.

26__Jean-Etienne Guettard/Antoine Grimoald Monnet, *Carte mineralogique d'un partie de la Picardie*, 1780, in: *Atlas et description minéralogiques de la France*, Folio, Tafel 9

gende der Aufsicht auch Schnitte durch die Erdoberfläche, in denen Gesteinsabfolgen zu schmalen Kolonnen aufgetürmt sind. Bisweilen werden diese geologischen Säulen zusätzlich durch breitere Profilschnitte ergänzt, wodurch eine umfassendere Einsicht in die Lage und Anordnung der oberen Gesteinsschichten gewährt wird.[27] Diesem Format folgend, erfassen die Tafeln des Atlas die gesamte Fläche Frankreichs nach mineralogischen Kriterien.

Trotz der Kombination von Aufsicht und Profilansicht derselben Regionen läuft die kartographische Darstellung im *Atlas et description minéralogiques de la France* aber einer

27 Siehe Rudwick: „A Visual Language for Geological Science", 1976, S. 164–166. Rudwick unterscheidet zwischen „Säulenschnitt" („columnar section") und „Querschnitt" („traverse section"). Bei beiden geologischen Darstellungsweisen handelt es sich um virtuelle, generalisierende Vertikalschnitte durch die Erdoberfläche und in diesem Sinne um Gedankenexperimente, die stets auch von theoretischen Annahmen ausgehen, von empirischen Daten abstrahieren und die individuellen Gesteinsformationen unberücksichtigt lassen. Während die Traverse die topographische Oberflächenstruktur mit aufnimmt, stellt die Säulendarstellung eine Abfolge von Gesteinsschichten aus einer bestimmten Region in ihrer Reihenfolge sowie in ihrer relativen Ausdehnung dar.

tatsächlichen räumlichen Erfassung der Erdoberfläche entgegen und unterscheidet sich damit deutlich von Humboldts Ansinnen, denn, wie Martin Rudwick feststellt,

> the generalized columnar sections are not accompanied by any attempt to construct a *traverse* section and thereby to integrate the vertical succession of strata with the horizontally extended features of the topographical surface. Significantly, even where a carefully measured profile traverse of the topography was included, no attempt was made to extrapolate the evidence of surface exposures downwards into any kind of structural section [...].[28]

Statt also von der präzisen topographischen Einzelbeobachtung des Terrains auszugehen, wird im *Atlas et description minéralogiques* eine geologische, in die Fläche abstrahierende Klassifikation Frankreichs vorgenommen. Obwohl der mineralogische Atlas dabei, wie auch Humboldts *Atlas géographique et physique du Nouveau Continent*, dreidimensionale Imaginationen des terrestrischen Raumes liefert, setzt er letztlich andere heuristische Maßstäbe an die Darstellungen an: Während in Humboldts Atlas induktiv gewonnene geographische Einzelbeobachtungen zu einem allgemeinen räumlichen Schema zusammengeführt werden, ist der mineralogische Atlas Frankreichs deduktiv organisiert. Ihm gingen klassifikatorische Überlegungen voraus, nach denen die Einteilung der Regionen vorgenommen wurde. Dieses unterschiedliche Vorgehen hat Konsequenzen für das heuristische Potential, mit dem die dreidimensionale Darstellung in beiden Fällen verbunden ist: Während sie im *Atlas géographique et physique du Nouveau Continent* wesentlich zur vollen Erfassung und Beurteilung der einzelnen Themen der Karten beiträgt, bietet der Erdschnitt im *Atlas et description minéralogiques* zwar die Voraussetzung dafür, eine klassifikatorische Einteilung des geographischen Raumes vornehmen und vorführen zu können – schließlich sind die geologischen Regionen Thema des Bandes –, das Verständnis vom räumliche Aufbau bildet aber nicht das eigentliche Erkenntnisinteresse. Gegenüber der zonalen Einteilung sind die spezifische Ausprägung des Reliefs und die räumliche Beschaffenheit der Topographie zweitrangig. Anders als in Humboldts Atlas zielen die Karten im mineralogischen Atlas also nicht auf die dreidimensionale Beschaffenheit selbst, sondern auf eine von der Vertikalen aus in die Fläche einer geographischen Region abstrahierende Generalisierung.

Mit dem räumlichen Schema, das die Organisation der Karten in Humboldts Atlas bestimmt und als Verbund verständlich macht, rückt er stattdessen in die Nähe einer Kartographie, wie sie der Franzose Philippe Buache (1700–1773) Mitte des 18. Jahrhunderts entwarf.[29] Bevor Buache sich der Geographie zuwandte, war er zum Mathematiker und

28 Ebd., S. 166–167 [Kursivierung im Original].

29 Zum Verhältnis von Buaches und Humboldts Theorien vgl. Debarbieux: „Mountains between corporal experience and pure rationality", 2009. Humboldts Kenntnis von Philippe Buaches Werk bleibt allerdings unklar, denn Debarbieux unterläuft eine Verwechselung. Er bezieht eine Passage aus Humboldts *Relation historique* auf eine Karte Philippe Buaches (1700–1773). Von Humboldt gemeint war indes eine

Architekten ausgebildet worden. Seiner gestalterischen Prägung nach hatte er also zunächst konkrete räumliche Entwurfs- und Konstruktionszeichnungen angefertigt und erst später Karten. In diesem Werdegang mag begründet liegen, dass Buaches Kartographie von einer intensiven Auseinandersetzung mit dreidimensionalen Darstellungsweisen geprägt ist, in denen sich geodätische Messtechnik und virtuelle geographische Imaginationen zu komplexen Raumstrukturen verbinden. Ebenso wie Humboldt beabsichtigte Buache, das topographische Relief möglichst weiträumig systematisch zu erschließen. Anders aber als Humboldt ließ Buache im Medium der Karte in hohem Maße spekulative topographische Ansichten einer wohlstrukturierten Erdoberfläche entstehen.[30]

Buaches dreidimensionalen Entwürfe sind bisweilen von einem äußerst experimentellen Charakter und zeigen nicht nur Profile von Kontinentalmassen, sondern auch von ausgedehnten Meerestiefen. Eine dieser Raumkonstruktionen findet sich in der *Carte de la partie de l'Océan vers l'Equateur entre les côtes D'Afrique et D'Amerique* (im Folgenden *Carte de la partie de l'Océan*) von 1737 (Abb. 27).[31] Auf ihr diskutierte Buache anhand des Ozeanabschnitts zwischen der afrikanischen und der amerikanischen Küste die dortige Beschaffenheit des Meeresbodens und, damit verbunden, des Strömungsverhaltens. Zugleich entstand die Karte im Kontext einer generalisierenden Erfassung der ozeanischen Oberfläche.

Die *Carte de la partie de l'Océan* setzt sich aus vier Teilkarten zusammen, wobei es sich um zwei Aufsichten und zwei Profildarstellungen handelt. Eine Diagonale gliedert den gesamten Blattspiegel von links unten nach rechts oben in zwei etwa gleich große Teilbereiche. Während der linke obere Bereich eine Gesamtansicht des anvisierten ozeanischen Gebietes und seiner Inseln zeigt, ist im rechten, unterhalb der Schräglinie befindlichen Teil ein vergrößertes Detail aus dieser ersten Aufsicht, der *Plan de l'Isle de Fernand*

Karte des Neffen von Philippe, dem ebenfalls als Geograph tätigen Jean-Nicolas Buache (1741–1825). Vgl. ebd., S. 90 und die entsprechende Passage bei Humboldt: *Voyage,* Teil 1 *(Relation historique),* Bd. 2, 1819, S. 707–708. Auch in der Tafel 14 seines *Atlas géographique et physique du Nouveau Continents* und in seinem *Examen critique* bezog sich Humboldt statt auf Philippe auf Jean-Nicolas Buache. Da jedoch auch Philippe als königlicher Geograph am französischen Hof im 18. Jahrhundert bedeutende Karten Amerikas und der übrigen Weltteile anfertigte, steht zu vermuten, dass Humboldt während seiner intensiven kartographiehistorischen Auseinandersetzungen auch Teile dieser Karten studierte. Eine kompositorische Nähe lässt sich etwa zwischen Philippe Buaches vergleichender, zum *Essai d'un Parallele des Fleuves de l'Europe* (1752) gehörigen Flusskarte und Humboldts Tafel 13 zu den *Example de Bifurcations et de Deltas d'Affluens* des *Atlas géographique et physique du Nouveau Continent* (Lieferung 5, 1825) ausmachen.

30 Vgl. Debarbieux: „Mountains between corporal experience and pure rationality", 2009, insbesondere S. 104.

31 Buache, Philippe: *Carte de la partie de l'Océan Vers l'Equateur entre les côtes D'Afrique et D'Amerique où la situation des isles, bancs, et vigies montre qu'elles peuvent être soit à la disposition du fonds de la mer, entre les deux continents soit la cause des variétés observées dans les courants de ces mers,* Paris 1737, 64 × 48 cm, Maßstab ca. 1 : 13 500 000.

27__Philippe Buache, *Carte de la partie de l'Océan Vers l'Equateur entre les côtes D'Afrique et D'Amérique*, 64 × 48 cm, 1737

de Noronha, zu sehen. Beide Aufsichten werden um zwei vignettenartig eingefügte Profil-schnitte ergänzt, wobei der eine eindeutig der Inselaufsicht zugeordnet ist, während der andere im rechten oberen Bereich der Karte die trennende Diagonale kompositorisch unterbricht und beiden Aufsichten zuzurechnen ist. Auf diesem oberen, geographisch weit aufgespannten Profil wird der Meeresboden an jener Stelle in der Vertikale aufge-nommen, an der die Küsten des amerikanischen und des afrikanischen Kontinents die geringste Entfernung zueinander aufweisen. Anhand einer Punktlinie, der „Linie des tra-versen Schnittes"[32], die in die obere Aufsicht eingefügt ist, lässt sie die vertikale Ansicht darin geographisch verorten. Das zweite Profil auf dem Blatt wiederum, das in die rechte untere Ecke der Karte montiert der Aufsicht der Isle de Fernand de Noronha zugeordnet ist, zeigt ebenfalls einen bis zum Meeresgrund reichenden Querschnitt, hier nun jedoch einen, der lediglich durch die Brasilien vorgelagerte Insel verläuft. Auch dieses Profil lässt sich dank einer entsprechend eingefügten Punktlinie, nun in der unteren Aufsicht der *Carte de la partie de l'Océan*, lokalisieren.

32 Im Original: „Ligne de la Coupe de cette traversée dont la direction forme un Angle de 30 a 35 deg avec l'Equateur".

Der genaue Blick auf diese topographischen Aufnahmen zeigt, dass sie gezielt inszeniert und verzerrt wurden, um eine bestimmte Argumentation zu stützen: So integrierte Buache etwa in den oberen, weiträumigen Profilschnitt des gesamten Ozeans die Insel Fernand de Noronha, obwohl sich diese eigentlich abseits der als Punktlinie eingezeichneten „Linie des traversen Schnitts" befand. Doch erst durch diese Anpassung der geographischen Darstellung lässt sich die Insel als thematischer Angelpunkt und damit als zentrales Argument für eine bestimmte Beschaffenheit des Meeresgrundes anführen. Auch in den Teilkarten, die der Insel zugeordnet sind, richtet sich die topographische Darstellung nicht nach festgelegten Projektionsregeln, sondern nach der Argumentation der Gesamtkarte. Statt darin etwa das Profil der Insel aus dem Süden aufzunehmen, wie die genordete Aufsicht vermuten lassen würde, entschied sich Buache für einen südwestlichen Standpunkt. Aufgrund dessen geraten die sich weit erstreckenden Sandbänke, die der Insel nördlich vorgelagert sind, in den Blick. Zudem transformierte Buache den Schnitt in eine teilperspektivische Ansicht, indem er ihn an der Meeresoberfläche leicht nach hinten kippen ließ und den Blick auf einen Teil der Meeresoberfläche – einen von Wellen bewegten Ozean mit der aus ihm aufragenden, nordöstlichen Landzunge der Insel Fernand de Noronha und deren Nachbarinsel – freigab. Diese topographische Inszenierung auf der *Carte de la partie de l'Océan* diente, um Buaches Diskussion einer regelhaften Verteilung von Bergmassiven auf dem Erdball zu stützen, in die er die Struktur des Meeresbodens mit einbezog. In diesem Kontext sollte die *Carte de la partie de l'Océan*, wie ihr randständiger Kommentar verrät, mit ihren kombinierten Ansichten eine exemplarische Einsicht in den strukturellen Aufbau des Meeresgrundes, die aus ihm aufragenden Inseln sowie das daraus resultierenden Strömungsverhalten liefern.[33]

Gegenüber Humboldts dreidimensionaler Präsentation des topographischen Raumes, wie er sie in seinem *Atlas géographique et physique du Nouveau Continent* ausgehend von sehr präzisen und regelgeleiteten Einzelkartierungen umsetzte, sind Buaches Raummodellierungen deutlich spekulativer. Einen wesentlichen Teil der Argumentation stellte hierbei nicht sichtbares ozeanisches Terrain dar. Humboldts Karten und die durch ihre Kombination erzeugte dreidimensionale Evokation der Erdkruste beruhten dagegen auf methodisch angeleiteten Projektionsmethoden, die sowohl auf möglichst genauen geographischen Messdaten als auch auf einer morphologisch orientierten Beobachtungspraxis basierten. Auf dieser Grundlage erarbeitete Humboldt strenge graphische Vorga-

33 Wie bei Humboldt, so war auch bei Buache diese Kenntnis kein Selbstzweck. Aus ihr, so erhoffte sich Buache, könnten beispielsweise Meeresströmungen abgeleitet werden. Zudem ließ sich historisches Wissen generieren: In einer Zeit, als die Nautik noch deutlich größeren Schwierigkeiten ausgesetzt gewesen sei, so Buache, hätten nicht zuletzt kulturelle Austauschprozesse von derartigen Phänomenen wie der Strömung des Meeres abgehangen. Vgl. den randständigen Kommentar zur Karte, in dem es heißt: „Les suites d'Isles [,] de Bancs & c. montreront de même com[m]ent ces Peuplades on pupasser par Mer, d'un continent dans un autre lorsque la Navigation ctoit encore grossiere."

ben für seine Karten, die den zugrunde liegenden Daten ebenso wie der Wiedergabe der individuellen Physiognomie gerecht werden sollten. Derart transparenten, datengestützten Vorgaben entziehen sich Buaches spekulative Profile des Meeres und sein freies, argumentativ zugespitztes Zusammenspiel der Ansichten. Aber auch bei einer Evokation von Räumlichkeit, wie sie sich im *Atlas et description minéralogiques* oder in den Vertonungen auf Seekarten finden, lässt sich eine Fokussierung auf die schematische Beschreibung des topographischen Reliefs nicht mit einer heuristischen Dringlichkeit finden, wie Humboldt sie in seinem *Atlas géographique et physique du Nouveau Continent* verfolgte.

Verknüpfendes Sehen II: Hypothesen zur Erdentstehung

Vulkankarten

Neben einer Evokation der dreidimensionalen Beschaffenheit der Erdoberfläche zielte Humboldts systematische Zusammenschau verschiedener Kartentypen im *Atlas géographique et physique du Nouveau Continent* auf eine weitere Erkenntnis: die der vulkanischen Erdentstehung. Sie wurde dadurch thematisiert, dass in den einzelnen Lieferungen nicht nur Profil- und Flächenprojektion zusammentraten, sondern sich überdies eine der Karten mit einem vulkanologischen Thema auseinandersetzte.[34] Hierdurch verknüpfte sich das medial inszenierte Raumprinzip mit einer Prozessualität, die auf das sukzessive Gewordensein des topographischen Raumgefüges verwies und die Aktivität der Erdoberfläche selbst in den Blick geraten ließ.

Im engeren Sinne handelt es sich bei fünf Karten in Humboldts Atlas, den Tafeln 26 bis 30, um vulkanologische Karten. Die vier Aufsichts- und eine Profilkarte verteilte Humboldt jeweils auf unterschiedliche Lieferungen.[35] Ihrer heuristischen Zielsetzung nach unterscheidet sich die Gruppe der vulkanischen Karten deutlich von den übrigen Karten des Atlas. Dies zeigt sich vor allem im Vergleich der Profilkarten: Gegenüber denen, die den Atlas eröffnen, ist diejenige der vulkanologischen Gruppe sowohl inhaltlich anders ausgerichtet als auch kompositorisch abweichend organisiert. Statt wie die Höhenkarten Humboldts verschiedene Gipfel zu virtuellen Höhenprofilen zu verbinden, stellt das vulkanologische Profil einen konkreten Schnitt durch einen Vulkan dar.[36] Mit dieser

34 Die Tafel 9, die mit der Lieferung 5 herausgegeben wurde, kann hier als Ersatz für eine Karte aus der vulkanologischen Themengruppe gewertet werden. Vgl. in der vorliegenden Untersuchung das Kapitel *Das konzeptionelle Gerüst. Themenbereiche, Aufbau und Publikationsweise des* Atlas géographique et physique du Nouveau Continent, Fußnote 48.

35 Die vulkanologischen Karten bilden damit die dritte und letzte thematische Abteilung der anfangs für den Atlas vorgesehenen 30 Tafeln. Vgl. das Unterkapitel *Publikationsprozess* der vorliegenden Untersuchung.

36 Die Tafel 9 nimmt kompositorisch eine Zwischenstellung ein. Zwar ist dieses Profil des Chimborazo der ersten Gruppe zugeordnet, lässt sich aber weder ganz der Höhenkarte noch dem vulkanologischen

Verschiebung des Fokus auf die individuelle Ansicht eines bestimmten Gipfels – genauer: eines Vulkans – ist eine heuristische Neujustierung verbunden, die auch die vulkanologischen Aufsichtskarten betrifft und diese Kartengruppe innerhalb des Atlas klar von den anderen Karten trennt: Während deren topographischen Aufnahmen stets zu anderen Fragestellungen, etwa der der Pflanzenverbreitung in der Höhe oder der des Flusses als Transportweg von Rohstoffen, überleiteten, steht bei der Kartierung der Vulkane das dargestellte Naturphänomen selbst im Zentrum der kartographisch geführten Diskussion.

Humboldts geologische Überlegungen im zeitgenössischen Kontext

Das hier sinnfällig werdende, besondere Interesse Humboldts an vulkanologischen Fragestellungen entstand von dem Hintergrund einer seit dem 18. Jahrhundert deutlich wachsenden Auseinandersetzung mit geologischen Prozessen. Seit der Aufklärung näherten sich die sich langsam ausdifferenzierenden Spezialwissenschaften nach und nach und aus unterschiedlichen Blickwinkeln der Natur als einem vom Menschen unabhängigen Forschungsgegenstand an. Im Zuge dessen wurde auch die Erdentstehung zu einem bestimmenden Thema, das bald hitzige Debatten auslöste. Um 1800 rieb sich die Wissenschaft etwa an Überlegungen auf, ob und inwiefern vulkanische Aktivität für das Gewordensein der Erdkruste mitverantwortlich sei. Vulkane und Vulkanismus wurden nun „zunehmend als Teil des Ganzen der Natur gesehen, wobei ‚Natur' wie kein anderer Begriff der Zeit ein Versprechen der Sinnfülle"[37] enthielt. „Wie unergründlich auch immer die Natur im Vulkan erscheint – man vertraut ihr und auch den in ihr wirkenden Kräften. Dem leisten die Begegnungen mit aktiven Vulkanen Vorschub."[38]

Die konkrete Beschäftigung mit Vulkanen ebenso wie die allgemeine geologische Theoriebildung jener Zeit entwickelte sich in engem Bezug auf die damaligen wissensgeschichtlichen Entwicklungen, mit denen sich insgesamt eine veränderte Wahrnehmung von der Zeitlichkeit historischer Prozesse herausbildete. Diese Wende zur Verzeitlichung ging mit der Beschleunigung des weltweiten Wissenszuwachses zusammen, der die *terra incognita* in rasantem Tempo kleiner werden, Datenmengen hingegen wachsen ließ: In einer weltumspannenden Vernetzung schien der Raum dank der schnelleren Überwindung von räumlichen Entfernungen immer weiter zu schrumpfen, zugleich stieg das quantitative Wissen über die Erde deutlich an.[39] Raumvorstellungen verdichteten sich,

Schnitt zuordnen: Stärker als die anderen Profile changiert es zwischen den diagrammatischen Konstruktionsregeln der Höhenkarte, indem seine Gipfelkurve ein idealisiertes Höhenplateau ausprägt, und der physiognomisch individuellen Darstellung des Vulkanbergs Chimborazo. Daher kann es in der Lieferung 5 die vulkanologische Karte thematisch substituieren.

37 Thüsen, Joachim von der: *Schönheit und Schrecken der Vulkane. Zur Kulturgeschichte des Vulkanismus*, Darmstadt: Wissenschaftliche Buchgesellschaft 2008, S. 7.

38 Ebd.

39 Siehe Haberkorn, Michaela: *Naturhistoriker und Zeitseher. Geologie und Poesie um 1800. Der Kreis um Abraham Gottlob Werner*, Frankfurt am Main: Peter Lang 2004, S. 65.

während zeitliche Prozesse nicht mehr als Kontinuum eines einzigen fortlaufenden Stranges wahrgenommen wurden.[40] Diese veränderte Wahrnehmung beförderte auch ein neues Verständnis von der Naturgeschichte. Damit war die Herausforderung verbunden, die vielfältigen, ineinandergreifenden Entwicklungs- und Wirkungsprozesse in der Natur zu eruieren.

In dieser Zeit der wissenschaftlichen Neuorientierung, die bisweilen auch Verunsicherung auslöste, wurden genaue Beobachtungen zum Gradmesser für den Nachweis sicherer Erkenntnisse. Hierdurch gerieten die Wissenschaften unter einen Erfahrungsdruck, der von einer Empirisierungswelle begleitet wurde. Diese empirischen Beobachtungen führten um 1800 dazu, dass sich geschichtliche Denk- und Repräsentationsweisen in den Wissenschaften gegenüber räumlichen Vorstellungen etablieren konnten.[41] Während also, wie Wolfgang Lepenies betont, die „Verräumlichung […] eine vormoderne Technik dar[stellt]; [tritt] im Übergang vom 18. zum 19. Jahrhundert […] an ihre Stelle die Verzeitlichung komplexer Informationsbestände"[42]. Teil dieser wissensgeschichtlichen Neuausrichtung war es, dass sich die Fachrichtung der Geologie herausbildete. Sie behandelte die Fragen der Erdentstehung, anders als bis noch in das 18. Jahrhundert hinein geschehen, nun in Abhängigkeit von Fragen des dynamischen Kräftegefüges der Natur.[43]

Empirismus versus Historisierungsbestreben

Auch für Humboldt stellte die Empirie die methodologische Leitlinie seiner Wissenschaft dar, die er – und vielleicht in besonderem Maße, wie aus den vulkanologischen Karten des *Atlas géographique et physique du Nouveau Continent* gefolgert werden kann – unter anderem an seine geologischen Überlegungen anlegte und aus der möglichst genauen Beschreibung der räumlichen Verhältnisse deduzierte. Mit geologischen Fragestellungen begann Humboldt sich schon früh auseinanderzusetzen; er gehörte zu den ersten, die Berge, darunter Vulkane, wissenschaftlich visualisierten und klassifizierten.[44] In seinem 1802 angestellten und später vielbeachteten Versuch, den inaktiven Vulkan Chimborazo

40 Nun boten Darstellungsformate, die determinierte chronologische Abfolgen entwarfen, keine adäquate Lösung mehr für eine Visualisierung von naturgeschichtlichen Zusammenhängen. An ihre Stelle traten verzweigte wissenschaftliche Ordnungen, die eine entwicklungsgeschichtliche Denkweise auf den Weg brachten. Siehe Lepenies: *Das Ende der Naturgeschichte*, 1976, S. 12–13; vgl. ferner Maatsch, Jonas: *„Naturgeschichte der Philosopheme". Frühromantische Wissensordnungen im Kontext*, Heidelberg: Winter 2008.

41 Vgl. Lepenies: *Das Ende der Naturgeschichte*, 1976, S. 16–18.

42 Ebd., S. 18.

43 Erste Karten zur Erdschichte sind aus der Mitte des 18. Jahrhunderts bekannt. Auf ihnen wurden empirische Beobachtungen festgehalten, auf deren Basis sukzessive Hypothesen über die geologische Entwicklung der Erde angestellt wurden. Gegen Ende des Jahrhunderts verbreitete sich dieser Kartentypus immer stärker. Siehe Rudwick: „A Visual Language for Geological Science", 1976, S. 159. Vgl. ferner Haberkorn, Michaela: *Naturhistoriker und Zeitseher*, 2004, 66–67.

44 Siehe Debarbieux: „The Various Figures of Mountains", 2012, o. S., Absatz 9–13.

erstmals zu besteigen, verbindet sich geologisches Interesse mit praktiziertem Empirismus. Dieses Ereignis, das Humboldt sowohl hinsichtlich seines naturkundlichen Wissens als auch seiner physischen Belastbarkeit an die Grenzen führte, wurde nicht nur für ihn selbst, sondern auch in Berichten über ihn zu einem der wesentlichen Motive, die herangezogen wurden, um seine wissenschaftliche Arbeit zu charakterisieren.[45]

Geologische Überlegungen und Empirisierungsbestreben prägen auch den *Atlas géographique et physique du Nouveau Continent*. In der deskriptiven Darstellungsweise der vulkanologischen Karten spiegelt sich der Wille einer möglichst genauen Beobachtungspraxis. Die stellte die Voraussetzung für eine überzeugende wissenschaftliche Argumentation dar, die in besonderem Maße für eine derart umstrittene These wie die Erdentstehung gefordert war. Mit den Darstellungen konkreter Vulkane versuchte Humboldt offenbar, der anhaltenden fachlichen Brisanz zu begegnen: Die genaue, auf Empirie basierende Beobachtung sprach vermeintlich für sich selbst. Zugleich mag in Humboldts Entscheidung, bei den Vulkankarten von der möglichst genauen Darstellung des Einzelphänomens auszugehen, auch seine eigene Unsicherheit hinsichtlich dieses Themenkomplexes aufscheinen.[46] Noch zu Beginn seiner wissenschaftlichen Laufbahn hatte er die Formation der Erdkruste gemäß einer Genese, die sie über die Ablagerung aus dem Meer erklärte, als eher statisch aufgefasst. Mit den auf der Amerikanischen Reise angestellten Beobachtungen revidierte Humboldt aber seine neptunistische Position, wie sie sein Lehrer an der Freiberger Bergakademie, Abraham Gottlob Werner (1749–1817), vertreten hatte. Von ihm hatte Humboldt früh den Impetus einer genauen, induktiven Betrachtung übernommen, gelangte dann allerdings gerade auf der Grundlage dieser Leitlinie zu Erkenntnissen, die denen seines Lehrers prinzipiell widersprachen.[47] Denn Humboldts selbst angestellten Naturbeobachtungen brachten ihn, ebenso wie die aufkommende Paläontologie, der Überzeugung näher, dass – wie er später im *Kosmos* schreibt – das

> Seiende [...] aber, im Begreifen der Natur, nicht von dem *Werden* absolut zu scheiden [ist]: denn nicht das Organische allein ist ununterbrochen im Werden und Untergehen begriffen, das ganze Erdenleben

45 Vgl. u. a. den kommentierten Primärtext Humboldt: *Ueber einen Versuch den Gipfel des Chimborazo zu ersteigen*, 2006.

46 Humboldts Thesen zur Erdentstehung reichten offenbar noch nicht so weit, dass er eine verallgemeinernde Deduktion von der empirischen Beobachtung vorgenommen hätte. Diese Unsicherheit wird im *Atlas géographique et physique du Nouveau Continent* anhand der thematischen Unterscheidung deutlich, die Humboldt zwischen einer physisch-geognostisch und einer vulkanologisch orientierten Kartengruppe einzog. Auch die einzige Formationskarte des Atlas, die *Esquisse géognostique des formations entre la Vallée de Mexico, Moran et Totonilco*, Tafel 7 des Atlas, die konkrete Gesteinsschichten visualisiert, findet sich nicht etwa in der vulkanologischen, sondern in jener ersten Kartengruppe der allgemeinen geognostischen Phänomene. Eine solche Karte zu der Abfolge von Gesteinsablagerungen in die Gruppe der vulkanologischen Karten einzugliedern, hätte bedeutet, die Entstehung der Schichten eindeutig in eine bestimmte erdgeschichtliche Narration einzuordnen.

47 Vgl. Wilhelmy: „Humboldts südamerikanische Reise", 1986, S. 193.

mahnt, in jedem Stadium seiner Existenz, an die früher durchlaufenen Zustände. So enthalten die über einander gelagerten Steinschichten, aus denen der größere Theil der äußeren Erdrinde besteht, die Spuren einer fast gänzlich untergegangenen Schöpfung; sie verkünden eine Reihe von Bildungen, die sich gruppenweise ersetzt haben; sie entfalten dem Blick des Beobachters gleichzeitig im Raume die *Faunen* und *Floren* der verflossenen Jahrtausende. In diesem Sinne wären *Naturbeschreibung* und *Naturgeschichte* nicht gänzlich von einander zu trennen. Der Geognost kann die Gegenwart nicht ohne die Vergangenheit fassen.[48]

Aufgrund seiner Beobachtungen überzeugte sich Humboldt von der Annahme, dass die Gesteinsschichten einer Bewegung ausgesetzt wären, deren Analyse Aufschluss über das historische Werden der Erdformationen lieferte. Diese Forschungsergebnisse durch empirische Beobachtungen stützend, wollte er sich dezidiert von spekulativen geologischen Theorien des 17. und 18. Jahrhunderts abgrenzen, wie sie etwa der Jesuit Athanasius Kircher (1602–1680) in seinem Werk *Mundus subterraneus* von 1664 entworfen hatte.[49] Auf solche Theoriegebäude bezogen bemerkte Humboldt, man habe sich

> von jeher mehr damit beschäftigt, über die Entstehung der Dinge nachzusinnen, als ihre gegenwärtige [sic] Verhältnisse genau zu erforschen. Daher unsere Dürftigkeit an sichern Beobachtungen über Schichtung und Lagerung der Gebirgsmassen […]![50]

Diese „sichern Beobachtungen" meinte Humboldt vor allem durch die möglichst genaue Beschreibung von Vulkane erlangen zu können, die für ihn den entscheidenden Schlüssel zum Verständnis der Erdgeschichte lieferten. Die Bewegung der Erdkruste und die damit verbundenen Veränderungen des topographischen Gefüges könnten, so Humboldt, zumindest teilweise auf vulkanische Aktivität zurückgeführt werden. Vulkane stellten damit für ihn ein verbindendes Glied zwischen dem Beobachtbaren des Seienden und der Geschichte der Erdkruste her. Einer generellen Verzeitlichung der Naturgeschichte kamen seine Überlegungen dennoch nicht gleich.[51] Diesen Theorien begegnete Humboldt nach wie vor vorsichtig, weil sie nur schwer ganz mit empirischen Grundsätzen in Einklang zu

48 Humboldt: *Kosmos*, Bd. 1, 1845, S. 63–64.

49 Vgl. zu spekulativen Überlegungen in der Geologie Wagenbreth: *Geschichte der Geologie in Deutschland*, 1999, S. 22–25. Humboldts Kritik zielte vermutlich u. a. auf die großen erdgeschichtlichen Entwürfe, wie sie Descartes *Principia Philosophiae* (1644), Burnets *Sacred Theory of the Earth* (1681–1690), Leibniz *Protogaea* (1693) und Buffons *Époques de la nature* (1779) darstellten. Siehe dazu Helmreich, Christian: „Geschichte der Natur bei Humboldt", *HiN* X (2009) 18, S. 53–67, hier S. 57.

50 Humboldt, Alexander von: *Versuche über die chemische Zerlegung des Luftkreises und über einige andere Gegenstände der Naturlehre*, Braunschweig: Friedrich Vieweg 1799, S. 179.

51 Zur „Verzeitlichung der Naturgeschichte" vgl. Lepenies: *Das Ende der Naturgeschichte*, 1976, insbesondere S. 24. Für eine Übersicht über diesen Historisierungsprozess im Bereich der Geologie und Paläontologie vgl. Rudwick, Martin J. S.: *Bursting the Limits of Time: The Reconstruction of Geohistory in the Age of Revolution*, Chicago: University of Chicago Press, 2005; Flügel, Helmut W.: *Der Abgrund der Zeit: Die Entwicklung der Geohistorik 1670–1830*, Berlin/Diepholz: Verlag für Geschichte der Naturwissenschaften und Technik 2004.

bringen waren: Vergangene Geschehnisse konnten auf dem Wege der Beobachtung lediglich als Resultate von Prozessen dokumentiert werden, eine sich über Jahrtausende erstreckende Entstehungsgeschichte ließ sich hingegen nicht belegen.

Dass letztlich auch seine eigenen Beobachtungen von Ambivalenzen durchsetzt waren und sich die Beschreibung des Seienden für ihn nicht gänzlich von der des Werdenden trennen ließ, blieb Humboldt selbst nicht verborgen:

> In das empirische Gebiet objectiver sinnlicher Betrachtung, in die Schilderung des *Gewordenen*, des dermaligen Zustandes unsres Planeten gehören nicht die geheimnißvollen und ungelösten Probleme des *Werdens*. Die *Weltbeschreibung*, nüchtern an die Realität gefesselt, bleibt nicht aus Schüchternheit, sondern nach der Natur ihres Inhaltes und ihrer Begrenzung, den dunkeln Anfängen einer *Geschichte der Organismen* fremd, wenn das Wort *Geschichte* hier in seinem gebräuchlichsten Sinne genommen wird.[52]

Wie sich in dieser Aussage bereits andeutet, führte auch Humboldt die Beschreibung des Seienden letztlich zu Hypothesen über natürliche Prozesse, die sich ihrer langzeitigen Intervalle wegen der empirischen Beobachtung entzogen. Im zweiten Band des *Kosmos* formulierte er ein auf diese Weise erlangtes Wissen schließlich als Möglichkeit einer Erkenntnis generierenden Option, wenngleich er sie im Duktus des ex negativo, d. h. als eine Leerstelle dessen beschrieb, was wissenschaftlich noch zu zeigen wäre: „Unsere Kenntniß von der Urzeit der physikalischen Weltgeschichte reicht nicht hoch genug hinauf, um das jetzt Daseiende als etwas Werdendes zu schildern."[53] In dieser deutlich markierten, in der Zukunft mutmaßlich zu füllenden Wissenslücke kommt diejenige Ambivalenz zum Ausdruck, die Humboldts Verhältnis zum Werdenden an vielen Stellen kennzeichnet.

Ihre sinnfällige Spiegelung findet diese Ambivalenz in den auf individuellen Darstellungen fußenden Vulkankarten des *Atlas géographique et physique du Nouveau Continent*. Diese bildeten dank der individuell umgesetzten graphischen Erfassung eine Brücke, mit der die Geschichte der Natur mit den Grundsätzen der empirischen Methode in Einklang gebracht werden konnte und von der Humboldt sich ein Korrektiv gegenüber rein hypothetischen geologischen Überlegungen versprach.

Indem Humboldt die vulkanologischen Karten in jedem Lieferungskonvolut mit dem räumlichen Konzept der Aufsichts- und Profilkarten gezielt zusammenführte, wurde im Atlas eine entsprechende Abhängigkeit suggeriert. Dass die Aktivität der Erdkruste und die Gestalt der Erdkruste zusammenhingen, ließ sich auf diese Weise vorschlagen, ohne dass Humboldt dabei vom deskriptiven Ansatz einer „physischen Weltbeschreibung" abrücken musste. Der Atlas blieb damit aufgrund der einzelnen, darunter die vulkanologischen Beobachtungen dem deskriptiven naturwissenschaftlichen Studium der Natur

52 Humboldt: *Kosmos*, Bd. 1, 1845, S. 367.
53 Humboldt: *Kosmos*, Bd. 3, 1850, S. 25.

verpflichtet, und vermied es, eine Geschichte der Natur klar zu umreißen.[54] Sehr wohl impliziert die mit den Vulkankarten aufgerufene Zeitlichkeit zwar prozessuale Veränderungen; die Tafeln verhandeln diese Fragen aber, ohne sie zu explizieren. Die Prozessualität der Erdgeschichte verbleibt damit im Status des Hypothetischen. Die systematische Ergänzung des in den Lieferungskonvoluten evozierten räumlichen Prinzips durch vulkanologische Karten im *Atlas géographique et physique du Nouveau Continent* schlägt somit eine Historisierung der Erde vor, ohne sie in einem definiten Narrativ einzuengen.

Vergleichendes Sehen: das Relief der Erde im Modell

Vergleichen als Methode um 1800

Mit der Wiederholung der Kombination von Profil-, Aufsichts- und Vulkankarten in den Lieferungskonvoluten des *Atlas géographique et physique du Nouveau Continent* gibt sich dessen konzeptionelles Gerüst zu erkennen. Es verweist, wie aufgezeigt, mittels visueller Verknüpfung auf die räumliche Dimension der Erde und ihre (mögliche) Entstehung in der Zeit. Hierbei fungieren die einzelnen Karten des Atlas als Bausteine der Konzeption. Keine von ihnen steht demnach für sich allein, sondern ist neben ihrer themenbezogenen Einzelaussage zugleich Teil eines übergeordneten Ganzen. Ein solches beginnt sich abzuzeichnen, sobald die Lieferungen als seriell organisierte Variationen einer bestimmten Kartenkombination erkannt werden.

Dem Erfassen und Beschreiben dieser Serie geht voraus, dass die einzelnen Lieferungen (Taf. II–VIII) in einen visuellen Vergleich überführt werden, denn erst auf der Basis der miteinander verglichenen Lieferungskonvolute zeichnet sich ab, dass sie demselben Aufbau folgen. Für diesen Vergleich gilt, wie für das Vergleichen im Allgemeinen, dass die Grundstruktur „aus den verglichenen Entitäten (‚*comparata*‘) und einem Vergleichs-Bezug, dem Dritten der Vergleichung (‚*tertium comparationis*‘)"[55], besteht. Das *tertium comparationis* stellt diesbezüglich ein Moment der Überschneidung beider *comparata* dar; bei ihm handelt es sich damit um ein Merkmal, das beiden *comparata* inhärent ist.[56] Auf den *Atlas géographique et physique du Nouveau Continent* bezogen werden diese verglichenen Entitäten von den einzelnen Lieferungskonvoluten gebildet, wobei sich das *tertium comparationis* als wiederkehrende Zusammenstellung bestimmter Kartentypen und

54 Vgl. Hartshorne, Richard: „El concepto de geografía como ciencia del espacio: De Kant y Humboldt a Hettner", *Documents d'Anàlisi Geogràfica* 18 (1991), S. 31–54, hier S. 40–42. Hartshorne weist auf die Nähe von Humboldts und Kants Ansätzen hin: „Tanto Kant como Humboldt se interesaron por la geografía desde los estudios de ciencias naturales, más que desde la historia." Ebd., S. 42.

55 Krause, G./Schenk, A.: Art. „Vergleich", in: *Historisches Wörterbuch der Philosophie*, Bd. 11, Basel: Tinner 2001, Spalte 677–680, hier Spalte 677.

56 Siehe Wolf, Falk: „Demonstration: Einleitung", in: *Vergleichendes Sehen*, 2010, S. 263–272, hier S. 265.

-themen erweist. Durch die als wiederholte Kartenkombination organisierte Serie lässt sich ein gemeinsames Prinzip erkennen, das sich von Lieferung zu Lieferung bestätigt und verfestigt.

Mit dem vergleichenden Sehen ist gegenüber dem verknüpfenden Sehen eine Neujustierung des Blicks und, damit einhergehend, eine andere Erkenntnisleistung verbunden: Während sich bei der Kombination heterogener Kartentypen innerhalb der einzelnen Lieferungskonvolute ein Überschuss des Bildlichen entwickelt, der sich aus dem ergänzenden Nebeneinander mehrerer unterschiedlicher Ansichten, Motive oder Themen ergibt, lässt sich das aus dem Vergleichen deduzierte Wissen demgegenüber als Überblendung beschreiben: Zwei oder mehr Bilder werden auf ihre Differenzen oder Kongruenzen hin befragt, wodurch sich kongruente Bildinhalte heuristisch ineinanderschieben. Durch dieses Verfahren werden die Gruppierungen der Kartentypen des *Atlas géographique et physique du Nouveau Continent* als gemeinsames, sich wiederholendes Moment und die Lieferungskonvolute als Serie erkennbar.[57]

Insgesamt wurde das systematisch angeleitete Vergleichen zu Humboldts Lebzeiten, d.h. um 1800 herum, wissenschaftsgeschichtlich besehen deutlich aufgewertet. Infolge eines Wandels der Episteme im 17. und 18. Jahrhundert etablierte sich eine gezielt vergleichende Konfrontation von Objekten als einflussreiche wissenschaftliche Methode. Dem vergleichenden Denken und Sehen kam nun „ein kaum zu überschätzender Status"[58] zu, mit dem die Analogiebildung des 16. Jahrhunderts verabschiedet wurde. Während diese noch an nicht genau benannten Eigenschaften orientiert gewesen war, setzten sich mit der systematisch vergleichenden Suche nach Kongruenzen und Differenzen von Objekten Klassifikationen durch, die neuen Ordnungsprinzipien folgten und damit fest umrissene Kriterien für den Vergleich statuierten. Auf dieser Basis konnten Ähnlichkeiten von Objekten überprüft und in der Folge entweder bestätigt oder suspendiert werden. Diese regelgeleitete Komparatistik erfüllte zwei wesentliche, an die wissenschaftliche Praxis nach 1800 gestellte Ansprüche, denen die nunmehr verabschiedete Analogiebildung nicht entsprochen hatte: Zum einen konnten wissenschaftliche Teilbereiche inhaltlich klar abgesteckt, zum anderen prinzipiell jedes Objekt über den Vergleich auf der Grundlage der entworfenen Systematik beurteilt, eingeordnet und das wissenschaftliche Feld da-

57 Zu Differenzen und Gemeinsamkeiten im vergleichenden Sehen vgl. Geimer, Peter: „Vergleichendes Sehen oder Gleichheit aus Versehen? Analogie und Differenz in kunsthistorischen Bildvergleichen", in: *Vergleichendes Sehen*, 2010, S. 45–69, hier S. 47–48.

58 Niehr, Klaus: „Experiment und Imagination – Vergleichendes Sehen als Abenteuer", in: *Vergleichendes Sehen*, 2010, S. 71–96, hier S. 74. Die Methode des vergleichenden Sehens wirkt bis heute in verschiedenen akademischen Disziplinen nach, als expliziten methodischen Zugriff benennen es etwa die Kunstgeschichte und die Klassische Archäologie. Vgl. zum Paradigmenwechsel der Wissensordnung die wegweisende Publikation von Foucault, Michel: *Die Ordnung der Dinge: eine Archäologie der Humanwissenschaften*, Frankfurt am Main: Suhrkamp 2017 [französische Erstausgabe: *Les mots et les choses. Une archéologie des sciences humaines*, 1966].

durch verdichtet werden. Auch für Humboldt stellte das Vergleichen weit über den *Atlas géographique et physique du Nouveau Continent* hinaus eine grundlegende Methode dar, die Natur und die in ihr ablaufenden Prozesse zu beschreiben. Einzelbeobachtungen der Natur ließen sich hierdurch in eine präzise epistemologische, ebenso klassifikatorisch organisierte wie ins Globale reichende Beurteilung überführen. Zugleich begünstigte der Vergleich von Naturphänomenen eine von Humboldt nachdrücklich geforderte, genaue empirische Betrachtung, die diesem Verfahren vorausging. Über das detaillierte Inspizieren des Objekts und den anschließenden Vergleich mit schon vorher Beschriebenem ließen sich auch Beobachtungen, die auf noch unbekanntem Territorium angestellt worden waren, an bereits Bekanntem anschließen.[59]

Die mediale Herrichtung der Karten des *Atlas géographique et physique du Nouveau Continent* für den Vergleich

Für den *Atlas géographique et physique du Nouveau Continent* im Speziellen gilt, dass die mediale Herrichtung[60] des Bandes primär aus der Methode des Vergleichens erschlossen werden kann: Erst über das vergleichende Sehen zeichnen sich die sich wiederholenden Strukturen ab, lassen sich differenzieren und schließlich erkennend zu einem systemischen Schema verknüpfen. Der einzelnen Karte oder der einzelnen Lieferung hingegen lässt sich diese Einsicht, die den Karten als Verbund erwächst, noch nicht – oder nur sehr bedingt – abringen. Gleichwohl bereiten die einzelnen Tafeln das vergleichende Sehen bereits vor: Durch Humboldts stark reduzierte Auswahl der Motive (Berge und Flüsse), der Kartentypen (Profil- und Aufsichtskarte) und des Komposits (physiognomisch klar umrissene Naturphänomene, die sich auf monochromem Grund abheben), führt der Atlas insgesamt enge Grenzen des Gezeigten und des sich Zeigenden vor. Thematische und inhaltliche Überschneidungen der Blätter werden mit Hilfe dieser gestalterischen Selektion bereits als mögliche *comparata* gekennzeichnet. So erleichtert etwa die kontrastreiche Linienführung der Flussverläufe und der Höhenlinien den vergleichenden Rezeptionsprozess zwischen den Karten enorm: Im Sinne einer kognitiven Mustererkennung treten Formen und Strukturen hervor, die sich von einer einzelnen Karte bzw. von einer Lieferung zur nächsten im vergleichenden Sehen überlagern und sich einem allgemeinen

59 Bei Humboldts methodischem Vorgehen des Vergleichens lässt sich erneut eine Orientierung am physiognomischen Ansatz Johann Kaspar Lavaters erkennen, der auch für Humboldts naturphysiognomische Theorie eine wichtige theoretische Bezugsgröße darstellt. Lavater hatte in seinen *Physiognomischen Fragmenten* vermerkt, dass „eigentlich alle, alle, alle unsre Urtheile nichts als Vergleichungen, nichts als Klassificationen, nichts als Zusammenhaltung und Verweisung der Aehnlichkeiten einer unbekanntern Sache mit einer bekanntern sind". Lavater, Johann Kaspar: *Physiognomische Fragmente, zur Beförderung der Menschenkenntniss und Menschenliebe: Erster Versuch. Mit vielen Kupfern*, Leipzig/Winterthur: Weidmanns Erben und Reich/Heinrich Steiner und Compagnie, 1775, S. 149.

60 Vgl. Gladić, Mladen/Wolf, Falk, „Guck doch … Kant zum Beispiel. Ästhetik als Übung im vergleichenden Sehen", in: *Vergleichendes Sehen*, 2010, S. 97–114, hier S. 99.

topographischen Schema bereits annähern.[61] Indem also bestimmte Merkmale auf den Karten betont werden, wird eine heuristische Zusammenschau über das Einzelblatt hinweg begünstigt, wodurch die übergeordnete Aussage des Bandes, d. h. das räumlich-zeitlich organisierte Schema der Erdoberfläche, deutlich an kognitiver Zugänglichkeit gewinnt.

Ist dieses Schema dank des verknüpfenden Sehens und des vergleichenden Sehens erkannt, fügt sich die einzelne in der Karte getroffene Überlegung (partiell) in eine allgemeine ein. Aus dem ineinandergreifenden Kartenwissen entsteht auf diese Weise ein alle Karten miteinander verwebendes Sinngefüge. Über das *tertium comparationis* wird dabei ein Kippmoment erzeugt: Sobald im Zusammenspiel der Karten ein ihnen zugrunde liegendes Muster erkannt wird, schlägt das Besondere, d. h. das in der einzelnen Karte separat Aufgenommene, in ein Allgemeines und damit in eine strukturelle und generalisierte Erfassung der Natur um. Der einzelnen Karte, die eine lokale geographische Struktur repräsentiert, ist somit immer auch das deiktische Potential inhärent, etwas Allgemeines zur Ansicht zu bringen.[62]

Ein Reliefmodell aus Karten entsteht

Das allgemeine topographische Prinzip, das sich aus dem Zusammensehen der einzelnen Karten im Atlas entwickelt, generiert eine virtuelle Rahmenkonstruktion, die es ermöglicht, die Kräfte der Natur zu beschreiben; der dreidimensionale Aufbau der Erdkruste in ihrer Höhen- und Flächenausdehnung und ihrer potentiellen Eigendynamik legen den Grundstein für weitere, detaillierte Erkenntnisse über das Zusammenwirken der Kräfte. Das im Atlas entworfene Prinzip lässt sich mithin als virtuelles Modell für die topographische Struktur der Erdoberfläche verstehen und damit als ein „Gebilde, das die inneren Beziehungen und Funktionen von etwas abbildet bzw. (schematisch) veranschaulicht (und vereinfacht, idealisiert)"[63]. Für den *Atlas géographique et physique du Nouveau Con-*

61 Freilich wird das von Humboldt entworfene Modell in den Lieferungen des *Atlas géographique et physique du Nouveau Continent* lediglich umkreist und nicht gänzlich freigelegt: Keine der Lieferungen erweist sich als präzisere oder deutlichere Annäherung an diese Konstruktion als eine andere. Ohnehin ist eine vergleichende Erkenntnis, die aus der Kartenanalyse erwächst, ohne eine generelle Übersicht über alle Lieferungen nur schwer zu leisten. Für eine solche sind die allgemeinen *comparata*, d. h. die überschneidenden Momente, die alle Karten des Atlas teilen, zu unspezifisch. An diese Feststellung schließt sich die Frage an, inwiefern sich das vom vergleichenden Sehen abhängige Erkennen des im Atlas entworfenen Prinzips in der zeitgenössischen Rezeption einlöste. Diese Frage muss im Rahmen der vorliegenden Untersuchung aufgrund bislang nicht aufgefundener zeitgenössischer Berichte offen bleiben.

62 Vgl. zu dieser Herleitung die Überlegungen zum Modell von Mahr, Bernd/Wendler, Reinhard: „Bilder zeigen Modelle – Modelle zeigen Bilder", in: *Zeigen. Die Rhetorik des Sichtbaren*, hg. von Gottfried Boehm u. a., München: Fink 2010, S. 183–206.

63 Dudenredaktion (o. J.): Art. „Modell", auf Duden online abrufbar unter https://www.duden.de/node/658605/revisions/1674550/view (online aufgerufen am 23. 07. 19).

tinent besteht das *demonstratum* des vergleichenden Sehens, d. h. das, was es über das vergleichende Sehen zu erschließen gilt, demnach in einem virtuellen, dreidimensionalen und potentiell als bewegt aufgefassten Modell der Erdkruste.[64] Dieses Modell ist eines *von* der räumlichen Struktur der Erdoberfläche, es zielt aber darauf, als Rahmenkonstruktion *für* die Beschreibung systemischer Kräftebeziehungen und Austauschprozesse im geographischen Raum verstanden zu werden. In dieser

> doppelten Identität eines als Modell aufgefassten Gegenstands, zugleich als *Modell von etwas* und als *Modell für etwas* aufgefasst zu sein, liegt das nicht ganz leicht zu fassende charakteristische Merkmal des Modellseins. Das Modellsein eines Gegenstands wird dementsprechend durch einen Perspektivwechsel bestimmt, den Wechsel vom *Von* zum *Für*.[65]

Für das Modell ist dabei kennzeichnend, dass ihm eine genuine Unbestimmtheit inhärent ist, d. h. dass es letztlich immer nur annäherungsweise erschlossen werden kann: So deckt sich auch in Humboldts Atlas keins der kartographisch aufgenommenen Phänomene in allen Aspekten mit dem nach logischen Regeln entworfenen Modell. Doch gerade in diesem vermeintlichen Defizit des Nicht-Zeigens, indem es „für etwas [steht], durch dessen Abwesenheit es überhaupt erst wirksam werden kann"[66], erweisen sich Modelle – und auch das von Humboldt – als experimentell und Erkenntnis fördernd. In Humboldts Fall gilt, dass es ihm erst durch den Entwurf seines kartographischen Modells möglich wurde, in seinem Atlas eine induktive, empirische Beobachtungs- und Darstellungspraxis mit einer allgemeinen, der Beschreibung des „Naturganzen" zuarbeitenden Theorie zu verbinden. Mit diesem Vermögen, Einzelnes und Allgemeines, empirische Beobachtung und kosmisches Ganzes, gemeinsam zu präsentieren, kehrt sich mit dem Atlas ein grundlegendes Charakteristikum von Humboldts epistemischer Vorgehensweise ins Sinnfällige; es wird im Material greif- und vermittelbar.

Bei dem virtuellen Modell des *Atlas géographique et physique du Nouveau Continent* handelt es sich prinzipiell um eines der gesamten Erdoberfläche, obwohl Humboldt dafür vor allem seine Karten von süd- und mesoamerikanischen Gebieten nutzte. Dass es sich dennoch prinzipiell auf den globalen Raum übertragen lässt, findet seine methodologische Voraussetzung darin, dass Humboldt im Mikrokosmos der Amerikas pars pro toto den Makrokosmos des natürlichen Systems zu erkennen meinte, denn dort kamen auf engstem Raum die Extreme der Natur zusammen. So traf etwa der Chimborazo, den Humboldt damals noch für die höchste Erhebung der Erde hielt, auf ausgedehnte, wasserreiche Flusssysteme; der Kontinent beherbergte zudem eine äußerst große Diversität der

64 Vgl. Wolf: „Demonstration: Einleitung", in: *Vergleichendes Sehen*, 2010, S. 265.
65 Mahr/Wendler: „Bilder zeigen Modelle – Modelle zeigen Bilder", 2010, S. 194.
66 Wendler, Reinhard: *Das Modell zwischen Kunst und Wissenschaft*, München: Fink 2013, S. 12.

Flora und Fauna, die die pflanzen- und tiergeographische Verteilung vor Augen führte.[67] Zugleich schien eine Gleichzeitigkeit des Ungleichzeitigen zu existieren: An den inaktiven und aktiven Vulkanen Amerikas ließen sich aus der Jetztzeit heraus geologische Thesen zur Erdgeschichte formulieren. Ferner begegneten sich mit Menschen amerikanischer, afrikanischer und europäischer Herkunft ethnische Gruppen verschiedener Erdteile, die nach einem teleologischen Verständnis der technisch voranschreitenden Menschheit auf unterschiedlichen Kulturstufen zu stehen schienen.[68] Mit dem Wissen um diese Sonderstellung, die Humboldt den Amerikas zuschrieb, lässt sich das virtuelle Modell der Erdkruste, das im *Atlas géographique et physique du Nouveau Continent* angelegt ist, auch seinen theoretischen Voraussetzungen nach als eines verstehen, das letztlich auf die Beschreibung des globalen Ganzen zielte. Vor diesem Hintergrund erklärt sich, weshalb Humboldt in die Tafeln des Atlas nicht nur amerikanische Gebiete aufnahm, sondern versprengt auch Karten von mitteleuropäischen Gegenden und von den Kanaren einbezog: Sie weisen auf das weltumspannende Prinzip hin, das dem Band zugrunde lag.

Das Erdenrund als ‚demokratische‘ Form

Die wissensgeschichtliche Voraussetzung für eine solche Erkenntnisleistung, bei der lokale Naturphänomene auf ein globales Raumkonzept bezogen werden, die Einzelbeobachtung also im Kontext des Ganzen verstanden und für dieses aussagekräftig wird, lieferte nach Humboldts Auffassung das mit Kolumbus (wieder)erlangte Wissen von der Kreisform der Erde, „la découverte de l'autre hémisphère"[69]. Die hierdurch erneut ins Bewusstsein gerückte Kugelform der Erde bedeutete für das geographische Wissen, dass es an eine Rundform rückgebunden werden konnte, die insofern hierarchiefrei war, als sie weder Zentrum noch Peripherie besaß: Dem einzelnen Naturphänomen konnte nun nicht mehr allein aufgrund seiner Lage eine größere globale Dominanz und eine stärkere Aussagekraft zugesprochen werden als einem anderen. Hiermit verbunden war die Beschreibung neuer Wege und Austauschprozesse in der Natur, denn mit dem Verlust eines Zentrums rückten zugleich wechselseitige Kräftebeziehungen im Raum in den Blick. Diese geschaffenen Möglichkeiten für die Beschreibung neuer Raumverhältnisse und die damit verbundenen neuen Erkenntnisdimensionen hob Humboldt in seinem Text des *Examen critique* hervor: Durch die Wiederentdeckung des Erdenrunds verschob sich die wissenschaftliche Perspektive, die auf „bestimmte Verbindungen von Tatsachen"[70] fokussierte

67 Wie das *Tableau physique des Andes* zeigt, nahm bereits der Chimborazo für sich genommen einen modellhaften Charakter für Humboldts Wissenschaft ein. An dem Vulkanberg ließ sich die Wechselwirkung in der Natur schematisch aufzeigen.

68 Vgl. Dill: *Metaphysik*, 2013, S. 158–160.

69 Humboldt: *Examen critique*, Bd. 1, 1836, S. XVII.

70 Im Original: „certaines combinaisons de faits". Humboldt: *Examen critique*, Bd. 1, 1836, S. XI.

und in der eine alle Breiten und Höhengrade umfassende, vergleichende Physikalische Geographie ihren Anfang nahm.[71]

Dass die Zuschreibung eines geographischen Zentrums ein wirkmächtiges und weit ausgreifendes Narrativ entfalten können, reflektieren bereits frühe der heute bekannten Karten. Durch eine mittige Ausrichtung werden Erdregionen in wesentliche und in randständige Bereiche unterteilt. Darin kommt, implizit oder explizit, der Gedanke einer geographischen Mitte der Welt zum Ausdruck, etwa indem Jerusalem oder Rom und damit der christliche Glaube ins Zentrum der Welt rückt. Erhalten Orte diese zentrale Position, so wird ihnen eine geographische Vorrang- oder Herrschaftsstellung attestiert und eine Machtposition zubilligt, mit der eine Auf- und Abwertung bestimmter Gegenden einhergeht. Diese Ausdeutung der Erdoberfläche, die John Brian Harley als „rule of ethnocentricity"[72], d.h. als eine vom jeweils eigenen Standpunkt aus vorgenommene Setzung des Zentrums bezeichnet, liefert die Grundlage für Argumentationsstrukturen, mit denen sich – etwa vom europäischen Zentrum aus besehen – vermeintlich natürliche Überlegenheiten und Dominanzen über marginalisierte geographische Randbereiche ableiten lassen. Die sich wandelnden Positionierungen von zentralen Orten auf Karten geben retrospektiv Auskunft über unterschiedliche und sich verschiebende Weltsichten und Mächteverteilungen. So rückt etwa Jerusalem in einer Weltkarte des Fra Mauro (1385–1459), die zwischen 1457 und 1459 entstand und auf die sich auch Humboldt in seinem *Examen critique* bezog, von der Mitte in den Westen und deutet damit auf eine veränderte Vorstellung von der Welt hin, die in die Neuzeit weist.[73]

Dass Humboldt die wiedererkannte Kugelform der Erde als Ausgangspunkt seiner Physikalischen Geographie festsetzte und implizit auch zur Grundlage des virtuellen Modells der Erdkruste seines *Atlas géographique et physique du Nouveau Continent* machte, zeigt seine Abwendung von einer (kartographisch) von Europa oder einem anderen Punkt aus vorgenommenen Zuschreibung eines geographisch dominanten Machtzentrums an. Iberoamerika galt ihm stattdessen als Modell, deren funktionale und räumliche Verfasstheit sich auf andere Erdregionen übertragen ließ. In den Amerikas ließen sich natürliche

71 Das Raumwissen eines Erdenrunds, schrieb Humboldt in seinem *Examen critique*, sei die Triebfeder für eine Fülle neuer Entdeckungen gewesen. Diese Anhäufung des neuen Wissens unterwürfe „fast unmerklich Meinungen, Gesetze und staatsrechtliche Verhältnisse der Völker durchgreiferenden Veränderungen […]. Niemals hat eine rein materielle Entdeckung durch Erweiterung des Gesichtskreises eine außerordentlichere und dauerhaftere Veränderung in geistiger Beziehung hervorzurufen vermocht", Im Original: „le contact avec tant de choses nouvelles, en donnant un vaste essor à l'intelligence a aussi modifié insensiblement les opinions, les lois et les mœurs politiques. Jamais une découverte purement matérielle, en étendant l'horizon, n'avait produit un changement moral plus extraordinaire et plus durable". Humboldt: *Examen critique*, Bd. 1, 1836, S. VIII–IX. Übersetzung übernommen aus Humboldt: *Entdeckung der Neuen Welt*, 2009, S. 13.

72 Siehe Harley: „Deconstructing the map", 1989, S. 156–158.

73 Siehe Schneider: *Die Macht der Karten*, 2004, S. 16.

Wechselwirkungen exemplarisch erkennen, deren Prozesse vergleichend auf das globale System der Natur übertragen werden konnten – allerdings ohne dass sich damit zugleich eine geographische Vormachtstellung des Kontinents verband.

Vielmehr war mit Humboldts Bezug auf die Kugelform, in der sein weltumspannendes Erdwissen seine Voraussetzung fand, auch eine naturphysiognomische Idealisierung verbunden, die sich wiederum auf den gesamten Erdball bezog.[74] Gegenüber der induktiven, empirischen Einzelbeobachtungen der Karten, die sich dank der Rundform der Erde auf das Ganze übertragen ließen, stellte diese deduktiv angelegte Idealform vom Allgemeinen ausgehend eine metatheoretische Setzung Humboldts dar. Sie wurzelte in einer weit zurückreichenden Reflexion über die kosmische Rundform, der gemäß der Kosmos der Inbegriff einer Ordnung war, in der sich Gleichmaß und Erkenntnis verschränkten. Die Kugel, teilweise auch der Kreis, galt als vollendetes Basiselemente des wohlgeordneten kosmischen Bauplans Gottes.[75] So stellte beispielsweise Platon (um 427 v. Chr. – 347 v. Chr.) in seinem *Timaeus*, einem Text mit poetischen, philosophischen und naturwissenschaftlichen Ansätzen, fest, dass in der Kugelform der Erde göttliche Vollkommenheit in Ordnung und Schönheit zusammenkomme. Im Kopf des Menschen, dem wertvollsten Teil seines Körpers, wiederhole sich diese.[76] Mit der Rundform sei jedoch ebenfalls deren unbeherrschbare Dynamik verbunden, die es einzuhegen gelte. Platon löste dieses Dilemma mit der Überlegung, es bedürfe des Körpers, der den Kopf trage und damit stabilisiere. Bei ihm, aber auch in anderen kulturellen Kontexten, verbanden sich in der Kugelform der Wille zur Macht über den Kosmos und die Idee der göttlichen Vollkommenheit.[77] So besaß die „platonische Kugel […] immer diese zwei Seiten. Während sie als Abbild kosmischer Vollendung in besonderer Weise befähigt war, die globale Herrschaft zu verkörpern, forderte sie als rollendes Rund ihre eigene Beherrschung."[78]

In Humboldts Wissenschaft findet sich die hier formulierte Ambivalenz, mit der die Kugelform belegt ist, wieder: Einerseits spiegeln sich in der Rundform das harmonische Ineinanderwirken, das ausgeglichene Kräftegefüge und die Ordnung der Natur. Die in sich ebenmäßige Grundform der Kugel stützt die Idee eines kosmischen und damit

74 Eine ähnliche Vorstellung des Weltaufbaus findet sich bei Immanuel Kant, der über die metaphysische Ordnung des Kosmos bemerkte: „Man kann das Weltgebäude nicht ansehen, ohne die trefflichste Anordnung in ihrer Einrichtung, und die sicheren Merkmale der Hand Gottes, in der Vollkommenheit ihrer Beziehungen, zu kennen." Kant, Immanuel: *Schriften zur Naturwissenschaft*, Erste Abtheilung, Leipzig: Modes und Baumann 1838, S. 434.

75 Vgl. Schaschke, Bettina/Thomson, Christina: „Schöpfung und Erkenntnis", in: *Der Ball ist rund – Kreis, Kugel, Kosmos*, hg. von Moritz Wullen, Bernd Ebert, Berlin: Staatliche Museen zu Berlin 2006, S. 28–29, hier S. 29.

76 Vgl. Bredekamp, Horst: „Fuß, Fortuna, Ball, oder: Platons Prinzip des Handicap. Der Kugelkörper und die Defizite der Vollendung", in: *Der Ball ist rund*, 2006, S. 12–17, hier S. 12.

77 Vgl. ebd.

78 Ebd., S. 14.

wohlgeordneten Weltganzen. Die Vermittlung dieses Weltganzen widersetzte sich jedoch der präzisen, empirischen Einzelbeobachtung. Humboldt begegnete dieser Herausforderung mit dem virtuellen Modell, das er mit seinem Atlas entwarf und das Einzelbeobachtungen und allgemeine Prinzipien eng verklammerte.

Bewegte Blicke – bewegende Blicke: Erkennen im Betrachten

Heterogene Wissenselemente im Atlas

Die Konzeption des *Atlas géographique et physique du Nouveau Continent* lässt sich in ihrer heuristischen Tragweite erst erfassen, sobald Berücksichtigung findet, dass es sich bei dem darin angelegten Modell der Erdkruste um ein virtuelles Gebilde handelt. Aus mehreren, als Kartenmaterial dinghaft vorliegenden Einzelelementen bestehend, ist es nicht fixiert, sondern entsteht erst im Zuge des Rezeptionsprozesses vor dem inneren Auge der Betrachtenden. Dieses sinnstiftende Zusammensehen wird durch die mediale Herrichtung des Atlas erleichtert: Insbesondere die Darstellungs- und Auslieferungsweise der Karten, bedingt auch ihre Anordnung im Band, sind so aufeinander abgestimmt, dass sie die Rezeption anleiten und befördern. Hierdurch tritt die zugrunde liegende Ordnung der gezielten Kombination von Aufsichts-, Profil- und Vulkankarten hervor. Ist dieser Aufbau als solcher erfasst, lassen sich die Darstellungsmodi und Themen der Karten nicht nur formal, sondern auch semantisch verknüpfen und entsprechend ausdeuten.

Auf die Erkenntnis bezogen ist in diesem Kontext wesentlich, dass der Atlas hinsichtlich seiner materiellen Ausführung potentiell um weitere Karten ergänzt werden könnte und daher prinzipiell offen angelegt ist: Die Serie der sich wiederholenden Kartenkombinationen bei der Publikation ließe sich der Idee nach fortführen, wodurch sich das zugrunde liegende Modell immer deutlicher konturieren würde. Diese Feststellung lässt sich auch auf den Erkenntnisprozess selbst übertragen, der aus der Rezeption der Karten erwächst: Indem das vollständige Modell nicht fixiert vorgeführt wird, sondern stets aus einzelnen Blättern besteht, die sowohl in ihrer Handhabung, durch Aufklappen, Blättern oder Über- und Nebeneinanderlegen, als auch hinsichtlich ihrer Semantik aktiv zusammengeführt werden müssen, ist die Erkenntnis, die dem Atlas erwächst, insofern anpassungsfähig, als das Material in verstärktem Maße auf die jeweilige Herangehensweise der Betrachtenden zu reagieren vermag. Ihre letztliche Gestalt nimmt die Erkenntnisleistung damit erst im Rezeptionsprozess an. Durch ihn wird die zentrale Aussage des Atlas – das virtuelle Modell – realisiert, sobald die *relata*, d. h. die einzelnen Karten, sinnstiftende Relationen eingehen.

Aus dieser offen angelegten, auf die Rezeption übertragenen Modellbildung resultiert eine Rhetorik des Möglichen, Hypothetischen. Denn statt ein eindeutig formuliertes Narrativ des Wissens zu behaupten, entwickelt sich die zentrale Erkenntnis im Atlas erst im Laufe des Rezeptionsvorgangs als gedankliche Leistung der Betrachtenden. Es ist diese

Offenheit der Präsentation von Wissen, auf der der *cargo*, d. h. das intellektuelle Frachtgut, das Humboldts virtuellem Modell inhärent ist, maßgeblich beruht. Dieser *cargo* besteht aus einer in der Kartenkombination vorformulierten Hypothese über die Erdentstehung wie auch über die Abhängigkeit von der aus ihr hervorgehenden terrestrischen Raumstruktur und den Prozessen im System der Natur. Statt aber konkret beschrieben zu werden, erwächst diese Kenntnis aus der assoziativen Zusammenführung der Karten.[79] Die Organisation des Materials liefert hierbei die Grundlage, um anhand der Karten zu einer bestimmten Hypothese zu leiten. Im Akt der Betrachtung reformuliert sich, mit anderen Worten, die im Material angelegte Annahme.

Die Nähe zur Kunstkammer

Vor diesem Hintergrund lassen sich zwei Aspekte benennen, die für die Heuristik, die Humboldts Atlas birgt, kennzeichnend sind: Zum einen nähert sich der Band dem Naturwissen in einer gezielten Zusammenführung materiell gesonderter, thematisch heterogener Wissenselemente an, zum anderen ist für das Verständnis seines gesamten Verbundes wesentlich, dass diese Elemente einer zweckgerichteten Regulierung folgen, die eine angeleitete, zugleich aber individuell angelegte Betrachtung ermöglichen. Sowohl hinsichtlich der hierin angesprochenen Vermittlungs- und Rezeptionsweise als auch mit Blick auf die im Atlas verhandelte Naturgeschichte stellt sich damit eine Nähe zu den Kunst- und Wunderkammern aus Renaissance und Barock her. In diesen Sammlungen fanden heterogene Objekte der Natur zusammen; *naturalia* (Gegenstände der Natur), *artificialia* (Kunstwerke) und *scientifica* (Instrumente, die der Naturformung und -erkundung dienten) wurden gemeinsam präsentiert. Der Organisation dieser Sammlungen lag, wie Humboldts Atlas auch, die Überzeugung zugrunde, dass die genaue und empirische Beobachtung der Objekte die Grundlage für ein gesichertes Wissen über sie und ihre Beziehung zueinander sei.[80] Aus der heterogenen Anlage der Präsentation in der Kunstkammer ließen sich zwischen den Objekten Relationen herstellen und Zusammenhänge gedanklich erproben. Hinter der scheinbar vorherrschenden Unordnung der Sammlungen verbarg sich demzufolge ein tieferer Sinngehalt: „Das Arrangement der Genera dient nicht zur Trennung der verschiedenen Bereiche, sondern es baut visuelle Brücken, um der Spielfähigkeit der Natur das Assoziationsvermögen der Augen an die Seite zu stellen."[81] Mittels visueller Brücken, die während des Rezeptionsprozesses gebaut werden konnten, wurde es also möglich, sinnstiftende Verknüpfungen zwischen den Objekten herzustellen.

Basierend auf dieser induktiven Beobachtungspraxis wurde in den Kunstkammern eine Historisierung der Naturgeschichte bereits lange vor ihrer diskursiven wissenschaft-

79 Zum *cargo* eines Modells vgl. Mahr/Wendler: „Bilder zeigen Modelle – Modelle zeigen Bilder", 2010, S. 194.

80 Siehe *Schimmern aus der Tiefe*, 2013, S. 10.

81 Bredekamp, *Antikensehnsucht und Maschinenglauben*, 2007, S. 71.

lichen Festschreibung formuliert. Insofern war das vermeintlich auf Kant beruhende „Konzept einer Naturgeschichte in der *Zeit*, die sich von der klassifizierenden Beschreibung im *Raum* trennt, [...] keineswegs neu. Es beruhte auf der Erfahrung, die sich auf visuellem Gebiet seit mehr als zweihundert Jahren in den Sammlungen der Kunstkammern ergeben hatte."[82] Ebendiese betrieben „eine Dynamisierung der Natursicht [...], die [...] durch den puren Augenschein zu einer historischen Vertiefung der Naturgeschichte gelangte"[83]. Indem also die Zusammenschau heterogener Objekte und Wissensbereiche in der Kunstkammer den Makrokosmos der Natur im Mikrokosmos des Dispositivs der Sammlung sinnfällig werden ließ, führte sie die zahlreichen Spielarten der Natur und mit ihnen deren zeitliches Gewordensein vor. Im Modell des kosmischen Ganzen, das die Kunstkammer darbot, verwoben sich dessen verschiedene Elemente im verknüpfenden Blick zu einer Erkenntnis generierenden Anordnung und darin zu einem dynamischen, ineinandergreifenden und sich fortentwickelnden Gefüge.

Diese epistemische Verfasstheit kommt der des *Atlas géographique et physique du Nouveau Continent* sehr nahe: Auch Humboldts Band basiert auf der Konzeption einer vermeintlichen Unordnung heterogener thematischer Elemente – jene der dargebotenen Karten –, die mit Hilfe visueller Brücken bei der Rezeption in eine sinnstiftende Relation überführt werden können. Zudem erhebt der Atlas ebenfalls den Anspruch, direkt vom empirisch erfahrbaren Objektwissen auszugehen,[84] das über ein gezielt zusammengestelltes Dispositiv eine Ordnung innerhalb der Fülle des „Naturganzen" freilegt. Das eigentliche heuristische Potential, das beide – die Kunstkammer und Humboldts Atlas – hierbei verbindet, ist darin zu sehen, dass der (partiell) offen angelegte Rezeptionsprozess die Erkenntnisgenese an das Subjekt bindet: In beiden Fällen sind die Relationen zwischen den Objekten und die Eigenzeitlichkeit der Erde lediglich vorformuliert und gerade nicht als definite Narration vorgegeben.[85] Stattdessen wird dieses Wissen in das Assoziationsvermögen der Betrachterinnen und Betrachter verlagert, und artikuliert sich im Akt der Rezeption, d. h. beim Durchqueren der Sammlung oder beim Durchblättern der Karten.

Hypothetizität als *cargo* des virtuellen Modells

Den visuellen Brücken, die Humboldt in seinem Atlas nutzte, war vorausgegangen, dass sich im Laufe des 18. Jahrhunderts ein theoretischer Diskurs formiert hatte, mit dem der

82 Ebd., S. 17 [Hervorhebungen im Original].

83 Ebd.

84 Vgl. *Schimmern aus der Tiefe*, 2013, S. 10.

85 Im Kontext der Kartographie macht Tanja Michalsky darauf aufmerksam, dass in der gemeinsamen Präsentation von Karten und Bildern in Sammelatlanten eine Nähe zwischen diesen und Kunstkammern hergestellt werden kann: „In dieser vom Sammler frei variierbaren Form ist, abgesehen von den Kunstkammern, die gegenseitige Ergänzung von Bildern und Karten wohl am konkretesten zu greifen." Michalsky: *Projektion und Imagination*, 2011, S. 78.

Akt des Betrachtens als wesentlicher Bestandteil des Erkenntnisprozesses aufgefasst worden war. Auch von theoretischer Seite her war den Rezipierenden damit zugestanden worden, einen wesentlichen Beitrag im Erkenntnisprozess zu leisten. Statt auf rein äußere Faktoren zurückgeführt werden zu können, stellte die Wissensgenese somit auch das Resultat des individuellen Denkprozesses dar. Diese epistemologische Neubewertung leitete ein, dass die zeitlose Wahrheit und das normative Werturteil sukzessive durch distinkte zeit- und kontextbezogene Erkenntnis ersetzt wurden.[86] Vor diesem Hintergrund organisierte Humboldt die Karten in seinem *Atlas géographique et physique du Nouveau Continent* derart, dass sie sich im erkennenden Schauen individuell zu sinnstiftenden Anordnungen zusammenführen ließen.[87]

Dass die Rezipientinnen und Rezipienten am Erkenntnisprozess mitarbeiteten, bedeutete, dass die einzelnen Wissensbausteine flexibel zusammengeführt werden konnten, jedoch waren sie dabei zugleich in den Rahmen einer weitgehend stabilen Raum- und Zeitstruktur eingefasst. Während die Höhe, die Fläche und der Zeitenlauf also als vergleichsweise konstante Größen installiert wurden, veränderten sich durch die individuelle Zusammenführung der Karten bei der Rezeption lediglich die beobachteten Einzelphänomene, die sich in diesem Rahmen bewegten. Raum und Zeit gaben mithin den Rahmen vor, um regelhafte Bewegungen in der Natur überhaupt nur erkennen und in ihrem wiederholten Auftreten beschreiben zu können. Die in der Natur vorherrschende Dynamik, Veränderbarkeit oder das Ineinandergreifen von Bewegungen, d. h. die Bewegungsabläufe selbst, waren dagegen nicht eigentlicher Teil des im Visuellen Verhandelten.

Eine entsprechende Differenzierung lässt sich in der Transzendentalphilosophie Immanuel Kants finden, auf die Humboldt sich an verschiedener Stelle in seinem Werk bezog: Kant gestand dem Subjekt zwar eine wesentliche Mitarbeit am Erkenntnisprozess zu, verortete diesen aber in einem stabilen Raum-Zeit-Gefüge und grenzte die Fähigkeit von den Möglichkeiten der diskreten Beschreibung von Bewegungen im Raum und des Raumes ab. Bewegungsabläufe ließen sich demnach zwar aus dem Moment heraus mit den Sinnen wahrnehmen, jede differenzierte Analyse der Veränderung von Dynamiken war auf dieser Grundlage aber schwer mit einer von Kant geforderten wissenschaftlichen Empirie zu vereinbaren.[88] Dies berücksichtigend erklärt sich, warum auch die Naturge-

86 Siehe Hofmann, Werner: „Zeitzerfall und Zeitverdichtung um 1800", in: *Bild und Zeit: Temporaliät in Kunst und Kunsttheorie seit 1800*, hg. von Thomas Kisser, München: Fink 2011, S. 155–175, hier S. 173; vgl. ferner Blümle, Claudia: „Augenblick oder Gleichzeitigkeit", in: *Simultaneität· Modelle der Gleichzeitigkeit in den Wissenschaften und Künsten*, hg. von Philipp Hubmann und Till Julian Huss, Bielefeld: transcript 2013, S. 37–55.

87 Diese Entwicklung spiegelt sich auch in der Malerei aus der Zeit um 1800, bei der die Gemäldekompositionen von einem polyfokalen Nebeneinander aus entworfen wurden. Vgl. Hofmann: „Zeitzerfall und Zeitverdichtung um 1800", 2011, S. 173.

88 Vgl. Hubmann, Philipp/Huss, Till Julian: „Einleitung", in: *Simultaneität. Modelle der Gleichzeitigkeit in den Wissenschaften und Künsten*, hg. von dies., Bielefeld: transcript 2013, S. 9–36, hier S. 16–17.

schichte als dynamischer Prozess im *Atlas géographique et physique du Nouveau Continent* erst über den zusammenführenden Blick hineinfindet. Die Karten des Atlas verdichten so zwar noch immer Beobachtungen der Natur in einem Zeit- bzw. Blickpunkt,[89] werden in der Betrachtung des Atlas aber in die gezielte Kombination von Karten überführt. Hierin kommt letztlich der Grundgedanke einer Auffassung zum Ausdruck, nach der das in sich bewegte „Naturganze" mit der menschlichen Wahrnehmung nie gleichzeitig in allen ihren Facetten (und Bewegungen) erfasst werden kann. Obwohl sich auch die Simultaneität der vielen natürlichen Prozesse letztlich einer konkreten Beschreibung ihrer genauen Bewegungsmuster widersetzt, bietet die offene Rezeptionsstruktur des Atlas die Möglichkeit einer Schnittfläche der heterogenen Dynamiken, die zugleich und auf der Grundlage eines für sie alle gültigen, raum-zeitlich angelegten Modells wechselseitig aufeinander verweisen.[90]

Zusammenfassend lässt sich sagen, dass der dem Atlas unterlegte Erkenntnis generierende Aufbau ebenso einfach wie potentiell folgenreich ist: Die dreidimensionale Struktur des topographischen Raumes wird als Axiom des Wissens über das „Naturganze", den Kosmos, entworfen, sobald es im Rezeptionsprozess erkannt ist. Dennoch bleibt die empirische Beobachtung der Ausgangspunkt aller Beschreibung. In Humboldts Wissensvermittlung zeigt sich der bewegte Blick auf diese Weise als Mittler, der nicht nur verschiedene Blickpunkte und Themen, sondern zugleich diskrepante theoretische Ansätze – Idealismus und Empirismus – zusammenführt. Mittels eines über ein kohärentes Zeichensystem gezielt gelenkten, wandernden Blicks über die Karten wird hierbei eine räumliche Vorstellung erzeugt, die ihrer eigenen Bewegtheit in der Zeit der Rezeption ausgesetzt ist. In Humboldts Atlas wird auf diese Weise im erkenntnisreichen Sehen ein über die Einzelbeobachtung stets hinausgehender heuristischer Überschuss produziert. Der Atlas kann so (auch) als mediale Reflexion der in der Natur beobachteten Prozesshaftigkeit selbst verstanden werden: Indem Humboldt eine bewegte Blickführung über verschiedenen Karten hinweg voraussetzte, um die im Atlas entwickelte Hypothese zu reformulieren, betonte er die Handhabung des Mediums in ihrer dynamischen Wesenheit; das darin angelegte Raum-Zeit-Modell kann erst dank der physischen Bewegung der Karten in Verbindung mit visuellen Brücken, die die miteinander konfrontierten Karten mental zusammenführen, als solches verstanden werden.

89 Wie Wolfgang Schäffner feststellt, spiegelt sich dieser Prozess auf der Ebene der Produktion wider: Teile der Datenmengen, die auf den Karten relationiert sind, wurden zu unterschiedlichen Zeiten beobachtet, aber über eine Mittelwertbildung in eine homogene Zeitlichkeit transferiert. Siehe Schäffner: „Topographie der Zeichen", 2000, S. 376.

90 Vgl. Mößner, Nicola: „Das Beste aus zwei Welten? Ludwik Fleck über den sozialen Ursprung wissenschaftlicher Kreativität", in: *Simultaneität*, 2013, S. 111–131, hier S. 111. Mößner verweist in diesem Zusammenhang auf Ludwik Flecks *Entstehung und Entwicklung einer wissenschaftlichen Tatsache*.

Humboldtian Visualizing

Mit Blick auf Humboldts Schreibstil zeigt sich, dass das virtuelle Modell der Erdoberfläche, das im *Atlas géographique et physique du Nouveau Continent* angelegt ist, unmittelbar in den Kern der Humboldtschen Wissensgenese und -vermittlung weist. Nicht nur für den Atlas, sondern auch für Humboldts Texte ist charakteristisch, dass einzelne thematische Aspekte in potentiell immer neue sinnstiftende Zusammenhänge gesetzt werden können. So lassen sich etwa die Passagen der *Voyage* auf unterschiedlichen Wegen miteinander verbinden, wodurch multiple Lesarten mit jeweils anderen Deutungshorizonten entstehen.[91] Zwar ergeben die einzelnen Textabschnitte auch für sich allein Sinn, lassen sich darüber hinaus aber auf unterschiedliche Weise zu neuen, verdichteten Strukturen verknüpfen. Ulrike Leitner empfiehlt entsprechend: „Wenn man sich also mit einem Teil der Reise […] oder einem bestimmten Thema beschäftigen möchte, so ist hier geraten, die verschiedenen Bände parallel oder gleichzeitig zu lesen."[92] Diese mehrschichtige textuelle Vernetzung in Humboldts Texten bezeichnet Ottmar Ette als *Humboldtian Writing*.[93] Es bezieht sich auf einen nicht linearen, nicht chronologischen und vermeintlich nicht systematischen Schreibstil, der durch eine spezifische Kombinatorik von Wissensbausteinen gekennzeichnet ist. Diese stelle, so Ette, „zwischen den unterschiedlichsten Gegenstandsbereichen, Wissensgebieten und Methodologien Verbindungen [her]" und weise so das „Zusammendenken als Herzstück Humboldtscher Wissenskonzeption [aus]"[94].

Ette schließt mit seiner Begriffsprägung des *Humboldtian Writing* an Susan Faye Cannons Terminus der *Humboldtian Science*[95] an. Während es sich bei dieser um eine grundständige epistemologische Struktur handelt, bei der das Zusammenwirken der Natur-

91 Vgl. Leitner: „Vielschichtigkeit und Komplexität im Reisewerk", 2005, S. 57–61. Zu den Vernetzungen im Reisewerk vgl. Ette: „Blick auf die Neue Welt", 1991, S. 1577–1578.

92 Leitner: „Vielschichtigkeit und Komplexität im Reisewerk", 2005, S. 58. Wird der *Atlas géographique et physique du Nouveau Continent* nun als „genereller Reise-Atlas" zu der *Voyage* hinzugezogen, ließe sich dieser Vorschlag Leitners nicht nur um dessen separate, verknüpfende und vergleichende Kartenbetrachtung, die im Rahmen dieser Arbeit geleistet wird, ergänzen. Vielmehr bietet sich ebenso eine Rezeption an, bei der Tafeln und Text nebeneinandergelegt nachvollzogen werden können, wodurch die textuelle Rahmung einen breiteren Kontext der jeweiligen Tafeln eröffnen würde. Im Rahmen dieser Arbeit kann eine solche Lesart indes nicht vorgenommen werden; ferner liegt eine erste, jüngst erschienene Untersuchung hierzu bereits vor: Tobias Kraft analysiert im Reisewerk ein „transgenerisches Schreiben", das zwischen verschiedenen Gattungen changiert. Vgl. Kraft: *Figuren des Wissens*, 2014, insbesondere S. 11–25.

93 Vgl. Ette, Ottmar: „Eine »Gemütsverfassung moralischer Unruhe« – Humboldtian Writing: Alexander von Humboldt und das Schreiben in der Moderne", in: *Alexander von Humboldt – Aufbruch in die Moderne*, 2001, S. 33–56.

94 Ebd., S. 51.

95 Nach Faye Cannon: *Science in Culture*, 1978, S. 73–110.

kräfte über eine numerische Datenaufnahme, ein relationales Ordnungsgefüge und die Methode des Vergleichens beschrieben wird, benennt das von Ette konstatierte *Humboldtian Writing* nun deren epistemische Praxis[96]. Findet Berücksichtigung, dass zwischen epistemischer Struktur und epistemischer Praxis eine Differenz besteht und sich beide Verfahren nicht bruchlos aufeinander abbilden lassen,[97] so kann für die Konzeption des *Atlas géographique et physique du Nouveau Continent* im Anschluss an Ette von einem Verfahren des *Humboldtian Visualizing* gesprochen werden: In diesem Band lassen sich einzelne Wissenselemente maßgeblich aufgrund der Art und Weise ihrer bildlichen Darstellung entlang der Interessen des Publikums zu neuen sinnstiftenden Aussagen verknüpfen. Die sich in der deutschen Übersetzung auftuende zweifache Konnotation des *visualizing* als Ideengestaltung und Sichtbarmachung erweist sich hierbei als fruchtbare Verquickung der Bedeutungsebenen: Humboldts visuelle Vermittlungsstruktur macht einen Raum für die Präsentation von Wissen auf, auf dessen Grundlage dieses nicht nur vorgeführt wird, sondern dass erst im Rezeptionsprozess zu seiner endgültigen Form findet.[98]

Gegenüber dem *Humboldtian Writing* lässt sich das *Humboldtian Visualizing* insofern als dessen mediale Ergänzung oder als dessen visuelles Pendant verstehen. Die begrenzten Darstellungstechniken des Textes – etwa bezüglich einer simultan und räumlich vernetzenden Datenpräsentation – werden ebenso vervollständigt, wie die visuelle Ebene wiederum um die erläuternde Dimension des Textes erweitert wird. Erst aus der Verschränkung beider Verfahren, so kann aus der engen Bezüglichkeit vom Text der *Voyage* und dem *Atlas géographique et physique du Nouveau Continent* gefolgert werden, ließen sich für Humboldt die Facetten des „Naturganzen" vor Augen stellen. Letztlich ergibt sich gerade aus der Kombination beider Medienformate die Möglichkeit, das Wissen über die Natur differenziert und vielschichtig, zugleich aber unter Einbeziehung einer allgemeinen, diesem Wissen zugrunde liegenden topographischen Struktur zu beschreiben.[99]

96 Unter der epistemischen Praxis wird verstanden, dass Wissen mit einer erkenntnistheoretischen Prämisse versehen aus einer bestimmten Forschungsperspektive heraus präsentiert wird. Vgl. zum Begriff der epistemischen Praxis Ammon, Sabine: „Entwerfen – eine epistemische Praxis", in: *Long Lost Friends: Wechselbeziehungen zwischen Design-, Medien- und Wissenschaftsforschung*, hg. von Claudia Mareis und Christof Windgätter, Zürich: Diaphanes, 2013, S. 133–155, hier S. 134.

97 Bei Ottmar Ette wird zwischen beiden Ebenen nicht klar unterschieden. Vgl. Ette: „Eine »Gemütsverfassung moralischer Unruhe« – Humboldtian Writing", 2001.

98 Vgl. zur Begriffsdiskussion des „Visualizing" im Kontext der Wissenserzeugung technischer Bilder Bruhn, Matthias: „Sichtbarmachung/Visualisierung", in: *Das Technische Bild*, 2008, S. 132–135.

99 Vgl. hierzu auch die Einführung Ulrich Päßlers in: *Humboldt – Ritter: Briefwechsel*, 2010, S. 11–23, insbesondere S. 17; Kraft: *Figuren des Wissens*, 2014.

Die einzelnen Tafeln des Atlas: Funktionsebenen des Erdmodells

„Alles ist Wechselwirkung"

Fügt sich der *Atlas géographique et physique du Nouveau Continent* im vergleichenden und verknüpfenden Sehen zu einem (virtuellen) Modell der Erdkruste zusammen, so lassen sich die einzelnen Karten als dessen Funktionsebenen verstehen. Dies gilt sowohl strukturell – d.h. hinsichtlich des mit den Karten entworfenen räumlichen Schemas der terrestrischen Topographie – als auch systemisch – d.h. hinsichtlich der in den Karten getroffenen, einzelnen Aussagen über die Natur. Insofern richtet sich die spezifische funktionale Bestimmung der jeweiligen Karte im Gesamtkomplex des Bandes einerseits nach ihrer Darstellung der Vertikalen oder aber der Horizontalen und andererseits nach der thematischen Einzeldiskussion des Blattes.

In diesem zweiten Punkt, den verschiedenen Themenschwerpunkten, weisen die Karten des Atlas eine große Heterogenität auf. Sie machen eine komplexe Zusammenschau von Einsichten in Naturphänomene auf, bei denen es sich zum Teil um lokal orientierte Beobachtungen, zum Teil aber auch um weltumspannende Naturgesetze handelt. Gemeinsam ist den Karten dabei, dass der auf ihnen dargestellte Raum hinsichtlich seiner Voraussetzungen für mögliche oder tatsächliche Austauschprozesse in der Natur ausgelotet wird. Entsprechend handelt es sich bei den Karten der ersten beiden thematischen Gruppen des *Atlas géographique et physique du Nouveau Continent* meist um Spielarten von Wege- und Verteilungskarten, auf denen Bewegungslinien von natürlichen Kräften oder aber deren Wirkungsbereiche, d.h. Kräftefelder, sichtbar werden;[100] die Karten der dritten Gruppe zeigen hingegen von spezifischen Vulkanen ausgehende geognostische Abhängigkeiten auf.

Humboldts viel zitierter Ausspruch „Alles ist Wechselwirkung"[101] kann mit dieser Fokussierung der Kartendarstellung enggeführt werden. Sie lässt sich als Resultat von Humboldts Überlegungen zur Beschreibung der bewegten Natur, deren Kräftegefüge harmonisch ineinandergriff, verstehen. Dennoch stand Humboldt, wie sich mit Blick auf die Karten des *Atlas géographique et physique du Nouveau Continent* bestätigt, der konkreten Beschreibung von natürlichen Bewegungen kritisch gegenüber, weil eine solche Festschreibung mit seiner empirischen Leitlinie schwer zu vereinbaren war.[102] Dieser Problematik begegnete er im Atlas, indem darin Naturprozesse nicht in ihrem konkreten Bewegungsverlauf vorgeführt, sondern stattdessen Phänomene ausgewählt und kombiniert

100 Wegekarten verzeichnen mögliche Verbindungswege innerhalb eines Gebietes. Bei Verteilungskarten handelt es sich hingegen um Karten, die die statistische Häufigkeit des Vorkommens eines Naturphänomens und seine Verteilung innerhalb eines geographischen Gebietes visualisieren.

101 Humboldt: *Reise auf dem Rio Magdalena*, 2003, S. 358.

102 Vgl. in der vorliegenden Untersuchung die Unterkapitel *Verknüpfendes Sehen II: Hypothesen zur Erdentstehung* und *Bewegte Blicke – bewegende Blicke: Erkennen im Betrachten*.

wurden, die mutmaßlich voneinander abhängige Faktoren darstellen. Die Karten disku-
tieren somit nicht Bewegungsverläufe in der Natur und deren Prozesshaftigkeit selbst,
sondern visualisieren Erscheinungen der Natur, die entweder Resultate oder Determinan-
ten bestimmter Wechselwirkungen vorstellten.

Bewegungslinien

Um diese möglichen Austauschbeziehungen aufzeigen zu können, setzte Humboldt in
einem Großteil der Karten aus dem Atlas bei der graphischen Wiedergabe von Flüssen
und Bergen an, da sie für ihn die maßgeblichen Faktoren darstellten, die trennend oder
verbindend auf natürliche Austauschprozesse einwirkten. Beide Naturphänomene deter-
minierten die natürlichen Prozesse, indem sie sie förderten oder hemmten. So wird auch
der Orinoko, der in vielen von Humboldts Karten das zentrale Motiv darstellt, selbst als
Vektor von Naturprozessen inszeniert. Zwar markierte der Orinoko auch eine natürliche
Grenze, weil er die Landmasse durchschnitt, diente zugleich aber als Weg und somit der
Wechselbeziehung in der Natur. Nicht zuletzt wurde dank ihm der angrenzende, dichte
Urwald für den durch Amerika reisenden Humboldt selbst in Teilen passierbar. Um diese
Funktionalität topographischer Elemente, hier des Flusses, als Bewegungslinie im Raum
herauszustellen, bediente sich Humboldt dem Itinerar. Diese Darstellungsweise zählt zu
den ältesten Kartentypen überhaupt. Es handelt sich dabei um Karten, die von einem be-
stimmten Transportmittel oder einer Fortbewegungsart ausgehend Verbindungswege
zwischen verschiedenen Orten aufzeigen und oft auch Längenangaben zwischen diesen
angeben. Itinerare lassen sich schon sehr früh, etwa für die ägyptische Hochkultur
2000 Jahre vor unserer Zeitrechnung nachweisen. Die verschiedenen Einheiten, mit de-
nen die Distanzen jeweils angegeben werden – etwa Tagesetappen oder astronomische
Ortsbestimmungen –, lassen Rückschlüsse auf die kulturellen Praktiken zu, in deren Kon-
text das Itinerar jeweils entstand.[103] Auch der Blick auf Humboldts Orinokodarstellung ist
diesbezüglich aufschlussreich: Das alternative Raummaß, das Humboldt dem europäisch
normierten Längenmaß etwa auf der *Carte itinéraire de l'Orénoque* (Abb. 5) mit den An-
gaben seiner eigenen individuellen Reisegeschwindigkeit an die Seite stellte, eröffnet die
Möglichkeit für eine Raumdarstellung, die sich an einem physischen Durchqueren des
Gebietes orientiert und damit den Fluss explizit als Verbindungs- und Transportweg
kennzeichnet.

Wegekarten, über die potentielle Verbindungsmöglichkeiten in der Natur aufgezeigt
werden, finden sich im *Atlas géographique et physique du Nouveau Continent* aber nicht
nur in den auf Flüsse fokussierten Aufsichts-, sondern auch in den Profilkarten. So orien-
tiert sich etwa die Tafel 3, *Chemin de La Guayra à Caracas, par la Cumbre* (Abb. 28), an
einem Pfad in Venezuela, der die zwei im Titel genannten Städte miteinander verbindet.
Dieser Weg ist von enormen Höhenunterschieden gekennzeichnet, die bei der Rezeption

103 Art. „Route Map", in: *Cartographical Innovations*, 1987, S. 57.

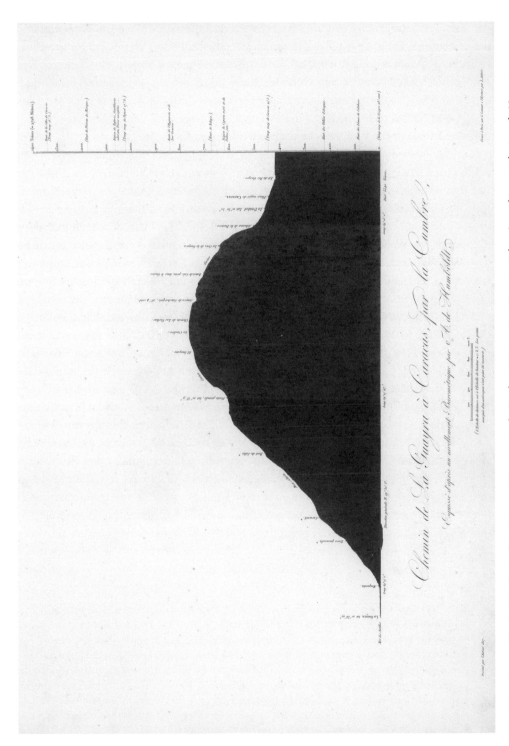

28_Alexander von Humboldt, *Chemin de La Guayra à Caracas, par la Cumbre*, 1819, ca. 43 × 60 cm, in *Atlas géographique et physique du Nouveau Continent*, Tafel 4 (Lieferung 3), Berlin, SBB, Foto SBB

der Karte, in Leserichtung von links nach rechts, als imaginierte Gratwanderung entlang der Höhenlinie überwunden werden. Indem der Blick auf diese Weise gezielt durch und über das Kartenbild gelenkt wird, erfüllen sich zwei Anliegen Humboldts zugleich: Der natürliche Raum erschließt sich einerseits hinsichtlich eines potentiellen Verbindungsweges, der Austauschprozesse in der Natur vor Augen führt, andererseits erleichtert das Mitreisen im Kartenbild das sich auf der Basis der Topographie der Höhe ergebende gedankliche Verknüpfen verschiedener der darauf dargestellten Aspekte.

Kräftefelder

Die Verbindungswege – oder Vektoren – der natürlichen Phänomene, die in den Itineraren von Humboldts Karten ansichtig werden, finden ihre Ergänzung in kartographisch verzeichneten Kräftefeldern, die den Bereich eines bestimmten Austausches von Kräften und damit von Wechselwirkungen in der Natur angeben. Letztlich kann meist das ganze Blatt einer Karte als ein solches Kräftegefüge verstanden werden, besonders markant treten diese Kräftefelder jedoch in Humboldts Profilkarten zur Pflanzengeographie hervor. Die Wirkungsbereiche der natürlichen Wechselwirkungen werden hier der Höhe nach als gestaffelte Zonen des Bewuchses voneinander abgegrenzt. Im *Tableau physique des Iles Canaries* (Taf. XIII),[104] der Tafel 2 des *Atlas géographique et physique du Nouveau Continent*, die den Pico del Teide zeigt, folgen fünf solcher übereinander gelagerter Pflanzenzonen aufeinander: die „Région des Plantes Africaines de 0-200 T[oise]", die „Région des Vignes et des Céréales de 200–430 T[oise]", die „Région des Forêts de Lauriers de 430–680 T[oise]", die „Région des Pins […] de 680–1050 T[oise]" sowie schließlich die „Région du Retama […] de 1050–1600 T[oise]". Im äußeren rechten Bereich der Graphik findet diese sprachliche Klassifikation ihre bildhafte, figurative Entsprechung: Fünf übereinander angeordnete Höhenlagen beherbergen jeweils unterschiedliche, für die entsprechende Höhe typische Pflanzengruppen. In der untersten Zone sind vereinzelte Palmen und Kakteen dargestellt, darüber von Ackerland umgebene Laub- und Nadelbäume, gefolgt von niedrigem Wald, auf zweitoberster Stufe karger Bewuchs aus niedrigen Büschen und abschließend sehr vereinzelte graugrüne, bodennahe Gewächse.[105]

104 Zu Humboldts Besteigung des Pico del Teide auf Teneriffa siehe Ette/Lubrich: „Versuch über Humboldt", 2006, S. 51. Für seine Karte zog Humboldt zudem, wie auf der Karte ausgewiesen, Beobachtungen Leopold von Buchs und Christian Smiths (1785–1816) heran.

105 Auf den Kanarischen Inseln beobachtete Humboldt verschiedene Austauschprozesse im Kleinen, die er später im Großen, dem amerikanischen Kontinent, auch feststellte. Dies galt sowohl für Naturgesetze – etwa die pflanzengeographische Zonen, die er auf dem Pico del Teide erkannte (Taf. XIII) – als auch für politische Zusammenhänge. Dieses Muster der Übertragung lässt sich mit der kolonialgeschichtlich greifenden These engführen, nach der die Kanarischen Inseln einen Versuchsraum für jene Prozesse dargestellt hätten, die später in den Amerikas umgesetzt werden sollten. Vgl. Herbers, Klaus: *Geschichte Spaniens im Mittelalter: vom Westgotenreich bis zum Ende des 15. Jahrhunderts*, Stuttgart: Kohlhammer

Indem die Pflanzen folglich der Höhe nach in typische Gruppen des Bewuchses zusammengefasst werden, leitet nicht die Beobachtung einer singulären botanischen Art die Auswahl des in die Karte Aufgenommenen, sondern die Frage, ob eine Art als typisch für einen der pflanzengeographischen Bereiche gelten könnte oder nicht. Die Idee, die darin sinnfällig wird, ist ein Faktorenmodell, mit dem sich Wechselwirkungen unterschiedlichen Wirkungsbereichen zuordnen lassen. Eine abgegrenzte pflanzengeographische Zone ist demnach von bestimmten, von anderen zu unterscheidenden Faktoren determiniert – etwa einem geographischen Bereich der Höhe –, die zu einem spezifischen Pflanzenbestand führen. Überlegungen zu einer solchen Geographie der Pflanzen, d. h. zu einer regional zu unterscheidenden Verteilung botanischer Arten auf der Erdoberfläche, stellte Humboldt wiederholt an. Erste Reflexionen dieser Thematik finden sich bereits in den 1780er Jahren. Humboldt erkannte, dass die spezifische Ausprägung der Pflanzendecke letztlich das Ergebnis komplexer Austauschprozesse in der Natur war. Verschiedene Faktoren, etwa die geographische Höhe, Breite und Länge, wirkten sich auf den Bewuchs aus. Humboldt folgerte aus dieser Einsicht eine der Höhe nach gestaffelte, zonale Einteilung von botanischen Bereichen. Seine Ergebnisse führte er komprimiert in dem Text der *Geographie der Pflanzen* und dem dazugehörigen *Tableau physique des Andes* (Abb. 1) zusammen.[106]

Weltumspannende Naturgesetze

Aus dem Verweis auf das *Tableau physique des Andes* wird deutlich, dass das *Tableau physique des Iles Canaries* zwar eine lokale Struktur und ein lokales Kräftefeld der Wechselwirkung beschreibt, dass darin aber zugleich auf das allgemeine Phänomen der pflanzengeographischen Höhenverteilung auf der Erdoberfläche verwiesen wird. Auch die übrigen Darstellungen von Naturphänomene, wie sie die Karten des *Atlas géographique et physique du Nouveau Continent* zeigen, verbinden Spezifisches und Allgemeines in der thematischen Auswahl. So fügt sich zum Beispiel der *Plan du Volcan de Jorullo* (Abb. 16) in die Abteilung vulkanologischer Karten ein und lässt als Teil dieser Gruppe allgemeinere Schlussfolgerungen über vulkanische Aktivität und den geognostischen Aufbau von Vulkanen zu. Zugleich aber thematisiert die Karte einen bestimmten Aspekt des Naturwissens und vermehrt es dadurch spezifisch: Sie beschreibt den mexikanischen Vulkanberg Jorullo, der laut Humboldt in Europa bis zum damaligen Zeitpunkt eine kaum beachtete

2006, S. 294, vgl. hierzu ferner die kritische Position zu diesem Topos von Sánchez Robayna, Andrés: „El papel de Canarias en la conformación de la cultura virreinal americana", in: *Oro y plomo en las Indias. Los tornaviajes de la escritura virreinal*, hg. von Antonio Cano Ginés und Carlos Brito Díaz, Madrid: Iberoamericana 2017, S. 183 – 204.

106 Vgl. Humboldt: *Schriften zur Geographie der Pflanzen*, 1989. Für eine Übersicht der Thematik vgl. Becks Kommentar im selben Band, S. 285 – 328. Die *Geographie der Pflanzen* eröffnete, als zuerst erschienene Publikation daraus, das gesamte Reisewerk.

Erscheinung darstellte.[107] Diese auf das Globale zielende Dimension, die bereits die Repräsentation des Lokalen in sich birgt, tritt in Humboldts Atlas auch im Zusammensehen der Karten innerhalb einer thematischen Kartengruppe als morphologische Struktur hervor. Im visuellen Nebeneinander des Gezeigten werden Überschneidungsmomente der Form bei Naturphänomenen augenfällig, die aus weit auseinanderliegenden Regionen stammen können.

Auf anderen Karten des Atlas wird die globale Dimension bereits direkt adressiert. Auch hierbei diente Humboldt die methodische Verfahrensweise des visuellen Vergleichs dazu, die aufgenommenen Phänomene in eine großräumige Beurteilung einzubinden.[108] Kaum zufällig führt schon die mit der ersten Lieferung 1814 erschienene Tafel 1 des *Atlas géographique et physique du Nouveau Continent* mit dem Titel *Limite inférieure des Neiges perpétuelles à différentes Latitudes* (im Folgenden: *Limite inférieure des Neiges*)[109] ein allgemeines Naturgesetz im vergleichenden Sehen vor Augen (Taf. XIV). Die Eingangskarte kann damit als Leseanweisung für den gesamten Atlas verstanden werden, da dessen Konzeption sich erst im kartenübergreifenden Miteinander und im vergleichenden Betrachten der Lieferungskonvolute ganz erschließt. Nicht die einzelnen visualisierten Elemente auf den Karten, so gibt bereits die Tafel 1 zu verstehen, sondern das Zusammensehen dieser Elemente wirkt auf das volle Verständnis des Gezeigten.

Mit *Limite inférieure des Neiges* wird das Naturgesetz der zu den Polen hin in der Höhe sinkenden Grenze des ewigen Schnees vor Augen geführt. Hierfür stellte Humboldt vier virtuelle Bergprofile, die unterschiedlichen Regionen der Nordhalbkugel zugeordnet sind, nebeneinander. Vom Äquator auf der linken Seite des Blattes bis hin zum Nordpol auf der rechten Seite sinkt ihre Schneegrenze ebenso wie ihre relative Höhe zueinander abnimmt. Die Diskussion des Naturgesetzes gewinnt an Anschaulichkeit, indem die Gipfelprofile vergleichend nebeneinandergestellt sind. In Leserichtung beginnend, ragen im höchsten Profil ganz links auf dem Blatt die Gipfel des Chimborazo und des Cotopaxi der südamerikanischen Anden auf; das nachfolgende, etwas niedrigere Profil zeigt die meso-

107 Siehe Humboldt: „Sur les matériaux", 1817, S. 35–37. Vgl. zu der Karte auch Kraft: „Die Geburt der Gebirge", 2014.

108 Mit Bezug auf den *Atlas géographique et physique du Nouveau Continent* gilt dies insbesondere für die Tafel 1 und die Tafel 13. Bei der letzteren, die Karte der *Exemple de bifurcations et de deltas d'affluens pour servir d'éclaircissement aux discussions d'Hydrographie comparée*, die 1825 mit der fünften Lieferung erschien, handelt es sich, wie der Titel vorausweist, um eine visuell vergleichende Diskussion von Wasserläufen. Hierfür wählte Humboldt sieben europäische und südamerikanische Flusssysteme und -mündungen aus, die er jeweils auf einem Bogen nebeneinandersetzte. Über den Vergleich dieser Beobachtungen, d. h. ihrer Differenzen und Kongruenzen, konnten für den globalen Raum allgemeine Relationen und Gesetzmäßigkeiten des Fließverhaltens abgeleitet werden.

109 *Limite inférieure des Neiges perpétuelles à différentes Latitudes* wurde laut Angabe auf dem Kupferstich bereits 1808 von Friedrich Friesen entworfen. Es ist der einzige Entwurf des preußischen Bauzeichners für diesen Atlas, der bereits an mehreren Stichen des „pittoresken Atlas" mitgearbeitet hatte.

amerikanischen Gipfel des Popocatepetl und des Ixtaccihuatl [sic]; das dritte, wiederum an Höhe abnehmende Profil wird von den mitteleuropäischen Bergen Mont Blanc und Mont Perdu[110] gebildet, während im letzten, ganz rechten und zugleich niedrigsten Profil zwei nicht namentlich ausgewiesene skandinavische Bergspitzen die Abfolge abschließen. In jeder der vier Profilgruppen sind die Gipfelpunkte jeweils durch eine gemeinsame Profillinie verbunden, sodass auf der Tafel letztlich vier virtuelle, der Höhe nach abnehmende Bergmassive nebeneinander aufgereiht sind, deren jeweilige Schneegrenze augenscheinlich proportional zur Gipfelhöhe und damit zugleich mit größerer Nähe zum Nordpol kontinuierlich absinkt.

Diese vier Massive sind in ein Koordinatensystem der geographischen Höhe und Breite eingefügt. Jedes der vier Gipfelprofile weist eine eigene y-Achse auf, die die Höhe der Berge in Toises angibt, während allen Profilen eine gemeinsame x-Achse zugrunde liegt. Sie zieht die Längengrade auf der Blattfläche zu einer graphischen Linie zusammen und markiert gleichzeitig die Höhe des Meeresspiegels. Die Skala dieser x-Achse gibt die Breitengrade an, wobei die Gradzahl von links nach rechts steigt: Bei etwa 0° und damit nahe dem Äquator beginnend, setzt sie sich von links, äquatornah, nach rechts, äquatorfern, fort. Durch diese x-Achse egalisiert sich die geographische Entfernung der Bergphänomene hinsichtlich ihrer geographischen Länge: Indem die Längengrade auf einer Linie zusammenfallen und den dreidimensionalen Raum auf der zweidimensionalen Fläche zusammenziehen, eine Dimension also wegfällt, verringert sich die räumliche Distanz der Phänomene deutlich, die die Berge auf der Erdoberfläche eigentlich aufweisen. Nicht erst die voneinander separierten Profile sind von dieser Komprimierung der Distanzen betroffen, sondern bereits die Gipfel innerhalb dieser. Sie entstammen, anders als die virtuellen Profillinien es auf der Graphik suggerieren, nicht in allen Fällen demselben geographischen Bergmassiv. Vielmehr weisen auch diese Gipfel im Realraum bisweilen noch eine große Distanz zueinander auf.[111]

Dass Humboldt diese geographischen Informationen verschliff, lässt sich auf die visuelle Argumentation der Tafel zurückführen: Über die gezielte Auswahl von Informationen und ihre entsprechende Darstellung wird erreicht, dass jedes der vier Profile als das verkleinerte bzw. vergrößerte Äquivalent des benachbarten erscheint. Zwar weisen die Profile jeweils unterschiedliche Maximalpunkte der Höhe auf, stimmen in der Gestalthaftigkeit des Umrisses und der Farbgebung aber überein: An zwei aufeinanderfolgende, beschneite Gipfel schließen zwei bis drei nicht beschneite Kuppen an. Ihrer formalen Wiederholung

110 Gebräuchlicher ist heute der spanische Name Monte Perdido. Der Berg befindet sich nahe der französischen Grenze auf spanischem Nationalgebiet und stellt die dritthöchste Erhebung der Pyrenäen dar.

111 So beträgt die Entfernung zwischen Mont Blanc und Mont Perdu etwa 650 Kilometer Luftlinie, halbiert sich jedoch etwa, sobald lediglich die Distanz der Breitengrade berücksichtigt wird. In *Limite inférieure des Neiges* können beide Berge daher im selben virtuellen Massiv als nebeneinanderliegend dargestellt werden.

entspricht die einheitliche Kolorierung der Silhouetten: Über einer braunen, an Felsgestein erinnernden Flächigkeit hebt sich der weiße Schnee der Gipfel ab. Zudem sind jeweils, mit Ausnahme des kleinsten, skandinavischen Profils, auf den ersten Hochebenen unterhalb der Schneegrenze Städte verzeichnet.

Damit sich diese Kongruenz einstellt, ist freilich eine strenge Auswahl aus der breiten Variationsmöglichkeit geographischer Referenzen, hier Bergspitzen, notwendig: Die Gipfel müssen sich den vier unterschiedlichen, von Humboldt ausgewählten Regionen der Nordhalbkugel zuordnen lassen, innerhalb dieser Gruppierung einen bestimmten Abstand der geographischen Breitengrade und zudem innerhalb des eigenen Profils zu den anderen dargestellten Gipfeln einen relationalen Höhenunterschied aufweisen, der dem jeweiligen der anderen Profile entspricht. Erst mit Hilfe einer solchen Herrichtung der Daten lassen sich formale Analogien der Gipfelprofile erzeugen, die in der Höhe insgesamt ab- und an geographischer Breite zunehmen. Das hierbei zugleich erfolgende Sinken der Schneegrenze suggeriert eine Stetigkeit des dargestellten Naturphänomens. Diese Beobachtung wird, wie sich an den kurz unterhalb der Schneegrenze eingezeichneten Städten zeigt, darüber hinaus zum Indikator für eine systeminhärente, nach klimatischen Gesetzmäßigkeiten erfolgende menschliche Besiedelung der Erdoberfläche.

An der Tafel *Limite inférieure des Neiges* tritt mithin die Bedeutung, die der (naturphysiognomische) Vergleich natürlicher Phänomene für Humboldts Wissensgenese hatte, deutlich hervor. Sie motiviert letztlich die Darstellungsweise des gesamten Atlas: Dank dieser Methode ließen sich selbst natürliche Phänomene aus weit voneinander entfernten geographischen Regionen in eine gemeinsame Aussage überführen und zugrunde liegende Naturgesetze ablesen.[112] Im visuellen Vergleich zeichnen sich sowohl Überschneidungsmomente – etwa die Existenz des ewigen Schnees – als auch Differenzen – nämlich das beständige Sinken der Schneegrenze – deutlich ab. Die lokale Naturbeobachtung wird hierbei in ein systemisches, ineinanderwirkendes Prinzip des „Naturganzen" eingebettet. Diese Vorgehensweise ermöglichte es Humboldt, eine singuläre Beobachtung an einem beliebigen Punkt auf der Erdoberfläche potentiell in einen heuristischen Zusammenhang zu überführen und sein Gesichtsfeld demnach prinzipiell – und schon in der einzelnen Karte – auf weltumspannende Zusammenhänge zu erweitern. Für die Eingangskarte, die Tafel 1 des *Atlas géographique et physique du Nouveau Continent*, gilt zugleich, dass sie die Rezeption des Atlas anleitet und somit wesentlich zum Verständnis insgesamt beiträgt.

Kartierte Handlungsfelder des Menschen
Zu den maßgeblichen Faktoren, die die natürlichen Dynamiken in der Natur mit bedingten, gehörte für Humboldt immer auch der Mensch. Auch dies spiegeln die Karten des

112 Anders als bei dem Vergleich der einzelnen Lieferungen des *Atlas géographique et physique du Nouveau Continent* war bei diesem Vorgehen die geographische Standortbestimmung von Naturphänomenen für das Erkennen und Beschreiben der Naturgesetze wesentlich.

Atlas géographique et physique du Nouveau Continent. Der Mensch trug etwa zur Verbreitung von Pflanzenarten bei, indem er sie mit seinen Schiffen von Europa und Afrika aus über den Ozean nach Amerika brachte und vice versa. Zugleich wurde wiederum der Bewegungsradius des Menschen durch geographische Bedingungen determiniert, etwa durch hohe Berge, die die Erreichbarkeit bestimmter Gebiete erschwerten. Eine wesentliche Rolle spielte für Humboldt in diesem Kontext aber nicht nur die topographische Formation selbst, sondern auch das Wissen über sie. Erst dessen Anreicherung führte bisweilen dazu, dass neue Wege gesucht, beschritten und in der Folge Austauschprozesse in Gang kamen. Insofern, als in Humboldts Überlegungen also die gegenseitige Bedingtheit von menschlicher Aktion und geographischen Gegebenheiten bzw. der Kenntnis über sie einfloss, lassen sich seine Karten immer auch als Darstellungen von auf den Menschen bezogenen Handlungs- und Wissensräumen verstehen. Vom Status quo ausgehend weist die kartographische Beschreibung des Raumes daher immer auch in die Zukunft, denn sie bereitet den Raum für neue Handlungsoptionen vor – nicht zuletzt mit geopolitischer Reichweite. Auf der Grundlage des geographischen Überblicks, den die Karten ermöglichten, diskutierte Humboldt, welche Optionen sich daraus für den Handlungsspielraum des Menschen ergeben könnten.

Zu einer der wichtigen Überlegungen, die Humboldt in diesem Zusammenhang anstellte, zählt eine für die Schifffahrt geeignete Verbindung der Ozeane am mittelamerikanischen Isthmus. Humboldt verfolgte diese Idee über fünf Jahrzehnte hinweg, wobei er den Vorteil von schiffbaren „Communications-Mitteln zwischen beiden Meeren"[113], dem Atlantik und dem Pazifik, nicht nur für den Handel und für die Erschließung von Rohstoffen sah, sondern explizit auch für den kulturellen Austausch.[114] Auf mehreren seiner Karten setzte sich Humboldt mit diesem Thema auseinander, darunter auf der *Carte hydrographique de la Province du Chocó*, der Tafel 25 des *Atlas géographique et physique du Nouveau Continent* (Abb. 9).

113 Humboldt, Alexander von: „Das Hochland von Caxamarca", in: ders.: *Ansichten der Natur*, Bd. 2, Stuttgart: Cotta 1849, S. 315–407, hier S. 389 (Endnote 18).

114 Siehe ebd. Humboldt verwies hier auf weitere Karten und Textpassagen, in denen er sich mit dem Isthmus und dem Projekt des Kanalbaus beschäftigte, beispielsweise auf die Tafel 4 aus dem *Atlas de la Nouvelle-Espagne* und die Tafeln 22 und 23 aus dem *Atlas géographique et physique du Nouveau Continent*. Allerdings unterlief Humboldt hierbei offenbar eine Verwechslung, denn dem Inhalt nach müsste es sich statt um die Tafel 23, die *Carte de l'ile de Cuba*, um die Tafel 25, die *Carte hydrographique de la Province du Chocó*, gehandelt haben. Als Textpassagen benennt Humboldt selbst die *Voyage*, Teil 1 *(Relation historique)*, Bd. 3, 1825, S. 117–154, und den *Essai politique sur le royaume de la Nouvelle-Espagne*, Bd. 1, 1825 (2. Auflage), S. 202–248. Vgl. zu Humboldts Projekt eines Panama-Kanals Brescius, Moritz von: „Connecting the New World. Nets, Mobility and Progress in the Age of Alexander von Humboldt", *HiN* XIII (2012) 25, S. 11–33, hier S. 26–29.

Wegen ihrer besonderen Geländeformation und reichen Bodenschätze findet die südamerikanische Gegend in den Reiseberichten Humboldts immer wieder Erwähnung. Auf der *Carte hydrographique de la Province du Chocó* wird nun der kolumbianische Teil der Provinz in der Aufsicht ansichtig. Am oberen Rand schließt das Kartenfeld mit der Landenge des nördlichen Kolumbiens und, östlich von dieser gelegen, mit dem Golf d'Urabá in der Karibischen See ab, während sich die westliche, zum Pazifik hin gelegene Küstenlinie vom oberen bis zum unteren Kartenrand durch das gesamte Kartenbild zieht. Parallel zu dieser langgestreckten, vertikal verlaufenden Uferlinie sind auf der Landmasse lediglich die Höhen der Kordilleren namentlich markiert. Beidseitig werden sie von graphisch verzeichneten Flusssystemen gesäumt: im Osten vom Hauptstrom Caura und seinen Nebenflüssen und im Westen von dem nördlich gelegenen Flusssystem des Atrato und dem südlich gelegenen des San Juan. Feine Doppelstriche, die die jeweiligen Hauptströme markieren, durchziehen die Karte vom oberen bis zum unteren Rahmenrand. Nur wenige Elemente, die sich nahe den Flüssen befinden – insbesondere Städte und Dörfer sowie Gold- und Platinminen –, ergänzen die Darstellung. In ihrer topographischen Ausgestaltung daher weitgehend auf die Wasserarme sowie die Küstenlinien der Karibischen See und des Pazifiks reduziert, gibt die Karte das auf ihr verhandelte Thema leicht zu erkennen: die Lage der Flusssysteme zueinander und zu den Meeren sowie die regionalen Vorkommen von Bodenschätzen.

Humboldts kartographische Vorarbeit zu dieser Karte (Abb. 10) legt einen gedanklichen Prozess offen, der auf der Basis einer möglichst genauen topographischen Erfassung danach fragt, ob und inwiefern der San Juan und der Atrato dienen könnten, um miteinander verbunden als Schifffahrtsstraße genutzt zu werden.[115] Diese Auseinandersetzung führte schließlich, wie die letztlich gedruckte Karte zeigt, zu einer völlig anderen Bewertung als derjenigen, die Humboldt anfangs noch vorgenommen hatte. Ursprünglich war er von einer bereits existierenden wasserführenden Verbindung der Flusssysteme ausgegangen, denn Ende des 18. Jahrhunderts war mit dem Canal de Raspadura zwischen beiden Flüssen ein künstlicher Wasserweg angelegt worden. Die Frage war aber, ob der Kanal zukünftig auch als Schifffahrtsweg zweckmäßig sein würde.

Zunächst schien Humboldt der Kanal offenbar durchaus geeignet, regelmäßigen Schiffsverkehr zwischen den Meeren zu ermöglichen.[116] Auch auf der oben erwähnten zeichnerischen Vorarbeit zur *Carte hydrographique de la Province du Chocó* von 1819 platzierte Humboldt den Kanal mittig und damit an zentraler Stelle: Auf der skizzierten Landmasse treten in deutlicher Strichführung Doppellinien hervor, mit denen die zwei Flusssysteme markiert sind, die sich später auch in der *Carte hydrographique de la Province du*

115 Vgl. zu den Vorarbeiten das Unterkapitel *Teamarbeit am Atlas* der vorliegenden Untersuchung.
116 Vgl. Humboldt, Alexander von: „Projet d'un canal maritime sans écluses entre l'Océan Atlantiques et l'Océan Pacifique par la voie des rivières Atrato et Truando", Brief von Humboldt an Kelley, *Zeitschrift für allgemeine Erdkunde* 2 (1857), S. 562 – 563.

Chocó wiederfinden: das der nördlich verlaufenden Flüsse Atrato und Quitó[117] sowie das des südlich in den Pazifik mündenden Rio San Juan mit seinen Nebenflüssen. Beide, den Atrato und den San Juan, verbindet auf der Skizze ein deutlich markierter „Canal de Raspadura".[118] Den kartographischen Entwurf kennzeichnet seine Vorläufigkeit: Zwischendurch brechen die Linien der Flussverläufe immer wieder ab oder sind statt mit der Feder nur mit dem Bleistift eingesetzt. Zudem fügte Humboldt einige der Wasserarme lediglich namentlich ein, ohne ihren Verlauf gleichzeitig graphisch nachzuvollziehen. Offenbar markierte er auf diese Weise den jeweils verschiedenen Status des Aufgenommenen: Thematisch und geographisch bereits gesicherte Aspekte differenzierte er dahingehend, ob zu ihnen noch Informationsdefizite, etwa hinsichtlich genauer topographischer Daten, vorlagen oder ob ihnen insgesamt weniger Bedeutung für das auf der Karte verhandelte Thema zukam. Noch in der fertigen Karte (Abb. 9) werden qualitative Unterschiede auf diese Weise kenntlich gemacht: Während wesentliche Aspekte figurativ verzeichnet und mit ihrer geographischen Bezeichnung versehen sind, sind andere, wie die Kordilleren, die nur sekundär zur zentralen Thematik der Karte beitragen, lediglich namentlich erwähnt, wodurch sich die thematisch wesentlichen Flusssysteme umso deutlicher im Kartenfeld abheben.

Vor allem aufgrund neuer geographischer Messwerte aus der Region, die Humboldt Mitte der 1820er Jahre erhielt, verschob sich seine räumliche Einschätzung deutlich:[119] Die Flusssysteme erschienen nun unwegsamer, vor allem aber waren sie nicht dauerhaft miteinander verbunden. In die gedruckte Fassung der *Carte hydrographique de la Province du Chocó* nahm Humboldt den Canal de Raspadura daher nicht mehr auf, denn der Wasserweg war, wie Humboldt nun wusste, nur für kleine Boote und zudem unter erschwerten Bedingungen befahrbar.[120]

Humboldts kartographische Auseinandersetzung mit dem Chocó verdeutlicht, dass er nach ersten Informationen zunächst erwog, der Canal de Raspadura könnte der Schlüssel zu einer dauerhaften Verbindung des Pazifiks und der Karibischen See bzw. des Atlantiks sein, da bereits die natürlichen Flussverläufe einander beinahe berührten.[121] Im Laufe der Zeit aber kam er schließlich zu einem abschlägigen Urteil hinsichtlich des zunächst als naheliegend Erscheinenden: Auf der Grundlage seiner topographischen Analyse müsse –

117 Auf der Skizze ist der Fluss von Humboldt als „Rio Quibdo" ausgewiesen.

118 Noch in seine 1825 gedruckte *Carte générale de Colombia* (Taf. I), Tafel 22 des *Atlas géographique et physique du Nouveau Continent*, nahm Humboldt den Canal de Raspadura mit auf. Trotz des kleinen Maßstabs lässt er sich gut im Kartenbild erkennen.

119 Vgl. hierzu die Materialen des Krakauer Nachlass zur *Carte hydrographique de la Province du Chocó*. BJK, HA, Nachlass Alexander von Humboldt 8, 2. Teil, nicht foliiert.

120 Vgl. Humboldt, Alexander von: *Lateinamerika am Vorabend der Unabhängigkeitsrevolution*, hg. von Margot Faak, Berlin: Akademie-Verlag 2003, S. 99.

121 Vgl. Humboldt, Alexander von: *Essai politique sur l'île de Cuba: avec une carte et un supplément*, Bd. 2, Paris: Gide 1826, S. 285.

so lässt sich die *Carte hydrographique de la Province du Chocó*, ihre verschlungenen Wasserwege und die kartographisch immer weiter schwindende Bedeutung des Kanals verstehen – nach einer anderen Möglichkeit der Verbindung beider Ozeane gesucht werden.

Die Überlegungen, die der *Carte hydrographique de la Province du Chocó* zugrunde lagen, waren Teil eines visionären Projekts, dessen Anfänge sich, so schrieb Humboldt selbst, bereits auf 1805 datieren lassen. Zunächst stellte er sich die Frage, ob die beiden Ufer, die den Isthmus Panamas umfingen, mit einer Eisenbahnlinie verbunden werden könnten, dehnte diese Erwägungen aber schnell auf einen Kanalbau aus.[122] Die damit einhergehenden Herausforderungen beschrieb Humboldt 1827 in der Zeitschrift *Hertha* wie folgt:

> In mehren meiner Schriften habe ich zu entwickeln gesucht, daß bevor man auf irgend einem Punkte zu der Eröffnung eines Kanals zwischen der Südsee und dem atlantischen Ozean schreitet, die ganze Zahl der Landengen aufgenommen, nivellirt und physikalisch untersucht werden müßte, welche bisher, als zu einer solchen Verbindung geeignet, vorgeschlagen worden sind.[123]

Mit dieser Aussage scheint Humboldt auch seine eigenen kartographischen Überlegungen direkt angesprochen zu haben, darunter diejenigen, die er im Laufe der Arbeit an der *Carte hydrographique de la Province du Chocó* angestellt hatte.

Das Projekt des Kanalbaus blieb für Humboldt zeitlebens eine Vision, die ihn um- und antrieb: Da die Kordilleren ein für den Menschen nur schwer zu überwindendes Naturphänomen darstellten, war eine Verbindung der beiden Meere von umso größerer Bedeutung. Die hohen Gipfelzüge behinderten den gewünschten materiellen und kulturellen Austausch zwischen Mittel- und Südamerika ebenso wie denjenigen zwischen Europa, der südamerikanischen Westküste und Asien. Humboldts Idee eines Kanals durch den zentralamerikanischen Isthmus erfasste damit nicht nur eine von Europa aus gedachte, ökonomische Zielrichtung, sondern war auf einen globalen Austausch bezogen.[124]

Mit seinen Überlegungen nahm Humboldt die Idee eines Verbindungsweges zwischen den Meeren, die noch aus den Anfängen der Kolonialgeschichte Mittelamerikas stammte, erneut auf. Damals war sowohl nach einem geeigneten Ort für eine künstliche

122 Moritz von Brescius verweist auf diese frühe Nennung durch Humboldt in einem Brief, den dieser am 5. Mai 1858 (?) an Alexander W. Thayer schrieb. Vgl. Brescius: „Connecting the New World", 2012, S. 25 (Fußnote 116). Vgl. über die Verbindung der Ozeane Humboldt: *Essai politique sur le royaume de la Nouvelle-Espagne*, Bd. 1, 1811 (Oktav), insbesondere Kapitel 2, S. 223 – 261. Auch im *Atlas de la Nouvelle-Espagne* setzte Humboldt sich kartographisch mit dem Thema auseinander.

123 Humboldt, Alexander von: „Neuste Beschlüsse der mexiko'schen Regierung über einen Handelsweg in der Landenge von Goazacoalco und Tehuantepec", *Hertha, Zeitschrift für Erd-, Völker- und Staatenkunde* 9 (1827), S. 5 – 28, hier S. 5.

124 Vgl. Brescius: „Connecting the New World", 2012, S. 27 – 29. Brescius zeigt auf, dass Humboldt auch potentielle negative Folgen in seine Überlegungen mit einbezog.

Wasserstraße als auch nach einem natürlichen Wasserweg gesucht worden. Durch Humboldt erhielten diese Pläne in den ersten Dekaden des 19. Jahrhunderts, d. h. nach der Unabhängigkeit der iberoamerikanischen Staaten, neuen Auftrieb und wurden unter anderem von dem südamerikanischen Unabhängigkeitskämpfer Simón Bolívar (1783–1830) entscheidend vorangetrieben. Bolívar gab die oben erwähnte, von Humboldt vorgeschlagene Nivellierung des Isthmus schließlich in Auftrag.[125] Der tatsächliche Bau sollte dennoch erst mehr als ein halbes Jahrhundert nach Humboldts Tod den US-Amerikanern gelingen; ab 1914 konnte der Panama-Kanal von Schiffen passiert werden.

Auf diesen Kanal weist die *Carte hydrographique de la Province du Chocó* neben anderen Karten Humboldts bereits voraus.[126] Sie zeigt exemplarisch, dass Humboldts kartographischen Auseinandersetzungen immer auch auf die Möglichkeiten bezogen waren, die sich aus dem geographischen Wissen, das in Karten ebenso gespeichert wie erst verfügbar gemacht wurde, für das menschliche Handeln ergaben. Nicht nur für die natürliche, sondern auch für die kulturliche Sphäre lag ein Hauptaugenmerk also darauf, welche Wege des Austausches und der Bewegung der jeweilige Raum zu eröffnen vermochte. Nicht zuletzt hierin zeigt sich eine politische Dimension im Denken Alexander von Humboldts, ohne die der *Atlas géographique et physique du Nouveau Continent* und das ihm zugrunde liegende Konzept eines virtuellen Modells der Erdkruste nur unzureichend erfasst wären.

Humboldts Modell der Erdoberfläche im Kontext? – Kartographische Modelle der Welt vor und um 1800

Experimente mit geographischen Modellen der Welt vor und um 1800

Für ein aus Karten zusammengefügtes virtuelles Modell der Erdkruste, wie Alexander von Humboldt es mit seinem *Atlas géographique et physique du Nouveau Continent* entwarf, sind hinsichtlich der thematischen und konzeptionellen Komplexität bislang keine vergleichbaren Entwürfe bekannt.[127] Dennoch lässt sich für die Zeit um 1800 insgesamt eine erneute und experimentelle Hinwendung zu geographischen Modellen von Teilen der Erdoberfläche oder gar der ganzen Welt ausmachen, wobei eine Vielzahl neuer Spielarten

125 Humboldt hatte, wie er selbst sagte, Simón Bolívar zu diesen Plänen motiviert. Vgl. Humboldt: „Das Hochland von Caxamarca", 1849, S. 390.

126 Als weitere Karte, die im *Atlas du Noveau Continent* in direktem Zusammenhang mit dem Projekt des Kanalbaus durch den mittelamerikanischen Isthmus entstand, ist die Tafel 32, die *Carte de l'isthme de Tehuantepec*, 1834, zu nennen.

127 Vermutlich lässt sich ein entsprechendes Vorbild für die Atlaskonzeption auch deshalb nicht finden, weil Humboldt selbst angab, diverse Kartentypen, etwa die „physischen Karten" in Ergänzung der „geographischen Karten", eigenständig entwickelt zu haben, auf deren Kombination die Konzeption des *Atlas géographique et physique du Nouveau Continent* maßgeblich beruht.

von diesen Darstellungsmitteln entstand. Das gesteigerte Interesse an geographischen Modellierungen der Welt mag zum damaligen Zeitpunkt durch den Umstand einen entscheidenden Antrieb erhalten haben, dass von nahezu der gesamten Erdoberfläche, und sukzessive auch von ihrem Höhenrelief, verhältnismäßig genaue geographische Messdaten vorlagen und es zudem deutlich einfacher geworden war, auch weite geographische Strecken zu bewältigen. Diese Entwicklungen führten zu einer neuen Wahrnehmung globaler Räume, die das – gleichwohl schon damals ambivalent verhandelte – Empfinden mit sich brachte, die Welt und die Natur seien beherrschbar.[128] Der Variantenreichtum an Weltmodellen ist insofern auch als Ausdruck eines Herrschaftsgestus über das Weltganze zu verstehen. Bei Alexander von Humboldt findet sich dieses Moment, wenngleich immer wieder kritisch reflektierend relativiert, im holistischen Anspruch seiner Wissenschaft wieder.

Im Zuge der Auseinandersetzung mit kartenbasierten Weltmodellen rückt die kartographische Problematik in den Blick, dass sich die dreidimensionale Topographie der Erdoberfläche auf der zweidimensionalen Oberfläche der Karte nicht verzerrungsfrei darstellen lässt.[129] Je größer die geographische Fläche ist, die auf der Karte wiedergegeben werden soll, umso stärker fallen diese Verzerrungen ins Gewicht, denn relativ zur Ausweitung des kartierten Gebietes nimmt auch die Krümmung der Erdoberfläche zu, die durch die Projektion auf dem zweidimensionalen Papier ausgeglichen werden muss. Um 1800 traf diese Problematik zusätzlich auf den Umstand, dass die wissenschaftlichen Ansprüche an die kartographische Darstellung wuchsen: Diese sollte zwar auf den technischen Innovationen der Zeit basierend geodätisch präzise und metrisch korrekt, gleichzeitig aber noch immer anschaulich sein.[130] Das einzige maßstabsgerechte, verzerrungsfreie, d. h. längen-, flächen- und winkeltreue Modell der gesamten Erdoberfläche liefert letztlich der Globus. Sollen nur Teile der Erdoberfläche dargestellt werden, so lassen sie sich mit dreidimensionalen Reliefmodellen maßstäblich nachbilden. Im mitteleuropäischen Raum

128 Vgl. Schröder: *Wissen von der ganzen Welt*, 2011. Im Kontext der Raumwahrnehmung bei Humboldt vgl. Ette, Ottmar: *Alexander von Humboldt und die Globalisierung: Das Mobile des Wissens*, Frankfurt am Main: Insel 2009. Die in der vorliegenden Untersuchung angesprochene Ambivalenz zeigt sich etwa in romantischen Weltentwürfen, die rationalen, aufklärerischen Bewegungen eine häufig religiös konnotierte, ganzheitliche Perspektive entgegenstellten.

129 Die generelle kartographische Problematik, auf welche Weise die dreidimensionale Erdoberfläche im zweidimensionalen Raum der Zeichenfläche dargestellt werden konnte, gewann mit dem Aufkommen des immer genaueren Messwesens und der disziplinären Geodäsie an neuer Dringlichkeit. Zu den Schwierigkeiten gehörte etwa zu klären, auf welche Weise eine präzise vermessene Topographie aus der Aufsicht in ihrem Höhenrelief dargestellt werden konnte. Zu diesem Zweck wurde zunächst die Schraffendarstellung entwickelt (1799) und später, nachdem Humboldt selbst nicht mehr aktiv Karten produzierte, um Höhenlinien und Schummerung ergänzt. Zur Entwicklung des Kartenbildes vgl. Pápay: Art. „Kartographie und Abbildung", 2014.

130 Vgl. ebd., S. 190 – 191.

29__Martin Waldseemüller, Erdglobus-Segmentkarte, ca. 1507, 34 × 24 cm, Minneapolis, James Ford Bell Library

des 18. Jahrhunderts diversifizierte sich ihr Variantenreichtum deutlich. Zu den damals einflussreichen Entwicklern gehörte der schweizerische Leutnant Franz Ludwig Pfyffer von Wyher (1716 – 1802), der später auch in Alexander von Humboldts *Essay de Pasigraphie* Erwähnung finden sollte. Pfyffer von Wyher baute in der zweiten Hälfte des 18. Jahrhunderts über mehrere Jahrzehnte hinweg ein auf zahlreichen Messungen fußendes Reliefmodell der Zentralschweiz, das auch Humboldt selbst in Augenschein nahm.[131]

Dreidimensionale Modelle, wie es Globen und Reliefmodelle sind, waren in der Produktion indes meist deutlich aufwändiger als die ohnehin schon kostspieligen Karten und stellten zudem größere Herausforderungen bei ihrer Verbreitung dar. Es wurden daher schon früh Versuche unternommen, Modelle des gesamten Erdballs auf Karten zu entwerfen. Zu ihnen gehört die 1507 entstandene Erdglobus-Segmentkarte (Abb. 29) von Martin Waldseemüller (um 1472 – 1520). Sie besteht aus zwölf mandelförmigen, senkrecht aneinander anschließenden Segmenten, die die Erdkugel entlang des Äquators auf

131 Vgl. Beck: „Profil – Reliefmodell – Panoramakarte – Reliefkarte – Hochgeprägte Reliefkarte", 1985, S. 25; vgl. ferner Imhof, E. „Kartenverwandte Darst[ellungen] der Erdoberfläche", *Internationales Jahrbuch für Kartographie* (1963), S. 87 – 92.

die zweidimensionale Zeichenfläche übertragen. Zu Humboldts Zeiten war diese jedoch, im Gegensatz zu anderen Karten Waldseemüllers, nicht bekannt. Ein experimenteller Versuch aus Humboldts Zeit, der ihm geläufig gewesen sein könnte, stammt dagegen von dem deutschen Kartographen Christian Gottlieb Reichard (1758–1837). Dieser veröffentlichte 1803 mit seinem *Atlas des ganzen Erdkreises* sechs geographisch aneinander anschließende Karten, aus denen sich ein quadratischer Globus, also ein Kubus des Erdkörpers, zusammensetzen ließ. Die Karten zeigten die dreidimensionale Erdoberfläche als Ganzes und ebenso anschaulich wie maßstabsgerecht. Da die Kartenblätter im Buchformat publiziert und rezipiert werden konnten, ließen sie sich nicht nur vergleichsweise leicht verbreiten, es vermehrten sich auch ihre Präsentations- und Rezeptionsmöglichkeiten.[132]

Philippe Vandermaelens *Atlas universel*

In direkter Auseinandersetzung mit Alexander von Humboldts *Atlas géographique et physique du Nouveau Continent* und seinem *Atlas de la Nouvelle-Espagne* entwickelte der belgische Kartograph Philippe Vandermaelen (1795–1869) ein anderes kartographisches Erdmodell. 1827 gab er den sechs Bände umfassenden *Atlas universel* heraus,[133] der etwa 380 in gleichem Maßstab angefertigte Lithographien mit kartographischen Projektionen enthält, denen 40 statistische Blätter vorausgehen. Bereits hierin ist eine Nähe zu Alexander von Humboldts Werk auszumachen, denn auch Humboldt stellte seinem *Atlas de la Nouvelle-Espagne* mit den „Tablas geográfico-políticas" – die Angaben zu Bevölkerung, den wichtigen Städten, der Landwirtschaft und den wirtschaftlichen Erträgen enthalten – statistische Tabellen zur Landeskunde voran.

Die geographischen Karten des *Atlas universel* sind so aufeinander abgestimmt, dass sie sich aneinandergelegt zu einem 7,75 m großen, dreidimensionalen Globus aus Papier zusammenbauen lassen.[134] Der vierte Band des Atlas ist *Amérique Septentrionale* gewidmet. Hier ergänzte Vandermaelen die Aufsichten auf die Erdoberfläche um sieben Querschnitte durch sie hindurch. Bei diesen handelt es sich um lithographisch angefertigte

132 Reichard, Christian Gottlieb: *Atlas des ganzen Erdkreises*, Weimar: Bertuch 1803. Vgl. zum Erdkubus Christoph, Andreas: „Vom Atlas zum Erdkubus. Eine kleine Geschichte zur Quadratur des Kreises", in: *Die Werkstatt des Kartographen*, 2011, S. 49–66, hier S. 51.

133 Vandermaelen, Philippe: *Atlas universel de géographie physique, politique, statistique et minéralogique, sur léchelle de 1/1641836 ou d'une ligne par 1900 toises*, Zeichnungen von Philippe Vandermaelen, Lithographie von H. Ode, Brüssel: Philippe Vandermaelen 1827, 6 Bände: Bd. 1: *Europe*, Bd. 2: *Asie*, Bd. 3: *Afrique*, Bd. 4: *Amérique Septentrionale*, Bd. 5: *Amérique Méridionale*, Bd. 6: *Océanique*, alle 56 cm × 41 cm.

134 Die Princeton University Library hat die Blätter digitalisiert und auf dieser Grundlage ein virtuelles 3D-Modell von Vandermaelens Globus entwickelt. Es lässt sich, ebenso wie der gesamte Atlas, im Internet abrufen unter: http://libweb5.princeton.edu/visual_materials/maps/websites/vandermaelen/home.htm (letzter Zugriff 02.11.2019).

Nachdrucke physischer Höhenkarten, die Humboldt von Süd- und Mesoamerika entworfen und nur kurze Zeit vorher in seinen beiden oben genannten Atlanten publiziert hatte. Vandermaelens Platzierung der Schnittdarstellungen auf den jeweiligen Tafeln erschließt sich aus der Ansicht der einzelnen Blätter noch nicht, da sich Schnitt und Aufsicht geographisch nicht direkt aufeinander beziehen. Erst in der Zusammenschau aller Karten der amerikanischen Kontinente wird deutlich, dass die Höhenkarten die Uferlinien beidseitig umfangen (Taf. XV). Auf diese Weise entsteht eine eindeutige Relation zwischen Höhenprofilen und Landmasse. Dass Vandermaelen bei der Konzeption seines Atlas Humboldts Publikationen genau studiert hatte, unterstreicht eine weitere Tafel seines *Atlas universel*, die den darin enthaltenen topographischen Karten vorangestellt ist: das *Tableau comparatif des principales Hauteurs du Globe*, das kompositorisch an Humboldts *Culminations-Punkte (Höchste Gipfel) und Mittlere Höhen (Kammhöhen) der Gebirgsketten von Europa, America und Asien* (Abb. 2) anschließt. Auch Vandermaelens Blatt setzt die mittleren Höhen der Kontinentalmassen vergleichend nebeneinander und weist deren jeweils prominentesten Bergspitzen aus. Hiermit griff Vandermaelen auf den bei Humboldt vorformulierten Anspruch einer Reflexion des dreidimensionalen Erdkörpers zurück, um sie der Vielzahl an Aufsichtskarten seines *Atlas universel* – gewissermaßen als heuristisches Leitbild – voranzustellen.

Archäologie der Karten. Historisches Wissen über die Erde im *Atlas géographique et physique du Nouveau Continent*

Zwischen 1835 und 1837 publizierte Alexander von Humboldt in jeweils einzelnen Lieferungen (Lieferungen 10 bis 16) sieben Nachstiche historischer Karten, die den *Atlas géographique et physique du Nouveau Continent* um eine vierte thematische Abteilung ergänzten: die des historischen geographischen Wissens. Als Tafeln 33 bis 39 schlossen sie mit ihrer Nummerierung unmittelbar an die 32 zum damaligen Zeitpunkt bereits edierten Karten des Bandes an. Ebenso wie die Tafeln 31 und 32 hatte Humboldt diese Nachstiche noch nicht für die ursprüngliche Version des Atlas vorgesehen; er ließ sie erst auf den Markt bringen, nachdem er diesen schon für abgeschlossen erklärt hatte.[1]

Entsprechend fügen sich die ergänzten Tafeln nicht in die zunächst entwickelte Konzeption des virtuellen Erdmodells ein. Die sieben Nachstiche bilden stattdessen gewissermaßen das archäologische Fundament des *Atlas géographique et physique du Nouveau Continent*: Mit ihnen erweiterte Humboldt die ersten 32 Karten, die weitestgehend den Stand des zeitgenössischen Wissens über die Erdoberfläche zeigten, um die Perspektive der historischen Entwicklung des Wissens über die Geographie Amerikas. Die Einschränkung „weitestgehend" bezieht sich hierbei auf zwei Karten des ursprünglichen Atlasteils, in denen Humboldt eine kartographische Auseinandersetzung mit früherem erdgeschichtlichem Wissen bereits erprobt hatte. Einmal mehr hatte ihm dabei das vergleichende Sehen gedient, um seine kartographisch verfassten Überlegungen zu generieren und zu vermitteln, wobei er auf jeweils demselben Blatt verschiedene historische Zeitschichten der Kartographiegeschichte sinnstiftend gegenüberstellte. Auf diesem Vorgehen aufbauend lassen sich die Nachstiche verstehen, die sich nun nicht mehr auf einzelne Karten, sondern auf den gesamten Atlas bezogen.

Durch die Konfrontation, mit der Humboldt die Differenz von früherem und aktuellem Kartenwissen im *Atlas géographique et physique du Nouveau Continent* hervorhob, wurde die mit der Zeit voranschreitende Anreicherung des geodätischen Wissens sinnfällig. Vor dem Hintergrund dieser Kenntnis war es Humboldt möglich, auf historische

1 Vgl. Humboldt: *Tableau de cartes géographiques et physiques,* 1834.

Wandlungen der Vorstellungen von der Welt und von diesen aus auf Motivationen für zurückliegende Denk-, Handlungs- und Entscheidungsprozesse zu schließen. Dieser Wissenszuwachs, gewonnen durch die vergleichende Gegenüberstellung, geht mit einer wissenschaftstheoretischen Reflexion des 18. Jahrhunderts zusammen, bei der sich die Erkenntnis durch Vergleichen nicht nur auf Wissensobjekte selbst bezog, sondern auch auf mentale Prozesse. Im *tertium comparationis* zeigten sich demnach nicht nur übergreifende Strukturen von Dingen, auf die auch Humboldt bei seinem Vergleich von Naturphänomenen aus unterschiedlichen Regionen der Erde abzielte, sondern auch gedankliche Vorgänge und mit ihnen eine ideengeschichtliche Entwicklung.[2]

Zeitgenössische Karten im historischen Vergleich

Analysen der geographischen Wissensanreicherung in der Zeit

Bei einer der beiden Karten, in denen Humboldt bereits in der ursprünglich konzipierten Fassung des *Atlas géographique et physique du Nouveau Continent* historische und zeitgenössische raumbezogene Informationen vergleichend nebeneinanderstellte, handelt es sich um die Tafel 18, die *Carte de la Partie Orientale de la Province de Varinas comprise entre l'Orenoque, l'Apure et le Rio Meta* (im Folgenden: *Carte de la Province de Varinas*)[3] (Abb. 30). Diese Karte des zentral-venezolanischen Hinterlandes erschien 1814 mit der ersten Lieferung des Atlas. Im Kern war dessen historische Tiefenschicht, die später in den Nachstichen explizit betont werden sollte, also von Beginn an angelegt, wenngleich sie zunächst weitgehend hinter der Präsentation eines zeitgenössischen geographischen Wissens zurücktrat.

Die querformatige Aufsicht der *Carte de la Province de Varinas* basiert, wie der Kartenkommentar erläutert, vor allem auf geographischen Messdaten, die Humboldt bei seiner Amerikanischen Reise im Jahre 1800 vor Ort aufnahm. Auf dem Hintergrund des Blattes, der von regelmäßigen, wenig kraftvoll gezeichneten, niedrigen Bewuchs andeutenden Strichen überzogen ist, hebt sich eine Vielzahl feiner, dennoch deutlich markierter Flussverläufe ab, die in weichen, nach unten geöffneten Bogenformen im zentralen Teil des Kartenblattes übereinander gestaffelt angeordnet sind. Zum rechten Rand des Kartenspiegels hin verdickt sich ihre Strichführung leicht. Hier laufen sie auf den Orinoko zu, der sich als breiter Strom von der Mitte des unteren bis zur Mitte des rechten Kartenrandes zieht. Durch diese Positionierung im Kartenbild wird die untere rechte Ecke des Blatt-

2 Vgl. Eggers: „»Vergleichung ist ein gefährlicher Feind des Genusses.«", 2008, S. 628.

3 Heute wird mit Barinas eine der 23 Provinzen Venezuelas bezeichnet. Sie liegt jedoch weiter westlich als jenes Gebiet, das Humboldt in seiner *Carte de la Province de Varinas* aufnahm. Humboldt ging in *Sur les matériaux* auf die Tafel 18 ein, führte sie hier jedoch unter dem Titel *Embranchemens des Rivières situées entre l'Apure et le Meta* an. Siehe Humboldt: „Sur les matériaux", 1817, S. 26–28.

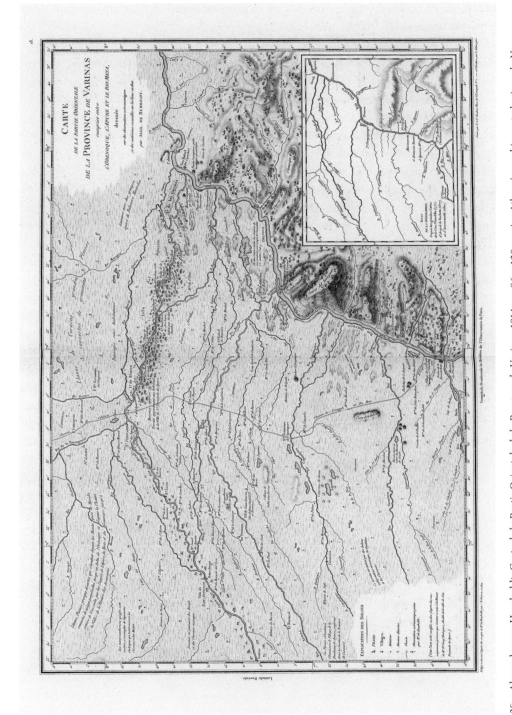

30___Alexander von Humboldt, *Carte de la Partie Orientale de la Provínce de Varinas*, 1814, ca. 86 × 120 cm, in: *Atlas géographique et physique du Nouveau Continent*, Tafel 18 (Lieferung 1), Berlin, SBB, Foto SBB

spiegels optisch separiert. In diesen Bereich montierte Humboldt in einem ebenfalls nahezu quadratischen Querformat eine Nebenkarte.

Während Humboldt in anderen Karten des *Atlas géographique et physique du Nouveau Continent* Nebenkarten nutzte, um Detailvergrößerungen oder geographische Ergänzungen vorzunehmen und auf diese Weise genauere Auskunft über einzelne Aspekte der Hauptkarte zu geben,[4] fungiert der Zusatz der *Carte de la Province de Varinas* hingegen als historische Diskussion. Das vergleichende Zusammensehen beider Kartenelemente wird durch ihre formale Ausgestaltung begünstigt: Das hohe Querformat, das Haupt- und Nebenkarte gleichermaßen aufweisen, regt zum vergleichenden Hin- und Herblicken ebenso an wie die auffällige, sich entsprechende Anordnung der Bildelemente zueinander: Der mit dicker Stichführung hervorgehobene Verlauf des Orinoko dominiert beide Kartenteile, wobei er den Kartenspiegel jeweils von der unteren bis zur rechten Rahmenlinie durchquert. Sowohl in der Haupt- als auch in der Nebenkarte münden zudem diverse Wasserläufe in diesen Hauptstrom. Auf der Grundlage dieser formalen Analogien treten auch die gestalterischen Differenzen beider Teilkarten deutlich hervor: Während diejenige Darstellung, die auf zeitgenössischem Wissen beruht, eine detailliert inszenierte, topographische Oberflächengestaltung der Gegend vor Augen führt, weist die Einfügung mit dem historischen Wissensstand einen monochromen Blattgrund mit einfachen, lediglich mit Namen versehenen Linien auf, die Flüsse und Höhenzüge repräsentieren.[5]

In den Anmerkungen, die in die jeweiligen Teile der *Carte de la Province de Varinas* eingefügt sind, legte Humboldt die unterschiedlichen geographischen Datengrundlagen beider klar. Während die Hauptkarte auf Humboldts eigene Beobachtungen und Messungen vor Ort zurückzuführen ist, sind in der Nebenkarte drei unterschiedliche historische Karten ineinander gesetzt. Es handelt sich um eine Karte des spanischen Kartographen Juan de la Cruz Cano y Olmedilla (1734–1790) von 1775, eine posthum gestochene Karte des in London ansässigen Louis Stanislas d'Arcy de la Rochette (1731–1802) von 1807 sowie eine Karte des ebenfalls in London tätigen Kartographen Aaron Arrowsmith (1750–1823) von 1810.[6] Humboldts Gegenüberstellung der beiden auf unterschiedliche

4 Vgl. zu Humboldts Verwendung von Nebenkarten insbesondere die in der vorliegenden Untersuchung näher erläuterten Tafeln 16 (Unterkapitel *Datenerhebungen*) und Tafel 25 (Unterkapitel Verknüpfendes Sehen II: *Hypothesen zur Erdentstehung*) des *Atlas géographique et physique du Nouveau Continent*.

5 Die Ausgestaltung der Nebenkarte der *Carte de la Province de Varinas* ist anders als die anderen Nebenkarten in Humboldts Atlas graphisch auf einfache Striche reduziert. Hierdurch scheint sie weniger an einer kartographischen Darstellungsweise orientiert als vielmehr an einer solchen, wie sie die zahlreichen Klebezettel Humboldts aufweisen, die er in seinen Notizen benutzte. Mit ihnen hielt er Informationen vorläufig und skizzenhaft fest, kombinierte oder korrigierte sie. Auch funktional lässt sich bei der Nebenkarte der *Carte de la Province de Varinas* eine Nähe zu einem solchen primär diagrammatisch organisierten, vereinfachenden Visualisierungsprinzip erkennen.

6 Aller Wahrscheinlichkeit nach handelte es sich bei den hier angeführten Karten um Cruz Cano y Olmedillas *Mapa Geográfico de America Meridional* (1775), um d'Arcy de la Rochettes' *Colombia Prima or*

Messwerte zurückgehenden Kartenteile macht das Verdienst der neuen Kartierung offenkundig. In dem Kommentar zur Karte, den Humboldt im Textfragment *Sur les matériaux* publizierte, heißt es: Am „Vergleich vom Verlauf des Apure, des Arauca, des Capanaparo und des Sinarucu, welcher in meiner Karte und auf solchen von La Cruz und von Arrowsmith skizziert ist, wird man sehen, wie sehr über diesen hydrographischen Abschnitt bislang Unsicherheit geherrscht hat"[7]. Im Gegensatz zu den genannten Kartographen hatte Humboldt die Gegend selbst besuchen und vermessen können. Statt also fremdes Material zu kompilieren, legte er eine Karte vor, die geprüftes geographisches Wissen enthielt. Dies scheint die darauf dargestellte ausdifferenzierte, mit Gebüsch und Gefälle versehene Topographie auch graphisch zu verdeutlichen.

Ideengeschichtliche Prozesse

Doch fasste Humboldt Karten nicht nur als komplexe Speicher des sich sukzessive akkumulierenden geographischen Wissens über die Erde auf, sondern zugleich als ein reiches Reservoir an kultur- und ideengeschichtlichen Zusammenhängen. Deutlich wird diese heuristische Dimension an der *Histoire de la Géographie de l'Orénoque*, der Tafel 14 des *Atlas géographique et physique du Nouveau Continent* (Abb. 31), die 1825 mit dessen fünfter Lieferung erschien.[8] In dieser Karte wird die geographische Verortung des Lac Parime, an dessen Ufer das mythische El Dorado vermutet worden war, einer kritischen Revision unterzogen.

Hierfür arrangierte Humboldt auf einem Blatt elf Detailansichten von Karten, die in den vorangegangenen gut 200 Jahren in Europa gefertigt worden waren. Sie zeigen alle die Gegend des fiktiven Sees, wobei dieser in unterschiedlichen geographischen Lagen verzeichnet ist. Humboldt gruppierte die Kartenausschnitte im Querformat eines Großfolio-Doppelbogens zu drei horizontalen Reihen, die weitgehend chronologisch organisiert der Leserichtung von links nach rechts folgen: Während das älteste Detail in der linken oberen Ecke auf den Flamen Jodocus Hondius (1563–1612) von 1599 zurückgeht, stammt das

South America, die der in London tätigen Kartograph und Publizist William Faden (1749–1836) 1807 herausgegeben hatte, sowie um Arrowsmiths *Outlines Of The Physical And Political Divisions of South America*, die erst 1811 publiziert wurde, deren genutzte Datengrundlage Arrowsmith aber auf 1810 festsetzte.

7 Im Original: „En comparant le cours de l'Apure, de l'Arauca, du Capanaparo et du Sinaruco, tel qu'il est tracé sur ma carte et sur celles de La Cruz et d'Arrowsmith, on verra combien cette partie de l'hydrographie a été incertaine jusqu'ici." Humboldt: „Sur les matériaux", 1817, S. 28.

8 Vgl. zu dieser Karte Buchholz, Amrei: „Die Entdeckung von El Dorado: Politische Handlungsräume der Karte", in: *Handeln mit Bildern. Bildpraxen des Politischen in historischen und globalen Kulturen*, hg. von Birgit Mersmann und Christiane Kruse, Paderborn: Fink [im Druck]; Fechner, Fabian: „Zerfallene Synopse, verlorene Grundkarte. Experimente mit Bildfolgen im Zeitalter der Entdeckungsgeographie", in: *Verkoppelte Räume. Karte und Bildfolge als mediales Dispositiv*, hg. von Ulrike Boskamp u. a., München: Hirmer 2020, S. 281–307.

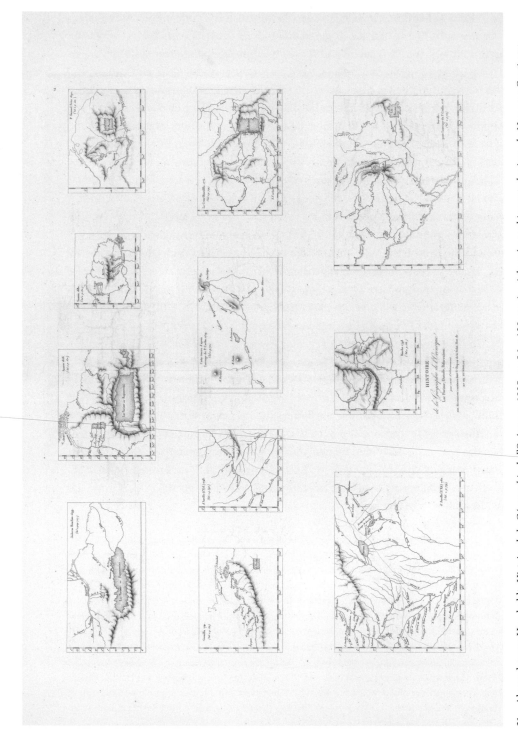

31_ Alexander von Humboldt, *Histoire de la Géographie de l'Orénoque*, 1825, ca. 86 × 120 cm, in: *Atlas géographique et physique du Nouveau Continent*, Tafel 14 (Lieferung 5), Berlin, SBB, Foto SBB

jüngste von 1798 in der unteren Reihe mittig von Humboldts Zeitgenossen, dem französischen Kartographen Jean-Nicolas Buache (1741–1825). Jeder Ausschnitt ist jeweils um einen schriftlichen Vermerk ergänzt, der das ursprüngliche Entstehungsdatum der Karte sowie die Textpassage anführt, in der Humboldt im zweiten Band der *Relation historique* den entsprechenden Kartenteil diskutierte.

Die in Europa von der Mitte des 16. Jahrhunderts an verbreiteten Berichte über ein in Südamerika gelegenes El Dorado basierten auf einer vorkolonialen Legende: Das Oberhaupt eines indigenen Stammes, so hieß es, habe seinen Körper als Initiationsritus mit Goldstaub überzogen und diesen beim anschließenden Baden in einem Binnensee abgewaschen; nach anderen Erzählungen wurden zusätzlich goldene Gegenstände als Opfergaben im Wasser versenkt. In der Interpretation der edelmetallhungrigen Kolonialbevölkerung verwandelte sich der vergoldete Häuptling „El Dorado" („der Goldene") in einen goldenen See, eine goldene Stadt oder gar in einen ganzen goldenen Landstrich.

Humboldt stellte sich im Zusammenhang mit diesem Mythos die Frage, weshalb und wann er kartographisch verzeichnet worden wäre. Erstmals geschah dies, so heißt es in der *Relation historique*, Ende des 16. Jahrhunderts, nachdem der Engländer Walter Ralegh (1554–1618) von seiner Reise durch Amerika von El Dorado berichtet hatte:[9]

> Der grosse Parime-See erscheint auf den Karten nicht früher, als nach der ersten Reise Ralegh's. Jodocus Hondius war es, der vom Jahr 1599 an die Vorstellungen der Erdbeschreiber geleitet und das Innere vom spanischen Guiana als ein völlig bekanntes Land geschildert hat.[10]

Auf dieser Karte des Hondius waren, wie Humboldt hier hervorhob, die unterschiedlichen Qualitäten, die der Darstellung zugrunde lagen – topographische Invention einerseits und topographische Dokumentation andererseits –, nicht mehr kenntlich. Zwischen realen und fiktionalen Informationen ließ sich allein über die Betrachtung des Blattes nicht mehr unterscheiden. Nachdem der See einmal im Kartenbild verzeichnet worden war, breitete er sich daher in der europäischen Kartenproduktion schnell weiter aus. Zwar wanderte die konkrete Verortung, wenn neue geographische Informationen dies notwen-

9 Bereits Walter Ralegh erwähnte eine Karte, die er von der Gegend angefertigt haben wollte. Heute wird sie mit einem Manuskript in Verbindung gebracht, das die British Library besitzt. Vgl. zu dieser Kartenzeichnung Burnett, D. Graham: „Fabled Land", in: *Mapping Latin America. A Cartographic Reader*, hg. von Jordana Dym und Karl Offen, Chicago: University of Chicago Press 2011, S. 38–41; für eine ausführlichere Beschäftigung mit dem Thema vgl. Nicholl, Charles: *The Creature in the Map. A Journey to El Dorado*, Chicago: University of Chicago Press 1997, zur Verortung El Dorados auf Karten vgl. hier S. 9–19.

10 Humboldt: *Reise in die Aequinoctial-Gegenden*, Bd. 4 [Octav], 1823, S. 734. Im Original: „Le grand lac Parime ne paroît sur les cartes qu'après le premier voyage de Ralegh. C'est Jodocus Hondius qui, dès l'année 1599, a fixé les idées des géographes, et figuré, comme un pays entièrement connu, l'intérieur de la Guyane espagnole." Humboldt: *Voyage*, Teil 1 *(Relation historique)*, Bd. 2 [Quarto], 1819, S. 707.

dig machten, durch das Kartenbild, doch bestand El Dorado als Teil der kartographischen Darstellung fort – und zwar auch dann noch, als der Mythos als solcher bereits enttarnt war. Entsprechend führte Humboldt die kartographische Stabilität von El Dorado nicht nur auf eine geographische Unkenntnis zurück, sondern auch auf die unflexible Arbeitsweise der Kartographen selbst:[11]

> Astronomische Beobachtungen, topographische Angaben häufen sich eine lange Reihe von Jahren hindurch, ohne dass davon Gebrauch gemacht wird; und von dem, sonst sehr löblichen Princip der Stabilität und Erhaltung geleitet, mögen die Verfertiger von Karten lieber noch auf Zusätze verzichten, als dass sie einen See, eine Bergkette oder Flussvereinigungen aufopfern wollen, die man seit Jahrhunderten figuriren zu sehen gewohnt war.[12]

Humboldts kritische Kartenreflexion in der *Histoire de la Géographie de l'Orénoque* machte diese kartierten Verschiebungen im südamerikanischen Gebiet augenfällig.[13] Letztlich zielte er jedoch darauf ab, die Tiefenschicht freizulegen, die zu der spezifischen Verortung des Mythos geführt hatte. Indem sich über die historischen Karten, so Humboldt, das damalige geographische Wissen ablesen lasse, könnten wiederum bestimmte Annahmen über die Natur und letztlich auch über El Dorado erklärt werden, denn:

> Allen Mährchen liegt irgend etwas Wahrhaftes zum Grund; das *Mährchen* vom *Dorado* gleicht jenen *Mythen* des Alterthums, die, von einem Lande zum andern wandernd, jedesmal den verschiedenen Oertlichkeiten angepasst wurden. Um die Wahrheit vom Irrthum zu unterscheiden, kann es in wissenschaftlichen Dingen meist hinreichen, die Geschichte der Meinungen darzustellen und ihren allmählichen Entwicklungen zu folgen.[14]

11 Heute kann davon ausgegangen werden, dass sich das Kartenbild auch im politischen Interesse verschiedener Akteure des kolonialen Amerika änderte. Vgl. Buchholz: „Politische Handlungsräume der Karte".

12 Humboldt: *Reise in die Aequinoctial-Gegenden*, Bd. 4 [Octav], 1823, S. 677. Im französischen Original: „Des observations astronomiques, des renseignemens de topographie s'accumulent, pendant une longue suite d'années, sans qu'on en fasse usage; et, par un principe de stabilité et de conservation, très-louable d'ailleurs, ceux qui construisent des cartes aiment souvent mieux ne rien ajouter que de sacrifier un lac, une chaîne de montagnes ou un embranchement de rivières que l'on a pris l'habitude de figurer depuis des siècles." Humboldt: *Voyage*, Teil 1 *(Relation historique)*, Bd. 2 [Quarto], Paris 1819[–1821], S. 677.

13 Diese Verquickung von fiktionalen und geographischen Qualitäten der Informationen, die im Kartenbild El Dorados aufgenommen wurden, hatte bis in Humboldts Gegenwart Bestand. So hatte noch Jean-Nicolas Buache 1798 – gestützt auf vorangegangene Karten und in dem Glauben, wiederum andere zu korrigieren – angenommen, dass es zwischen dem Orinoko und dem Amazonas, die beide das vermeintliche Gebiet des El Dorado durchzogen, keine Verbindung gegeben hätte. Humboldt nahm in seine *Voyage* eine Notiz aus Jean-Nicolas Buaches Karte auf, in der dieser jene Verbindung als „geographische Ungeheuerlichkeit" („une monstruosité en géographie") bezeichnete. Humboldt: *Voyage*, Teil 1 *(Relation historique)*, Bd. 2 [Quarto], 1819, S. 538.

14 Humboldt: *Reise in die Aequinoctial-Gegenden*, Bd. 4 [Octav], 1823, S. 673 [Hervorhebungen im Original]. Im französischen Original: „Toutes les fables ont quelque fondement réel; celle du *Dorado* ressemble à ces *mythes* de l'antiquité qui, voyageant de pays en pays, ont été successivement adaptés à des

Hinsichtlich des Lac Parime diagnostizierte Humboldt dieses „Wahrhafte", das der dargestellten Topographie zugrunde lag, als eine Kombination verschiedener natürlicher Faktoren, die im Gebiet zwischen Amazonas und Orinoko zusammenkamen: Verschiedene Wasserläufe mündeten ineinander und waren aufgrund ihrer Wassermassen in der europäischen Interpretation zu Binnenseen geworden; ein schimmerndes Gestein der Region, das an der Wasseroberfläche reflektiert wurde, hatte den Mythos eines goldenen Landes weiter genährt; auch Übersetzungsprobleme zwischen indigenen Ethnien vor Ort und der Kolonialbevölkerung spielten hinein.[15] Zudem konnte Humboldt für das Gold, das in Guyana gefunden worden war und das zur Formulierung des Mythos beigetragen hatte, eine alternative Begründung liefern: Es beruhte keineswegs auf der tatsächlichen Existenz von El Dorado, sondern auf der von Humboldt nachgewiesenen Wasserverbindung zwischen den Kordilleren und der Küste.[16]

So erweisen sich die Tafel 14, aber auch die Tafel 18 des *Atlas géographique et physique du Nouveau Continent* als kritische Ausgangspunkte für punktuell ausgeführte kartengeschichtliche Überlegungen Humboldts, die bereits im ursprünglich konzipierten Kartenkonvolut angelegt waren. Schon diesen Auseinandersetzungen lag die Annahme zugrunde, dass sich mit der Rekonstruktion des geographischen Wissens zugleich ein Einblick in ideengeschichtliche Zusammenhänge eröffnen würde. Auf diese Weise lassen sich beide Tafeln als erste experimentelle Vorstufen einer visuellen Argumentation verstehen, die Humboldt in der späteren Ergänzung des Atlas durch die historischen Nachstiche noch einmal deutlich vertiefen sollte.

Sieben Nachstiche historischer Karten

Erste Pläne Humboldts zu kartographiehistorischen Kartenanalysen

Erste Pläne für einen eigenen Abschnitt kartographiehistorisch ausgerichteter Karten im *Atlas géographique et physique du Nouveau Continent* und einen entsprechenden Text entwickelte Humboldt vermutlich in den 1830er Jahren, als die ursprüngliche, aus 30 Karten bestehende Fassung des Atlas bereits fast vollständig gedruckt vorlag. Indes hatte Humboldt sich schon in den Jahrzehnten zuvor intensiv mit kartographiegeschichtlichen Themen auseinandergesetzt. Im *Examen critique*, in dem er sie explizit zum zentralen Gegenstandsbereich erhob, merkte Humboldt entsprechend an, es handele sich bei der „geschichtlichen Untersuchung, welche ich in diesem Augenblicke der Öffentlichkeit

localités différentes. Pour distinguer la vérité de l'erreur, il suffit le plus souvent, dans les sciences, de retracer l'histoire des opinions et de suivre leurs développemens successifs." Humboldt: *Voyage*, Teil 1 *(Relation historique)*, Bd. 2 [Quarto], 1819, S. 675 [Hervorhebungen im Original].

15 Vgl. Humboldt: *Voyage*, Teil 1 *(Relation historique)*, Bd. 2 [Quarto], 1819, S. 684.

16 Vgl. ebd., 712–713.

übergebe" um „Auszüge meiner Arbeiten, denen ich während dreißig Jahren meines Lebens alle Stunden der Muße, die ich erübrigen konnte, mit besonderer Vorliebe widmete"[17]. Aus dieser Passion heraus erklärt sich, dass solche Überlegungen schon lange vor den 1830er Jahren in Humboldts Arbeit zu finden sind, etwa in seinen amerikanischen Reisetagebüchern (1799–1804), in dem Fragment *Sur les matériaux* (1817), dem *Essai politique sur le royaume de la Nouvelle-Espagne* (1808–1811) oder auch in diversen der von ihm entwickelten Karten – neben den im vorherigen Abschnitt genannten beispielsweise auch die *Carte que présente les fausses positions attribuées aux ports de la Vera-Cruz et d'Acapulco, et à la capitale e Mexico*, die Tafel 10 des *Atlas de la Nouvelle-Espagne*.[18]

Humboldts Auseinandersetzungen mit historischem Kartenmaterial reiften zu einer zentralen Fragestellung heran, als er 1832 in der Pariser Bibliothek Charles Athanase Walckenaers (1771–1852) die verschollen geglaubte Weltkarte des Juan de la Cosa entdeckte (Taf. XVI). Seines Zeichens Kapitän des Kolumbus, hatte dieser auf ihr neben großen Teilen der Alten Welt erstmals amerikanisches Festland verzeichnet.[19] Humboldt selbst identifizierte sie als Karte de la Cosas: „Man hatte sie für eine Portugiesische Weltkarte gehalten von ganz unbekanntem Alter, bis ich […] bei fleissigen Arbeiten in den Pariser Bibliotheken im Jahre 1832 die Worte entdeckte: *Juan de la Cosa la fizo en el Puerto de Sta. Maria en año de 1500*."[20] Inspiriert von dieser „bis auf den heutigen Tage gänzlich neuen

17 Humboldt: *Die Entdeckung der Neuen Welt*, 2009, S. 13. Im französischen Original: „Les recherches historiques que je publie en ce moment, sont l'extrait d'un travail auquel, pendant trente ans, je me suis livré dans tous mes momens de loisir et avec une extrême prédilection." Humboldt: *Examen critique*, Bd. 1, 1836, Préface, S. X.

18 Zu dieser Karte wurde Humboldt durch die Karte *Germaniae Mappa ciritica* (Nürnberg, 1750) des Astronomen Tobias Mayer den Älteren angeregt. Sicherlich war Humboldt auch die *Carte de France corrigée par ordre du roi sur les observations de Mrs de l'Academie des sciences* (1693) bekannt, die zeigt, dass das Gebiet Frankreichs nach den neuen Vermessungen deutlich kleiner war als ursprünglich angenommen. Von der langjährigen Beschäftigung Humboldts mit kartenhistorischen Materialien zeugt der wissenschaftliche Nachlassteil Humboldts, der in Krakau verwahrt wird; vgl. v. a. BJK, HA, Nachlass Alexander von Humboldt 8 (acc. 1893, 216), 1. und 2. Teil, nicht foliiert.

19 Juan de la Cosa: Weltkarte, 1500, 93 × 183 cm, Tinte und Aquarell auf Pergament, am linken Rand im Halbrund abgeschlossen. Die Karte wird heute im Museo Naval de Madrid verwahrt. Vgl. zu Juan de la Cosas Karte insbesondere die umfassende Analyse Silió Cervera, Fernando: *La carta de Juan de la Cosa: análisis cartográfico*, Santander: Fundación Marcelino Botín, 1995; vgl. ferner Martín-Merás Verdejo, Luisa: „La carta de Juan de la Cosa: Interpretación e historia", *Monte Buciero* 4 (2000), S. 71–86. Zu einer vertiefenden Lektüre, insbesondere zum Projektionsverfahren der Karte, vgl. Robles Macias, Luis A.: „Juan de la Cosa's Projection: A Fresh Analysis of the Earliest Preserved Map of the Americas", *Coordinates*, Series A, 9 (2010).

20 Humboldt, Alexander von: „Ueber die ältesten Karten des Neuen Continents und den Namen Amerika", in: *Geschichte des Seefahrers Ritter Martin Behaim nach den ältesten vorhandenen Urkunden bearbeitet von Dr. F. W. Ghillany*, Nürnberg: Bauer und Raspe, 1853, S. 1–12, hier S. 1 [Hervorhebungen im Original].

Urkunde"[21] machte Humboldt sich an die Arbeit einer umfassenden Abhandlung über die Geschichte der Kartographie mit einem Schwerpunkt auf der Darstellung der (süd-) amerikanischen Topographie. Hieraus entstanden nicht nur der Text des *Examen critique*, sondern auch die Nachstiche historischer Karten, die Humboldt dem *Atlas géographique et physique du Nouveau Continent* hinzufügte.[22]

Das *Examen critique* und die Nachstiche

Das *Examen critique*, das ab 1834, und die Nachstiche, die ab 1835 erschienen, wurden in weitgehend parallel edierten Lieferungen herausgegeben, wobei der Text die in den Nachstichen visuell vorgeführte, historisch vergleichende Kartendiskussion analytisch einbettete und zudem deutlich ausweitete. Humboldt hatte das *Examen critique* nach eigener Aussage im Anschluss an seine zeitgenössische Kartenproduktion des *Atlas géographique et physique du Nouveau Continent* zunächst als selbstreflexive Überlegung begonnen, jedoch verselbständigten sich diese Ausführungen im Laufe der Zeit und wuchsen zu einem allgemeinen ideengeschichtlichen, letztlich unvollständig gebliebenen Abriss über die ‚Entdeckung' Amerikas an. Von den „Ursachen, welche die Entdeckung der Neuen Welt vorbereitet und herbeigeführt haben", sollte der Text sich ursprünglich bis zu einer differenzierten Analyse des daraus hervorgegangenen wissenschaftlichen Fortschritts erstrecken, jedoch riss der Text vorher ab, sodass von den vier geplanten Teilen schließlich nur zwei erschienen.[23] Im *Examen critique* wertete Humboldt neben Karten auch andere historische Quellen aus. Sie seien zwar vielfach bekannt, so Humboldt, doch dadurch, dass er sie zusammenführend betrachtet hätte, sei das Material mit neuer Erkenntnis überzogen worden: „Neben einige neue Tatsachen habe ich ältere gestellt, welche – ich gestehe es gern zu – recht allgemein bekannt sind, aber in der Verbindung, in die ich sie zu setzen gewußt habe, zu neuen Wahrnehmungen führen."[24] Von dieser komparatistischen Vorgehensweise geleitet, organisierte Humboldt auch die Nachstiche des *Atlas géographique et physique du Nouveau Continent*, und zwar einerseits untereinander und andererseits, indem er sie den von ihm selbst entworfenen Karten vergleichend an die Seite stellte.

21 Humboldt: *Die Entdeckung der Neuen Welt*, 2009, S. 230. Im französischen Original: „la mappemonde […] est un document entièrement inconnu jusqu'à ce jour". Humboldt, Alexander von: *Examen critique*, Bd. 3, Paris: Gide 1837, S. 174.

22 Hinweis auf diese Erweiterung finden sich bei Humboldt selbst, etwa in Humboldt, *Examen critique*, Bd. 3, 1837, S. 174. Vgl. ferner Engelmann: „Alexander von Humboldts kartographische Leistung", 1970, S. 17.

23 Vgl. zur ursprünglich geplanten Anlage des Textes Humboldt: *Examen critique*, Bd. 1, 1836, S. 9–10; das genannte Zitat entstammt ebd.

24 Humboldt: *Entdeckung der Neuen Welt*, 2009, S. 15. Im französischen Original: „A coté de quelques faits nouveaux, j'ai placé des faits anciennement connus peut-être, mais offrant des combinaisons et des aperçus nouveaux." Humboldt: *Examen critique*, Bd. 1, 1836, S. XXII.

Alle sieben Nachstiche basieren auf Vorlagen, die eine frühe europäische Sicht auf die Neue Welt zeigen. Während die Tafeln 33 bis 36 (Taf. IX–XII) Details aus der von Juan de la Cosa angefertigten Weltkarte aufnehmen, gehen die weiteren drei Nachstiche auf Karten bzw. Kartenteile, die kurz nach dieser gefertigt wurden, zurück: Die Vorlage der Tafel 37 (Abb. 21) findet sich in der *Tabula Terre Nove*, die Vorlagen der Tafel 38 (Abb. 20) stellen die *Tabula Moderna Norbegie et Gottie* und die *Orbis Typus Universalis juxta Hydrographorum Traditionem* dar. Die Originale wurden von Martin Waldseemüller als zeitgenössische Ergänzungen zu einem 1513 erschienen Ptolemäischen Atlas verantwortet.[25] Tafel 39 (Abb. 22) hingegen geht auf die Karte *Universalior Cogniti Orbis Tabula Ex Recentibus Confecta Obsevationibus* (1507) zurück, die Johannes Ruysch (um 1460–1533) anfertigte. Alle historischen Karten stammen somit aus einer Übergangszeit, in der von Europa aus besehen alte und neue Vorstellungen vom globalen Raumgefüge aufeinandertrafen. Waldseemüllers Werk maß Humboldt in diesem Kontext besondere Bedeutung bei, weil sich in diesem erstmals das Toponym „America" fand.

De la Cosas Karte (Taf. XVI) kommt dagegen die Rolle zu, nicht nur das erste, sondern auch das einzige Dokument zu sein, das ein graphisches Zeugnis vom globalen geographischen Wissen zur Zeit der ersten Reisen in die Neue Welt ablegt. Bei de la Cosas Weltkarte handelt es sich um eine Portolankarte, wie sie vom Mittelalter an für die Navigation auf See angefertigt wurden: Neben einem Netz aus Rumbenlinien, das die auf der Karte dargestellte Meeresoberfläche überzieht und zur Kursbestimmung mit dem Kompass diente, geben drei orthogonale Linien den Äquator, den nördlichen Wendekreis der Sonne und den Meridian an. Diese nautischen Insignien transformieren die Kartendarstellung in einen global vernetzten, über graphische Mittel vereinheitlichten Wissens- und Bewegungsraum, der eine von Europa aus gedachte, dank der Seefahrt mögliche Erreichbarkeit aller Orte auf der (damals bekannten) Erdoberfläche verspricht. Zugleich führt de la Cosas Karte jedoch wesentliche Unterschiede vor, mit denen die Vorstellungen von der Alten und der Neuen Welt jeweils belegt waren. Diese Differenzierung lässt sich zunächst an der Kolorierung festmachen: Während das amerikanische Festland am linken Rand der Karte großflächig grün ausgestaltet ist, wodurch der Raum sowohl als unberührte, geschichtslose Natur wie auch als ungewisses geographisches Terrain ausdeutet wird, hebt sich in der Alten Welt auf weißem Grund eine Fülle von Figuren und Bauwerken aus sakralen und weltlichen, zum Teil aus mythologischen Kontexten ab. Diesen zahlreichen Details der Alten Welt gegenüber fügte de la Cosa in den Bereich der Neuen Welt lediglich

25 Die *Tabula Terre Nove* und die *Tabula Moderna Norbegie et Gottie* gehörten zu 20 *Tabulae modernae*, die 1513 als Ergänzungen des von Johann Schott in Straßburg herausgegebenen Ptolemaios-Atlas erschienen. Während die darin enthaltenen 27 *Tabulae antiquae* auf die Ulmer Ausgabe von 1482 zurückgehen und antikes Wissen zeigen, erweiterten die *Tabulae modernae* den Atlas um zeitgenössische Erkenntnisse und stellen dementsprechend auch Amerika dar.

mittig eine einzige emblematische Figur ein: den Heiligen Christophorus, Schutzheiligen der Reisenden – und zugleich Namenspate von Kolumbus.

Humboldts Interpretation von de la Cosas Weltkarte

Wie groß die Bedeutung war, die de la Cosas Karte als erstes Zeugnis des topographischen Wissens über die Neue Welt für Humboldt besaß, zeigt sich daran, dass die Darstellung für vier der sieben Nachstiche des *Atlas géographique et physique du Nouveau Continent* die Vorlage lieferte. Indes griff Humboldt, um eine bestimmte visuelle Argumentation vorzunehmen, bei der Anfertigung seiner Stiche deutlich in die ursprüngliche Darstellung des Raumes ein. Hierbei bediente er sich Methoden der Sichtbarmachung, die er in seinen vorher veröffentlichten Karten des *Atlas géographique et physique du Nouveau Continent* bereits erprobt hatte: So weisen die Nachstiche gegenüber dem Original lediglich eine selektive Auswahl des ursprünglich Dargestellten auf und sind farblich entschieden zurückhaltender ausgestaltet. Der Blick wird somit nicht nur in den ersten 32 Karten des Atlas, sondern auch in den Nachstichen gezielt auf bestimmte Aspekte der kartographischen Darstellung gelenkt, was die karteninterne Ausdeutung ebenso leitet, wie es eine kartenübergreifend verknüpfende und vergleichende Betrachtung befördert.

Um einer solchen heuristisch motivierten Blicklenkung zuzuarbeiten, wählte Humboldt für seine Nachstiche aus de la Cosas Karte „die ersten Bruchstücke derselben"[26] aus, wobei er vor allem Details der Neuen Welt entnahm. Die dortigen Küstenlinien, Flussmündungen, geographischen Ortsbezeichnungen und kolonialen Besitznahmen treten in Humboldts Nachstichen markant hervor.[27] Die gegenüber dem Original deutlich reduzierte Farbigkeit unterstützt diese Auswahl: Von dem ursprünglich großflächigen Einsatz der Farbe übernahm Humboldt lediglich diejenige des Heiligen Christophorus und die der Flaggen, mit denen de la Cosa die unterschiedlichen nationalen Besitzergreifungen des amerikanischen Festlandes gekennzeichnet hatte. Durch diese Eingriffe verschieben sich in den Nachstichen die ursprünglichen Wertungen im Kartenbild sichtlich: Neben dem Heiligen kommen sowohl dem Küstenverlauf als auch den ersten Anlandungen mit ihren jeweiligen nationalen Zuordnungen zu den europäischen Seefahrernationen sowie den Ortsbezeichnungen und ihrer relationalen Lage an der amerikanischen Küste zueinander gegenüber de la Cosas Ausgestaltung eine enorme Bedeutungssteigerung zu.

Humboldts Auswahl erklärt sich mit Blick auf seine wissensgeschichtliche Fragestellung, von der er bei der Untersuchung des Materials ausging. Zunächst war hierbei entscheidend, Anhaltspunkte für den Stand des damaligen geographischen Wissens zu gene-

26 Humboldt: *Die Entdeckung der Neuen Welt*, 2009, S. 230. Im französischen Original: „les cartes […] offrent les premiers fragmens". Humboldt: *Examen critique*, Bd. 3, 1837, S. 174.

27 Vgl. hierzu etwa die Vergrößerungen der Tafel 16 (*Carte itinéraire de l'Orénoque*) des *Atlas géographique et physique du Nouveau Continent*.

rieren. Diesbezüglich waren die kartographisch verzeichneten Ortsnamen von besonderem Wert, wie aus dem *Examen critique* hervorgeht:

> Bei den geographischen Nachforschungen muß man, sobald man sich auf einem schwankenden Boden befindet, mit der *Übereinstimmung der Benennungen* beginnen. Nachdem man auf den Karten die von den Reisenden aufbewahrten Namen gefunden hat, muß man sehen, ob die *gegenseitige Lage* der Orte gleichfalls mit den Reiseberichten übereinstimmt und ob diese Lage oder vielmehr die *Reihenfolge* der Orte dieselbe ist wie die, welche die Reisenden, gleichviel ob mit Recht oder mit Unrecht, angenommen haben […].[28]

Dank der toponymischen Analyse ließ sich also eine Raumvorstellung rekonstruieren, die das topographische Wissen sowohl für einen bestimmten Zeitpunkt als auch – anhand der nachvollzogenen Anlandungen – aus der Sicht einer bestimmten europäischen Nation freilegte. Mit diesem Vorgehen konnte zugleich aber auch eine zeitliche Entwicklung dieses Wissens nachvollzogen werden – etwa über die Gegend, in der Kolumbus in der Neuen Welt angelangt, die also von Europa aus erschlossen worden war.

Eine solche Analyse historischer Karten bot Humboldt eine wesentliche Grundlage, um das geographische Wissen einer bestimmen Zeit zu rekonstruieren. Mit der aufeinander aufbauenden Abfolge der Nachstiche im *Atlas géographique et physique du Nouveau Continent* von Tafel 33 bis 39 führte er diese Methode der Erkenntnisgewinnung graphisch vor, d. h., er vollzog in der Organisation der Nachstiche den Prozess seiner eigenen Annäherung an das historische geographische Wissen über Amerika nach. Ausgangspunkt war dabei ein mit der Tafel 33, *Le Nouveau Continent figuré dans la mappemonde de Juan de la Cosa en 1500* (Taf. IX), präsentierter Gesamtüberblick über das von de la Cosa erfasste amerikanische Festland. Es schließen sich mit den Tafeln 34 und 35 (Taf. X und XI) Vergrößerungen daraus an, die jeweils einen Teilaspekt aus dem ersten Nachstich genauer zeigen und den Blick so auf bestimmte Küstenstreifen und die dortigen Ortsbezeichnungen scharfstellen.

Mit dem vierten Nachstich, der Tafel 36 (Taf. XII), wird das amerikanische Küstengebiet schließlich um eine ergänzende geographische Perspektive erweitert. Auch die drei darauf reproduzierten Teilkarten stammen aus de la Cosas Karte, zeigen nun aber nicht mehr Vergrößerungen der Tafel 33, sondern weitere Details des Originals: Auf dem ersten

28 Humboldt: *Die Entdeckung der Neuen Welt*, 2009, S. 230 [Hervorhebungen im Original]. Im französischen Original: „Avant d'entreprendre de deviner quelles sont les positions des cartes modernes qui répondent à celles des cartes de l'antiquité classique, on doit examiner les opinions que les géographes anciens s'étaient formées eux-mêmes de l'emplacement relatif des lieux. […] Dans les investigations géographiques, il faut commencer, dès que l'on se trouve sur un terrain douteux, par l'*identité des noms*. Après avoir reconnu sur les cartes les dénominations conservées par les voyageurs, il faut voir si la *position relative* des lieux s'accorde aussi avec les itinéraires, et si cette position, ou plutôt l'*ordre de succession* des lieux est tel que les voyageurs l'ont supposé à tort ou à raison." Humboldt: *Examen critique*, Bd. 3, 1837, S. 175–177 [Hervorhebungen im Original].

Fragment ist Indien dargestellt, auf dem zweiten die Region des Nordmeers und auf dem dritten das zentralatlantische Gebiet zwischen der afrikanischen und der brasilianischen Küste. Während in den ersten drei Nachstichen also zunächst der amerikanische Kontinent selbst in den Blick gerät, weisen die Ergänzungen der Tafel 36 sowohl auf den Umstand zurück, dass Kolumbus bei seiner Reise ursprünglich ein anderes Ziel hatte erreichen wollen, als auch darauf voraus, dass sich viele neue Wege und Erkenntnisse unmittelbar in der Folge von Kolumbus' vermeintlicher Irrfahrt ergeben hatten: Indien hatte dieser zwar nicht erreicht, doch fand Vasco da Gama (1469–1524) kurze Zeit später, 1497/98, den Seeweg dorthin. De la Cosas verzeichnete dessen Ankunft in Indien bereits auf seiner Karte. Das zweite von Humboldt gewählte Fragment der Tafel 36, das Nordmeer, bezog sich darauf, dass die Normannen Nordamerika auf diesem Wege bereits deutlich vor 1492 erreicht hatten. Humboldt beschäftigte diesbezüglich die Frage, inwiefern dieses frühe Kapitel in der Geschichte der skandinavischen Seefahrt schon vor Kolumbus' Aufbruch hätte bekannt gewesen sein können.[29] Das dritte Fragment zeigt alsdann den Uferstreifen des Atlantiks, an dem der spanische Seefahrer Vicente Yáñez Pinzón (1463–1514), der voher an Kolumbus' Überfahrt nach Amerika teilgenommen hatte, 1500 angelandet war. Hierdurch war der Weg frei geworden, von Europa aus das südliche Festland des amerikanischen Kontinents zu erschließen.

Diese in den Tafeln 33 bis 36 begonnene visuelle Argumentation weitete Humboldt in den übrigen Nachstichen des *Atlas géographique et physique du Nouveau Continent*, den Tafeln 37 bis 39, aus: Während der Nachstich von Martin Waldseemüllers *Tabula Terre Nove* (Abb. 21) den amerikanischen, afrikanischen und europäischen Küstenverlauf zwischen Südengland und der heutigen Elfenbeinküste, zwischen dem heutigen Yucatán und Brasilien zeigt, liefern die Nachstiche der *Tabula Moderna Norbergie et Gottie* sowie ein Fragment der *Orbis Typus Universalis* (Abb. 20) Ansichten des Nordmeers und der asiatischen Küste. Abschließend gibt ein Teil aus Ruyschs *Universalior Cogniti Orbis Tabula Ex Recentibus Confecta Obsevationibus* (Abb. 22) noch einmal einen großflächigen Überblick über den um 1500 bekannten Küstenverlauf der gesamten Neuen Welt. Auf diese Weise ermöglichen die Nachstiche im *Atlas géographique et physique du Nouveau Continent* eine vergleichende Betrachtung zwischen kartographischen Repräsentationen, die alle auf den Zeitraum kurz nach der Ankunft von Kolumbus in Amerika datieren.

Dass Humboldt auch bei der Organisation seiner Nachstiche – ebenso wie im zuerst edierten Teil des *Atlas géographique et physique du Nouveau Continent* – einerseits die numerische Folge und thematische Bündelung der Karten im Blick hatte, andererseits aber eine Rezeptionslenkung im Sinne des vergleichenden Sehens voranzutreiben gedachte, wird dadurch deutlich, dass offenbar auch die Nachstiche nicht in ihrer numerischen Reihenfolge erschienen: So wurde beispielsweise die Tafel 37 (Abb. 21), die auf das Original Waldseemüllers zurückging, nicht erst nach der Publikation aller Details aus de la

29 Vgl. Humboldt, Alexander von: *Examen critique*, Bd. 2, Paris: Gide 1837, hier insbesondere S. 86.

Cosas Karte, sondern bereits mit der Lieferung 12, der dritten Lieferung der Nachstiche, herausgegeben.[30] Somit folgte die Tafel 37 vermutlich der Tafel 34 (Taf. X) und damit demjenigen Ausschnitt aus de la Cosas Karte nach, der wie Waldseemüllers Karte eine genauere geographische Übersicht über das karibische Meer, dessen Inselgruppe und die nordöstliche Küste Südamerikas gewährte.

Kolumbus als Spiritus Rector

Neben dem Küstenverlauf, den Ortsbezeichnungen und den nationalen Zuschreibungen des Festlandes erfährt auch das Emblem des Heiligen Christophorus in den Nachstichen eine deutliche Bedeutungssteigerung, und zwar insbesondere deshalb, weil es darin als eines der wenigen Elemente farbig ausgestaltet ist. Dass es derart betont wird, lässt sich zunächst darauf zurückführen, dass Humboldt an dieser Stelle des Originals die Signatur de la Cosas entdeckte. Dank ihr konnte die Karte historisch zugeordnet und dementsprechend analysiert werden. Zudem steht der Heilige für das christliche Heilsversprechen einer vermeintlichen europäischen Zivilisation, mit deren Export die Brücke zwischen Alter und Neuer Welt sinnbildlich eingefangen wird. Nicht zuletzt spielt das Emblem aber auch auf Christoph Kolumbus als den „Entdecker" eines neuen Kontinents an: Neben der Namensvetternschaft verweist auch das Patronat des Heiligen über die Reisenden auf den Seefahrer.[31]

Für Humboldt nahm Christoph Kolumbus die Rolle eines Spiritus Rector ein, der die Wissens- und Wissenschaftsgeschichte vom 16. Jahrhundert an maßgeblich geprägt hatte. Laut Humboldt war es vor allem Kolumbus zu verdanken, dass die runde Form der Erde um 1500 erneut ins Bewusstsein des Menschen gerückt war. Obwohl dieser seine Fahrt überhaupt erst aufgrund fehlerhafter Annahmen angetreten hatte, ging Humboldt davon aus, dass Kolumbus' „große[n] [...] Entdeckungen auf der westlichen Halbkugel [...] kein Werk des Zufalls"[32] gewesen seien.[33] Vielmehr lägen die Ursachen eines solchen Erkenntnisprozesses in vorangegangenen kritischen Untersuchungen begründet, bei denen sich die Seefahrer, so Humboldt, im ausgehenden 15. Jahrhundert bereits „richtige Begriffe von der Form der Erde und von der Länge der Entfernungen gemacht hatten, welche zu durchlaufen waren; weil sie verstanden, die Arbeiten ihrer Vorgänger zu be-

30 Vgl. Fiedler/Leitner: *Alexander von Humboldts Schriften*, 2000, S. 162–163.

31 Vgl. Humboldt: „Ueber die ältesten Karten des Neuen Continents und den Namen Amerika", 1853, S. 1–2. Die Namensvetternschaft ist im Spanischen leichter erkennbar, denn Christoph Kolumbus heißt hier Cristóbal Colón, der Heilige San Cristóbal.

32 Humboldt: *Die Entdeckung der Neuen Welt*, 2009, S. 20. Im französischen Original: „Les grandes découvertes de l'hémisphère occidental ne furent point le résultat d'un heureux hasard." Humboldt: *Examen critique*, Bd. 1, 1836, S. 7–8.

33 In seinem *Examen critique* weist Humboldt nach, dass die Kartographen auf eine Wiederentdeckung der Kreisform der Erde bereits vorbereitet waren. Vgl. zu dieser Thematik auch Michalsky, Tanja/Schmieder, Felicitas/Engel, Gisela: „Einleitung", in: *Aufsicht – Ansicht – Einsicht*, 2009, S. 7–17, hier S. 7.

nutzen und anzuwenden"[34]. Darauf, diese „richtigen" Vorstellungen vom Erdgefüge, derer Kolumbus sich bereits bewusst gewesen sei, am historischen Material nachweisen, zielte Humboldts Analyse im *Examen critique* ab. Das hierbei rekonstruierte Wissen über die Gestalt der Erdoberfläche für die Zeit um 1500 eröffne, so Humboldt, den Zugang zu einem umgreifenden Wissen über das „Zeitalter hervorstechender Entdeckungen im Raum, neuer Wege, die den Verbindungen der Völker dargeboten wurden, der frühesten Wahrnehmung einer Geographie, welche alle Breiten- und Höhengrade umfasste"[35]. In der geographischen „Entdeckung" Amerikas durch Kolumbus wurzelten, mit anderen Worten, zugleich die Anfänge einer wissenschaftlichen Entdeckung des für den globalen Raum analysierten „Naturganzen", wie es Humboldt in den Blick nahm.

Erst auf der Grundlage der mit Kolumbus wiedererlangten Kenntnis des Erdenrunds ließen sich also die von Humboldt beobachtete Wechselwirkung in der Natur, die den Globus umspielte, beschreiben und erklären. Wie er an seiner eigenen Forschung erkannte, hatten sich durch die geographische Kenntnis von Amerika letztlich nicht nur die Radien physischer Bewegungs- und Handlungsoptionen ausgeweitet, sondern auch – und grundlegend – neue intellektuelle Felder erschlossen. Seine kartenhistorische Analyse, die den Fortgang der geographischen Vorstellungen ebenso berücksichtigte wie den stetigen Zuwachs dieses Wissens, legte somit zugleich eine wissensgeschichtliche Perspektive frei, die räumliche bzw. geographische Kenntnis als Movens des Denkens markierte.

Da Humboldt wesentliche seiner eigenen Naturbeobachtungen in Amerika angestellt hatte und er diese als Ausgangspunkt vieler seiner naturgeschichtlichen Erkenntnisse verstand, setzte er sich, gewissermaßen als zweiter Entdecker der Neuen Welt, selbst in übertragenem Sinne in die Nachfolge des Kolumbus.[36] Heute zeigt die iberoamerikanische Rezeption des Werkes und der Figur Alexander von Humboldts, dass sich diese Eigenzuschreibung zu einem Topos gewandelt hat: Humboldts naturgeschichtliche Perspektive, in der er die Eigentümlichkeit des amerikanischen Kontinents betonte, wurde und wird vor Ort vielfach als Kontrast zum vorherigen kolonialen Blick wahrgenommen. Bereits die iberoamerikanische Unabhängigkeitsbewegung Anfang des 19. Jahrhunderts fand in Humboldt eine wesentliche Identifikationsfigur. Ein Beispiel hierfür liefert Domingo Faustino Sarmiento (1811–1888), der sich in seinem 1845 erstmals erschienenen Buch *Facundo o civilización y barbarie*, einem der zentralen Werke der lateinamerikanischen

34 Im französischen Original: „Ils ont fait d'importantes découvertes parce qu'ils avaient des idées justes de la figure de la terre et de la longueur des distances à parcourir; parce qu'ils savaient discuter les travaux de leurs devanciers". Humboldt: *Examen critique*, Bd. 1, 1836, S. 8.

35 Humboldt: *Die Entdeckung der Neuen Welt*, 2009, S. 13. Im französischen Original: „Le quinzième siècle est celui des grandes découvertes dans l'espace, de nouvelles voies tracées aux communications des peuples, des premiers aperçus d'une géographie physique embrassant tous les climats et toutes les hauteurs." Humboldt: *Examen critique*, Bd. 1, 1836, S. VIII.

36 Vgl. dazu auch Ette: „Nachwort: Zwischen Welten", 2009, S. 237–240.

Gründungsliteratur, an verschiedener Stelle direkt und indirekt auf Humboldt bezieht.[37] Noch heute prägt dieser in Iberoamerika geführte Diskussionen über die Geschichte des Eigenen der nationalen Identität. So hinterfragt etwa der argentinische Schriftsteller César Aira (*1949) in seiner Novelle *Un episodio en la vida del pintor viajero* (2000) – gleichwohl kritisch – die mit Alexander von Humboldt assoziierte ‚neue‘ Sicht auf den Subkontinent.[38]

Mit dieser Feststellung langt die hier vorgelegte Analyse des *Atlas géographique et physique du Nouveau Continent* bei einem Aspekt aus, der bis in die Gegenwart reicht. Indes ist es heute kaum möglich, die multiplen Dimensionen von Humboldts Atlas ohne eine kartenhistorische Herangehensweise zu erschließen. Es gilt, den Blick gewissermaßen auch zwischen die Karten fallen zu lassen: nicht nur auf die Zwischenräume, über die hinweg die Karten mittels visueller Brücken sinnstiftend verknüpft werden können, sondern auch auf Humboldts wissenschaftlichen Nachlass, andere seiner Atlanten und auf die Textbände der *Voyage*. Auf diese Weise vermag sich beim Durchblättern des *Atlas géographique et physique du Nouveau Continent* auch heute ein virtuelles Modell des Ganzen der Natur zu entfalten, das Humboldts Wirken und Werk im Kern berührt.

37 Nachdem die Kapitel aufeinanderfolgend in der chilenischen Zeitung El Progreso erschienen waren, wurde Sarmientos Buch schließlich gebunden herausgegeben. Vgl. Sarmiento, Domingo Faustino: *Civilización i barbarié. Vida de Juan Facundo Quiroga*, Santiago: Imprenta del Progreso 1845. Ab 1868 erschien das Buch unter dem heute bekannteren Titel *Facundo o civilización y barbarie*; für die umfassend kommentierte deutsche Übersetzung: Sarmiento, Domingo Faustino: *Barbarei und Zivilisation. Das Leben des Facundo Quiroga*, ins Deutsche übertragen und kommentiert von Berthold Zilly, Frankfurt am Main: Eichborn 2007.

38 Humboldts Texte sind im universitären Kontext im Kanon verschiedener Disziplinen, beispielsweise in der Literaturwissenschaft der Universidad de Buenos Aires, fest verankert. Dauerausstellungen von Kunstsammlungen, etwa im Museu Nacional de Belas Artes in Rio de Janeiro oder im Museo Nacional de Bellas Artes in Buenos Aires, lassen die chronologische Narration einer nationalen Kunstgeschichte bei den von Humboldt protegierten Reisemalern und ihrem auf Humboldts Wissenschaft gestützten, vermeintlichen neuen Blick auf die Eigentümlichkeiten der lateinamerikanischen Landschaft beginnen.

Zwischen Karten. Abschließende Bemerkungen

Der *Atlas géographique et physique du Nouveau Continent* und die Humboldtsche Wissenschaft

Grundlegende Aspekte der gesamten Wissenschaft Alexander von Humboldts sind im *Atlas géographique et physique du Nouveau Continent* vereint: Dieser führt wesentliche thematische Überlegungen – zu der basalen Beschreibung des Reliefs der Erdoberfläche und dessen Bedeutung für die Wechselwirkung in der Natur bis hin zu ideengeschichtlichen Auseinandersetzungen – zusammen. In der Konzeption werden ferner ein empirischer, vom Einzelnen ausgehender und ein holistischer, aufs Allgemeine zielender Ansatz verknüpft. Zudem basiert die Organisation der Karten auf einer vernetzenden Präsentation von Wissen, bei der die Themenfelder nicht nur innerhalb des Bandes aufeinander, sondern auch auf verschiedene Bereiche des Reisewerks als Ganzes – und diese wiederum zurück auf den Atlas – verweisen.

Bei der Rezeption des Atlas lässt sich Humboldts eigener Weg zu dieser Erkenntnis nachvollziehen, der sich von der singulären Naturbeobachtung in situ aus nach und nach auf ein Wissen über das Ganze der Natur erstreckte. Dies reflektiert der Atlas, indem die Karten zunächst einzelne, von Humboldt auf seiner Amerikanischen Reise besuchte Regionen, die seinerzeit in Europa noch weitgehend unbekannt waren, ansichtig machen. Sie sind mit ihren Straßen, Siedlungen, Rohstoffvorkommen und Missionen genau verzeichnet. Aus diesen Darstellungen erwächst beispielsweise das Wissen über die Verbindung der Flusssysteme von Orinoko und Amazonas, sie liefern eine präzise Beschreibung Kubas oder aber geologische Kenntnisse über die Vulkane der Neuen Welt. Im Kartenverbund werden diese Einzelbeobachtungen sodann aufeinander bezogen und durch einen schematischen Überbau sinnstiftend zusammengeführt. Er strukturiert den Atlas als Ganzes heuristisch, sodass sich in der kartenübergreifenden Betrachtung ein virtuelles Modell vom Zusammenwirken der Naturkräfte herauszubilden vermag.

Der *Atlas géographique et physique du Nouveau Continent* lässt sich auf diese Weise sowohl über verschiedene Wege als auch mit unterschiedlichen Erkenntnisinteressen erschließen; ebenso wie das Studium einzelner Themenbereiche möglich ist, so können auch komplexere Verknüpfungen vorgenommen werden. Die individuelle Karte besitzt dementsprechend einen doppelten Status: Sie ist – als einzelne Tafel – sowohl Träger einer

spezifischen Information von Wissen über die Natur als auch – innerhalb des virtuellen Modells, das aus ihrem Zusammensehen entsteht – Teil eines übergeordneten Prinzips. Während das Modell nur im Kartenverbund erkennbar ist, können die einzelnen thematischen Aspekte durch die Lektüre ausgewählter Passagen des Reisewerks auch selektiv erfasst und gesondert vertieft werden. Indem die intensive Auseinandersetzung mit einzelnen Schwerpunkten wiederum auf das Ganze, das Modell, rückbezogen werden kann, befördert das Zusammenspiel der unterschiedlichen medialen Ausdrucksmöglichkeiten letztlich das volle Verständnis der systemischen Wechselwirkung des „Naturganzen".

Vermutlich zielte diese Komplexität des *Atlas géographique et physique du Nouveau Continent*, durch die verschiedene Wege zu seiner Erschließung angeboten werden, nicht nur auf eine vielschichtige visuelle Aufbereitung des Wissens über die Natur, sondern auch darauf, ein breites Publikum, Fachleute ebenso wie (gebildete und interessierte) Laien, zu adressieren. Insbesondere mit Blick auf das mediale Ineinandergreifen vom Text des Reisewerks und den Karten kann der *Atlas géographique et physique du Nouveau Continent* mit didaktischen Überlegungen aus der Zeit um 1800 zusammengebracht werden. Unter diese fallen etwa diejenigen Joachim Heinrich Campes (1746–1818), dem einflussreichen Anhänger der reformpädagogischen Bewegung des Philanthropismus und kurzzeitigen Hauslehrer der Brüder Humboldt. In seinen *Pädagogischen Unterhandlungen* heißt es in dem Abschnitt der „Erdbeschreibung", dass Karten und Texte insbesondere im Zusammenhang mit historischen und politischen Themen aufeinander bezogen rezipiert werden sollten: „Mit allem historischen Unterrichte, und mit dem Lesen der politischen Nachrichten, wird die Geographie verbunden. Man empfiehlt es auch den Zöglingen, bey allen historischen Lectüren in der Folge die Landkarte zur Hand zu haben, wenn sie das Gelesene ganz verstehen und behalten wollen."[1] Campe setzte eine entsprechende mediale Kopplung in seinen Publikationen selbst um. So enthielt auch *Die Entdekkung von Amerika, ein angenehmes und nützliches Lesebuch für Kinder und junge Leute*, das 1781 erstmals erschien, beigefügtes Kartenmaterial, um den Inhalt des Textes auf dem Fundament der geographischen Visualisierung zu vergegenwärtigen.[2]

1 Basedow, Johann Bernhard/Campe, Joachim Heinrich: *Pädagogische Unterhandlungen*, Dessau: Steinacker 1777, S. 1125–1126.
2 Campes Forderungen stützten sich auf eine lange zurückreichende Tradition, nach der Karten als „Auge der Geschichte" verstanden wurden. Schon Abraham Ortelius hatte am Beginn der Vorrede seines 1570 publizierten *Theatrum orbis terrarum* hervorgehoben, dass historisches Wissen mit Hilfe von Karten in besonderer Weise anschaulich werde. Vgl. Ortelius, Abraham: *Theatrum orbis terrarum*, Antverpiae: Apud Aegid. Coppenium Diesth 1570, nicht paginierte Vorrede.

Alexander von Humboldt sei schon als Kind, wie er selbst anmerkte, durch diese und andere (Karten-)Lektüren zum Forschen angeregt worden.[3] Wie der *Atlas géographique et physique du Nouveau Continent* zeigt, ging er selbst später bei der medialen Verschränkung von Text und Bild gleichwohl deutlich weiter, als Campe es in seinen *Pädagogischen Unterhandlungen* zunächst vorgeschlagen hatte: Statt Karten bei der Wissensvermittlung lediglich zur Textlektüre hinzuzuziehen, versah Humboldt ihre Zusammenschau mit einem ganz eigenen Anspruch. Das Gelesene sollte durch diese nicht allein vorgeführt, sondern vor dem inneren Augen der Rezipierenden als hochkomplex verknüpftes, räumliches Schema, das der Text so nicht einholen konnte, vorstellbar werden. Diese intellektuelle Herausforderung des Vor-Augen-Stellens bot dem Text gegenüber dezidiert eine eigene heuristische Qualität auf.

Über den *Atlas géographique et physique du Nouveau Continent* hinaus

Erste Annäherung aus der Forschung lassen vermuten, dass Humboldts *Vues des Cordillères* eine dem *Atlas géographique et physique du Nouveau Continent* ähnliche, von einer visuellen Verknüpfung der Inhalte ausgehende Konzeption zugrunde liegt;[4] auch dieser „pittoreske Atlas" des Reisewerks stellt einen Band dar, dessen Tafeln sich auf unterschiedliche Weise sinnstiftend verbinden lassen. Ursprünglich hatte Humboldt die Graphiken der *Vues des Cordillères*, die Landschaften, Naturszenen mit Menschen, Bauwerke und Stadtansichten, Kunstwerke und Bild-Codices zeigen, für die *Relation historique* entworfen, indes entwickelte sich während der Arbeit an ihnen ein eigenständiger Text-Bild-Verbund.[5] Im Nachhinein konstatierte Humboldt: „Der pittoreske Atlas hat einen eigenen Text, der das Werk ganz unabhängig macht"[6]. Die 69 Tafeln der *Vues des Cordillères* werden – meist einzeln, hin und wieder auch zu zweit oder zu dritt – explizit von separaten Textteilen begleitet, wobei die Überschriften der Kapitel zuerst jeweils die Nummer bzw. die Nummern der Stiche und darauf im Untertitel das Dargestellte auch diskursiv erfas-

3 Dass Campe hieran einen nicht unwesentlichen Anteil gehabt haben mag, bemerkt auch Kurt Schleucher in seinem Buch *Alexander von Humboldt: Der Mensch, der Forscher, der Schriftsteller*, Darmstadt: Eduard Roether 1985, S. 15; vgl. für Humboldt: *Kosmos*, Bd. 2, 1847, S. 4.

4 Diese Konzeption deutet sich bei Ottmar Ettes und Oliver Lubrichs Analyse des Textes an. Ette, Ottmar/Lubrich, Oliver: „Die Reise durch eine andere Bibliothek: Nachwort", in: Humboldt, Alexander von: *Ansichten der Kordilleren und Monumente der eingeborenen Völker Amerikas*, hg. und kommentiert von dies., Frankfurt am Main: Eichborn 2004, S. 407–422, hier S. 412–414.

5 Siehe Fiedler/Leitner: *Alexander von Humboldts Schriften*, 2000, S. 133.

6 Siehe Humboldt an Cotta am 09.09.1809, in: *Briefwechsel: Alexander von Humboldt und Cotta*, Berlin 2009, S. 103.

sen. Text und Bilder sind auf diese Weise eindeutig aufeinander bezogen. Dadurch unterscheidet sich der Aufbau der *Vues des Cordillères* zunächst deutlich von demjenigen des *Atlas géographique et physique du Nouveau Continent*, in dem das Verhältnis zu den Textteilen des Reisewerks vage ist.

Aufgrund des eindeutigen Bezugs von Tafeln und Text aufeinander, wie es in den *Vues des Cordillères* gegeben ist, scheint die Konzeption zunächst leichter verständlich zu sein als jene des *Atlas géographique et physique du Nouveau Continent*. Doch erweist sich letztlich auch die Rezeption der *Vues des Cordillères* als anspruchsvoll: In der numerischen Abfolge der Kapitel ist keine klare inhaltliche Struktur erkennbar. Erst wenn die Kapitel als das offene Gefüge eines großen Ganzen aufgefasst werden, können sie in wechselnden Kombinationen zu sinnstiftenden Ordnungen zusammengeführt werden. Wie Ottmar Ette und Oliver Lubrich feststellen, lassen sich die *Vues des Cordillères* auf ganz unterschiedlichen Lektürewegen erschließen, und zwar

> linear, entlang der Abfolge der Tafeln; geographisch, nach der Sequenz der Reiseroute; historisch, nach dem Alter der dargestellten Phänomene; thematisch, zum Beispiel nach historischen Gegenständen; künstlerisch, nach gestalterischen Aspekten der Bilder; oder frei assoziativ […]. Intratextuelle Verweise (im Haupttext und in den Fußnoten) stellen immer wieder interne Bezüge her.[7]

Humboldt wies auf einen dieser Rezeptionswege selbst hin. In die Einleitung der *Vues des Cordillères* integrierte er eine Übersicht der im Werk enthaltenen Tafeln, jedoch löste er bei dieser Auflistung deren numerische Reihenfolge zugunsten einer thematischen Zusammenstellung auf.[8] Die neu entstandenen Gruppierungen der Tafeln unterschied Humboldt nach „Monumens", d. h. nach Objekten und Bauwerken, und „Sites", d. h. nach Städten und Naturphänomenen. Diese Teilung ist sodann noch einmal nach Kulturräumen untergliedert. Wie Ette und Lubrich unterstreichen, lässt sich diese Anordnung Humboldts jedoch nicht als eine eindeutige Lektüreanweisung, sondern vielmehr als eine von diversen Optionen zur Gruppierung der Tafeln werten; viele weitere sinnstiftende Anordnungen sind möglich.

Vor diesem Hintergrund lässt sich vermuten, dass der Zusammenstellung der Themen in den *Vues des Cordillères*, ähnlich wie den Tafeln des *Atlas géographique et physique du Nouveau Continent*, zwar ein übergeordnetes Prinzip zugrunde liegt, sich die letztendliche, Erkenntnis generierende Anordnung aber erst durch die individuelle Rezeption ergeben soll. Wird diese Offenheit der Konzeption als programmatisch verstanden, so verbirgt sich hinter der scheinbaren Konzeptlosigkeit die Aufforderung zu einer aktiven

7 Ette/Lubrich: „Die Reise durch eine andere Bibliothek: Nachwort", in: Humboldt: *Ansichten der Kordilleren*, 2004, hier S. 413.
8 Vgl. Humboldt: *Vues des Cordillères*, 1810, S. III–IV.

Lesart, bei der die Inhalte spielerisch und konstruktiv verknüpft werden. Auf der Basis ausgewählter Beobachtungen werden so multiple Wege der Erkenntnisfindung frei.

Dass Humboldts sinnstiftende Zusammenschau von Graphiken als Reflexion eines zeit- und kontextgebundenen Bild(er)wissens zu verstehen ist, hat die Analyse des *Atlas géographique et physique du Nouveau Continent* gezeigt. Die hierbei wirkmächtigen epistemischen Zusammenhänge sind von der Forschung indes erst in Ansätzen erschlossen worden. Bezogen auf Humboldts Atlas mag insbesondere der Blick auf gezielt zusammengeführte Bilder- bzw. Bilder-Text-Konvolute erhellend sein, die um 1800 herum erschienen sind. Sie bergen ein Wissen, das sich zwischen mehreren Bildern herausbildet; dabei ist ihnen gemeinsam, dass sie das Publikum aktiv in den Rezeptionsprozess einbinden und zum verknüpfenden Sehen herausfordern.

Ein Beispiel bietet hierfür die 1784 erschienene *Bilder-Akademie für die Jugend* des Theologen Johann Sigmund Stoy (1745–1808).[9] In dieser Bildenzyklopädie für Kinder wird die Ordnung der Welt sowohl in Texten als auch in Bildern vorgeführt. Für die Rezeption können die Tafeln nicht nur nacheinander durchblättert, sondern auch ausgeschnitten, auf Pappe gezogen und in einem Behälter angeordnet werden, sodass sich freie Kombinationen und direkte Vergleiche zwischen insgesamt 468 Bildern herstellen lassen. Stoys Publikation sollte Kindern helfen, die Welt im individuellen Erlebnis, in ihren Details und zugleich als kosmisches Gefüge zu verstehen. Eine solche individuelle Rezeption, bei der viele Details im Geiste zu einem großen Ganzen zusammengeführt werden sollen, lässt sich mit Humboldts *Atlas géographique et physique du Nouveau Continent* nicht nur hinsichtlich des strukturellen Aufbaus von Einzelansicht und Ganzem zusammenbringen, sondern auch insofern, als sich darin eine klare Anleitung der Rezeption mit einer an das Publikum delegierten Teilautonomie im Erkenntnisprozess verbindet.

Stoys didaktischer Publikation gegenüber lässt sich ein anderes, Anfang des 19. Jahrhunderts entstandenes Bilderensemble mit der räumlichen Evokation von Topographie, wie Humboldts Atlas sie ebenfalls leistet, zusammenbringen. 1815 gab der schweizerische Landschaftsmaler und Kartenzeichner Heinrich Keller (1778–1862) das *Panorama vom Rigi Berg* heraus, das erstmals die gesamte Rundschau vom Gipfel des Züricher Hausbergs zeigte. Die mehr als zwei Meter lange Ansicht lässt sich zur besseren Handhabung im Gelände auf ein Kleinformat zusammenfalten. Auf der Kuppe kann es sodann partiell aufgeklappt und die umliegenden Berge im vergleichenden Sehen, d. h. durch einen Blick, der zwischen graphischer Darstellung und der Landschaft hin und her wechselt, bestimmt werden. Wenig später fügte Keller diesem Panorama ergänzende Publikationen hinzu.

9 Vgl. Stoy, Johann Sigmund: *Bilder-Akademie für die Jugend*, Nürnberg 1784. Für die ausführliche Analyse der Publikation vgl. Heesen, Anke te: *Der Weltkasten: die Geschichte einer Bildenzyklopädie aus dem 18. Jahrhundert*, Göttingen: Wallstein-Verlag 1997.

Neben einem Kreisringpanorama und einem Textband mit Beschreibungen[10] gehören zu diesen auch 20 Bildtafeln in Postkartengröße, die sogenannten *Rigi-Blätter*.[11] Sie bieten detaillierte Ansichten der Rundschau und Einsichten in die Gegend um den Berg, darunter Gipfelaussichten und Darstellungen ausgewählter Pflanzen, zudem pragmatisch orientierte Karten zum Auf- und Abstieg sowie ein Höhenprofil der Gegend. Der Bergausflug samt schwindelerregender Gipfelschau wird auf diese Weise begleitet, angeleitet und im Nachhinein memorierbar, wobei die Landschaft nach den eigenen Interessen, Bedürfnissen und Erfahrungen medial rekonstruiert werden kann.[12]

Mehr als eine Karte: zur Erkenntnis, die zwischen (Karten-) Bildern entsteht

Das Potential der hier angeführten Beispiele für die gezielte Kombination von heterogenen Bildtypen und -themen verdeutlicht der *Atlas géographique et physique du Nouveau Continent* exemplarisch: Die unterschiedlichen Wissensbereiche- und Darstellungsweisen, die sinnstiftend zusammentreten, verfügen über eine Argumentationsfähigkeit, die über jene des Einzelbildes deutlich hinausgeht. Mit ihr können auch vermeintlich gegensätzliche Aspekte zugleich und in ihrem Bezug zueinander verhandelt werden. Zu nennen wären hier nicht nur verschiedene Perspektiven auf dasselbe Objekt, sondern etwa auch die gemeinsame Präsentation von Konkretion und Abstraktion, von Faktum und Hypothese, von ästhetischen und technischen Darstellungsweisen oder von verschiedenen Zeitschichten. Die Pole lassen sich im Rezeptionsprozess im Sinne einer stetig umschlagenden Kippfigur in fortdauernder Oszillation halten und treiben die Erkenntnisgenese damit kontinuierlich weiter an. Dieses Überschussmoment des Mehr-Bildlichen stellt das zentrale heuristische Moment von Humboldts *Atlas géographique et physique du Nouveau Continent* dar. Seine heterogenen, gezielt zusammengebrachten, linearen ebenso wie nichtlinearen Bildkombinationen sind hierfür konstitutiv. Deren wissenschaftliches

10 Vgl. Keller, Heinrich: *Beschreibung des Rigibergs, aller auf den selben führenden Wege und der berühmten Kulm-Aussicht. Von Heinrich Keller zur Erklärung seines Panorama*, Zürich: Füeßli 1823.

11 Heinrich Kellers Leben und Werk hat von der Forschung bislang nur wenig Berücksichtigung gefunden. Für eine inzwischen in die Jahre gekommene Biographie vgl. Hess, Johann Heinrich: *Das Leben des Heinrich Keller von Zürich, Landkarten- und Panorama-Zeichners* [sic], erschienen in der Reihe: *Neujahrsblatt der Künstlergesellschaft in Zürich für 1865: Neue Reihenfolge*, Zürich 1865.

12 Das Delegieren des Blickes durch Keller lässt sich mit der zeitgenössisch breitenwirksamen Faszination an der neuentdeckten Allumsichtigkeit des Panoramas engführen, deren Erfahrung der Weite zugleich eine vielfach mit Schwindelgefühlen assoziierte Unsicherheit ausgelöst hatte. Vgl. hierfür Oettermann, Stephan: *Das Panorama: die Geschichte eines Massenmediums*, Frankfurt am Main: Syndikat 1980, S. 12–13.

Potential ist mithin nicht allein vorgegeben, denn die darin aufgemachten Thesen werden bei der Rezeption selbst (re)formuliert – und vermögen dadurch umso stärkere Wirkmacht zu entfalten.

Anhang

Abkürzungs- und Kürzelverzeichnis

gr. = griechisch
BBAW = Berlin-Brandenburgische Akademie der Wissenschaften
BJK = Biblioteka Jagiellońska, Krakau
BNF = Bibliothèque nationale de France, Paris
ders.; dies. = derselbe; dieselbe/dieselben
HA = Handschriftenabteilung
lat. = lateinisch
o. S. = ohne Seitenangabe
SBB = Staatsbibliothek zu Berlin, Preußischer Kulturbesitz

Editorische Angaben zum *Atlas géographique et physique du Nouveau Continent*

Auflage: unbekannt; als Richtwert mag die der Folio Ausgabe der *Vues des Cordillères* dienen, die bei 600 Stück lag. Zu vermuten steht, dass die Auflage des *Atlas géographique et physique du Nouveau Continent* wegen der schwindenden finanziellen Mittel Humboldts deutlich darunter lag.
Verleger: Schoell (Lieferung 1, 1814), Vendrys (Lieferung 2, 1817), Maze (ab 1819, Lieferung 3 und 4, kauft vermutlich 1825 die Restauflagen von Vendrys und Schoell), Smith/Gide fils (Lieferung 5, 1825), Gide fils (Lieferung 6, 1831; Lieferung 7, 1834), Gide (Lieferung 9–16, 1835–1837).
Preis: Lieferung 1–5: je 36 Franc. Hochgerechnet ergäben sich hieraus Kosten von etwa 312 Franc für den gesamten Atlas. Ein später angegebener Gesamtpreis lag mit 360 Franc etwas darüber.
Format: Großfolio in Einzel- und Doppelbögen. Die Blattgröße beträgt für den Einzelbogen ca. 43 × 60 cm (Tafeln 2–4, 6–13, 15, 20–22, 26–27, 29–39) bzw. für den Doppelbogen ca. 86 × 120 cm (Tafeln 1, 5, 14, 16–19, 23–25, 28).

Übersicht der Lieferungen

Lieferung 1, 1814: Tafeln 1, 15, 18, 19, 28
Tafel 1: *Limite inférieure des Neiges perpétuelles à différentes Latitudes*; zeichnerischer Entwurf: Friedrich Friesen, 1808; Stich: Louis Bouquet, Schrift: L. Aubert père, 1813
Tafel 15: *Carte du Cours de l'Orenoque depuis l'Embouchure du Rio Sinaruco jusqu'à l'Angostura*; Entwurf: Alexander von Humboldt/J. B. Poirson, Stich: Bouclet, Schrift: L. Aubert père

Tafel 18: *Carte de la Partie Orientale de la Province de Varinas comprise entre l'Orenoque, l'Apure et le Rio Meta*; Entwurf: Alexander von Humboldt, durchgesehen und korrigiert von J. B. Poirson, 1812, Stich: P. A. F. Tardieu, Schrift: L. Aubert

Tafel 19: *Carte du Cours de Rio Meta et d'une partie de la Chaîne Orientale des Montagnes de la Nouvelle Grenade*; Entwurf: Alexander von Humboldt, durchgesehen und korrigiert von J. B. Poirson, 1813, Stich: P. A. F. Tardieu, Schrift: L. Aubert père; neue Fassung mit der Lieferung 2, 1817, redigiert nach Angaben von Alexander von Humboldt durch J. B. Poirson, 1817, Stich: P. A. F. Tardieu, Schrift: L. Aubert père

Tafel 28: *Tableau Géologique du Volcan de Jorullo*; Skizze: Alexander von Humboldt, zeichnerischer Entwurf: Juan Jose Rodriguez, École des Mines de Mexico 1804, Stich: Bouquet, Schrift: L. Aubert père

Lieferung 2, 1817: Tafeln 2, 16, 20, 29, verbesserter Neudruck der Tafel 19

Tafel 2: *Tableau physique des Iles Canaries. Géographie des Plantes du Pic de Ténériffe (Latitude 28° 16' 53")* *Fondée sur les observations de M^{rs} Léopold de Buch et Chr. Smith*; Entwurf: L. Marchais, Stich: Jean Louis Denis Coutant, Schrift: L. Aubert, 1817

Tafel 16: *Carte itinéraire du cours de l'Orénoque, de l'Atabapo, du Casiquiare, et du Rio Negro offrant la bifurcation de l'Orénoque et sa communication avec la Rivière des Amazones*; Entwurf: Alexander von Humboldt, Quito 1800/J. B. Poirson, Paris 1814, Stich: Blondeau, Schrift: L. Aubert

Tafel 20: *Carte du Rio Caura et des Missions qui ont été établies sur ses bords par les Religieux de S^t. François, esquissée sur des matériaux fournis par les Missionnaires de l'Orénoque en 1800*; Entwurf: Alexander von Humboldt/J. B. Poirson 1816, Stich: E. Aubert, Schrift: L. Aubert

Tafel 29: *Plan du Volcan de Jorullo*; Skizze: Alexander von Humboldt, Entwurf: H. Michaelis, Stich: Pierre Tardieu fils, Schrift: L. Aubert

Lieferung 3, 1819: Tafeln 4, 17, 21, 30

Tafel 4: *Chemin de La Guayra à Caracas, par la Cumbre, Esquissé d'après un nivellement Barométrique par A. de Humboldt*; Entwurf: Alexander von Humboldt, 1817; Stich: Jean Louis Denis Coutant, Schrift: L. Aubert

Tafel 17: *Carte du Cours du Rio Apure et d'une Partie de la Chaine des Montagnes de la Nouvelle Grenade*; Entwurf: Alexander von Humboldt, durchgesehen und korrigiert von J. B. Poirson, 1813, Stich: P. A. F. Tardieu

Tafel 21: *Carte spéciale de la partie du Rio Apure comprise entre la ville de S^n. Fernando et l'embouchure de la rivière/Cours du Rio Guaviare*; Skizze: Alexander von Humboldt, 1814, Entwurf: J. B. Poirson, Stich: Barriere père, Schrift: L. Aubert

Tafel 30: *Esquisse géologique des environs de Guanaxuato*; Skizze: Alexander von Humboldt und A. Davalos, 1803, fertiggestellt von H. Michaelis, 1817, Stich: Pierre Tardieu fils, Schrift: L. Aubert

Lieferung 4, 1821: Tafeln 6, 23, 24, 26

Tafel 6: *Profil du Chemin de Carthagene des Indes au Plateau de Santa Fe de Bogota*; Entwurf: Alexander von Humboldt, 1802/1820, Stich: L. Coutant, Schrift: L. Aubert

Tafel 23: *Carte d'ile de Cuba redigée sur les observations astronomiques des Navigateurs Espagnols et sur celles de M^r. de Humboldt. Par P. Lapie Chef d'Escadron au Corps royal des Ingénieurs géographes militaires de France. 1820*; Stich: Flahaut, Schrift: Lallemand; neue Fassung mit der Lieferung 7, 1834 (Jahresangabe im Kartenspiegel 1826)

Tafel 24: *Carte du Rio Grande de la Magdalena depuis le 4° Latitude jusqu'à son embouchure*; Skizze: Alexander von Humboldt, Entwurf: E. H. Michaelis, Stich: Pierre Tardieu fils, Schrift: L. Aubert père

Tafel 26: *Carte géologique du Nevado de Antisana*, Skizze: Alexander von Humboldt, Entwurf: E. H. Michaelis, Stich: Pierre Tardieu fils, Schrift: L. Aubert père

Lieferung 5, 1825: Tafeln 3, 9, 13, 14, 22

Tafel 3: *Profil de la Peninsule Espagnole*; zeichnerischer Entwurf: Alexander von Humboldt, 1823; Stich: Jean Louis Denis Coutant

Tafel 9: *Voyage vers la cime du Chimborazo, tenté le 23 Juin 1802 par Alexandre de Humboldt, Aimé Bonpland et Carlos Montufar*; zeichnerischer Entwurf: Alexander von Humboldt, Mexiko 1803/F. Marchais, Paris 1824

Tafel 13: *Exemple de Bifurcations et de Deltas d'Affluens pour servir d'éclaircissement aux discussions d'Hydrographie comparée. Contenues dans le Chap. 23 de la Relation historique de M^r. de Humboldt*

Tafel 14: *Histoire de la Géographie de l'Orénoque*[,]*– Lac Parime, Dorado, Bifurcation. pour servir d'eclaircissement aux discussions contenues dans le Chap. 24 de la Relat. Hist. de M^r. de Humboldt*

Tafel 22: *Carte générale de Colombia*; Skizze: Alexander von Humboldt; Entwurf: Adrien-Hubert Brué

Lieferung 6, 1831: Tafeln 5, 25, 27

Tafel 5: *Esquisse hypsometrique des nœuds de montagnes et des ramifications de la Cordillere des Andes*, zeichnerischer Entwurf: M. Brué, Stich (Bergdarstellung): F. P. Michel

Tafel 25: *Carte hydrographique de la Province du Chocó*; Entwurf: Adrien-Hubert Brué, 1827; Stich: Artus, Paris

Tafel 27: *Plan hypsométrique du Volcan de Pichincha*; Skizze: Alexander von Humboldt; zeichnerischer Entwurf: E. H. Michaelis; Stich: Pierre Tardieu, 1827; Schrift: J. D. Lale

Lieferung 7, 1834: Tafeln 7, 8, 10, 11, 12, verbesserte Version der *Carte d'ile de Cuba* (Tafel 23)

Tafel 7: *Esquisse géognostique des formations entre la Vallée de Mexico, Moran et Totonilco*; zeichnerischer Entwurf: Alexander von Humboldt während seines Aufenthalts am Colegio de Minas in Mexiko-Stadt (1803/1804), Stich: Berthe; gedruckt in Berlin 1832

Tafel 8: *Carte itinéraire de la Route de Zacatecas a Bolaños tracée en 1825 a l'état-major (IV.^e section) de la République Mexicaine*; Stich: Berthe, zeichnerischer Entwurf: S. Guzman, Mexiko 1825

Tafel 10: *Carte de la Province de Quixos*; zeichnerischer Entwurf: Alexander von Humboldt, Quito 1802, Stich: Berthe, Paris

Tafel 11: *Esquisse d'une Carte de la Province d'Avila*; zeichnerischer Entwurf: Alexander von Humboldt, Quito 1802, Stich: Berthe, Paris, redigiert von Heinrich Berghaus, Berlin 1833

Tafel 12: *Plan du Port et des Environs de Tampico*; zeichnerischer Entwurf: N. N., Mexiko 1827, Stich: Berthe, Paris 1833

Lieferung 8, 1834: Tafel 32?

Tafel 32: *Carte de l'isthme de Tehuantepec, ou du Terrain entre le Rio de Huasacualco (Coazacoalco) et le Rio Chicapa, tracée en 1827 à l'état-major (IV.me Section) de la République Méxicaine*; redigiert von Heinrich Berghaus, Berlin 1834, Stich: Berthe, Paris 1834

Lieferung 9, 1835: Tafel 31

Tafel 31: *Carte des environs de Honda, de Mariquita et des mines de Santana; tracée d'après des Opérations trigonométriques par M^r. le D^r. F. Roulin*; Entwurf: F. Roulin, 1825, Stich: Berthe, Paris 1834

Lieferung 10–16: Tafeln 33–39 (Nachstiche historischer Karten), 1835–1837

Lieferung 10–11: keine näheren Angaben; vermutlich Tafel 33: *Le Nouveau Continent figuré dans la mappemonde de Juan de la Cosa en 1500* und Tafel 34: *Fragment de la mappemonde dessinee au Port de Santa Maria l'An 1500 par Juan de la Cosa*; Stich: Pierre Tardieu

Lieferung 12: Tafel 37: *Tabula Terre Nove. Depromta ex ed. Geographiæ Ptolemæi Agentor. 1513. in folio. servatis in scriptura mendis omnibus, etiam manifestis*, Nachstich von *Tabula Terre Nove*, in: *Claudii Ptolemei viri Alexandrini Mathematic[a]e discipline Philosophi doctissimi Geographi[a]e opus*, hg. und redigiert von Martin Waldseemüller, Strassburg: J. Schott, 1513, hier eine von 20 Tabulae Modernae

Lieferung 13–16: keine näheren Angaben; vermutlich (je einzeln) Tafel 35: *Fragment de la mappemonde de Juan de la Cosa tracée en 1500*; Tafel 36: Trois *Fragmens de la mappemonde de Juan de la Cosa tracee en 1500*; Tafel 38: *Tabula Moderna Norbegie et Gottie* (Detail) und *Orbis Typus Universalis juxta Hydrographorum traditionem*; die Vorlagen zu den Nachstichen in *Claudii Ptolemei viri Alexandrini Mathematic[a]e discipline Philosophi doctissimi Geographi[a]e opus*, hg. und redigiert von Martin Waldseemüller, Strassburg: J. Schott, 1513, hier eine von 20 Tabulae Modernae; Tafel 39: *Universalior Cogniti Orbis Tabula Ex Recentibus Confecta Obsevationibus* (Detail); die Vorlage zum Nachstich stammt von Johannes Ruyschs Weltkarte, gedruckt in Rom 1507

Bibliographie

Schriften Alexander von Humboldts

Editorische Anmerkung: Die Jahreszahlen in eckigen Klammern geben den tatsächlichen Zeitraum der Veröffentlichung an und ergänzen damit die Angabe der Jahreszahl auf dem Titelblatt.

Versuche über die gereizte Muskel- und Nervenfaser nebst Vermuthungen über den chemischen Process des Lebens in der Thier- und Pflanzenwelt, Bd. 1, Posen u. a.: Decker 1797

Versuche über die chemische Zerlegung des Luftkreises und über einige andere Gegenstände der Naturlehre, Braunschweig: Friedrich Vieweg 1799

zus. mit Biot, Jean-Baptiste: „Sur les variations du magnétisme terrestre à différentes Latitudes", *Journal de Physique, de Chimie, d'Histoire Naturelle et des Arts* LIX (1804), S. 429–450, mit zwei Tafeln im selben Bd.

zus. mit Biot, Jean-Baptiste: „Ueber die Variationen des Magnetismus der Erde in verschiedenen Breiten", *Annalen der Physik und Chemie* XX (1805), S. 257–298

„Introducción a la Pasigrafía geológica", in: del Río, Andrés Manuel: *Elementos de Orictognosía o del conocimiento de los fósiles dispuestos según los principios de A.G. Werner*, Bd. 2, México D. F.: Hurtel 1805, S. 160–173

Ideen zu einer Physiognomik der Gewächse, Tübingen: Cotta 1806

Essai sur la géographie des plantes, accompagné d'un tableau physique, Paris: Schoell 1805 [auf dem Titelblatt irrtümlicherweise, tatsächlich erschienen 1807]

zus. mit Bonpland, Aimé: *Botanique. Plantes équinoxiales*, Bd. 1, Paris: Schoell/Tübingen: Cotta 1808 (*Voyage*, Teil 6)

Versuch über den politischen Zustand des Königreichs Neu-Spanien, Bd. 1, Tübingen: Cotta 1809

Essai politique sur le royaume de la Nouvelle-Espagne, Bd. 1, Paris: Schoell 1811

Essai politique sur le royaume de la Nouvelle-Espagne, Bd. 1, Paris: Renouard 1825 [zweite Auflage]

Recueil d'observations astronomiques, d'opérations trigonométriques et de mesures barométriques, Paris: Schoell 1810 [1808–1811]

Vues des Cordillères, et monumens des peuples indigènes de l'Amérique, Paris: Schoell 1810[–1813]

Atlas géographique et physique du royaume de la Nouvelle-Espagne, Paris: Schoell [1808–]1811

„Note sur la communication qui existe entre l'Orénoque et la rivière des Amazones", *Journal de l'École Polytechnique* 4 (1810) 1, S. 65–68

„Über die Verbindung zwischen dem Orinoko und dem Amazonenfluss", in: *Monatliche Correspondenz zur Beförderung der Erd- und Himmels-Kunde* 26 (1812), S. 230–235

Atlas géographique et physique des régions équinoxiales du Nouveau Continent, Paris: verschiedene Verleger 1814[–1837]

zus. mit Bonpland, Aimé: *Relation historique du voyage aux régions équinoxiales du Nouveau Continent: fait en 1799, 1800, 1801, 1802, 1803 et 1804*, Bd. 1 [Quarto], Paris: Gide 1814[–1817]

zus. mit Bonpland, Aimé: *Relation historique du voyage aux régions équinoxiales du Nouveau Continent: fait en 1799, 1800, 1801, 1802, 1803 et 1804*, Bd. 2 [Quarto], Paris: Schoell/Maze/Smith 1819[–1821]

zus. mit Bonpland, Aimé: *Relation historique du voyage aux régions équinoxiales du Nouveau Continent: fait en 1799, 1800, 1801, 1802, 1803 et 1804*, Bd. 3 [Quarto], Paris: Smith/Gide 1825[–1831]

zus. mit Bonpland, Aimé: *Relation historique du voyage aux régions équinoxiales du Nouveau Continent: fait en 1799, 1800, 1801, 1802, 1803 et 1804*, Bd. 4 [Octav], Paris: Smith 1817[–1818?]

zus. mit Bonpland, Aimé: *Relation historique du voyage aux régions équinoxiales du Nouveau Continent: fait en 1799, 1800, 1801, 1802, 1803 et 1804*, Bd. 7 [Octav], Paris: Smith 1822

„Sur les matériaux qui ont servi pour la construction de l'Atlas géographique et physique", in: Humboldt, Alexander von: *Relation historique*, Bd. 4 [Octav], Paris: Smith 1817[–1818], Appendix mit gesonderter Seitenzählung, S. 1–37

„Des lignes isothermes et de la distribution de la chaleur sur le globe", *Annales de Chimie et de Physique* 5 (1817), S. 102–111; mit Karte: *Carte des lignes Isothermes*

Reise in die Aequinoctial-Gegenden des Neuen Continents in den Jahren 1799, 1800, 1801, 1802, 1803 und 1804, in deutscher Bearbeitung von Hermann Hauff, Bd. 2 [Octav], Stuttgart/Tübingen: Cotta 1818

Reise in die Aequinoctial-Gegenden des Neuen Continents in den Jahren 1799, 1800, 1801, 1802, 1803 und 1804, in deutscher Bearbeitung von Hermann Hauff, Bd. 3 [Octav], Stuttgart/Tübingen: Cotta 1860

Reise in die Aequinoctial-Gegenden des Neuen Continents in den Jahren 1799, 1800, 1801, 1802, 1803 und 1804, in deutscher Bearbeitung von Hermann Hauff, Bd. 4 [Octav], Stuttgart/Tübingen: Cotta 1823

Reise in die Aequinoctial-Gegenden des Neuen Continents in den Jahren 1799, 1800, 1801, 1802, 1803 und 1804, in deutscher Bearbeitung von Hermann Hauff, Bd. 5 [Duodez], Cotta: Stuttgart 1862

„De quelques phénomènes physiques et géologiques qu'offrent les Cordillères des Andes de Quito et la partie occidentale de l'Himalaya", *Annales des Sciences Naturelles* 4 (1825), S. 225–256; die Karte zum Beitrag findet sich als *Planche 15* in den *Annales des Sciences Naturelles – Atlas*, T. 4–6 (1825), o. S.

„Von einigen physischen und geologischen Phänomenen, welche die Cordillera de los Andes bei Quito und der westliche Theil des Himalih-Gebirge darbieten", *Neue Allgemeine Geographische und Statistische Ephemeriden* 16 (1825) 1, S. 1–21

„Ueber die Gestalt und das Klima des Hochlandes in der iberischen Halbinsel", *Hertha. Zeitschrift für Erd-, Völker- und Staatenkunde* 4 (1825), S. 5–23

Essai politique sur l'île de Cuba: avec une carte et un supplément, Bd. 2, Paris: Gide 1826

„Neuste Beschlüsse der mexiko'schen Regierung über einen Handelsweg in der Landenge von Goazacoalco und Tehuantepec", *Hertha, Zeitschrift für Erd-, Völker- und Staatenkunde* 9 (1827), S. 5–28

Tableau de cartes géographiques et physiques. Provisorisches Inhaltsverzeichnis des *Atlas géographique et physique du Nouveau Continent*, vermutlich zus. erschienen mit der Lieferung 7 des Atlas, Paris 1834

Examen critique de l'histoire de la géographie du Nouveau Continent et des progrès de l'astronomie nautique aux quinzième et seizième siècles, Bd. 1, Paris: Gide 1836

Examen critique de l'histoire de la géographie du Nouveau Continent et des progrès de l'astronomie nautique aux quinzième et seizième siècles, Bd. 2, Paris: Gide 1837

Examen critique de l'histoire de la géographie du Nouveau Continent et des progrès de l'astronomie nautique aux quinzième et seizième siècles, Bd. 3, Paris: Gide 1837

„Ueber die Schwankungen der Goldproduktion mit Rücksicht auf staatswirthschaftliche Probleme", *Deutsche Vierteljahrs Schrift* 1 (1838) 4, S. 1–40

„Ueber den Manati des Orinoko", *Archiv für Naturgeschichte* 4 (1838) 1, S. 1–18, mit Tableau I und II

„Über einige sehr wichtige Punkte der Geographie Guayana's", in: *Robert Hermann Schomburgk's Reisen in Guiana und am Orinoko während der Jahre 1835–1839*, hg. von O. A. Schomburgk, Leipzig: Wigand 1841, S. 1–39

Kosmos. Entwurf einer physischen Weltbeschreibung, Bd. 1, Stuttgart/Tübingen: Cotta 1845

Kosmos. Entwurf einer physischen Weltbeschreibung, Bd. 2, Stuttgart/Tübingen: Cotta 1847

Kosmos. Entwurf einer physischen Weltbeschreibung, Bd. 3, Stuttgart/Tübingen: Cotta 1850

Kosmos. Entwurf einer physischen Weltbeschreibung, Bd. 4, Stuttgart/Tübingen: Cotta 1858

„Das Hochland von Caxamarca", in: Humboldt, Alexander von: *Ansichten der Natur*, Bd. 2, Stuttgart: Cotta 1849, S. 315–407

Kleinere Schriften, Bd. 1: *Geognostische und physikalische Erinnerungen*, Stuttgart/Tübingen: Cotta 1853

„Ueber die ältesten Karten des Neuen Continents und den Namen Amerika", in: *Geschichte des Seefahrers Ritter Martin Behaim nach den ältesten vorhandenen Urkunden bearbeitet von Dr. F. W. Ghillany*, Nürnberg: Bauer und Raspe, 1853, S. 1–12

Umrisse von Vulkanen aus den Cordilleren von Quito und Mexico. Ein Beitrag zur Physiognomik der Natur, Stuttgart/Tübingen: Cotta 1853

„Von den isothermen Linien und der Verteilung der Wärme auf dem Erdkörper", in: Humboldt, Alexander von: *Kleinere Schriften*, Bd. 1: *Geognostische und physikalische Erinnerungen*, Stuttgart/Tübingen: Cotta 1853, S. 206–314

Brief an M. Kelley, *Zeitschrift für allgemeine Erdkunde* 2 (1857), S. 562–563

Brief an Schiller vom 06.08.1794, *Berliner Revue. Social-politische Wochenschrift*, redigiert von Hermann Keipp, 17 (1859) 2, S. 539–540

Atlas géographique et physique du Royaume de la Nouvelle-Espagne – vom Verfasser auch kurz benannt: Mexico-Atlas, hg. und kommentiert von Hanno Beck und Wilhelm Bonacker, Stuttgart: Brockhaus 1969

Studienausgabe, Teil 1: *Schriften zur Geographie der Pflanzen*, hg. und kommentiert von Hanno Beck, Darmstadt: Wissenschaftliche Buchgesellschaft 1989

Studienausgabe, Bd. 4: *Mexico-Werk*, hg. und kommentiert von Hanno Beck, Darmstadt: Wissenschaftliche Buchgesellschaft 1991

Lateinamerika am Vorabend der Unabhängigkeitsrevolution, hg. von Margot Faak, Berlin: Akademie-Verlag 2003

Reise auf dem Rio Magdalena, durch die Anden und Mexico, Teil 1: *Texte*, Teil 2: *Übersetzung, Anmerkung und Register*, hg. von Margot Faak, mit einer einleitenden Studie von Kurt R. Biermann, Berlin: Akademie-Verlag 2003

Atlas geográfico y físico del reino de la Nueva España, hg. von der Universidad Nacional Autónoma de México, México D. F.: Siglo Veintiuno 2003

Ansichten der Kordilleren und Monumente der eingeborenen Völker Amerikas, hg. und kommentiert von Ottmar Ette und Oliver Lubrich, Frankfurt am Main: Eichborn 2004

Von Mexiko-Stadt nach Veracruz. Tagebuch, hg. von Ulrike Leitner, Berlin: Akademie-Verlag 2005

Kritische Untersuchung zur historischen Entwicklung der geographischen Kenntnisse von der Neuen Welt. Mit dem geographischen und physischen Atlas der Äquinoktial-Gegenden des Neuen Kontinents, Frankfurt am Main: Insel 2009

Das zeichnerische Werk. Die bislang unveröffentlichten Originalzeichnungen des genialen Forschungsreisenden, hg. von Dominik Erdmann und Oliver Lubrich, Darmstadt: wbg 2019

Sekundär- und Forschungsliteratur

Aira, César: *Un episodio en la vida del pintor viajero*, Rosario: Beatriz Viterbo 2000

Aira, César: *Humboldts Schatten*, Zürich: Nagel & Kimche 2003

Alexander von Humboldt – Carl Ritter: Briefwechsel, hg. von Ulrich Päßler, Berlin: Akademie-Verlag 2010

Alexander von Humboldt – Jean-Baptiste Boussingault: Briefwechsel, hg. von Ulrich Päßler und Thomas Schmuck, Berlin: Akademie-Verlag 2014

Ammon, Sabine: „Entwerfen – eine epistemische Praxis", in: *Long Lost Friends: Wechselbeziehungen zwischen Design-, Medien- und Wissenschaftsforschung*, hg. von Claudia Mareis und Christof Windgätter, Zürich: Diaphanes 2013, S. 133–155

Aufsicht – Ansicht – Einsicht. Neue Perspektiven auf die Kartographie an der Schwelle der Frühen Neuzeit, hg. von Tanja Michalsky, Felicitas Schmieder und Gisela Engel, Berlin: Trafo 2009

Azara, Francesca: „Die Neu-Spanien-Karten von Alexander von Humboldt und Zebulon Montgomery Pike", in: *Cartographica Helvetica* 47 (2013), S. 3–10

Bachelard, Gaston: *Die Bildung des wissenschaftlichen Geistes – Beitrag zu einer Psychoanalyse der objektiven Erkenntnis*, Frankfurt am Main: Suhrkamp 1984 [französische Erstausgabe: *La Formation de l'esprit scientifique. Contribution à une psychoanalyse de la connaissance objective* 1938]

Badenberg, Nana: „Sehnsucht nach den Tropen. Wissenschaft, Poesie und Imagination bei Humboldt und Rugendas", *Tropische Tropen – Exotismus. kultuRRevolution*, 32/33 (1995), S. 53–65

Balmer, Heinz: *Beiträge zur Geschichte der Erkenntnis des Erdmagnetismus*, Aarau: Sauerländer 1956

Bann, Stephen: *Parallel Lines: Printmakers, Painters, and Photographers in Nineteenth-Century France*, New Haven: Yale University Press 2001

Barck, Karlheinz: „»Umwandlung des Ohrs zum Auge«. Teleskopisches Sehen und ästhetische Beschreibung bei Alexander von Humboldt", in: *Wahrnehmung und Geschichte. Markierungen zur Aisthesis materialis*, hg. von Bernhard J. Dotzler u. a., Berlin: Akademie-Verlag 1995, S. 27–42

Basedow, Johann Bernhard/Campe, Joachim Heinrich: *Pädagogische Unterhandlungen*, Dessau: Steinacker 1777

Bauer, Matthias/Ernst, Christoph: *Diagrammatik. Einführung in ein kultur- und medienwissenschaftliches Forschungsfeld*, Bielefeld: transcript 2010

Beck, Hanno: „Alexander von Humboldts »Essay de Pasigraphie«, Mexico 1803/04", in: *Forschungen und Fortschritte. Nachrichtenblatt der deutschen Wissenschaft und Technik* 32 (1958) 2, S. 33–39

Beck, Hanno: *Alexander von Humboldt und Mexiko. Beiträge zu einem geographischen Erlebnis*, Bad Godesberg: Inter Nationes 1966

Beck, Hanno: „Einleitung", in: Alexander von Humboldt: *Atlas géographique et physique du Royaume de la Nouvelle-Espagne – vom Verfasser auch kurz benannt: Mexico-Atlas*, hg. und kommentiert von Hanno Beck und Wilhelm Bonacker, Stuttgart: Brockhaus, 1969, S. 11–34

Beck, Hanno: „Landschaften, Profile und Karten aus Alexander von Humboldts Atlanten zum amerikanischen Reisewerk", *Mitteilungen: Alexander von Humboldt Magazin* 40 (1982), S. 31–38

Beck, Hanno: „Profil – Reliefmodell – Panoramakarte – Reliefkarte – Hochgeprägte Reliefkarte. Das Problem der dritten Dimension in Geographie und Kartographie und die relieforientierte Geographie der Zukunft", in: *Speculum Orbis* 1 (1985), S. 24–28

Beck, Hanno: „Zu Alexander von Humboldts »Naturgemälde der Tropenländer«", in: *Orbis pictus: kultur- und pharmaziehistorische Studien. Festschrift für Wolfgang Hein zum 65. Geburtstag*, hg. von Werner Dressendörfer, Frankfurt am Main: Govi 1985, S. 31–42

Beck, Hanno: „Die Geographie Alexander von Humboldts", in: *Alexander von Humboldt: Leben und Werk*, hg. von Wolfgang-Hagen Hein, Frankfurt am Main: Weisbecker 1985, S. 221–238

Beck, Hanno: „Alexander von Humboldt als größter Geograph der Neuzeit", in: *Die Dioskuren. Probleme in Leben und Werk der Brüder Humboldt*, hg. von dems. und Herbert Kessler, Mannheim: Humboldt-Gesellschaft für Wissenschaft, Kunst und Bildung 1986, S. 126–182

Beck, Hanno: „Alexander von Humboldt – Kartograph der Neuen Welt. Profil des neuesten Forschungsstandes", in: *Die Dioskuren II*, hg. von Detlef Haberland u. a., Mannheim: Humboldt-Gesellschaft für Wissenschaft, Kunst und Bildung 2000, S. 45–68

Beck, Hanno: „Das literarische Testament Alexander von Humboldts 1799", *HiN – Internationale Zeitschrift für Humboldt-Studien* XIV (2013) 27, S. 87–94

Bender, John/Marrinan, Michael: *The Culture of Diagram*, Stanford: Stanford University Press 2010

Beobachtung und Ideal: Ferdinand Bellermann – ein Maler aus dem Kreis um Humboldt, hg. von Kai Uwe Schierz, Petersberg: Imhof 2014

Berghaus, Heinrich: *Physikalischer Atlas*, hg. und kommentiert von Petra Weigel, Darmstadt: wbg Edition 2018

Bild im Plural. Mehrteilige Bildformen zwischen Mittelalter und Gegenwart, hg. von David Ganz und Felix Thürlemann, Berlin: Reimer 2010

Blümle, Claudia: „Augenblick oder Gleichzeitigkeit", in: *Simultaneität: Modelle der Gleichzeitigkeit in den Wissenschaften und Künsten*, hg. von Philipp Hubmann und Till Julian Huss, Bielefeld: transcript 2013, S. 37–55

Böhme, Hartmut: „Ästhetische Wissenschaft. Aporien der Forschung im Werk Alexander von Humboldts", in: *Alexander von Humboldt. Aufbruch in die Moderne*, hg. von Ottmar Ette, Berlin: Akademie-Verlag 2001, S. 17–32

Böhme, Hartmut: „Alexander von Humboldts Entwurf einer neuen Wissenschaft", in: *Prägnanter Moment. Studien zur deutschen Literatur der Aufklärung und Klassik*, hg. von Peter-André Alt und Hans-Jürgen Schings, Würzburg: Königshausen & Neumann 2002, S. 495–512

Borsdorf, Axel: „Alexander von Humboldts Amerikanische Reise und ihre Bedeutung für die Geographie", in: *Ansichten Amerikas. Neuere Studien zu Alexander von Humboldt*, hg. von Ottmar Ette und Walther L. Bernecker, Frankfurt am Main: Vervuert 2001, S. 137–155

Bredekamp, Horst: *Die Fenster der Monade. Gottfried Wilhelm Leibniz' Theater der Natur und Kunst*, Berlin: Akademie-Verlag 2004

Bredekamp, Horst: „Denkende Hände. Überlegungen zur Bildkunst in den Naturwissenschaften", in: *Von der Wahrnehmung zur Erkenntnis — From Perception to Understanding*, hg. von Monika Lessl und Jürgen Mittelstraß, Berlin/Heidelberg: Springer 2005, S. 109–132

Bredekamp, Horst: „Fuß, Fortuna, Ball, oder: Platons Prinzip des Handicap. Der Kugelkörper und die Defizite der Vollendung", in: *Der Ball ist rund – Kreis, Kugel, Kosmos*, hg. von Moritz Wullen und Bernd Ebert, Berlin: Staatliche Museen zu Berlin 2006, S. 12–17

Bredekamp, Horst: *Antikensehnsucht und Maschinenglauben. Die Geschichte der Kunstkammer und die Zukunft der Kunstgeschichte*, Berlin: Wagenbach 2007 [1993]

Breidbach, Olaf: *Bilder des Wissens: Zur Kulturgeschichte der wissenschaftlichen Wahrnehmung*, München: Fink 2005

Brescius, Moritz von: „Connecting the New World. Nets, Mobility and Progress in the Age of Alexander von Humboldt", *HiN – Internationale Zeitschrift für Humboldt-Studien* XIII (2012) 25, S. 11–33

Briefe an Goethe, Bd. 2: *Briefe der Jahre 1764–1808*, kommentiert von Karl Robert Mandelkow, Hamburg: Wegner 1965

Briefe von Alexander von Humboldt an Varnhagen von Ense aus den Jahren 1827 bis 1858. Nebst Auszügen aus Varnhagen's Tagebüchern und Briefen von Varnhagen und Andern an Humboldt, hg. von Ludmilla Assing, Leipzig: Brockhaus 1860

Briefwechsel Alexander von Humboldt's mit Heinrich Berghaus aus den Jahren 1825 bis 1858, Bd. 1, hg. von Hermann Costenoble, Leipzig: Costenoble 1863

Briefwechsel: Alexander von Humboldt und Cotta, hg. von Ulrike Leitner, Berlin: Akademie-Verlag 2009

Brincken, Anna-Dorothee von den: „Die Rahmung der ‚Welt' auf mittelalterlichen Karten", in: *Karten Wissen: territoriale Räume zwischen Bild und Diagramm*, hg. von Stephan Günzel und Lars Nowak, Wiesbaden: Reichert 2012, S. 95–119

Bruhn, Matthias: „Sichtbarmachung/Visualisierung", in: *Das Technische Bild. Kompendium zu einer Stilgeschichte wissenschaftlicher Bilder*, hg. von Horst Bredekamp, Birgit Schneider und Vera Dünkel, Berlin: Akademie-Verlag 2008, 2008, S. 132–135

Buchholz, Amrei: Art. „Diorama, Panorama und Landschaftsästhetik", in: *Handbuch Bild*, hg. von Stephan Günzel und Dieter Mersch, Stuttgart u. a.: Metzler 2014, S. 181–187

Buchholz, Amrei: „Alexander von Humboldts Ansichten des Weltbaues. Ausgewählte Handzeichnungen aus seinen Tagebüchern", in: *Umreißen. Registrieren, Fehlgehen und Erfinden im Zeichnen*, hg. von Mira Fliescher, Lina-Maria Stahl u. a., Berlin: Diaphanes 2014, S. 99–114

Buchholz, Amrei: „Die Entdeckung von El Dorado: Politische Handlungsräume der Karte", in: *Handeln mit Bildern. Bildpraxen des Politischen in historischen und globalen Kulturen*, hg. von Birgit Mersmann und Christiane Kruse, Paderborn: Fink [im Erscheinen]

Buci-Glucksmann, Christine: *Der kartographische Blick der Kunst*, Berlin: Merve 1997

Burnett, D. Graham: „Fabled Land", in: *Mapping Latin America. A Cartographic Reader*, hg. von Jordana Dym und Karl Offen, Chicago: University of Chicago Press 2011, S. 38–41

Campe, Joachim Heinrich: *Die Entdekkung von Amerika, ein angenehmes und nützliches Lesebuch für Kinder und junge Leute*, Hamburg: Bohn 1782

Cartographical Innovations. An international Handbook of Mapping Terms to 1900, hg. von Helen M. Wallis und Arthur H. Robinson, Cambridge: Map Collector Publications 1987

Casey, Edward: *Representing Place. Landscape Painting and Maps*, Minneapolis: University of Minnesota Press 2002

Christoph, Andreas: „Vom Atlas zum Erdkubus. Eine kleine Geschichte zur Quadratur des Kreises", in: *Die Werkstatt des Kartographen. Materialien und Praktiken visueller Welterzeugung*, hg. von Steffen Siegel und Petra Weigel, München: Fink 2011, S. 49–6

Cosgrove, Denis E.: *Apollo's Eye. A Cartographic Genealogy of the Earth in the Western Imagination*, Baltimore: The Johns Hopkins University Press 2001

Cosgrove, Denis E.: „Maps, Mapping, Modernity: Art and Cartography in the Twentieth Century", in: *Imago Mundi* 5 (2005) 1, S. 35–54

Crampton, Jeremy W./Krygier, John: „An Introduction to Critical Cartography", in: *An International E-Journal for Critical Geographies* 4 (2006) 1, S. 11–33

Dacosta Kaufmann, Thomas: *Toward a Geography of Art*, Chicago: University of Chicago Press 2004

Datenbilder: zur digitalen Bildpraxis in den Naturwissenschaften, hg. von Ralf Adelmann u. a., Bielefeld: transcript 2009

Debarbieux, Bernard: „Mountains between Corporal Experience and Pure Rationality: Buache and von Humboldt's Contradictory Theories", in: *High Places. Cultural Geographies of Mountains, Ice and Science*, hg. von Denis Cosgrove u. a., London: Tauris 2009, S. 87–104

Debarbieux, Bernard: „The Various Figures of Mountains in Humboldt's Science and Rhetoric", *Cybergeo: European Journal of Geography* 21 (2012), o. S.

Der kartographische Blick, hg. von Lutz Hieber, erschienen in der Schriftenreihe *Kultur: Forschung und Wissenschaft*, Hamburg: Lit 2006

Dettelbach, Michael: „The Face of Nature: Precise Measurement, Mapping, and Sensibility in the Work of Alexander von Humboldt", *Studies in History and Philosophy of Science Part C: Studies in History and Philosophy of Biological and Biomedical Sciences* 30 (1999) 4, S. 473–504

Dettelbach, Michael: „El último de los hombres universales: Lo local y lo universal en la ciencia de Humboldt", *Redes. Revista de Estudios Sociales de la Ciencia* 14 (2008) 28, S. 113–126

Deutsches Wörterbuch von Jacob Grimm und Wilhelm Grimm, Bd. 14, Teil I: 1, hg. von der Deutschen Akademie der Wissenschaften zu Berlin, Leipzig: Hirzel 1955

Diener, Pablo: *Rugendas, 1802–1858: Catálogo de la obra*, Augsburg: Wißner 1997

Dill, Hans-Otto: *Alexander von Humboldts Metaphysik der Erde: Seine Welt-, Denk- und Diskursstrukturen*, Frankfurt am Main: Peter Lang 2013

Dünkel, Vera: „Vergleich als Methode", in: *Das Technische Bild. Kompendium zu einer Stilgeschichte wissenschaftlicher Bilder*, hg. von Horst Bredekamp, Birgit Schneider und Vera Dünkel, Berlin: Akademie-Verlag 2008, S. 24–28

Eggers, Michael: „»Vergleichung ist ein gefährlicher Feind des Genusses.« Zur Epistemologie des Vergleichs in der deutschen Ästhetik um 1800", in: *Kulturen des Wissens im 18. Jahrhundert*, hg. von Ulrich Johannes Schneider, Berlin: de Gruyter 2008, S. 627–636

Engberg-Pedersen, Anders: „Die Verwaltung des Raumes: Kriegskartographische Praxis um 1800", in: *Die Werkstatt des Kartographen*, hg. von Steffen Siegel und Petra Weigel, München: Fink 2011, S. 29–49

Engelmann, Gerhard: „Alexander von Humboldts kartographische Leistung", *Wissenschaftliche Veröffentlichungen des Geographischen Instituts der Deutschen Akademie der Wissenschaften*, 27/28 (1970), S. 5–21

Engelmann, Gerhard: „Alexander von Humboldts Mexiko-Atlas. Eine Nachlese", *Geographische Zeitschrift* 59 (1971) 4, S. 315–320

Engelmann, Gerhard: *Heinrich Berghaus. Der Kartograph von Potsdam*, Halle: Deutsche Akademie der Naturforscher Leopoldina, 1977

Erdmann, Dominik: „Alexander von Humboldts Schreibwerkstatt – Totalansichten aus dem Zettelkasten", [bislang unveröffentlichte Dissertation]

Erdmann, Dominik/Weber, Jutta: „Nachlassgeschichten – Bemerkungen zu Humboldts nachgelassenen Papieren in der Berliner Staatsbibliothek und der Biblioteka Jagiellońska Krakau", *HiN – Internationale Zeitschrift für Humboldt-Studien* XVI (2015) 31, S. 58–77

Erkenntnis, Erfindung, Konstruktion: Studien zur Bildgeschichte von Naturwissenschaften und Technik vom 16. bis zum 19. Jahrhundert, hg. von Hans Holländer, Berlin: Mann 2000

Espenhorst, Jürgen: *Andree, Stieler, Meyer und Co: Handatlanten des deutschen Sprachraums (1800–1945) nebst Vorläufern und Abkömmlingen im In- und Ausland. Bibliographisches Handbuch*, Schwerte: Pangaea 1994

Ette, Ottmar: „Der Blick auf die Neue Welt: Nachwort", in: Alexander von Humboldt: *Reise in die Äquinoktial-Gegenden des Neuen Kontinents*. Bd. 2, hg. von Ottmar Ette, Frankfurt am Main/Leipzig: Insel 1991, S. 1563–1597

Ette, Ottmar: „Eine »Gemütsverfassung moralischer Unruhe« – Humboldtian Writing: Alexander von Humboldt und das Schreiben in der Moderne", in: *Alexander von Humboldt – Aufbruch in die Moderne*, hg. von dems., Berlin: Akademie-Verlag 2001, S. 33–56

Ette, Ottmar: „Alexander von Humboldt, die Humboldtsche Wissenschaft und ihre Relevanz im Netzzeitalter", *HiN – Internationale Zeitschrift für Humboldt-Studien* VII (2006) 12, S. 31–39

Ette, Ottmar: „Unterwegs zu einer Weltwissenschaft? Alexander von Humboldts Weltbegriffe und die transarealen Studien", *HiN – Internationale Zeitschrift für Humboldt-Studien* VII (2006) 13, S. 34–54

Ette, Ottmar: *Alexander von Humboldt und die Globalisierung: Das Mobile des Wissens*, Frankfurt am Main: Insel 2009

Ette, Ottmar: „Nachwort: Zwischen Welten – Alexander von Humboldts Wege zum Weltbewußtsein", in: Humboldt, Alexander von: *Kritische Untersuchung zur historischen Entwicklung der geographischen Kenntnisse von der Neuen Welt. Mit dem geographischen und physischen Atlas der Äquinoktial-Gegenden des Neuen Kontinents*, Frankfurt am Main: Insel 2009, S. 227–241

Ette, Ottmar/Lubrich, Oliver: „Die Reise durch eine andere Bibliothek: Nachwort", in: Humboldt, Alexander von: *Ansichten der Kordilleren und Monumente der eingeborenen Völker Amerikas*, hg. und kommentiert von dies., Frankfurt am Main: Eichborn 2004, S. 407–422

Ette, Ottmar/Lubrich, Oliver: „Versuch uber Humboldt", in: Humboldt, Alexander von: *Ueber einen Versuch den Gipfel des Chimborazo zu ersteigen*, hg. und kommentiert von dies., Frankfurt am Main: Eichborn 2006, S. 7–76

Faak, Margot: „Einleitung", in: Humboldt, Alexander von: *Reise durch Venezuela: Auswahl aus den amerikanischen Reisetagebüchern*, hg. von dies., Berlin: Akademie-Verlag 2000, S. 11–31

Faye Cannon, Susan: *Science in Culture: The early Victorian Period*, New York: Science History Publications 1978

Fechner, Fabian: „Zerfallene Synopse, verlorene Grundkarte. Experimente mit Bildfolgen im Zeitalter der Entdeckungsgeographie", in: *Verkoppelte Räume. Karte und Bildfolge als mediales Dispositiv*, hg. von Ulrike Boskamp, Amrei Buchholz, Annette Kranen und Tanja Michalsky, Hirmer: München 2020, S. 281–307

Feger, Hans: „Die Realität der Idealisten. Ästhetik und Naturerfahrung bei Schiller und den Brüdern Humboldt", in: *Die Realität der Idealisten: Friedrich Schiller – Wilhelm von Humboldt – Alexander von Humboldt*, hg. von dems. u. a., Köln u. a.: Böhlau, 2008, S. 15–43

Fiedler, Horst/Leitner, Ulrike: *Alexander von Humboldts Schriften: Bibliographie der selbständig erschienenen Werke*, Berlin: Akademie-Verlag 2000

Fischel, Angela: „Bildbefragungen: Technische Bilder und kunsthistorische Begriffe", in: *Das Technische Bild. Kompendium zu einer Stilgeschichte wissenschaftlicher Bilder*, hg. von Horst Bredekamp, Birgit Schneider und Vera Dünkel, Berlin: Akademie-Verlag 2008, S. 22

Flügel, Helmut W.: *Der Abgrund der Zeit: Die Entwicklung der Geohistorik 1670–1830*, Berlin/Diepholz: Verlag für Geschichte der Naturwissenschaften und Technik 2004

Foucault, Michel: *Die Ordnung der Dinge: eine Archäologie der Humanwissenschaften*, Frankfurt am Main: Suhrkamp 2017 [französische Erstausgabe: *Les mots et les choses. Une archéologie des sciences humaines*, 1966]

Frank, Hilmar/Lobsien, Eckhard: Art. „Landschaft", in: *Ästhetische Grundbegriffe: Historisches Wörterbuch in sieben Bänden*, hg. von Karlheinz Barck u. a., Bd. 3, Stuttgart u. a.: Metzler 2001, S. 617–665

Frieß, Peter: *Kunst und Maschine: 500 Jahre Maschinenlinien in Bild und Skulptur*, Berlin/München: Deutscher Kunstverlag 199

Ganz, David: *Barocke Bilderbauten. Erzählung, Illusion und Institution in römischen Kirchen, 1580–1700*, Petersberg: Imhof 2003

Geimer, Peter: „Vergleichendes Sehen oder Gleichheit aus Versehen? Analogie und Differenz in kunsthistorischen Bildvergleichen", in: *Vergleichendes Sehen*, hg. von Lena Bader, Martin Gaier und Falk Wolf, München: Fink 2010, S. 45–69

Gierloff-Emden, Hans-Günter: *Geographie des Meeres: Ozeane und Küsten*, Bd. 1, Berlin: de Gruyter 1980

Gilbert, Ludwig Wilhelm: „Beobachtungen über das Gesetz der Wärmeabnahme in den höhern Regionen der Atmosphäre, und über die untern Gränzen des ewigen Schnees, von Alexander von Humboldt (im Auszuge)", *Annalen der Physik* 24 (1806), S. 1–49

Gladić, Mladen/Wolf, Falk, „Guck doch… Kant zum Beispiel. Ästhetik als Übung im vergleichenden Sehen", in: *Vergleichendes Sehen*, hg. von Lena Bader, Martin Gaier und Falk Wolf, München: Fink 2010, S. 97–114

Godlewska, Anne Marie Claire: „Von der Vision der Aufklärung zur modernen Wissenschaft? Humboldts visuelles Denken", in: *Ansichten Amerikas: neuere Studien zu Alexander von Humboldt*, hg. von Ottmar Ette u. a., Frankfurt am Main: Vervuert 2001, S. 157–194

Goodman, Nelson: *Sprachen der Kunst: Entwurf einer Symboltheorie*, Frankfurt am Main: Suhrkamp 1995 [englische Erstausgabe: *Languages of Art – An Approach to a Theory of Symbols* 1968]

Görbert, Johannes: *Die Vertextung der Welt. Forschungsreisen als Literatur bei Georg Forster, Alexander von Humboldt und Adelbert von Chamisso*, Berlin u. a.: de Gruyter, 2014

Graczyk, Annette: *Das literarische Tableau zwischen Kunst und Wissenschaft*, München: Fink 2004

Grosjean, Georges: *Geschichte der Kartographie*, Bern: Geographisches Institut der Universität Bern 1996

Günzel, Stephan/Nowak, Lars: „Das Medium der Karte zwischen Bild und Diagramm. Eine Einführung", in: *KartenWissen: territoriale Räume zwischen Bild und Diagramm*, hg. von dies., Wiesbaden: Reichert 2012, 2012, S. 1–32

Guettard, Jean-Etienne/Monnet, Antoine Grimoald: *Atlas et description minéralogiques de la France*, Paris: Didot/Desnos/Alexandre Jombert 1780

Güttler, Nils: *Das Kosmoskop. Karten und ihre Benutzer in der Pflanzengeographie des 19. Jahrhunderts*, Göttingen: Wallstein 2014

Haag, Johannes: Art. „Anschauung", in: *Neues Handbuch philosophischer Grundbegriffe*, hg. von Petra Kolmer u. a., Bd. 1, Freiburg im Breisgau: Alber 2011, S. 163–178

Haberkorn, Michaela: *Naturhistoriker und Zeitseher. Geologie und Poesie um 1800. Der Kreis um Abraham Gottlob Werner*, Frankfurt am Main: Peter Lang 2004

Haguet, Lucile: „Specifying Ignorance in Eighteenth-Century Cartography, a Powerful Way to Promote the Geographer's Work: The Example of Jean-Baptiste d'Anville", in: *The Dark Side of Knowledge,* hg. von Cornel Zwierlein, Leiden: Brill 2016, S. 358–381

Hake, Günter/Grünreich, Dietmar/Meng, Liqiu: *Kartographie. Visualisierung raumzeitlicher Informationen*, Berlin/New York: de Gruyter 2002

Harley, J. B.: „Deconstructing the Map", *Cartographica* 26 (1989) 2, S. 1–20

Harley, J. B.: *The New Nature of Maps: Essays in the History of Cartography*, Baltimore: The Johns Hopkins University Press 2001

Hartshorne, Richard: „El concepto de geografía como ciencia del espacio: De Kant y Humboldt a Hettner", in: *Documents d'Anàlisi Geogràfica* 18 (1991), S. 31–54

Helmreich, Christian: „Geschichte der Natur bei Humboldt", *HiN – Internationale Zeitschrift für Humboldt-Studien* X (2009) 18, S. 53–67

Heesen, Anke te: *Der Weltkasten: die Geschichte einer Bildenzyklopädie aus dem 18. Jahrhundert*, Göttingen: Wallstein-Verlag 1997

Herbers, Klaus: *Geschichte Spaniens im Mittelalter: vom Westgotenreich bis zum Ende des 15. Jahrhunderts*, Stuttgart: Kohlhammer 2006

Hess, Johann Heinrich: *Das Leben des Heinrich Keller von Zürich, Landkarten- und Panorama-Zeichners*, erschienen in der Reihe: *Neujahrsblatt der Künstlergesellschaft in Zürich für 1865: Neue Reihenfolge*, Zürich 1865

Hey'l, Bettina: *Das Ganze der Natur und die Differenzierung des Wissens: Alexander von Humboldt als Schriftsteller*, Berlin u. a.: de Gruyter 2007

Hiatt, Alfred: „Blank Spaces on the Earth", *The Yale Journal of Criticism* 15 (2002) 2, S. 223–250

Hofmann, Werner: „Zeitzerfall und Zeitverdichtung um 1800", in: *Bild und Zeit: Temporaliät in Kunst und Kunsttheorie seit 1800*, hg. von Thomas Kisser, München: Fink 2011, S. 155 – 175

Holl, Frank/Schulz-Lüpertz, Eberhard: *„Ich habe so große Pläne dort geschmiedet …": Alexander von Humboldt in Franken*, Gunzenhausen: Schrenk-Verlag 2012

Holländer, Hans: „Spielformen der Mathesis universalis", in: *Erkenntnis, Erfindung, Konstruktion: Studien zur Bildgeschichte von Naturwissenschaften und Technik vom 16. bis zum 19. Jahrhundert*, hg. von dems., Berlin: Mann 2000, S. 325 – 345

Horaz (Quintus Horatius Flaccus): „De arte poetica", in: ders.: *Opera*, hg. von Friedrich Klingner, Berlin: de Gruyter 2008, S. 294 – 311

Hubmann, Philipp/Huss, Till Julian: „Einleitung", in: *Simultaneität. Modelle der Gleichzeitigkeit in den Wissenschaften und Künsten*, hg. von dies., Bielefeld: transcript 2013, S. 9 – 36

Humboldt in the Americas – Special Issue of Geographical Review 96 (2006) 3

Imhof, E. Art. „Kartenverwandte Darst[ellungen] der Erdoberfläche", *Internationales Jahrbuch für Kartographie* (1963), S. 87 – 92

Iser, Wolfgang: *Das Fiktive und das Imaginäre – Perspektiven literarischer Anthropologie*, Frankfurt am Main: Suhrkamp 1991

Jehle, Oliver: „Dochtschere und Augenglas – Joseph Wright, John Locke und das denkende Auge", in: *In Bildern denken? Kognitive Potentiale von Visualisierung in Kunst und Wissenschaft*, hg. von Ulrich Nortmann und Christoph Wagner, Paderborn: Fink 2010, S. 175 – 193

Kant, Immanuel: *Schriften zur Naturwissenschaft*, Erste Abtheilung, Leipzig: Modes und Baumann 1838

Kehlmann, Daniel: *Die Vermessung der Welt*, Reinbek bei Hamburg: Rowohlt 2005

Keller, Heinrich: *Beschreibung des Rigibergs, aller auf den selben führenden Wege und der berühmten Kulm-Aussicht. Von Heinrich Keller zur Erklärung seines Panorama*, Zürich: Füeßli 1823

Kemp, Martin: *Bilderwissen: die Anschaulichkeit naturwissenschaftlicher Phänomene*, Köln: DuMont 2003

Kemp, Wolfgang: *Christliche Kunst: ihre Anfänge, ihre Strukturen*, München, Paris und London: Schirmer/Mosel 1994

Kemp, Wolfgang: „Bild? Bilder! (zumindest zwei)", in: *Was ist ein Bild? Antworten in Bildern*, hg. von Sebastian Egenhofer und Gottfried Boehm, München: Fink 2012, S. 59 – 61

Knobloch, Eberhard: „Naturgenuss und Weltgemälde", *HiN – Internationale Zeitschrift für Humboldt-Studien* V (2004) 9, S. 3 – 16

Knobloch, Eberhard/Pieper, Herbert: „Die Fußnote über *Geognosia* in Humboldts *Florae Fribergensis specimen*", *HiN – Internationale Zeitschrift für Humboldt-Studien* VIII (2007) 14, S. 42 – 58

Knobloch, Eberhard: „Alexander von Humboldts Weltbild", *HiN – Internationale Zeitschrift für Humboldt-Studien* X (2009) 19, S. 34 – 46

Knobloch, Eberhard: „Nomos und physis. Alexander von Humboldt und die Tradition antiker Denkweisen und Vorstellungen", *HiN – Internationale Zeitschrift für Humboldt-Studien* XI (2010) 21, S. 45 – 55

Knobloch, Eberhard: „Alexander von Humboldt und Carl Friedrich Gauß – im Roman und in Wirklichkeit", *HiN – Internationale Zeitschrift für Humboldt-Studien* XIII (2012) 25, S. 70 – 71

Köchy, Kristian: „Alexander von Humboldts Naturgemälde: Zum Verhältnis von Kunst und Wissenschaft", in: *Das bunte Gewand der Theorie: vierzehn Begegnungen mit philosophierenden Forschern*, hg. von Astrid Schwarz, Freiburg im Breisgau u. a.: Alber 2009

Konvitz, Josef W.: *Cartography in France, 1660 – 1848: Science, Engineering, and Statecraft*, Chicago u. a.: University of Chicago Press 1987

Kraft, Tobias: *Figuren des Wissens bei Alexander von Humboldt. Essai, Tableau und Atlas im Amerikanischen Reisewerk*, Berlin: de Gruyter 2014

Kraft, Tobias: „Die Geburt der Gebirge", *Arsprototo – Das Magazin der Kulturstiftung der Länder* 1 (2014), S. 32 – 36 (Themenheft: *Weltwissen. Die Reisetagebücher Alexander von Humboldts*)

Krämer, Sybille: „Operative Bildlichkeit. Von der ›Grammatologie‹ zu einer ›Diagrammatologie‹? Reflexionen über erkennendes ›Sehen‹", in: *Logik des Bildlichen. Zur Kritik des ikonischen Vernunft*, hg. von Martina Heßler und Dieter Mersch, Bielefeld: transcript 2009, S. 94–122

Krämer, Sybille: „Karten erzeugen doch Welten, oder?", *Soziale Systeme* 18 (2012) 1/2, S. 153–167

Krämer, Sybille: „Diagrammatisch", *Rheinsprung. Zeitschrift für Bildkritik* 11 (2013), S. 162–174

Krause, G./Schenk, A.: Art. „Vergleich", in: *Historisches Wörterbuch der Philosophie*, Bd. 11, Basel: Tinner 2001, Spalte 677–680

Kügelgen, Helga von: *„Amerika als Allegorie. Das Frontispiz zum Reisewerk von Humboldt und Bonpland"*, in: *Alexander von Humboldt: Netzwerke des Wissens*, hg. von der Kunst- und Ausstellungshalle der Bundesrepublik Deutschland GmbH, Ostfildern-Ruit: Cantz 1999, S. 132–133

Kunst um Humboldt. Reisestudien aus Mittel- und Südamerika von Rugendas, Bellermann und Hildebrandt im Berliner Kupferstichkabinett, hg. von Sigrid Achenbach, München: Hirmer 2009

Kunst und Wissenschaft, hg. von Dieter Mersch u. a., München: Fink 2007

Latour, Bruno: „Visualisation and Cognition: Drawing Things Together", *Knowledge and Society: Studies in the Sociology of Culture Past and Present* 6 (1986), S. 1–40

Lavater, Johann Kaspar: *Physiognomische Fragmente, zur Beförderung der Menschenkenntniss und Menschenliebe: Erster Versuch. Mit vielen Kupfern*, Leipzig/Winterthur: Weidmanns Erben und Reich/Heinrich Steiner und Compagnie, 1775

Lehmann, Johann Georg: *Darstellung einer neuen Theorie der Bezeichnung der schiefen Flächen im Grundriß, oder der Situationszeichnung der Berge*, Leipzig: Fleischer 1799

Lehmann, Johann Georg: *Die Lehre der Situations-Zeichnung oder Anweisung zum richtigen Erkennen und genauen Abbilden der Erd-Oberfläche in topographischen Charten und Situations-Planen*, Dresden: Arnold 1812

Lehn, Patrick: *Deutschlandbilder: historische Schulatlanten zwischen 1871 und 1990. Ein Handbuch*, Köln: Böhlau 2008

Leitner, Ulrike: „Alexander von Humboldts geowissenschaftliche Werke in Berliner Bibliotheken und Archiven", *Berichte der Geologischen Bundesanstalt* 35 (1996), S. 259–264

Leitner, Ulrike: „Unbekannte Venezuela-Karten Alexander von Humboldts", *HiN – Internationale Zeitschrift für Humboldt-Studien* II (2001) 3, o. S.

Leitner, Ulrike: „»Anciennes folies neptuniennes!« Über das wiedergefundene »Journal du Mexique à Veracruz«", *HiN – Internationale Zeitschrift für Humboldt-Studien* III (2002) 5, o. S.

Leitner, Ulrike: „Vielschichtigkeit und Komplexität im Reisewerk Alexander von Humboldts. Bibliographischer Hintergrund", *HiN – Internationale Zeitschrift für Humboldt-Studien* VI (2005) 10, S. 55–76

Lepenies, Wolf: *Das Ende der Naturgeschichte: Wandel kultureller Selbstverständlichkeiten in den Wissenschaften des 18. und 19. Jahrhunderts*, München: Hanser 1976

Löschner, Renate: *Lateinamerikanische Landschaftsdarstellungen der Maler aus dem Umkreis von Alexander von Humboldt*, Berlin: Universitätsschrift [Dissertation] 1976

Löwenberg, Julius: „Vaterhaus", in: *Alexander von Humboldt: eine wissenschaftliche Biographie*, hg. von Karl Bruhns, Bd. 1, Leipzig: Brockhaus 1872, S. 5–49

Logik des Bildlichen: Zur Kritik der ikonischen Vernunft, hg. von Martina Heßler und Dieter Mersch, Bielefeld: transcript 2009

Lubrich, Oliver: „Humboldts Bilder: Naturwissenschaft, Anthropologie, Kunst", in: Alexander von Humboldt: *Das graphische Gesamtwerk*, hg. von Oliver Lubrich unter Mitarbeit von Sarah Bärtschi, Darmstadt: Lambert Schneider 2014, S. 7–28, hier S. 24–26 („Karten")

Maatsch, Jonas: *„Naturgeschichte der Philosopheme". Frühromantische Wissensordnungen im Kontext*, Heidelberg: Winter 2008

Mahr, Bernd/Wendler, Reinhard: „Bilder zeigen Modelle – Modelle zeigen Bilder", in: *Zeigen. Die Rhetorik des Sichtbaren*, hg. von Gottfried Boehm u. a., München: Fink 2010, S. 183 – 206

Maimieux, Joseph de: *Pasigraphie ou Premiers élémens du nouvel art-science d'écrire et d'imprimer en une langue, de manière à être lu et entendu dans toute autre langue sans traduction*, Paris: au Bureau de la Pasigraphie 1797

Mappings, hg. von Denis Cosgrove, London: Reaktion Books 2002

Martín-Merás Verdejo, Luisa: „La carta de Juan de la Cosa: Interpretación e historia", *Monte Buciero* 4 (2000), S. 71 – 86

Meier, Helmut G.: *Weltanschauung: Studien zu einer Geschichte und Theorie des Begriffs*, Münster: Universitätsschrift [Dissertation] 1970

Meissner, Jochen: „Merkur und Minerva helfen Cuauhtémoc auf die Beine. Europäisierte Amerikaerfahrung im Medium der Antike bei Bartolomé de Las Casas und Alexander von Humboldt", in: *Aktualisierung von Antike und Epochenbewusstsein*, hg. von Gerhard Lohse, München und Leipzig: Saur 2003, S. 198 – 246

Meister, Carolin: „Diagramme", in: *Räume der Zeichnung*, hg. von Angela Lammert und Frank Badur, Berlin: Akademie der Künste 2007, S. 10 – 11

Melters, Monika/Wagner, Christoph: „Einleitung", in: *Die Quadratur des Raumes. Bildmedien der Architektur in Neuzeit und Moderne*, hg. von dies., Berlin: Gebrüder Mann Verlag 2017, S. 7 – 10

Mendelssohn, Moses: *Ästhetische Schriften*, hg. von Anne Pollok, Hamburg: Meiner 2006

Mersch, Dieter: „Visuelle Argumente. Zur Rolle der Bilder in der Naturwissenschaft", in: *Bilder als Diskurse – Bilddiskurse*, hg. von Sabine Maasen, Torsten Mayerhauser und Cornelia Renggli, Weilerswist: Velbrück 2006, S. 95 – 116

Mersch, Dieter: „Das Medium der Zeichnung. Über Denken in Bildern", in: *Medien denken. Von der Bewegung des Begriffs zu bewegten Bilder*, hg. von Lorenz Engell, Jiří Bystřický, Kateřina Krtilová, Bielefeld: transcript 2010, S. 83 – 109

Michalsky, Tanja: *Projektion und Imagination. Die niederländische Landschaft der Frühen Neuzeit im Diskurs von Geographie und Malerei*, München: Fink 2011

Michalsky, Tanja: „Karten unter sich. Überlegungen zur Intentionalität geographischer Karten", in: *Fürstliche Koordinaten. Landesvermessung und Herrschaftsvisualisierung um 1600*, hg. von Ingrid Baumgärtner, Leipzig: Leipziger Universitätsverlag 2014, S. 321 – 340

Michalsky, Tanja: „Stadt und Geschichte im Überblick. Die spätmittelalterliche Karte Roms von Paolino Minorita als Erkenntnisinstrument des Historiographen", in: *Europa in der Welt des Mittelalters. Ein Colloquium für und mit Michael Borgolte*, hg. von Tillman Lohse, Benjamin Scheller, Berlin/Boston: Walter de Gruyter 2014, S. 189 – 210

Mößner, Nicola: „Das Beste aus zwei Welten? Ludwik Fleck über den sozialen Ursprung wissenschaftlicher Kreativität", in: *Simultaneität. Modelle der Gleichzeitigkeit in den Wissenschaften und Künsten*, hg. von Philipp Hubmann u. a., Bielefeld: transcript 2013, S. 111 – 131

Model, Fritz: „Alexander von Humboldts Isothermen", *Deutsche Hydrografische Zeitschrift* 12 (1959) 1, S. 29 – 33

Müller, Irmgard: „Alexander von Humboldt – ein Teil, Ganzes oder Außenseiter der Gelehrtenrepublik?", in: *Die europäische République des Lettres in der Zeit der Weimarer Klassik*, hg. von Michael Knoche und Lea Ritter-Santini, Göttingen: Wallstein 2007, S. 193 – 210

Müller, Michael R.: „Figurative Hermeneutik. Zur methodologischen Konzeption einer Wissenssoziologie des Bildes", *Sozialer Sinn* 13 (2012) 1, Seiten 129 – 162

Naugl, David K.: *Worldview: the History of a Concept*, Michigan u. a.: Eerdmans 2002

Naumann-Beyer, Waltraud: Art. „Anschauung", in: *Ästhetische Grundbegriffe*, hg. von Karlheinz Barck u.a., Stuttgart u.a.: Metzler 2000, S. 208–246

Neudrucke von Schriften und Karten über Meteorologie und Erdmagnetismus, 4: *Die ältesten Karten der Isogonen, Isoklinen, Isodynamen*, hg. und kommentiert von G. Hellmann, Neudruck der Ausgabe Berlin: Asher 1895, Nendeln/Liechtenstein 1969

Nicholl, Charles: *The Creature in the Map. A Journey to El Dorado*, Chicago: University of Chicago Press 1997

Niehr, Klaus: „Experiment und Imagination – Vergleichendes Sehen als Abenteuer", in: *Vergleichendes Sehen*, hg. von Lena Bader, Martin Gaier und Falk Wolf, München: Fink 2010, S. 71–96

N.N.: „Humboldt's works", *The North American Review* 16 (1823) 38, S. 1–30

N.N.: Art. „Humboldt, Alexander von", in: *Westermann Lexikon der Geographie*, Bd. 2, Braunschweig: Westermann 1969, S. 467–468

Oettermann, Stephan: *Das Panorama: die Geschichte eines Massenmediums*, Frankfurt am Main: Syndikat 1980

Ortelius, Abraham: *Theatrum orbis terrarum*, Antverpiae: Apud Aegid. Coppenium Diesth 1570

Pápay, Gyula: Art. „Kartographie und Abbildung", in: *Handbuch Bild*, hg. von Stephan Günzel und Dieter Mersch, Stuttgart/Weimar: Metzler 2014, S. 187–194

Pedras, Lúcia Ricotta Vilela Pinto Brando: *A totalidade encantada. Natureza, ciência e arte em Alexander von Humboldt*, Rio de Janeiro: Universitätsschrift [Dissertation] 2004

Pelletier, Monique: *La carte de Cassini: L'extraordinaire aventure de la carte de France*, Paris: Presses de l'École Nationale des Ponts et Chaussée 1990

Pelletier, Monique: *Les cartes de Cassini: La science au service de l'État et des provinces*, Paris: CTHS 2013

Pendant Plus. Praktiken der Bildkombinatorik, hg. von Gerd Blum, Steffen Bogen, David Ganz und Marius Rimmele, Berlin: Reimer 2012

Pérez Mejía, Ángela: „Sutileza de la producción cartográfica en el mapa del Orinoco de Humboldt", *Terra Brasilis* 7/8/9 (2007), S. 2–11

Pérez Mejía, Ángela: *La geografía de los tiempos difíciles: escritura de viajes a Sur América durante los procesos de independencia 1780–1849*, Medellín: Edición Universidad de Antioquía 2002

Philipp, Klaus Jan: „Die Imagination des Realen: Eine kurze Geschichte der Architekturzeichnung", in: *Die Realität des Imaginären: Architektur und das digitale Bild*, hg. von Jörg H. Gleiter, Norbert Korrek und Gerd Zimmermann, Weimar: Schriften der Bauhaus-Universität 2007, S. 147–157

Pollok, Anne: „Sinnliche Erkenntnis und Anthropologie", in: *Handbuch Literatur und Philosophie*, hg. von Hans Feger, Stuttgart u.a.: Metzler 2012, S. 21–46

Pratschke, Margarete: „Bildanordnungen", in: *Das Technische Bild. Kompendium zu einer Stilgeschichte wissenschaftlicher Bilder*, hg. von Horst Bredekamp, Birgit Schneider und Vera Dünkel, Berlin: Akademie-Verlag 2008, S. 116–119

Rau, Susanne: *Räume. Konzepte, Wahrnehmungen, Nutzungen*, Frankfurt am Main: Campus Verlag 2013

Rebok, Sandra: *Alexander von Humboldt und Spanien im 19. Jahrhundert. Analyse eines wechselseitigen Wahrnehmungsprozesses*, Frankfurt am Main: Vervuert 2006

Rees, Joachim: „Daten und Bilder", in: Humboldt, Alexander von: *Sämtliche Schriften (Aufsätze, Artikel, Essays)*, Berner Ausgabe, hg. von Oliver Lubrich und Thomas Nehrlich, dtv: München 2019, hier Bd. 10: *Forschungsband*, redigiert von Johannes Görbert, S. 559–587

Rees, Roland: „Historical Links between Cartography and Art", *Geographical Review* 70 (1980) 1, S. 60–78

Reichard, Christian Gottlieb: *Atlas des ganzen Erdkreises*, Weimar: Bertuch 1803

Rheinberger, Hans-Jörg: *Historische Epistemologie zur Einführung*, Hamburg: Junius 2007

Robinson, Arthur/Wallis, Helen: „Humboldt's Map of Isothermal Lines: A Milestone in Thematic Cartography", *The Cartographic Journal* 4 (1967) 2, S. 119–123

Robles Macias, Luis A.: „Juan de la Cosa's Projection: A Fresh Analysis of the Earliest Preserved Map of the Americas", *Coordinates*, Series A, 9 (2010)

Rudwick, Martin J. S.: „The Emergence of a Visual Language for Geological Science 1760–1840", *History of Science* XIV (1976), S. 149–195

Rudwick, Martin J. S.: *Bursting the Limits of Time: The Reconstruction of Geohistory in the Age of Revolution*, Chicago: University of Chicago Press, 2005

Rupke, Nicolaas A.: „Humboldtian Distribution Maps. The Spatial Ordering of Scientific Knowledge", in: *The Structure of Knowledge: Classifications of Science and Learning since the Renaissance*, hg. von Tore Frängsmyr, Berkeley: Office for History of Science and Technology, University of California 2001, S. 93–116

Sánchez Robayna, Andrés: „El papel de Canarias en la conformación de la cultura virreinal americana", in: *Oro y plomo en las Indias. Los tornaviajes de la escritura virreinal*, hg. von Antonio Cano Ginés/Carlos Brito Díaz, Madrid: Iberoamericana 2017, S. 183–204

Sarmiento, Domingo Faustino: *Civilización i barbarié. Vida de Juan Facundo Quiroga*, Santiago: Imprenta del Progreso 1845

Sarmiento, Domingo Faustino: *Facundo: Civilización y barba*rie, Madrid: Cátedra 2003

Sarmiento, Domingo Faustino: *Barbarei und Zivilisation. Das Leben des Facundo Quiroga*, ins Deutsche übertragen und kommentiert von Berthold Zilly, Eichborn: Frankfurt am Main 2007

Schäffner, Wolfgang: „Verwaltung der Kultur. Alexander von Humboldts Medien (1799–1834)", in: *Interkulturalität zwischen Inszenierung und Archiv*, hg. von Stefan Rieger, Schamma Schahadat und Manfred Weinberg, Tübingen: Narr 1999, S. 353–366

Schäffner, Wolfgang: „Topographie der Zeichen. Alexander von Humboldts Datenverarbeitung", in: *Das Laokoon-Paradigma. Zeichenregime im 18. Jahrhundert*, hg. von dems., Inge Baxmann und Michael Franz, Berlin: Akademie-Verlag 2000, S. 359–382

Schäffner, Wolfgang: „El procesamiento de datos de Alexander von Humboldt", in: *Un colón para los datos: Humboldt y el diseño del saber*, erschienen in der Reihe *Redes. Revista de Estudios Sociales de la Ciencia* 14 (2008) 28, S. 127–145

Schaschke, Bettina/Thomson, Christina: „Schöpfung und Erkenntnis", in: *Der Ball ist rund – Kreis, Kugel, Kosmos*, hg. von Moritz Wullen und Bernd Ebert, Berlin: Staatliche Museen zu Berlin 2006, S. 28–29

Schimmern aus der Tiefe. Muscheln, Perlen, Nautilus, hg. von Karin Annette Möller, Petersberg: Imhof 2013

Schleucher, Kurt: *Alexander von Humboldt: Der Mensch, der Forscher, der Schriftsteller*, Darmstadt: Eduard Roether 1985

Schneider, Birgit: „Diagrammatik", in: *Das Technische Bild. Kompendium zu einer Stilgeschichte wissenschaftlicher Bilder*, hg. von Horst Bredekamp, Birgit Schneider und Vera Dünkel, Berlin: Akademie-Verlag 2008, S. 192–196

Schneider, Birgit: „Linien als Reisepfade der Erkenntnis", in: *KartenWissen: territoriale Räume zwischen Bild und Diagramm*, hg. von Stephan Günzel und Lars Nowak, Wiesbaden: Reichert 2012, S. 175–199

Schneider, Birgit: „Berglinien im Vergleich. Bemerkungen zu einem klimageografischen Diagramm Alexander von Humboldts", *HiN – Internationale Zeitschrift für Humboldt-Studien* XIV (2013) 26, S. 26–43

Schneider, Ute: *Die Macht der Karten. Eine Geschichte der Kartographie vom Mittelalter bis heute*, Darmstadt: Primus 2006

Schröder, Iris: *Das Wissen von der ganzen Welt: Globale Geographien und räumliche Ordnungen Afrikas und Europas 1790–1870*, Paderborn: Schöningh 2011

Schwarz, Ingo/Biermann, Kurt R.: „»Irrtümer, die vorzugsweise in den höheren Volksklassen fortleben«", in: *Alexander von Humboldt: Netzwerke des Wissens*, hg. von der Kunst- und Ausstellungshalle der Bundesrepublik Deutschland GmbH, Ostfildern-Ruit: Cantz 1999, S. 204

Seeberger, Max: „»Geographische Längen und Breiten bestimmen, Berge messen«", in: *Alexander von Humboldt: Netzwerke des Wissens*, hg. von der Kunst- und Ausstellungshalle der Bundesrepublik Deutschland GmbH, Ostfildern-Ruit: Cantz 1999, S. 57

Seeberger, Max: „»Die besten Instrumente meiner Zeit«: Humboldts Liste seiner in Lateinamerika mitgeführten wissenschaftlichen Instrumente", in: *Alexander von Humboldt: Netzwerke des Wissens*, hg. von der Kunst- und Ausstellungshalle der Bundesrepublik Deutschland GmbH, Ostfildern-Ruit: Cantz 1999, S. 58–63

Siegel, Steffen: „Die ganze Karte. Für eine Praxeologie des Kartographischen", in: *Die Werkstatt des Kartographen. Materialien und Praktiken visueller Welterzeugung*, hg. von dems. und Petra Weigel, München: Fink 2011, S. 7–28

Silió Cervera, Fernando: *La carta de Juan de la Cosa: análisis cartográfico*, Santander: Fundación Marcelino Botín, 1995

Sherwood, Robert M.: *The Cartography of Alexander von Humboldt: Images of the Enlightenment in America*, Saarbrücken: VDM 2008

Spatial Turn: Das Raumparadigma in den Kultur- und Sozialwissenschaften, hg. von Jörg Döring und Tristan Thielmann, Bielefeld: transcript 2008

Steigerwald, Joan: „The Cultural Enframing of Nature: Environmental Histories during the Early German Romantic Period", *Environment and History* 6 (2000) 4, S. 451–496

Stekeler-Weithofer, Pirmin: „Die soziale Logik der Anschauung", in: *Was sich nicht sagen lässt: das Nicht-Begriffliche in Wissenschaft, Kunst und Religion*, hg. von Joachim Bromand u. a., Berlin: Akademie-Verlag 2010, S. 235–256

Stoy, Johann Sigmund: *Bilder-Akademie für die Jugend*, Nürnberg 1784

Theater der Natur und Kunst/Theatrum Naturae et Artis. Wunderkammern des Wissens: Essays, hg. von Moritz Ulrich u. a., Berlin: Henschel 2000

The Charts and Coastal Views of Captain Cook's Voyages, hg. von Andrew David, London: The Hakluyt Society in association with the Australian Academy of the Humanities 1988, Bd. 1: *The Voyage of the Endeavour, 1768–1771*

The Picture's Image. Wissenschaftliche Visualisierung als Komposit, hg. von Inge Hinterwaldner u. a., München: Fink 2006

Thürlemann, Felix: *Mehr als ein Bild. Für eine Kunstgeschichte des hyperimage*, München: Fink 2013

Thüsen, Joachim von der: *Schönheit und Schrecken der Vulkane. Zur Kulturgeschichte des Vulkanismus*, Darmstadt: Wissenschaftliche Buchgesellschaft 2008

Utz, Peter: *Das Auge und das Ohr im Text: literarische Sinneswahrnehmung in der Goethezeit*, München: Fink 1990

Valerio, Vladimiro: „Cartography, Art and Mimesis", in: *The Osmotic Dynamics of Romanticism: Observing Nature – Representing Experience 1800–1850*, hg. von Erna Fiorentini, Berlin: Max-Planck-Institut für Wissenschaftsgeschichte 2005, S. 57–71

Vandermaelen, Philippe: *Atlas universel de géographie physique, politique, statistique et minéralogique, sur léchelle de 1/1641836 ou d'une ligne par 1900 toises*, Zeichnungen von Philippe Vandermaelen, Lithographie von H. Ode, 6 Bde., Brüssel: Philippe Vandermaelen 1827

Vergleichendes Sehen, hg. von Lena Bader, Martin Gaier und Falk Wolf, München: Fink 2010

Visuelle Modelle, hg. von Ingeborg Reichle, Steffen Siegel und Achim Spelten, München: Fink 2008

Vorläufige Anzeige der Buchhändler Levrault und Schoel [sic], die Werke betreffend, welche Alex. von Humboldt über seine Reise nach Amerika in ihrem Verlage herausgeben wird, Annalen der Physik 20 (1805), S. 361–368

Voss, Julia: „Das Unsichtbare sichtbar machen. Alexander von Humboldt als Zeichner", *Arsprototo – Das Magazin der Kulturstiftung der Länder* 1 (2014), S. 28 – 32 (Themenheft: *Weltwissen. Die Reisetagebücher Alexander von Humboldts*)

Wagenbreth, Otfried: „Alexander von Humboldt als Student der Bergakademie in Freiberg", *Glückauf* 129 (1993) 4, S. 295 – 299

Wagenbreth, Otfried: *Geschichte der Geologie in Deutschland*, Stuttgart: Thieme 1999

Was ist ein Bild?, hg. von Gottfried Boehm, München 1994

Wendler, Reinhard: *Das Modell zwischen Kunst und Wissenschaft*, München: Fink 2013

Werner, Petra: *Naturwahrheit und ästhetische Umsetzung: Alexander von Humboldt im Briefwechsel mit bildenden Künstlern*, Berlin: Akademie-Verlag 2013

Wiese, Bernd: *Weltansichten. Illustrationen von Forschungsreisen deutscher Geographen im 19. und frühen 20. Jahrhundert*, Köln: Universitäts- und Stadtbibliothek 2011

Wild, Adolf: *Von Gutenberg zu Diderot: die Handwerke des Buches im Kupferstich der Aufklärung*, Mainz: Edition Erasmus 2000

Wilhelmy, Herbert: „Humboldts südamerikanische Reise und ihre Bedeutung für die Geographie", in: *Die Dioskuren. Probleme in Leben und Werk der Brüder Humboldt*, hg. von Hanno Beck und Herbert Kessler, Mannheim: Humboldt-Gesellschaft für Wissenschaft, Kunst und Bildung 1986, S. 183 – 198

Wittmann, Barbara: „Papierprojekte. Die Zeichnung als Instrument des Entwurfs", *Zeitschrift für Medien- und Kulturforschung* 1 (2012), S. 123 – 138

Wolf, Falk: „Demonstration: Einleitung", in: *Vergleichendes Sehen*, hg. von Lena Bader, Martin Gaier und Falk Wolf, München: Fink 2010, S. 263 – 272

Wood, Denis: *The Power of Maps*, New York und London: Guilford 1992

Zögner, Lothar: „Carl Ritter und Alexander von Humboldt. Ihr Beitrag zur Entwicklung der thematischen Kartographie", *Studia Geographica*, hg. von Wolfgang Eriksen, Bonn: Dümmler 1983, S. 393 – 406

Zögner, Lothar: Art. „Humboldt", in: *Lexikon der Geschichte der Kartographie von den Anfängen bis zum ersten Weltkrieg*, hg. von Erik Arnberger, Wien: Franz Deuticke 1986, S. 321 – 322

Zögner, Lothar: „Alexander von Humboldt und die Kartografie", in: *Alexander von Humboldt: Netzwerke des Wissens*, hg. von der Kunst- und Ausstellungshalle der Bundesrepublik Deutschland GmbH, Ostfildern-Ruit: Cantz 1999, S. 134

Archivalien

1. Wissenschaftlicher Nachlass Alexander von Humboldt

1.1 SBB, HA

1.1.1 Reise-Tagebücher:

Humboldt, Alexander von: Tagebuch der Amerikanischen Reise IV, 1800 [Ergänzungen bis 1859]

Humboldt, Alexander von: Tagebuch der Amerikanischen Reise VIIa/b, 1801–1802

Humboldt, Alexander von: Tagebuch der Amerikanischen Reise VIIbb/c, 1801–1802

Humboldt, Alexander von: *Testamente littéraire*, Nachlass Alexander von Humboldt, Tagebuch der Amerikanischen Reise VIII, 1802–1804, S. 326,1 [167V] – 326,2 [167R], 167r–167v (nach neuer Zählung des BMBF-Verbundprojekts „Alexander von Humboldts Amerikanische Reisetagebücher")

1.1.2 Kollektaneen:

Humboldt, Alexander von: Manuskript zum *Essay de Pasigraphie*, gr. Kasten 5, 88, letztes Blatt

Humboldt, Alexander von: Skizze zur abnehmenden Schneegrenze, gr. Kasten 6, Nr. 41.42, Bl. 7–10

Humboldt, Alexander von: Skizze zu einem inkaischen Gebäude *(Maison de l'Inca)*, Kleiner Kasten 7b, 47a, Blatt 15

1.2 BJK, HA

Nachlass Alexander von Humboldt 8 (acc. 1893, 216), 1. und 2. Teil, nicht foliiert, online abrufbar unter: http://humboldt.staatsbibliothek-berlin.de/werk/

2. SBB, Kartenabteilung:

N. N.: *Die physikalische Geographie von Herrn Alexander v. Humboldt, vorgetragen im Semestre 1827/28* (Manuskript). SBB Berlin (Kartenabteilung), Signatur 8" Kart. GfE O 79; digitalisiert vom Deutschen Textarchiv, online abrufbar unter: http://www.deutschestextarchiv.de/book/view/nn_oktavgfeo79_1828?p=603 (zuletzt aufgerufen am 31.10.19)

Internetquellen

Stams, Werner: Art. „Schraffen", in: *Lexikon der Kartographie und Geomatik*, URL: https://www.spektrum.de/lexikon/kartographie-geomatik/ (zuletzt aufgerufen am 31.10.19)

Dudenredaktion (o.J.): *Modell*, in: Duden online, URL: https://www.duden.de/node/658605/revisions/1674550/view (zuletzt aufgerufen am 31.10.19)

http://avh.bbaw.de/chronologie (zuletzt aufgerufen am 31.10.19)

Bildnachweise

Cover: SBB, Kartenabteilung

Abb. 1, 14, Taf. XV: David Rumsey Historical Map Collection

Abb. 2, 7, 24, 27: Amrei Buchholz

Abb. 3, 4, 10, 11, 13: JBK

Abb. 5, 8, 9, 15, 16, 17, 18, 19, 20, 21, 22, 28, 30, 31, Taf. I–XIV: SBB, Kartenabteilung

Abb. 6, 23: Alexander von Humboldt, Das graphische Gesamtwerk, 2014

Abb. 25: wellcomecollection

Abb. 26: Université de Strasbourg

Abb. 29: James Ford Bell Library

Taf. XVI: Circa 1492: Art in the Age of Exploration, hg. Jay A. Levenson, 1991

Dank

Diese Schrift wurde 2016 als Dissertation an der Fakultät Bildende Kunst der Universität der Künste Berlin verteidigt und anschließend für die Publikation überarbeitet und aktualisiert.

Hilfreich unterstützt wurde mein Dissertationsprojekt insbesondere von Tanja Michalsky, die meinen Überlegungen mit ihrer ebenso weitsichtigen wie scharfsinnigen Beratung immer wieder neue Motivation und Impulse gab. Auch Andreas Köstler hat maßgeblich dazu beigetragen, dass der vorliegende Text zu seiner endgültigen Form gefunden hat.

Meine Dissertation ist im Rahmen des DFG-Graduiertenkollegs Sichtbarkeit und Sichtbarmachung. Hybride Formen des Bildwissens an der Universität Potsdam entstanden, deren Mitgliedern ich viele wichtige Hinweise verdanke. Vor allem Dieter Mersch, Ottmar Ette, Fabian Goppelsröder und Birgit Schneider haben meinen Weg hier begleitet. Entscheidende Kritik und zentrale Anregungen stammen auch von den Mitarbeiterinnen und Mitarbeitern der ehemaligen Alexander von Humboldt-Forschungsstelle an der Berlin-Brandenburgischen Akademie der Wissenschaften, vor allem von Ulrike Leitner, sowie dem dortigen Alexander von Humboldt-Doktorand*innen-Kolloquium. Zu nennen seien insbesondere Pauline Barral, Julia Bayerl, David Blankenstein, Dominik Erdmann, Sandra Ewers, Johannes Görbert, Tobias Kraft, Markus Lenz, Aniela Mikolajczyk und Christian Thomas. Auch das Kolloquium Tanja Michalskys an der Universität der Künste Berlin und die Arbeitsgruppe zur spanischen und iberoamerikanischen Kunstgeschichte unter der Leitung von Margit Kern waren für meine Überlegungen sehr wertvoll.

Bei der Recherche nach Kartenmaterial und Forschungsliteratur, von der mir bisweilen private Bände zur Verfügung gestellt wurden, waren mir die Mitarbeiterinnen und Mitarbeiter der Kartenabteilung an der Staatsbibliothek zu Berlin, Preußischer Kulturbesitz, insbesondere Wolfgang Crom und Markus Heinz, behilflich. Sie ermöglichten mir zudem einen vertieften Einblick in die kartographische Praxis sowie in feine Details und Kuriositäten aus der Geschichte der Kartographie. Hilfreich unterstützt haben mich ferner die Mitarbeiterinnen und Mitarbeiter der Handschriftenabteilungen der Staatsbibliothek zu Berlin und der Biblioteka Jagiellońska in Krakau, der Kartensammlung des Ibero-Amerikanischen Instituts, Preußischer Kulturbesitz, sowie der Kartenabteilung der Pariser Bibliothèque nationale de France und des Archivs des Palacio de Minería in

Mexiko-Stadt. Ferner danke ich Andrea Mesecke für das Lektorat des Textes und Vivien Kristin Buchhorn für die gründliche Durchsicht des Manuskripts sowie Katja Richter und Arielle Thürmel vom Verlag De Gruyter für ihre freundliche und gewissenhafte Unterstützung. Über die gesamte Dauer der Arbeit haben Till Breyer, Leonie Herbers-Schuster, Anne-Lena Mösken und Johannes Skowronek mit mir Raumkonstellationen durchmessen, Berge erklommen und Kanäle befahren. Mein Dank gilt nicht zuletzt Angelika, Manfryd und Frauke, Philipp, Lene und Lisbeth.

Zu besonderem Dank bin ich der Deutschen Forschungsgemeinschaft und der Potsdam Graduate School, Universität Potsdam, verpflichtet, deren finanzielle und institutionelle Unterstützung es mir maßgeblich erleichtert haben, die vorliegende Untersuchung zu realisieren.

Register

Farbtafeln

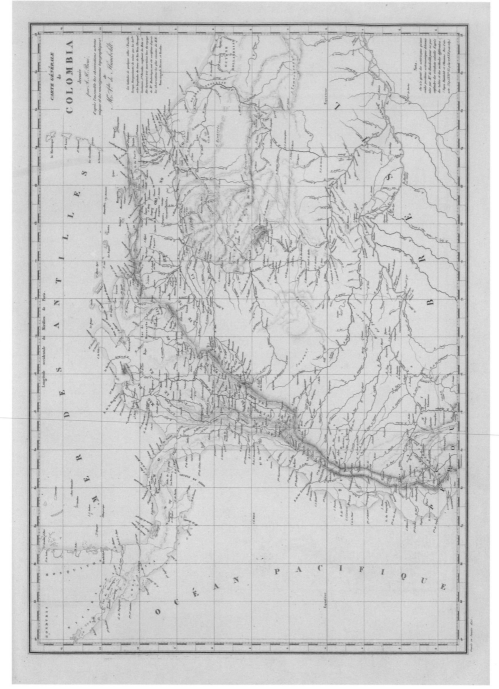

Tafel I_Alexander von Humboldt, *Carte générale de Colombia*, 1825, ca. 43 × 60 cm, in: *Atlas géographique et physique du Nouveau Continent*, Tafel 22 (Lieferung 5), Berlin, SBB, Foto SBB

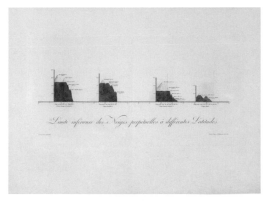

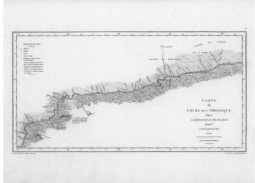

1

15

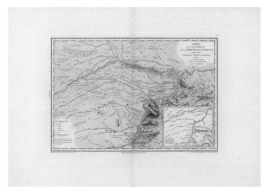

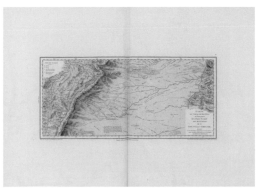

18

19

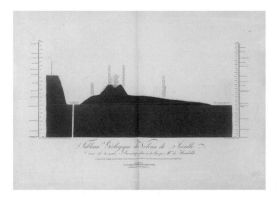

28

Tafel II__Alexander von Humboldt, Lieferung 1 des *Atlas géographique et physique du Nouveau Continent*, 1814 (Tafeln 1, 15, 18, 19, 28), Berlin, SBB, Fotos SBB

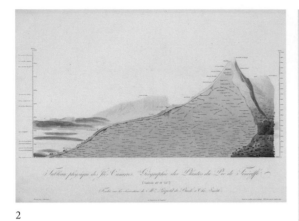

2

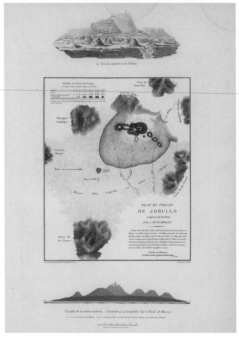

16

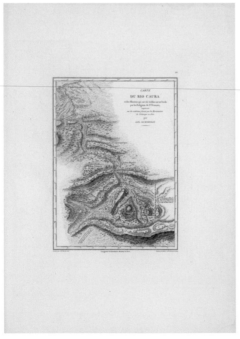

20

29

Tafel III__Alexander von Humboldt, Lieferung 2 des *Atlas géographique et physique du Nouveau Continent*, 1817 (Tafeln 2, 16, 20, 29), Berlin, SBB, Fotos SBB

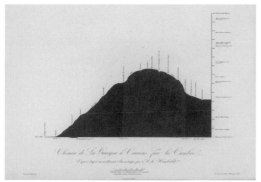

4

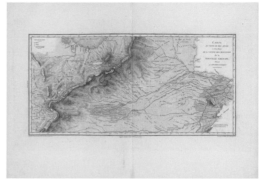

17

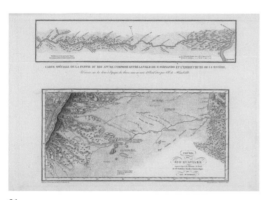

21

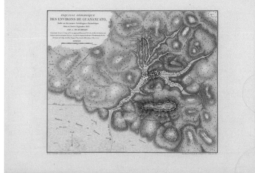

30

Tafel IV__Alexander von Humboldt, Lieferung 3 des *Atlas géographique et physique du Nouveau Continent*, 1819 (Tafeln 4, 17, 21, 30), Berlin, SBB, Fotos SBB

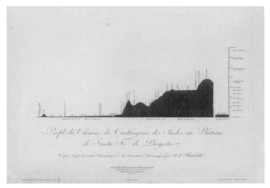

6

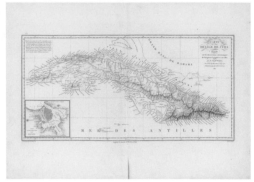

23

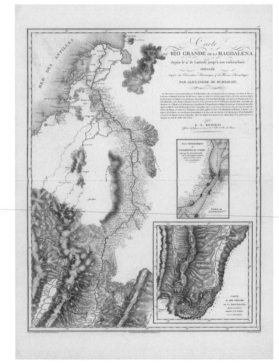

24

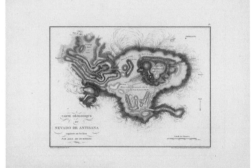

26

Tafel V__Alexander von Humboldt, Lieferung 4 des *Atlas géographique et physique du Nouveau Continent*, 1821 (Tafeln 6, 23, 24, 26), Berlin, SBB, Fotos SBB

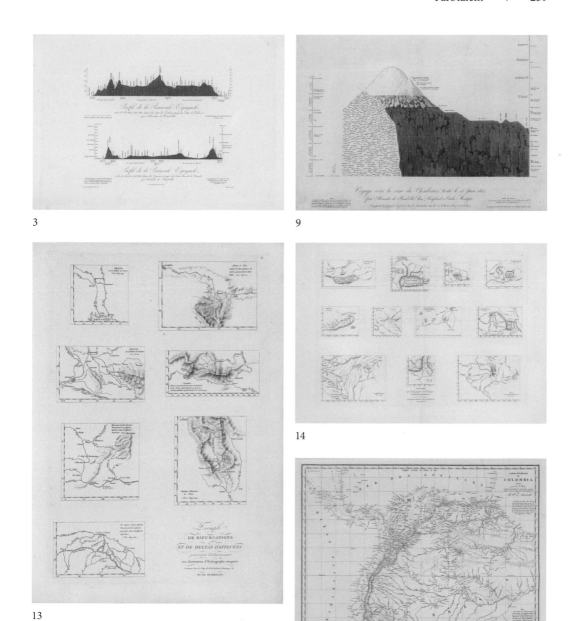

3

9

14

13

22

Tafel VI__Alexander von Humboldt, Lieferung 5 des *Atlas géographique et physique du Nouveau Continent*, 1825 (Tafeln 3, 9, 13, 14, 22), Berlin, SBB, Fotos SBB

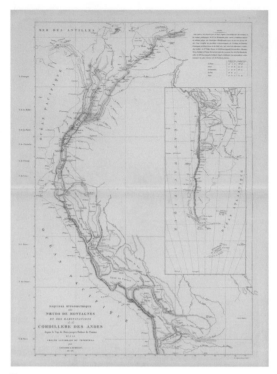

5

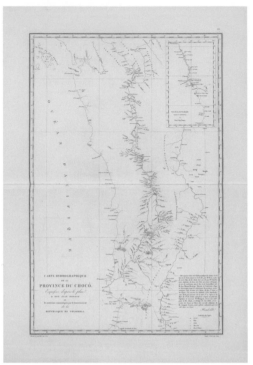

25

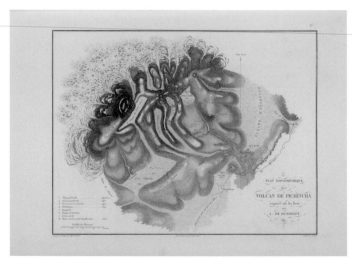

27

Tafel VII__Alexander von Humboldt, Lieferung 6 des *Atlas géographique et physique du Nouveau Continent*, 1831 (Tafeln 5, 25, 27), Berlin, SBB, Fotos SBB

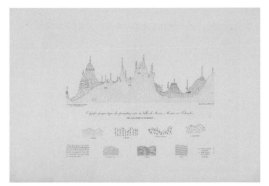

7

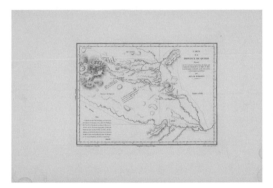

8

10

11

12

Tafel VIII__Alexander von Humboldt, Lieferung 7 des *Atlas géographique et physique du Nouveau Continent*, 1834 (Tafeln 7, 8, 10, 11, 12), Berlin, SBB, Fotos SBB

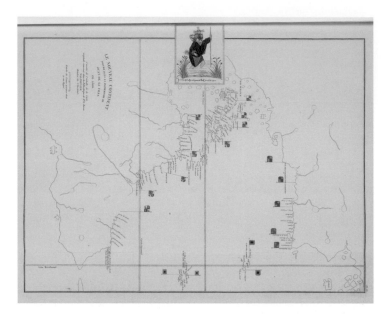

Tafel IX__Alexander von Humboldt, *Le Nouveau Continent figure dans la mappemonde de Juan de la Cosa en 1500*, Nachstich von Juan de la Cosas Weltkarte (Detail), zwischen 1835 und 1837, ca. 43 × 60 cm, in: *Atlas géographique et physique du Nouveau Continent*, Tafel 33 (Teil der Lieferungen 10–16), Berlin, SBB, Foto SBB

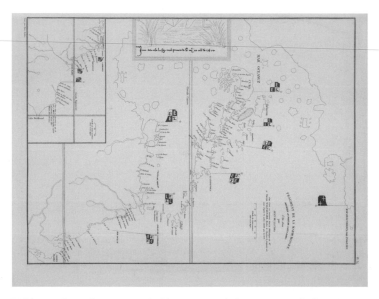

Tafel X__Alexander von Humboldt, *Fragment de la mappemonde dessinée au Port de Santa Maria*, Nachstich von Juan de la Cosas Weltkarte (Detail), zwischen 1835 und 1837, ca. 43 × 60 cm, in: *Atlas géographique et physique du Nouveau*, Tafel 34 (Teil der Lieferungen 10–16), Berlin, SBB, Foto SBB

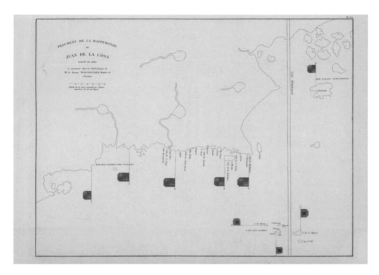

Tafel XI__Alexander von Humboldt, *Fragment de la mappemonde de Juan de la Cosa*, Nachstich von Juan de la Cosas Weltkarte (Detail), zwischen 1835 und 1837, ca. 43 × 60 cm, in: *Atlas géographique et physique du Nouveau Continent*, Tafel 35 (Teil der Lieferungen 10–16), Berlin, SBB, Foto SBB

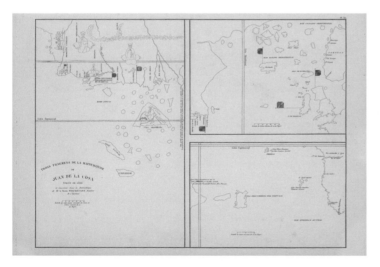

Tafel XII__Alexander von Humboldt, *Trois fragmens de la mappemonde de Juan de la Cosa*, Nachstich von Juan de la Cosas Weltkarte (Details), zwischen 1835 und 1837, ca. 43 × 60 cm, in: *Atlas géographique et physique du Nouveau Continent*, Tafel 36 (Teil der Lieferungen 10–16), Berlin, SBB, Foto SBB

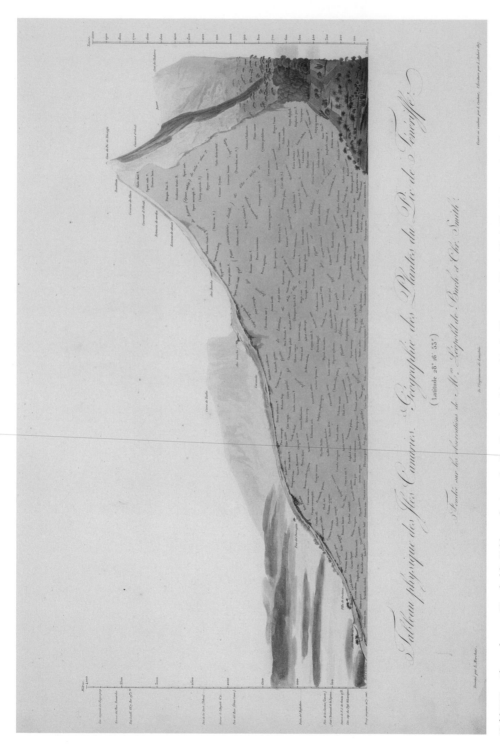

Tafel XIII_Alexander von Humboldt, *Tableau physique des Iles Canaries. Géographie des Plantes du Pic de Ténériffe*, 1817, ca. 43 × 60 cm, in: *Atlas géographique et physique du Nouveau Continent*, Tafel 2 (Lieferung 2), Berlin, SBB, Foto SBB

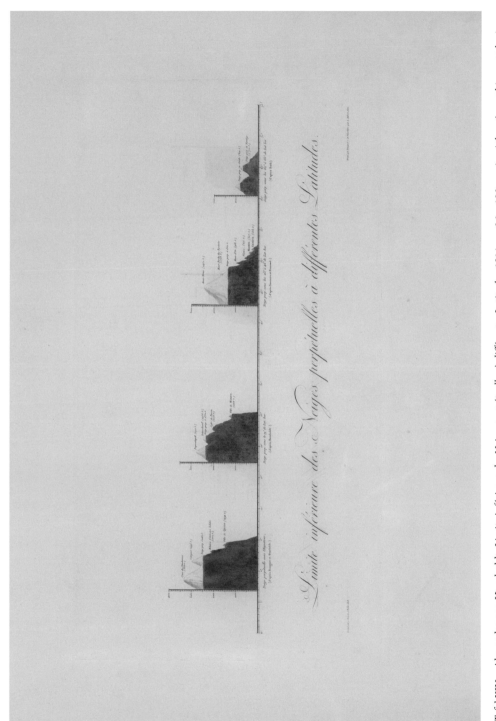

Tafel XIV_Alexander von Humboldt, *Limite inférieure des Neiges perpétuelles à différentes Latitudes*, 1814, ca. 86 × 120 cm, in: *Atlas géographique et physique du Nouveau Continent*, Tafel 1 (Lieferung 1), Berlin, SBB, Foto SBB

Tafel XV__Philippe Vandermaelen, collagiertes Kartenensemble, *Atlas universel*, 1827, daraus Bd. 4: *Amérique Septentrionale*, Tafel 1–76, und Bd. 5: *Amérique Méridionale*, Tafel 1–43, jeweils 56 cm × 41 cm

Tafel XVI_Juan de la Cosa, Weltkarte, 1500, Tinte und Aquarell auf Pergament, 93 × 183 cm, am linken Rand im Halbrund abgeschlossen, Museo Naval de Madrid